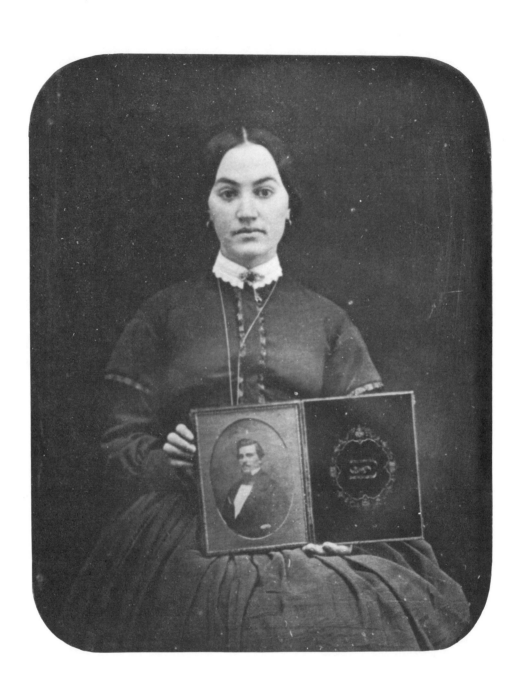

THE DAGUERREOTYPE
IN AMERICA

by
Beaumont Newhall

THIRD REVISED EDITION

DOVER PUBLICATIONS, INC., NEW YORK

Preface to the Dover Edition

This third edition has been expanded by the addition of sixteen more pages of plates; corrections and minor revisions have been made in the text; and the Bibliography has been brought up to date to include reprints of obscure and long out-of-print manuals, and microfilms of periodicals. I thank Dover Publications, Inc., for bringing the book back into print; it is my hope that it will not only be useful to scholars, collectors and the general reading public, but that it will also stimulate further research into one of America's most lasting contributions to the history of photography.

October 1975 BEAUMONT NEWHALL

◆

Copyright © 1961, 1976 by Beaumont Newhall.
All rights reserved under Pan American and International Copyright Conventions.

Published in Canada by General Publishing Company, Ltd., 30 Lesmill Road, Don Mills, Toronto, Ontario.
Published in the United Kingdom by Constable and Company, Ltd., 10 Orange Street, London WC 2.

This Dover edition, first published in 1976, is a revised and enlarged edition of the work first published in 1961 by Duell, Sloan & Pearce.

International Standard Book Number: 0-486-23322-7
Library of Congress Catalog Card Number: 76-691

Manufactured in the United States of America
Dover Publications, Inc.
180 Varick Street
New York, N.Y. 10014

Contents

Part I: AN ART AND AN INDUSTRY

Part II: PLATES

following page 112

Part III: A TECHNIQUE AND A CRAFT

Part IV: BIOGRAPHIES AND NOTES

Plates

following page 112

1. The family daguerreotype, about 1850.
2. Self-portrait. By Henry Fitz, Jr., probably 1839.
3. King's Chapel Burying Ground, Boston. By Samuel Bemis, 1840.
4. Merchants' Exchange, Philadelphia. By Walter R. Johnson, 1840.
5. Old Patent Office, Washington, D. C. By John Plumbe, Jr., about 1846.
6. Third Street at Chestnut, Philadelphia. By George Read, 1842.
7. Chestnut Street, Philadelphia, about 1844.
8. John Quincy Adams. By Philip Haas, 1843.
9. Andrew Jackson. Probably by Dan Adams, before 1845.
10. Zachary Taylor, about 1850.
11. John Tyler, about 1845.
12. State Street at Main, Rochester, New York. By Edward Tompkins Whitney, about 1852.
13. Ruins of the American Hotel, Buffalo, New York, about 1850.
14. Man sitting on sofa with dog, about 1850.
15. Butterfly collector, about 1850.
16. Mrs. Joseph Elisha Whitman, Sr., and her son Joseph Elisha, Jr., born 1853.
17. Cobbler, about 1850.
18. Tole ware maker, about 1850.
19. Frederick Warren, city marshal of Worcester, Massachusetts, about 1850.
20. "The Woodsawyer's Nooning." By George N. Barnard, 1853.
21. Seamstress, about 1850.
22. Woman with sheet music, about 1850.
23. Henry Brewer, of the H. & J. Brewer Drug Store, Springfield, Massachusetts, about 1850.
24. Ship in dry dock, Boston Navy Yard. By Southworth & Hawes, about 1852.
25. Locomotive "Hoosac."
26. Train wreck on the Providence and Worcester Railroad. By L. Wright, 1853.
27. Burning mills at Oswego, New York. By George N. Barnard, 1853.
28. Woodward Woolen Mill, Woodstock, Vermont, about 1850.
29. Steamship in dry dock, Boston. By Southworth & Hawes, about 1855.
30. Quaker sisters, about 1850.
31. Dog. By Sheldon Nichols, about 1855.
32. Girl, about 1850.

Illustrations in the Text

Introduction

PHOTOGRAPHY first came to America in 1839 in the form of the daguerreotype. For twenty years it is through the daguerreotype that we see the men and the places of the United States. In galleries all over the country silvered copper plates were polished mirror bright; fumed straw yellow and rose red with vapors of iodine, chlorine, and bromine; exposed in bulky wooden cameras; developed over heated mercury; fixed, gilded, washed, and fitted like jewels in cases. Thousands earned their livelihoods with Daguerre's invention; hundreds of thousands of Americans, rich and poor, famous and unknown, proud and meek, young and old, faced the mesmeric lens of the daguerreotypist's camera for the eternity of twenty to forty seconds of immobility.

More daguerreotypes have survived than would be imagined. Fortunately the process is relatively permanent. In their velvet-lined cases daguerreotypes are precious objects, which no one wants to throw carelessly away. In spite of the fact that many were melted down for their silver, and many others were ruined in bungling attempts to clean their tarnished surfaces, thousands remain in pristine condition, eloquent yet forgotten remembrances of the past.

No other pictorial technique was more popular in America in the 1850's: as Horace Greeley said, "In daguerreotypes we beat the world." There were more daguerreotype galleries in New York City than in all of England in 1853, and more on Broadway alone than in London. Americans were more grateful to Daguerre than Frenchmen. When he died, he was mourned by the daguerreotypists of New York, who voted to wear crape on their left sleeves for the space of thirty days. "Ah, what regard for immortality, what sentiment!" exclaimed the vice-president of the Société Libre des Beaux-Arts at a memorial service to Daguerre in the French town of Bry-sur-Marne, where he died in 1851. "America has shown herself grateful to our illustrious countryman, when French photographers were forgetful. . . . "

Introduction

In writing this history, my first debt is to the collectors who have preserved and generously made available to me not only daguerreotypes but documents and notes about some of the men who made them: the late Alden Scott Boyer of Chicago, who during his lifetime gave his entire collection on the history of photography to the George Eastman House, and who for five years sent me daily bulletins of "plucks and culls" from his extensive reading in the books he had collected; Mrs. Zelda P. Mackay of San Francisco; Helmut and Alison Gernsheim of London; Señor Julio F. Riobò of Buenos Aires; Dale Walden of Boise, Idaho; A. R. Phillips, Jr., of Los Angeles; Richard B. Holman of Boston; and Walter Scott Shinn of New York. I was made welcome with typewriter and copying camera in many libraries, historical societies, and museums. I thank in particular the Trustees of the Camera Club, New York; Mr. Clarence S. Brigham, retired Director of the American Antiquarian Society in Worcester, Mass.; Mr. R. W. G. Vail, retired Director of the New-York Historical Society; Mr. Walter M. Whitehill, Director and Librarian of the Boston Athenaeum; Mr. A. Hyatt Mayor, Curator of Prints, The Metropolitan Museum of Art, New York; Miss Grace Mayer, Special Assistant to the Director of Photography of the Museum of Modern Art, New York; Dr. Louis Walton Sipley, Director of the American Museum of Photography, Philadelphia; Mr. Paul Angle, Director of the Chicago Historical Society; and Mr. Charles Van Ravenswaay, Director of the Missouri Historical Society. Friends and colleagues have encouraged me by sharing their research and pointing out untapped sources of pictures and information: I am particularly grateful to Ansel Adams, Albert Boni, Roger Butterfield, I. Bernard Cohen, Marshall Davidson, Jay Leyda, and Ferdinand Reyher. The late John A. Tennant was my sole direct link with the past: he knew men who were daguerreotypists; from his vast knowledge of more than three quarters of a century's activity as writer, editor, and publisher he gave me help I could not have found elsewhere.

My wife Nancy has accompanied me every step of the way into the past and in the task of organizing the fruits of this research. She made the final selection of daguerreotypes for reproduction and the sequence of their presentation.

BEAUMONT NEWHALL

12

PART I

An Art and an Industry

1. A Wonder from Paris

AMERICA first heard about Daguerre's invention from Samuel F. B. Morse, the painter and inventor. He was in Paris in the winter of 1838-39, when he presented his electric telegraph to the Academy of Sciences, and held weekly demonstrations. "I am told every hour," he wrote his brother, "that the two great wonders of Paris just now, about which everybody is conversing, are Daguerre's wonderful results in fixing permanently the image of the *camera obscura* and Morse's Electro-Magnetic Telegraph."[1]

Just before he left Paris for home, Morse visited Daguerre, saw his daguerreotypes, and wrote about them on March 9, 1839, in a letter to his brother which was published in the New York *Observer*.

> They are produced on a metallic surface, the principal pieces about 7 inches by 5, and they resemble aquatint engravings; for they are in simple chiaro oscuro, and not in colors, but the exquisite minuteness of the delineation cannot be conceived. No painting or engraving ever approached it. For example: In a view up the street, the distant sign would be perceived, and the eye could just discern that there were lines of letters upon it, but so minute as not to be read with the naked eye. By the assistance of a powerful lens which magnified fifty times, applied to the delineation, every letter was clearly and distinctly legible, and so also were the minutest breaks and lines in the walls of the buildings; and the pavements of the streets. The effect of the lens upon the picture was in a great degree like that of the telescope in nature. . . . The impressions of interior views are Rembrandt perfected.[2]

All who saw Daguerre's pictures for the first time were equally impressed. They marveled that skill of hand played no part in their creation, and the amount of detail which was, so to speak, automatically recorded seemed almost beyond belief. No pictures like them had ever before been seen.

Many had already tried to accomplish what was now a reality: the fixation of the image of the camera. Morse must have shared the feelings of the German

scientist who, reading of the discovery, "felt something like the enviers of Colum-
bus, when he made the egg stand on its end."[3] For Morse, years before, had
made experiments while he was at Yale University "to ascertain if it were possible
to fix the image of the Camera Obscura."[4] Like most others, he did not succeed.
"Finding that light produced dark and dark light, I presumed the production of
a true image to be impracticable, and gave up the attempt. M. Daguerre has
realized in the most exquisite manner this idea."[5] The method by which Daguerre
achieved this long-sought-for end remained his secret during the time that Morse
was in Paris.

Like Morse, Louis Jacques Mandé Daguerre was a painter. Since 1822 one
of the popular Parisian spectacles was his "Diorama"—a theater without actors.
Scenery alone, of the most illusionistic kind, provided the amusement. There were
three separate stages inside the Diorama around a circular auditorium, the floor
of which was a great turntable that revolved to face, in turn, the stages, where
were shown huge paintings, seventy-two by forty-eight feet in size. When illumin-
ated from the top, the front alone of each picture could be seen; when lighted from
behind, another picture, painted on the back, became visible through the semi-
transparent canvas. By controlling the lighting, the pictures dissolved one into
another. Parisians paid admission to see such make-believe scenes as an Alpine
village before and after its destruction by an avalanche, or Midnight Mass at the
Church of St.-Etienne-du-Mont. The latter was one of the most popular of the
presentations: as night fell the church gradually darkened, the devout came to
take their places, and, to the peals of an organ and the fumes of incense, choir
boys lit candles. The Mass was sung, the faithful disappeared, the candles were
extinguished, and daybreak illuminated the stained-glass windows. The illusion-
ism was so perfect that a lad from the country threw a coin onto the stage "to
find out if it really was space in front of him." When an art student set up an
easel and began to paint the Diorama of Napoleon's Tomb, Daguerre said to him,
"Young man, come as often as you want to, but don't work here, because you'll
be making nothing but a copy of a copy. If you want to study seriously, go out
doors."[6]

The success of the Diorama depended almost entirely on its scenery. To
assist him in obtaining exact perspective, Daguerre, like so many other artists of
the day, used a camera obscura. This instrument was simply a box, with a lens

16

at one end and a ground glass at the other, on which the lens formed an image. By laying thin paper over the glass, the image could be traced.

It is difficult to establish exactly when Daguerre first had the idea of recording the camera image chemically, rather than by the laborious use of pencil and paper. It is likely that by 1826 he was well along the way to discovering this technique, which was to be known as photography. At least Charles Chevalier, the Parisian optician who supplied him with lenses, recollected that Daguerre said to him in that year: "I have fixed the images formed in the camera obscura."[7] At the suggestion of Chevalier, Daguerre began to correspond with a fellow countryman, Nicéphore Niépce, who, the optician said, was working along the same lines. After three years of mutual distrust and suspicion, the two became partners. Daguerre later recollected: "I contributed a camera, which I modified for this use and which, by extending greater sharpness over the larger field of the image, had much to do with our later success. Certain important modification which I had applied to the process, added to the further research of M. Niépce, led us to predict a happy conclusion when [in 1833] death tore from me this man, whose heart was as great as his knowledge profound. . . . Overwhelmed by this loss, I gave up our work for the time being; but soon I followed it up with zeal and attained the goal we had aimed for."[8] The first of his successful pictures which now exists is a view of the corner of his studio, showing statues, pictures, a wicker-covered bottle, bric-a-brac. The original, dated 1837, is in the collection of the Société Française de Photographie in Paris.

Daguerre kept his technique a secret.

By the fall of 1838 he was ready to market his invention. He announced an exhibition of his daguerreotypes, to open on January 15, 1839. The show never took place, for in the meantime François Arago, one of France's most distinguished scientists, Secretary of the French Academy of Sciences, and a Deputy in the Chamber from the Department of Pyrénées-Orientales, had become deeply interested. On January 7 he lectured about the daguerreotype to the Academy, and suggested that the French Government reward Daguerre for his invention and donate it to the entire world. He announced that he would make this request to the Minister of the Interior or the Chambers as soon as Daguerre proved to him that the process was indeed practical, inexpensive, simple, and portable.

Only a few months before, Morse had presented his electric telegraph before

17

the Academy, and had gained the respect of Arago and other distinguished Academicians. For this reason he had no difficulty in arranging the rendezvous with Daguerre which he reported to his brother.

Daguerre paid Morse the compliment of a return visit at noon on March 8, climbed the three flights to the apartment Morse shared with the Rev. Edward Kirk on the Rue Neuve-des-Mathurins, and spent over an hour examining the new invention. It was an unlucky hour for him: across the city the Diorama was in flames. Before word of the fire reached Daguerre, the building had burned to the ground. Everything was destroyed, Morse said, "all his beautiful works, his valuable notes and papers, the labor of years of experiments."[9] Happily the government was already making plans to award Daguerre, now left without means of support, a pension.

On his return to America, Morse persuaded the National Academy of Design, of which he was president, to elect Daguerre an honorary member. To our knowledge this recognition of photography as an art by an official body of painters is unique. "When I proposed your name," Morse wrote Daguerre. "it was received with wild enthusiasm, and the vote was *unanimous*. . . . I hope, before this reaches you, that the French Government, long and deservedly celebrated for its generosity to men of genius, will have amply supplied all your losses by a liberal sum. If, when the proper remuneration shall have been secured to you in France, you should think it may be for your advantage to make an arrangement with the government to hold back the secret for six months or a year, and would consent to an exhibition of your *results* in this country for a short time, the exhibition might be managed, I think, to your pecuniary advantage."[10]

Daguerre answered in July: "I am very proud of the honor which has been conferred upon me. . . . The transaction with the French Government being nearly at an end, my discovery shall soon be made public. This cause, added to the immense distance between us, hinders me from taking advantage of your good offer to get up at New York an exhibition of my results."[11]

The plan which the French Government adopted was to grant Daguerre a yearly pension of six thousand francs in return for a complete disclosure of his process. Isidore Niépce, who had succeeded to the partnership on the death of his father, was to receive four thousand francs. The bill was passed by both Chambers of government and it was announced that the disclosure would be made at a

18

special joint meeting of the Academy of Sciences and the Academy of Fine Arts in Paris on August 19, 1839.

By three o'clock on the afternoon of that day, every seat in the auditorium of the Palace of the Institute was taken, and two hundred stood outside in the courtyard. It was expected that Daguerre would explain the process, but Arago spoke in his stead. He began with an apology: "I have to express my regret that the inventor of this most ingenious apparatus has not himself undertaken to explain all its properties," he said. "Only this morning I begged the able artist to accede to a wish which I well knew was universal; but a bad sore throat—fear of not being able to render himself intelligible . . . proved obstacles which I have not been able to surmount."[12] Beyond these words, no transcript exists of the speech. But it was widely reported.

The London *Literary Gazette* for August 24 stated that Arago spent a good deal of time recounting the history of the discovery, "a subject already pretty well known to the public." After giving a résumé of Niépce's work, his partnership with Daguerre, his death, and Daguerre's subsequent discovery of "entirely new methods," the correspondent summarized Arago's description of the process "as now used by the author" in the following words:

A sheet of copper, plated with silver, is washed carefully in a solution of nitric acid, which removes from it all the extraneous matters on its surface, and especially any traces of copper from the silver surface. A slight degree of friction is requisite in this process, but it must not be applied always in the same direction. M. Daguerre has observed, that with the friction used in a particular manner, a sheet of copper thus plated with silver answered better than a sheet of silver alone; and he infers from this, that voltaic agency is not unconnected with the effect. When the sheet is thus prepared, it is placed in a closed box and exposed to the vapour of iodine. This vapour is made to pass through a very fine sheet of gauze, to render its distribution more equable over the surface of the silver, and in order to effect this object (which is quite indispensable) more certainly, the sheet has a small metallic rim raised all around its edges. A thin coating, of a yellow colour, is thus formed on the surface of the sheet, which is estimated by M. Dumas* at not more than a *millionth part of a millimetre* in thickness. The sheet, when covered with this substance, is of the most excessive sensibility to light; and is thus ready for the camera obscura. M.

*Jean-Baptiste-André Dumas (1800-1884), French chemist.

19

Daguerre, in the instrument which he uses, employs a piece of unpolished [i.e., ground] glass, which he brings first of all into the focus of the lens, in order to determine the exact point at which the sheet should be placed; and, as soon as this is determined, the sheet is placed accordingly. A few seconds, or minutes, according to the time of day, the state of the atmosphere, &c., suffice for forming the photogenic image; but it is hardly, if at all, visible on the surface of the sheet. To make it so, the sheet is placed in another box, and exposed to the vapour of mercury, heated to 60° Reamur, or 167° of Fahrenheit. One of the most curious circumstances attending this part of the process is, that the mercury must act at a certain angle. If the drawing is intended to be seen vertically, it must be suspended over the mercury at an angle of 45°; if it is to be seen at an angle of 45°, it must be suspended horizontally. On being taken out from the mercury-bath, the sheet is plunged into another bath of hypo-sulphite of soda; this solution attacking the parts upon which the light has not been able to act, and respecting the light parts,—being the very inverse of the action of the mercury. It may be supposed, therefore, observed M. Arago, that the light parts of the image are formed by an amalgamation of mercury and silver, and the dark parts by a sulphuret of silver at the expense of the hypo-sulphite of soda. M. Arago observed, that no satisfactory reason has yet been given for this latter part of the process. The sheet is finally washed in distilled water, and the operation is terminated. The drawing, thus obtained, is perfectly insensible to the action of light, but it is liable to injury, just like a crayon or pencil-drawing, and requires to be preserved under a glass. The effect of the whole is miraculous: and as an instance, we may mention that one of the drawings exhibited by M. Daguerre, on Monday, was the view of a room with some rich pieces of carpet in it; the *threads* of the carpet were given with mathematical accuracy, and with a richness of effect that was quite marvellous. . . .

We need hardly say that the most enthusiastic cheers responded from the grave benches even of the Academy, on the termination of M. Arago's description, and the President, M. Chevreul,* complimented M. Daguerre in the warmest terms.[13]

Once the secret of how to make a daguerreotype was announced, a fever for photography ran high in Paris. Marc-Antoine Gaudin, a young scientist who had invented a pneumatic pump, was in the audience. Years later he told how eager he and his friends were to try making daguerreotypes themselves. He rushed

*Michel-Eugène Chevreul (1786-1889), French chemist; later director of the Gobelins tapestry works; famous for his theories of color vision.

20

out to buy iodine right after the meeting, and was disappointed that the sun was already setting and that he would have to put off the trial until the next morning. "As soon as day broke," he recollected, "my camera was ready. It consisted of an ordinary lens of three-inches focal length, fixed in a cardboard box. After having iodized the plate while holding it in my hand, I put it in my box which I pointed out of my window, and bravely waited out the fifteen minutes that the exposure required; then I treated my plate, inclined at the normal 45° angle, with mercury, heating the glue pot which contained it with a candle. The mystery was done at once: I had a Prussian blue sky, houses black as ink, but the window frame was perfect! . . ."[14] Gaudin could hardly wait to show his picture to his friends; they were all getting the same kind of result; nobody had anything to compare with the poorest of Daguerre's pictures.

The process was not as easy as it looked. At the request of the government and in response to popular demand, the inventor gave a series of public demonstrations, and an instruction manual was published.

The book, titled *Historique et description des procédés du Daguerréotype et du Diorama,* first appeared in Paris under the imprint of Alphonse Giroux et Cie. on August 21, 1839. It was a paper-covered pamphlet of seventy-nine pages, containing lucid instructions and detailed scale drawings of the needed apparatus. Almost at once, English, German, Italian, Spanish, and Swedish translations were published; by the end of the year it had appeared in more than thirty variant editions.[15]

From this booklet Morse, like others all over the Western world, learned Daguerre's technique. "The first brochure which was opened in America at the bookseller's containing your exposé of your process, I possess," he wrote Daguerre.[16]

21

2. *First Trials*

IN HIS LETTER to Daguerre, Morse did not say when he received the published instructions and began to attempt to duplicate the pictures which had so impressed him in Paris. The *American Journal of Science and Arts* in its October, 1839, issue stated that Daguerre's book had arrived on September 20 via the crack steamer *British Queen,* seventeen days out of Liverpool. By the twenty-eighth, Morse exhibited a view of the Unitarian church, taken from the third story of New York University. The time of exposure, he recollected, was fifteen minutes.

This daguerreotype, which apparently no longer exists, was hailed by the *Journal of Commerce* as "the first fruits of Daguerre's invention, as put in practice in this country."[1] On reading this report, Morse at once wrote to the editor: "If there is any merit in first producing these results in this country, that merit I believe belongs to Mr. D. W. Seager of this city, who has for several days had some results at Mr. Chilton's* on Broadway. The specimen I showed you was my first result."[2]

Of D. W. Seager we know but little. On November 7, 1839, he presented to the American Institute "a specimen of the Daguerreotype which I produced in the month of September and exhibited at your last fair."[3] In the letter of transmittal which we have quoted, now in the George Eastman House, he claimed that his first result was on September 16—four days before the arrival of the *British Queen.* How he learned to make daguerreotypes is something of a mystery. There is a picturesque story, related by the brother of George W. Prosch, who built Morse's camera and later became a daguerreotypist, that Seager was in England when the news of Daguerre's secret technique was made public. Just as the ship in which Seager was sailing to America was leaving the dock in London, a friend threw him a copy of Daguerre's manual, fresh from the press. Was it this choice of a *bon voyage* gift which brought the daguerreotype to America?

*James R. Chilton, 263 Broadway, New York; chemist and, later, daguerreotypist.

22

No work by Seager exists. On October 5 he lectured on the process at the Stuyvesant Institute; the announcement stated that "the following gentlemen have given permission to be referred to as being familiar with the process and its extraordinary results: President Duer,* Columbia College; Professor Morse; James R. Chilton, Esq.; Jno. L. Stephens, Esq.†"[4] As the meeting was scheduled for 7:30 P.M., it is most unlikely that Seager was able to demonstrate the process. Full sunshine was practically a necessity, so weak in light sensitivity were plates made from Daguerre's specifications.

America's first photographer disappeared from the scene almost as soon as he arrived. He was in Mexico in 1867, where for more than ten years he had been economic adviser to the government; apparently he had long given up his photographic interests.[5]

Morse, who was one of America's most skilled and respected portrait painters, almost immediately began to attempt what Daguerre had told him was impossible: the taking of portraits by the daguerreotype process. He recollected that toward the end of September or early in October he succeeded in making "full length portraits of my daughter, single, and also in groups with some of her young friends. They were taken out-of-doors, on the roof of a building, in the full sun-light, and with the eyes closed. The time was from ten to twenty minutes."[6] The only trace of these experiments is a crude wood-engraving of a double portrait, printed by America's first photographic historian, Marcus A. Root, in his *The Camera and the Pencil*. The draftsman who copied the daguerreotype drew the eyes open.

At about the same time Morse's friend, John W. Draper, began identical experiments. As a scientist he had long been interested in the chemistry of light, and had used light-sensitive materials in the study of the solar spectrum. When William Henry Fox Talbot's "photogenic drawing" process was published in the spring of 1839, Draper repeated the Englishman's experiments, and discovered that by using lenses of large aperture and short focal length, exposures could be reduced. When Daguerre's instructions arrived, he applied this principle. "I

*William Alexander Duer (1780-1858): judge, N. Y. Supreme Court; President of Columbia College.
†John Lloyd Stephens (1805-52): traveler and author; took daguerreotypes in Yucatán in 1841 (see pp. 73-75.)

23

resorted to a lens of five inches diameter and seven inches focus [i.e., *f*/1.4], which I still have. I dusted the sitter's face with flour and pushed the back of the camera to the violet focus."[7]

Draper sent a sample of his portraiture to the English scientist, Sir John F. W. Herschel, on July 28, 1840; it was a portrait of his sister, taken at an exposure of 65 seconds. The daguerreotype was in existence until 1933, when the image was washed away in an attempt to clean it. It has been widely reproduced as the world's first portrait photograph. Draper made no such claim. In his letter to Herschel he simply stated that it was "no better in point of execution than those ordinarily obtained."[8]

He did, however, claim that he was the first to take a portrait by Daguerre's technique. "I believe I was the first person here who succeeded in obtaining portraits from the life," he wrote Herschel; and he later stated: "How any doubt can now be entertained as to who took the first sun-portrait, passes my comprehension."[9]

Morse was more modest. In 1849 he wrote: "If mine were the first, other experimenters soon made better results, and if there are any who dispute that I was the first, I shall have no argument with them; for I was not so anxious to be the *first* to produce the result, as to produce it in any way. I esteem it but the natural carrying out of the wonderful discovery, and that the credit was after all due to Daguerre. I lay no claim to any improvements."[10]

Others in America were taking daguerreotypes in these first weeks of enthusiasm. Joseph Saxton of the United States Mint in Philadelphia threw together a magnifying glass and a "seegar" box to make a camera and with other home-made equipment somehow succeeded in taking a recognizable picture of the Central High School. The daguerreotype, which Saxton said he took on October 16, 1839, and which was described in the *United States Gazette* on October 24, is now in the collection of the Pennsylvania Historical Society in Philadelphia. It is the only existing American daguerreotype that can be surely documented as having been taken in 1839. Its small size (1¾ by 2⅜ inches), its lack of detail, and its short tonal scale—the image is hardly more than a silhouette—are in marked contrast to Daguerre's results. If it is typical of what was being produced elsewhere in the country, Americans had much to learn.

Saxton had his plates made by Robert Cornelius, a lamp maker and metal-

24

worker skilled in plating. Almost at once Cornelius himself became interested in the daguerreotype, learned the process, and added his claim of priority in portraiture to those of Morse and Draper. He took, he said, a self-portrait in his backyard. "I was alone and ran in front of the camera," he told Julius F. Sachse, historian and editor of the *American Journal of Photography,* some thirty years later.[11] The portrait, now in the private collection of Mrs. Joseph Carson, is obviously an early experiment, but its 1839 production date cannot be documented. Even Sachse, the most ardent champion of Cornelius, had to admit that "unfortunately the exact date of this successful experiment at portraiture has not come down to us, nor is Mr. Cornelius able to recall it to a certainty."[12] The records of the American Philosophical Society state that Cornelius showed a daguerreotype at the December 6, 1839, meeting, but the subject is not specified. Had it been a portrait, the fact would surely have been noted.

In the winter or spring of 1840 Cornelius established the first portrait gallery in Philadelphia; it was patterned on the New York studio of John Johnson and Alexander S. Wolcott which the New York *Sun,* in its issue of March 4, 1840, called "the first daguerreotype gallery for portraits."

John Johnson recollected that he brought Alexander Simon Wolcott of New York a description of Daguerre's discovery on October 6, 1839, and that they at once made a camera and took a "profile miniature" on that very day.[13] As proof, he offered the entry in his daybook of the purchase of chemicals. The camera was miniature; 4 by 2 by 2 inches. Instead of a lens they used a concave mirror. The light-sensitive silvered plate was placed in front of the mirror, in the focus of the rays it reflected. Johnson said he sat in a beam of sunlight for five minutes; the result was "a profile miniature on a plate not quite ⅜ in. square."[14]

Wolcott and Johnson were encouraged and by the end of the year built a larger camera of the same design with the assistance of Henry Fitz, Jr., a telescope maker who had just returned from a trip to England in November. Experiments were tried on 2-by-2½-inch plates "with tolerable success." One of these experiments is believed to be the self-portrait of Fitz with eyes closed, now in the Smithsonian Institution, Washington (Plate 2). Wolcott patented this camera on May 8, 1840,[15] just after he and Johnson moved their gallery in New York from 52 First Street to the Granite Building on the corner of Broadway and Chambers Street.

25

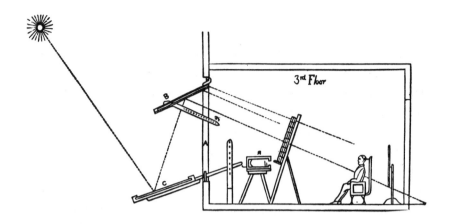

Their studio was an unusual sight. Hanging out of an upper-story window, right over the street, were two huge mirrors. The lower mirror reflected the sun's rays upwards to the surface of the second mirror which, in turn, bounced the sunbeam directly onto the face of the sitter, who was seated in a posing chair, his head held immobile by an iron clamp. To soften somewhat this harsh light, Wolcott and Johnson intercepted the sunbeam with a rack of glass bottles filled with a blue solution of copper sulphate.

Wolcott's camera was introduced to England by Johnson's father, and was used by Richard Beard in his portrait studio in London.

> *London Morning Chronicle, Sept. 12, 1840.* By this new process the time required for a person to sit for his portrait is reduced so that under the different circumstances of the intensity of light, &c., a likeness may be taken in from one to four minutes. At the same time the pain of sitting exposed to the direct rays of the sun is greatly diminished as the light is modified, by being transmitted through coloured glass, so that any person even with the weakest sight can bear it without any inconvenience.

Despite the claims of Morse, Draper, Wolcott, and Johnson, Americans were not the first to make portraits by photography. Before details of the technique had crossed the Atlantic, portraits were already being taken in France. They were probably no better—nor worse—than the corpse-like images Morse produced of his daughter and her friends, with whitened face and closed eyes, or the tiny miniatures of Wolcott and Johnson which would not cover a thumbnail. In the Parisian satirical magazine *Charivari* for August 30, 1839, we learn how it

was done. We translate: "You want to make a portrait of your wife. You fit her head in a fixed iron collar to give the required immobility, thus holding the world still for the time being. You point the camera lens at her face; but, alas, you make a mistake of a fraction of an inch [in focusing], and, when you take out the portrait it doesn't represent your wife—it's her parrot, her watering pot—or worse."

An edition of Daguerre's manual published by Susse Frères and Lerebours before November, 1839, gave more serious advice; "To make a portrait, you must have access to bright light, and this is even more important with subjects whose complexion is vivid, for red is, so to speak, the equivalent of black. Success will only come in exposing the sitter to the sun, in the open air, with reflectors of white cloth. You can, as Arago has shown, put in front of the sitter a large pane of blue glass; this will eliminate the fatigue which causes the inevitable closing of the eyes. . . ."

François Gouraud, a pupil of Daguerre's who was visiting America, wrote that "within fifteen days after the publication of the process of M. Daguerre in Paris, people in every quarter were making portraits. At first they were all made with *the eyes shut*. M. Susse, of the Place de la Bourse, was one of the first amateurs who succeeded in making them in the most satisfactory manner."[16]

Gouraud arrived on the S.S. *British Queen* on November 23, 1839. He came to America as the agent of Alphonse Giroux & Cie., the Paris firm which sold not only Daguerre's manual but also the only daguerreotype apparatus personally endorsed by him. The visitor's mission was to establish a central overseas agency for the sale of cameras and apparatus so that "the artists and amateurs of the two Americas should enjoy the same advantages that are offered to France by the new discovery of Mr. Daguerre, and to guard them from the frauds of a reckless competition prejudicial to the process."[17]

Although English translations of Daguerre's manual were readily available in America,[18] written instructions, however lucid and specific, were no substitute for personal demonstrations. This François Gouraud supplied. He also showed examples of Daguerre's work in New York, Boston, and Providence which so excelled anything that had been done in America that Morse and other pioneers became his eager pupils.

27

3. *Daguerre's Agent*

MONSIEUR Gouraud lost no time. Within a week after landing he called at the office of the newspaper which had published Morse's first account of Daguerre's discovery.

New York Observer, November 30, 1839. THE DAGUERREOTYPE.
We have been favored with the sight of a large number of pictures from a collection of the exquisitely beautiful results of this wonderful discovery, just arrived from Paris; several of them *taken by Daguerre himself.* The collection is in the hands of M. Gourraud [sic], a gentleman of taste, who arrived on Saturday in the British Queen. . . . M. Gourraud is on his way to the Havana for the purpose of transmitting to Paris, photographic views of the scenery of that part of the world.

Our readers may suppose that, after reading the highly wrought descriptions of the new art, which we have transferred to our paper from European points, we were prepared to form something like an adequate conception of its power; but we can only say as the Queen of Sheba said after examining the exhibition of the glory of Solomon, "The half was not told us." We can find no language to express the charm of these pictures, painted by no mortal hand. . . . We are told that the shop-windows in Paris, in which the photographic pictures are exhibited, are so beset by the crowd that the streets are impassable in their vicinity. . . . We hope M. Gourraud will stay so long among us as to give us a few practical lectures, and also to furnish an opportunity for our citizens to see this collection of Nature's own paintings.

The editor's hope was fulfilled when Gouraud sent prominent New Yorkers a lithographed invitation to a private viewing of the collection on December 4 at the Hotel Francois, 57 Broadway.

He exhibited some thirty pictures. From eyewitness accounts, the daguerreotypes must have been similar to those Daguerre showed in Paris during the previous winter and spring—brilliant, highly detailed images on silvered copper plates 6½ by 8½ inches in size. To the French subjects, Gouraud added a few

taken by himself in New York. Philip Hone, onetime mayor of New York City, wrote in his diary that the exhibition consisted of "views in Paris, and an exquisite collection of objects of still life. . . . Every object, however minute, is a perfect transcript of the thing itself; the hair of the human head, the gravel on the roadside, the texture of a silk curtain, or the shadow of the smaller leaf reflected upon the wall, are all imprinted as carefully as nature or art has created them in the objects transferred; and those things which are invisible to the naked eye are rendered apparent by the help of a magnifying glass."[1]

On December 20 Gouraud moved the collection uptown to the more accessible Granite Building on the corner of Chambers Street and Broadway. He reduced the admission fee from $1.00 to 50 cents, and gave lessons. Samuel F. B. Morse became an eager student, hoping that from the personal instruction of Daguerre's pupil he would master details of manipulation which were unclear in the inventor's instruction manual. On January 14, 1840, he noted: "Nothing particular in the polishing, except that the acidizing process is more essential than I had supposed, and requires greater delicacy in the manipulation."[2]

His technique improved so that the *Evening Post,* on February 18, praised one of his daguerreotypes as "remarkable for its strength and distinctness, quite as much so as the best of those executed by Daguerre himself, which has been brought to this country." Morse took this daguerreotype with a camera he built himself. On the twenty-first there appeared this letter in *The Evening Star:*

> Mr. Editor—I am glad to learn, from a respectable journal of this city, that Professor Morse has executed a specimen of photogenique drawing as distinct as it could be done by Mr. Daguerre himself, and that he has, from Mr. Daguerre's work, constructed the instrument with great nicety himself. Having endeavored, during two months, to give to Mr. Morse all the instructions in my power, I am naturally pleased to hear of his success, as I should of the success of all the numerous amateurs who have attended my private or public instructions of the process of Daguerreotype.
>
> I remain, sir, your obedient servant,
>
> > FRANÇOIS GOURAUD
> > Pupil of Mr. Daguerre

Morse replied that before Gouraud had arrived in the United States, he had already made daguerreotypes from the instructions in Daguerre's book. He

29

had eagerly taken the opportunity of studying with Gouraud, but the two months' instruction led to nothing. "He revealed nothing *new* to me. . . . All the instruction professed to be imparted by M. Gouraud, I have felt it necessary to forget."[3] A few days later Morse publicly accused Gouraud of degrading the name of Daguerre by selling toilet articles at his exhibition of daguerreotypes.

In the midst of this exchange of letters, Gouraud left New York for Boston; he apparently had given up his project of going to Cuba. On March 6, 1840, he held a private opening of his collection of daguerreotypes at the Tremont House; on the eleventh the public was invited to view them at Horticultural Hall, and on the twenty-fourth he began a series of four lectures at the Masonic Temple.

> *Boston Daily Evening Transcript, March 28, 1840.* The explanation of the process of producing the Daguerreotype pictures, gave the utmost possible satisfaction to an audience of five hundred ladies and gentlemen, the number of whom would have been twice or thrice increased if the lecturer had not judiciously limited the issue of tickets, to prevent confusion and give every auditor a full opportunity to hear and see. During his lecture Mr. Gouraud prepared a plate, describing the mode of operation as he proceeded, which, when finished, was placed in the camera obscura, and the whole apparatus being then set on a window of the hall commanding a view of Park Street from the Church to Beacon Street, including a portion of the Common—a most beautiful and perfect picture was produced in *ten minutes,* to the delight and astonishment of the spectators.

Edward Everett Hale, who was to become famous as the author of "The Man Without a Country," was one of Gouraud's pupils. He tried to make a portrait on April 15, with the help of his cousin, Frank Durivage. "Took a view of Mr. Mott's Church," he wrote in his journal. "I stood in the picture myself, getting Frank to open and close the camera at the right time. But this operation was rather a failure, for having stood mostly against a strong dark shade, nothing could be seen but my white shirt bosom and face and my two legs, which came against a light in the picture. It seemed really more wonderful than ever to think that the picture took itself so entirely that I, who was the artist if any one was, was represented (and correctly) in the drawing."[4]

On the very day that young Hale was making this experiment, Gouraud sold a complete apparatus to another student, a Boston dentist named Samuel Bemis. The outfit, neatly packed in the original wooden case in which it was de-

livered, is now in the George Eastman House, Rochester—the camera, its brass-mounted lens and ground-glass screen; the iodizing box with its wooden cup for the particles of iodine; the slotted box to hold the plates; the silvered copper plates themselves, 6½ by 8½ inches in size; the mercury bath, a tapered box on four legs with an iron bottom, a thermometer on its side, curtained window, and inside a sloping rest for the plate; the alcohol lamp with which to heat the mercury and dry the plate after washing.

Dr. Bemis paid Gouraud $51 for the apparatus, $2.00 apiece for twelve plates, and $1.00 for freight; the receipted bill is preserved with the camera. Four days after he had bought the equipment he made a daguerreotype of King's Chapel Burying Ground (Plate 3). On the back of the homemade frame is the handwritten note:

> *Boston, April 19 1840. –S. A. Bemis's first daguerreotype experiment.—Iodizing process 25 mts. (apparatus new), camera process 40 mts.—Wind N.W., sky clear, air dry and very cold for the season.—Lens Meniscus Daguerr's apparatus.—Time 4.50 to 5.30 p.m.; N. Y. plate, ordinary.*

The state of the weather was noted because so little was known about the factors which influence exposure. Later on, daguerreotypists learned that their plates were more sensitive in dry weather than in damp, and that just before a thunderstorm broke, their exposures were the shortest.

The picture which Dr. Bemis made on that April day in 1840 is an excellent record. Like all early daguerreotypes, it is a mirror image: the buildings are laterally reversed. The doctor photographed with an eye for detail, and yet the picture hangs together; miraculously we behold the very atmosphere of Boston over a hundred and twenty years ago.

Only a dozen more daguerreotypes by Dr. Bemis are known to exist. They are all in the George Eastman House collection. Most of them are other views of King's Chapel and the Burying Ground, taken probably in the winter of 1840-41, for changes are discernible in the buildings, and a heavy snow has fallen. One is most curious: it is on silver paper. Presumably it is an experiment, for the image is so faint that it is barely visible.

While in Boston, Gouraud published, under the title *Description of the Daguerreotype Process,* a condensation of Daguerre's manual.[5] In it he reprinted from the *Boston Daily Patriot and Advertiser* of March 26, 1840, an account of how to take

portraits by the daguerreotype. Before he had left Paris—which must have been before November 1, 1839, when the *British Queen* sailed from Liverpool—Abel Rendu, "a young man in the employment of the Minister of Public Instruction," had shown him portraits taken on daguerreotype plates with a simple, uncorrected meniscus lens. Rendu was dissatisfied with the results, for they lacked "the positively mathematical perfection which M. Daguerre required." Gouraud stated that he did not bring any examples with him from Paris, thinking that he would take portraits in America. It is not known if he did so; no examples of his work in this field have come to light. Yet Philip Hone, on seeing the collection which Gouraud exhibited in New York, praised the exquisite detail of the daguerreotypes by pointing out that "the hair of the human head" could be distinguished in them. And the painter George Fuller wrote to his father from Boston, on April 11, 1840, that he proposed to purchase a camera from Gouraud and take lessons from him. "But two minutes' time is required to leave a complete impression of a man's countenance, perfect as nature can make it," Fuller wrote, and concluded, "We can afford to take a perfect likeness for $7.00; the plate and glass will cost $2.00, leaving $5.00. With custom enough fifty could be taken in one day."[6]

Abel Rendu himself came to America, sent by Alphonse Giroux to find out why Gouraud did not pay his bills. Gouraud was in financial distress. His New York landlord sued him for rent, and it is said that his personal effects were seized in April. In May we find Gouraud in Providence, Rhode Island, showing a collection at Union Hall. In 1842 he was in Buffalo: Walker's *Buffalo City Directory* of that year listed "Gonraud, Francois, daguerreotype." The typesetter must have misread *u* as *n,* for Samuel F. B. Morse met the Frenchman at Niagara Falls; all was forgiven, and Gouraud served as Morse's guide.

From Buffalo, Gouraud toured the country, lecturing to audiences of thousands on a bewildering yet spectacular memory system. He wrote a manual on the subject and a dictionary. He died before his book on shorthand, *Practical Cosmophonography,* appeared in 1850. He called himself François Fauvel-Gouraud then, and had long since abandoned the daguerreotype. What he thought of it he summed up in a terse sentence in his *Phreno-Mnemotechny:* "The Daguerreotype will hardly . . . afford subsistence for satisfying a tame hare."

32

4. *The Shaping of an Industry*

WHEN Gouraud reached his discouraging conclusion in 1845, daguerreotypes were so popular in America that the word was assimilated, not without difficulty, into everyday language. If the French had difficulty spelling it (the magazine *L'Artiste* wrote "Daguérotype," and the newspaper *Gazette de France*, "Daguerrotype"), Americans could be excused, though Edgar Allan Poe sternly pointed out "this word is properly spelt Daguerréotype, and pronounced as if written Dagairraioteep. The inventor's name is Daguerre, but the French usage requires an accent on the second e, in the formation of the compound term."[1] But the four-syllable pronunciation was already American usage.

> *New York Observer, December 7, 1839.* THE DAGUERREOTYPE. We have been asked how this novel name is pronounced. Some truly mangle it most sadly. *Dog-gery-type*, says one,—*Dag-gery-type*, says another,—*Daygwerryotype* says a third. We have endeavored to procure the right pronunciation.
>
> *Daguerre* is the name of the distinguished discoverer of this wonderful art. His name has been given to this process by the savants of Paris. His name, spelt in our language, will be *Dargair;* the accent on the last syllable. If to this be added the latter part of the word, *o-type*, the word is easily pronounced, and might be spelt to conform to the sounds of our language *Dar-ger-row-type*, making *g* hard before *e*, and putting the accent on the second syllable.—*J. of Com.*

Although an adjective, *daguerréotypical*, was made of the word by William Makepeace Thackeray, in common usage the inventor's name alone was used to form the adjective, which was spelled "Daguerreian," "Daguerrean," "Daguerrian," and "Daguerran." This adjective also served as a noun, synonymous with "daguerreotypist" or "daguerreotyper." The word "daguerreotype" was used frequently outside of its technical meaning; the Boston publication *The Daguerreotype: A Magazine of Foreign Literature and Science* was not a professional journal about photography. Its publisher set forth in a prospectus that the magazine was intended "to supply . . . a series of striking pictures of the constantly-

varying aspect of public affairs . . . and is, therefore, not inaptly, called the Daguerreotype."

Within a decade, daguerreotyping was recognized as an industry. The Commonwealth of Massachusetts officially reported in 1855 that 403,626 daguerreotypes had been taken in the state during the past twelve months, the work of 134 "Daguerreotype Artists" and 260 hands.[2] In 1860, at the end of the daguerreotype era, the United States Census reported 3,154 photographers. Every major city and town had at least one gallery—as the studios were universally called—and itinerant daguerreotypists traveled to remote backwoods and frontier areas in their horse-drawn "saloons," or floated down the rivers in houseboats. From Louisville, Kentucky, came the report in 1855: "There is not a place of one hundred inhabitants in any of the Southern or Western states that have not been visited by from one to any number of itinerants."[3]

Very little is known about most of these pioneer photographers. From city directories we can produce hundreds of names, for the classification "Daguerreotype Miniatures," or "Daguerreian Artists" began to appear in the 1840's, just above "Dentists," which they sometimes outnumbered. From these records we can gain knowledge of the periods of activity and the wanderings of a host of daguerreotypists. Occasionally an obituary or a newspaper article enables us to visualize a personality. But, with rare exceptions, we can seldom study a sufficient number of daguerreotypes known to be made by one person to attempt to distinguish individual style. Daguerreotypes were unique; nothing, neither negative nor proof, was left behind when the picture had been delivered; and although museums were suggested, no action was taken. Except for the thousands of extra daguerreotypes kept by Albert Sands Southworth and Josiah Johnson Hawes in their Boston gallery, no contemporary collections exist. Such extraordinary collections of daguerreotypes as the "National Portrait Gallery" of Mathew B. Brady, who was to win fame for his photographic documentation of the Civil War, or the three hundred daguerreotypes of California mining operations taken by Robert H. Vance are lost.

Daguerreotyping had its Vasaris in the persons of two devoted journalists, Samuel Dwight Humphrey and Henry Hunt Snelling, who independently and in competition founded the world's first photographic magazines. Humphrey was a daguerreotypist from Canandaigua, New York, who had moved to New York

City. On November 15, 1850, he began publication of *The Daguerreian Journal.* When he changed the title two years later to *Humphrey's Journal Devoted to the Daguerrean and Photogenic Arts* he claimed a circulation of two thousand. Snelling already had publishing experience when he went to work for Edward and Henry Tiebout Anthony in the New York stockhouse of photographic goods; while still working there he began publishing, in January, 1851, his *Photographic Art-Journal.* Three years later he changed the title to *Photographic and Fine Art Journal.* Both magazines were similar. They contained original contributions, reprints from English textbooks, translations from the French, and lively news from "the fraternity." If we lack exact biographical data about the men who established photography in America as a profession, we can vividly reconstruct their problems, their techniques, and their professional careers from the pages of these journals. We shall allow Humphrey and Snelling to speak frequently and freely in our account of daguerreotyping in America.

Yankee ingenuity transformed Daguerre's technique to a perfection undreamed of in Europe, and daguerreotypists in France and England boasted in advertisements that they worked "The American Process." At the Great Exhibition in the London Crystal Palace in 1851, Americans took three of the five medals in daguerreotyping. Editorials in the London and Paris press praised the American contributions with enthusiasm matched only by their praise for the yacht *America* and the exceedingly light construction of our racing sulkies. We have been able to reconstruct the American Process in detail, thanks again to Humphrey and Snelling, who published instruction manuals as well as their periodicals. This technical account forms Chapter 14 of this book.

In brief, the improvements that were worked out in America were largely mechanical. The silvered copper plates were re-silvered or "galvanised" by electrotyping. They were polished or "buffed" with more efficient tools, often power driven: twenty patents were issued for devices to hold the plate during this operation. The boxes used to sensitize or "coat" the plates first with iodine fumes and then with fumes of chlorine and bromine, separately or in combination, were functionally designed. Cameras became more compact: the first application of the accordion-like bellows to make the camera box collapsible was due to the ingenuity of William Lewis and William Henry Lewis of Daguerreville, near Poughkeepsie, New York, in 1851. Development over hot mercury, or "mercurial-

35

izing," was done in cast-iron pots. Apparatus was standardized, and mass-produced in factories.

Plate sizes were standardized.

4/4 or whole plate	6½ by 8½ inches
1/2 or half plate	4¼ by 5½ inches
1/4 or quarter plate	3¼ by 4¼ inches
1/6 or sixth plate (medium)	2¾ by 3¼ inches
1/9 or ninth plate	2 by 2½ inches

Cases to contain the finished pictures were manufactured in quantity. They were at first made of pressed paper, to imitate leather. The daguerreotype was covered by a brass cut-out mat. On top of this was placed a thick piece of plate glass of identical size. The sandwich was bound together with gummed paper or goldbeater's skin, and often enclosed in a delicate frame of gilded brass called a "preserver." The assembly fitted snugly into the boxlike case. Highly ornate, plastic "Union cases" became popular at the end of the daguerreotype era; their manufacture is the first recorded industrial use of thermoplastic in the world.

Most importantly, by improved sensitizing techniques developed in England, and by the use of imported Viennese and Parisian lenses of relatively large aperture, and consequently of greater light-passing power, exposures were reduced from minutes to seconds: the average portrait sitting lasted from twenty to forty seconds.

To learn to daguerreotype well enough to hang out a shingle took only a little instruction and a modest investment. George Reed, for example, bought a camera in February, 1844, from Anson Clark, a daguerreotypist in West Stockbridge, Massachusetts, and took instruction from him. By March he was in business, and in one month had cleared the sum of sixty dollars.[4]

Hundreds answered advertisements such as appeared in the *New York Herald* in 1852:

WANTED, fifty young men to learn the art of daguerreotyping. Instruction given in a few days, and a whole set of apparatus furnished for $50. Direct "Broadway Post Office" will meet with immediate attention.

The students came from all walks of life: masons, engravers, grocers, express men, window-shade manufacturers, locksmiths, jewelers, carpenters, writing

masters, and railroad men are in the roster of those who, at one time or another, were professional cameramen. Many of them were jacks-of-all-trades; one of them, Frank Gage, wrote in 1858: "Today you will find the Yankee taking daguerreotypes; tomorrow he has turned painter; the third day he is tending grocery, dealing out candy to the babies for one cent a stick."[5]

Not all were serious; the majority quickly dropped daguerreotyping as a profession. The Boston directories for the years between 1840 and 1861 listed 180 names under the heading "Daguerreotype Miniatures." Of these only seven stayed in business for ten years or more, and seventy-seven are listed for one year only. Too many saw in daguerreotyping a quick road to riches. John H. Fitzgibbon of St. Louis, who spent a lifetime in photography, echoed the concern of the handful of men who were dedicated to the art of Daguerre in *The Western Journal* for 1851:

> Many young men, suddenly captivated with a love for the Fine Arts, take it into their heads that they are destined to make a figure, or *figures* in the world, consequently their genius must no longer be hidden under a bushel, but expand its wings in a higher intellectual atmospheric region. Or, what is still more likely, they are lured into this pursuit by a prospect of an *easy* and rapid accumulation of money. Instantly they repair to an itinerant *professor* and for *ten, twenty* or *thirty dollars* are regularly manufactured in the short space of from three to six days into full-bred professors of the photographic art. Is it then to be wondered at that we find so many awful, ghost-like looking shadows poured out upon the world by a host of ignorant pretenders? Not at all![6]

The profession was divided into three classes, Snelling said: "Those who deservedly stand pre-eminent in the art; those who are not so successful in its practical details, but who aim at a higher standard; and those who have taken it up merely for the sake of a precarious and easy livelihood."[7] He was writing in 1853, but the schism had existed ever since daguerreotyping swept through the country.

Boston, Philadelphia, and New York were from the outset the centers of the daguerreotyping industry. In these cities the finest daguerreotypes the world has known were produced, in galleries where new techniques were constantly being developed, which their students spread throughout the country. In these cities, too, the cheapening of the process and the lowering of standards first began, which led to the replacement of the daguerreotype by the negative-positive processes on which present-day techniques are founded.

37

5. *Boston Pioneers*

Two galleries opened in Boston in 1841, the United States Photographic Institute of John Plumbe, Jr., and the Artists Daguerreotype Rooms of Albert Sands Southworth and Co. The careers of their proprietors and the fortunes of their enterprises are in sharp contast, and form a pattern which was to be followed elsewhere. Plumbe took up daguerreotyping to make money. As soon as he could he hired others to do the work, and established a chain of galleries in various cities. His name, stamped on the products of these galleries, was a trademark rather than a signature. His prices were low. His venture was short-lived. Southworth and his partners looked upon daguerreotyping as an art. They boasted that they did not employ cameramen, but personally posed their sitters. Their prices were high, and they refused to lower them in the face of competition. The studio was active throughout the entire daguerreotype era, and one of the partners, Josiah Johnson Hawes, continued in business at the same location for the rest of the century.

John Plumbe, Jr., was a railroad man. Born in Wales in 1809, at twenty-three he was superintendent of the railroad between Richmond, Virginia, and Roanoke, North Carolina. He was one of the first to dream the great American dream of a railroad linking the Atlantic and the Pacific. In 1838 Congress gave him $2,000 to survey the route from Milwaukee to Sinipee, Wisconsin. When the money was gone he was back in Washington where, Plumbe later recollected in the one and only issue of his magazine, *The Plumbeian,* "we continued to press the matter upon Congress—until, after having devoted nearly all our time, for upwards of three years, upon the line—exhausting all our means (pecuniarily)—we, at last, after being laughed at as a madman, were obliged to resort to taking Daguerreotype likenesses, in order to keep up the soul of our undertaking by supporting our body."[1]

By February, 1841, he was in Boston, "Professor of Photography" at Har-

38

rington's Museum. Where, or from whom, he learned to daguerreotype is not known. Within months he moved to a hall over the Whig Reading Room where he opened the United States Photographic Institute. He was quick to take advantage of each new technical development. He met Daniel Davis, Jr., who was to write the first book on electricity in America, and who was already experimenting with Daguerre's technique along with his brothers Ari and Asahel. Ari demonstrated the process at the Lowell Institute in February; in June he advertised cameras for sale. One of his employees, Elias Howe (who later invented the sewing machine), cut the metal mats.

Despite the official ring of its name, the United States Photographic Institute was a private enterprise. Plumbe took portraits, sold apparatus and materials, and gave instruction. His portraits were so popular that he had to keep a register of sittings, and require appointments. There is no trace of this early work, but it greatly impressed the public, to judge from the press notices which the Professor reprinted in a circular headed DAILY MAIL—EXTRA and datelined United States Photographic Institute, Boston, September, 1841. The *Bay State Democrat* wrote that Plumbe "takes the very life from a man, and transfers it to his silver plate. We saw one of KRANTZ the other day, taken by the Professor's Daguerreotype, so faithfully that he has not looked well since."

At the Institute Plumbe also sold apparatus and gave instruction. He forthrightly appealed to the pocketbook:

> The price of a Daguerreotype miniature, of medium size, including the morocco case, in this city, is five dollars; and I supply my pupils with a similar *plate and case* for one dollar (when a considerable quantity is wanted); thus leaving *four* dollars to pay for the *trouble* of taking a likeness, less the cost of the other articles used, which would be so little, as to render it difficult to compute the amount upon a single picture. . . . No one can possibly fail to acquire knowledge of the art, whose perseverance will extend to a few hours' application, every day for a month; and there is no reason why the very *first* trial may not result in the production of a good picture.[2]

One of Plumbe's cameras, now in the George Eastman House, is a crudely built reduced model of Daguerre's camera, with removable ground glass to which a mirror is hinged, so that the image can be seen by looking down on the camera. To measure the extension of the telescoping boxes, a metal scale is affixed to the

top of the inner box. The units, which range from 90 to 200, are purely arbitrary, for the scale was intended for a thermometer. It bears the first seven letters of the name "J. S. F. Huddleston," an instrument maker. He may well have built the camera. He was himself a daguerreotypist; three of his pictures were exhibited at the Massachusetts Charitable Mechanic Association in 1841.

The cases which Plumbe sold were made by William Shew who, with his brothers Myron, Jacob, and Trueman, learned daguerreotyping from Samuel F. B. Morse; built the first gallery in Ogdensburg, New York; worked for a while in Rochester and Geneva, New York; and formed the L. P. Hayden Company in New York for the manufacture and sale of daguerreotype material.

Plumbe rapidly expanded his operations. He bought from Daniel Davis his patent for a way to color daguerreotypes by electroplating selected areas of the silver surface with various metals, and peddled it to daguerreotypists in New England. Lucius H. Cathan wrote Southworth from Townshend, Vermont: "Mr. Plumbe has filled the country people's heads full, with the idea of his 'colored photography,' as I have seen but few of them I could discover nothing so 'wonderful' or 'astonishing' in those, I should be pleased to have your view upon the subject."[3] Plumbe sent Trueman Shew to superintend a gallery in Philadelphia in 1842. He was in New York in 1843. A New Yorker wrote Southworth in that year, "Mr. Plumbe is here making quite a stir in the Dage line. Pictures are taken here for $1.00 and case included."[4] Jacob Shew went to Baltimore to open a Plumbe gallery there. In 1845 Plumbe boasted of fourteen galleries in New York; Boston; Saratoga Springs; Louisville, Kentucky; Petersburg, Virginia; Alexandria, D. C. (now Virginia); Philadelphia; Baltimore; Harrodsburgh Springs, Kentucky; Newport, Rhode Island; Dubuque, Iowa; Cincinnati; and St. Louis.

His was the first of many chains of galleries. The product of every branch was stamped "PLUMBE," no matter what photographer had taken the picture. The pattern which was thus established was quickly followed by other daguerreotypists, to the confusion of the historian. With only a few exceptions, the names of those who took specific daguerreotypes remain unknown, lost in the blanket credit given to the proprietors of the galleries which employed them.

Plumbe pioneered in another field. He was the first to collect portraits of celebrities. In 1846 he began publication of *The National Plumbeotype Gallery,* a collection of lithographs based on daguerreotypes—"transferred," he called them,

though they are clearly hand drawn. He announced on November 2 a new series:

> The Proprietor of the Plumbe National Daguerrian [sic] Gallery, having discovered a method of transferring beautiful copies of Daguerreotypes to paper —proposes, by this means, to publish a *daily Portrait* of some interesting public character on fine quarto paper, constituting an appropriate ornament to the centre table, &c., &c., commencing January 1st, 1847.[5]

But the empire of John Plumbe was short-lived. He sold his New York gallery to William H. Butler, his head man there, in 1847, and the other galleries soon changed ownership, though the name "Plumbe's Daguerrean Gallery" was retained as late as 1852 in Boston (John P. Nichols, proprietor), and 1850 in Washington (Blanchard P. Paige, proprietor).

In 1849 Plumbe went to California. He had not forgotten his dream of a transcontinental railroad, and on the way overland he made a preliminary survey of a southern route. Back in Washington he met bitter opposition from Asa Whitney, who favored a northern route. In deep discouragement he locked himself in a room in his brother's house in Dubuque, Iowa, on the morning of May 29, 1857, and cut his throat with a razor.[6]

Albert Sands Southworth was born in West Fairlee, Vermont, in 1811. He recollected that he first became interested in daguerreotyping on attending one of Gouraud's demonstrations in Boston.

> His illustrative experiment resulted in his producing a dimmed and foggy plate, instead of the architectural details of buildings and the definite lines and forms of street objects. It happened to be a misty day, attended with both snow and rain. The professor appeared highly elated, and exhibited his picture with great apparent satisfaction that he had it in his power to copy the very mist and smoke of the atmosphere on a stormy day.
>
> Mr. Pennell* had a few months previously graduated at Bowdoin College, in his native town. He had gone to New York for the purpose of prosecuting a professional course of study, and had been led to interest himself in Professor Morse's experiments for the purpose of procuring pecuniary assistance by some employment of his leisure hours. He had been my former school and room mate, and had written me to visit New York and learn respecting the new art. He in-

*Joseph Pennell, friend of Southworth, a student and assistant of Samuel F. B. Morse, apparently unrelated to the internationally famous illustrator or the Kansas City photographer of the same name.

41

vited me also to join him as an associate in business for the purpose of making likenesses. He introduced me to Professor Morse, and from him we received all the information and instruction he was able to give upon the subject. . . . I do not remember that Professor Morse had then made any likenesses. Very clear, distinct views of Brooklyn buildings in the distance and the roofs in the foreground, taken from the top of buildings in Nassau-street, were upon his table. I do remember the coil of telegraph wire, miles in length, wound upon a cylinder, with which he was experimenting. . . .[7]

They formed a partnership, bought a camera and the needed apparatus, and returned to Massachusetts, where they opened a studio in Cabotville (now Chicopee). Southworth wrote his sister Nancy in May, 1840:

I cannot describe all the wonders of this Apparatus. Suffice it to say, that I can now make a *perfect* picture, in one hour's time, that would take a Painter Weeks to draw. The picture is represented *light and shade,* nicer by far than any Steel engraving you ever saw. . . . We have improved it much since we commenced, so much so that we have been high complimented by good judges. We have already sent some specimens to Europe.[8]

In September he wrote of further improvements:

I have succeeded in managing the Daguerreotype so as to make perfect likenesses. . . . In a fair day it requires three minutes sitting and we positively know that we can have an apparatus that will not require more than thirty seconds.[9]

They sent twenty-two miniatures to the 3rd Exhibition of the Massachusetts Charitable Mechanic Association; the judges voted them "the best exhibited."

In April, 1841, the partners moved to Boston, where they opened a gallery under the name "A. S. Southworth & Co." They had need of a helper, and Southworth asked his sister to join them: "I must have some one to wait upon ladies when they call upon us—to frame miniatures, and assist me in the process. There is nothing but what would be termed light work about our establishment." Nancy came; her brother paid $2.62½ per week for her board in July, we learn from the account books of the firm.

The dateline "Boston" first appears in the ledger on June 3, 1841; cash receipts are recorded over the past three months for seventy-three miniatures at prices varying from $2.00 to $5.00 each. Like Plumbe, they sold apparatus; more than a thousand dollars' worth was posted in the books up to the end of October.

Each customer paid $25 tuition in addition to the cost of the camera, apparatus, and basic supplies.

They sold imported lenses from France at $30. ("We warrant them superior to anything for that price.") Cameras cost from $50 up. ("We don't get up any cheap setts, $50 is the lowest, does good work, $60 is better finish. . . . We will warrant the Camera satisfactory, the Lenses set in a Brass Tube and the focus adjusted with a set screw. The Camera shall be elegant and the Brass work Bronzed. . . . If you send us $20.00 we will wait three months for the rest. . . .")[10]

They contracted for the manufacture of plates and cases, and a supply of chemicals. In this enterprise they were in direct competition with Plumbe, who seems to have been not wholly satisfactory. Gardner Warren, of Woonsocket, Rhode Island, asked the price of plates: "I lately purchased a lot of Mr. Plumbe . . . which were of very inferior quality."[11] L. C. Smith of Sharon, Vermont, complained: "I have ordered some Bromine on Plumbe and forwarded him $6.00. He sent me Bromide. I sent him five dollars for a few plates, he sent me plates of his own make which are worthless."[12] Southworth & Co. did not escape criticism themselves, however. Henry Moore wrote from Lowell that he could not use a plate "more than five times."[13] B. Foster, of Portland, Maine, complained that the gilding solution he received was not good: rush me more, he asked, "but let it be ever so much better." He was disappointed at the second shipment and asked to have his money returned.[14] They got into an unfortunate tangle with J. W. Talbot, of Petersborough, New Hampshire, who claimed he had been incorrectly billed. "I have paid you nearly $1400.00 for apparatus & stock, and I thought you intended to deal fairly. I hope so still. The difference of $5 is no great affair at any rate but right is right."[15]

In 1844, Pennell left Southworth to teach at a private school in the South; he did not abandon daguerreotyping, however, for he ordered from Charleston plates and cases. He later took a job in the daguerreotype platemaking department of J. M. L. & W. H. Scovill in Waterbury, Connecticut, from whom Southworth purchased material.

His place in the firm was taken by Josiah Johnson Hawes. Like Southworth, Hawes had determined to become a daguerreotypist on seeing one of Gouraud's demonstrations in Boston. He was by trade a carpenter, by avocation a painter: "I practiced painting on ivory, likewise portraits in oil, landscapes, etc., with no

43

teacher but my books. About this time—1840—the excitement of the discovery of the daguerreotype took place; some specimens of it which I saw in Boston changed my course entirely. I gave up painting and commenced daguerreotypy."[16]

Exactly when Hawes joined Southworth is not clear. He was already in business as a professional daguerreotypist, to judge from a trade card reading "Superior Colored Daguerreotypes by Hawes & Somerby" in the Hawes papers; nothing is known of the enterprise, nor of Somerby. Pennell was no longer with Southworth in 1844, and it is probable that the new partnership was formed in that year, when a new studio was built in the building owned by Amos Lawrence at 5½ Tremont Row (later renumbered 19), where Horatio Greenough, William Wetmore Story, and other Boston artists had their studios. For the past three years Southworth had leased space at $25 per quarter. On June 12, 1844, Southworth wrote to his landlord, proposing to lease the upper rooms in the building "provided we can put Skylights in the Roof. . . . Our plan is to take off the flat part of the Roof and put up a Roof-Sash 15 feet by 12, the width of the flat roof. The pitch of the sash to be 5 feet on a base of 6 feet or vary as may be best, over Room 15." The permission was granted. By 1845 the name of the firm was changed to Southworth & Hawes.

The business became a family affair in 1847, when Hawes married Southworth's sister Nancy.

The portraits produced by Southworth & Hawes are remarkable for the bold, simple presentation of the personality of the sitters. They avoided the stereotyped poses so characteristic of their competitors, and often broke convention. Southworth said:

> What is to be done is obliged to be done quickly. The whole character of the sitter is to be read at first sight; the whole likeness, as it shall appear when finished, is to be seen at first, in each and all its details, and in their unity and combinations. Natural and accidental defects are to be separated from natural and possible perfections; these latter to obliterate or hide the former. Nature is not at all to be represented as it is, but as it ought to be, and might possibly have been; and it is required of and should be the aim of the artist-photographer to produce in the likeness the best possible character and finest expression of which that particular face or figure could ever have been capable. But in the result there is to be no departure from truth in the delineation and representation of beauty, and expression, and character.[17]

44

When Chief Justice Lemuel Shaw of the Massachusetts Supreme Court came to the gallery, one of the partners met him at the entrance to the skylight studio or, as it was called, "operating room." A ray of sunlight threw the judge's massive features into strong relief, and they took him where he stood (Plate 95). Daniel Webster was brought to the gallery by William Willard, a portrait painter, who wanted to spare the aging statesman the long sittings that would be required to make a painting of him. What Southworth & Hawes produced will live long after the paintings which Willard made from the daguerreotype. They sought the unusual pose: Lola Montez, the adventuress who fled from Bavaria to America, from king's mistress to entertainer of the forty-niners in San Francisco, with a cigarette between her gloved fingers (Plate 54); Harriet Beecher Stowe, the author of *Uncle Tom's Cabin,* beside a sensitive plant (Plate 100). They pushed the medium to the utmost of its limits to take "available light" exposures in a schoolroom crowded with girls (Plate 57) and in a hospital operating room (Plate 64).

They daguerreotyped Boston from their studio; three daguerreotypes exist of the funeral of Abbott Lawrence in 1855 showing the cortege arriving and leaving the Brattle Square Church. They photographed ships in drydock (Plates 24 and 29), a proud clipper lying at an East Boston wharf (Plate 69), and even a ship at sea. The *Boston Daily Atlas* for May 20, 1854, in describing the cabin decorations of the clipper ship *Champion of the Seas,* noted that "over the transom sofa are three panels, which contain daguerreotype pictures. The first is a representation of the ship 'Great Republic,' under all sail by the wind, the second is the outline of the 'Champion of the Seas' as she now lies broadside on, and other objects in the background, and between the two ships is a picture of Mr. Donald McKay, their builder. These pictures were taken by Messrs. Southworth and Hawes, and are about the best of the kind we have seen."

The daguerreotype of the *Great Republic* we have not been able to locate, but the picture of the *Champion of the Seas* may well be the daguerreotype in the collection of Richard Parker (Plate 69), and the portrait of McKay may be the splendid whole plate in the Metropolitan Museum of Art which we reproduce (Plate 67), or the "mammoth," but blurred, plate in the same collection.

Whole-plate daguerreotypes of Niagara Falls in winter, with fantastic ice sculpture, and a rather dull set of views of Mt. Auburn Cemetery, along with a number of portraits, were made in pairs, with the camera moved slightly be-

tween exposures, for viewing in a stereoscope. As early as 1852, Southworth & Hawes showed a stereoscopic daguerreotype of the Greek sculpture "The Laocoön" in the Boston Athenaeum; the June issue of the magazine *To-day* found "the illusion . . . absolute. The spectator sees the copy of this celebrated group in complete relief, standing off from the curtain behind it; and has nothing whatever to confirm his judgement, which informs him that he looks on reflections from a perfectly flat surface. . . . The effect of the Laocoön in this stereoscope is really finer than one often gains in looking at the statue."

They built a "Grand Parlor and Gallery Stereoscope" which resembled a piano and contained a dozen pairs of stereoscopic daguerreotypes which the visitor changed by turning a crank. Admission was 25 cents; a season ticket, 50 cents. One of the pictures which visitors particularly admired was of a bride. This "tableau" inspired a poem in the *Boston Daily Atlas* for April, 1854. The partners reprinted it on the back of the ticket. We quote the last lines:

> A portrait so true no canvas can bear—
> O let it forever stand lingering there;
> Whatever the changes the far years betray,
> Still, still keep her *there,* a bride e'en for aye.

Southworth & Hawes boasted that they never employed operators (as cameramen were then called), but that "one of the partners being a practical artist," sitters could be assured of personal attention. Undoubtedly the reference was to Hawes, who gave up painting for photography in 1840. Certainly daguerreotypes made in the gallery in 1850 and 1851 were his work, for Southworth was in California, where he sought unsuccessfully to make his fortune in the gold fields. He was in poor health when he returned, and appears to have been less active in the firm than his partner. He was probably more mechanically gifted than Hawes, and was undoubtedly responsible for the two patents which were issued jointly to him and to Hawes.[18] A third patent, No. 12,700, dated April 10, 1855, was taken out by Southworth alone. It became infamous. It was titled "Plate-Holder for Cameras." The specifications read:

> The object of my invention is to bring in rapid succession different parts of the same plate or different plates, of whatsoever material prepared, for photographic purposes into the center of the field of the lens for the purpose of either

46

timing them differently, that the most perfect may be selected, or of taking different views of the same object with the least delay possible, or of taking stereoscopic pictures upon the same or different plates with one camera.

The device was not new, and photographers were indignant when they were sued for using similar apparatus not manufactured by Southworth. But time and again the validity of the patent was upheld by the courts. The patent was reissued in 1860; Southworth sold part rights to Simon Wing of Waterville, Maine, who was thus enabled to secure U. S. Patent 30,850 (December 4, 1860) for his greatly improved sliding plate holder, with which he claimed he could make 616 half-inch-square negatives on one plate. Southworth left Hawes in 1861; ten years later, the Supreme Court invalidated the patent. In the last years of his life Southworth was a handwriting expert. He died in 1894.

Hawes continued at the Tremont Row gallery. A manuscript in his hand, on a letterhead of the *Boston Daily and Weekly Globe,* dated 1877, is in the Hawes papers. It is obviously copy, apparently fragmentary, for an advertisement:

THE ANNOUNCEMENT

which Mr. J. J. Hawes of the old firm of Southworth & Hawes makes to the patrons of that old and popular establishment, located at 19 Tremont Row, will be read with interest by thousands of people. Mr. Hawes has all the negatives at this place, some fifty thousand in number, and also ten thousand daguerreotypes of prominent citizens of Boston, ladies and gentlemen, extending back to *1843.*

A newspaper reporter interviewed him in 1886:

Now and then Mr. Hawes takes from its box some striking daguerreotype and makes from it a large photograph, life-size, or nearly so. The sad-eyed Webster, looking tired and baffled, and with stern lips, is one of his; and he has just finished one of Webster far more impressive; a front face, dark and strong, and far from saintly, but full of intellect and will; no light in the deep-set eyes, no sweetness in the firmly shut mouth, no aspiration in the face. And yet one cannot get away from it. . . . More magnificent than any other is a large standing photograph of Chief Justice Shaw, taken from an old daguerreotype. It is wonderfully artistic, with brilliant lights and deep shadows, as if it were taken from a marble statue. It is a majestic picture with "the front of Jove himself," and the masses of wavy hair are very effective. It is one of the most remarkable photographs in existence. . . . There is a singular charm in these old pictures,

47

especially in the brilliant daguerreotypes. Most of them will never be reproduced, one day they will all be destroyed, but it is worth while to get now those that can be bought, for pictures keep their popularity but a little while, and drift out of the market.[19]

Happily the prediction was untrue. When Josiah J. Hawes died in 1901, on a brief vacation trip to New Hampshire, the collection was inherited by his son, Dr. Edward S. Hawes. He put them on public sale in 1934. It was a unique collection, in size and quantity; nothing else like it has survived from the daguerreotype era. The cream of the collection, including the finest portraits of celebrities, was acquired by the Metropolitan Museum of Art in New York. Another group is now in the Boston Museum of Fine Arts. Upward of a thousand portraits of unidentified sitters are in the George Eastman House, Rochester, New York, together with business letters, invoices, receipts, and account books, through the combined generosity of the late Alden Scott Boyer, Holman's Print Shop, Boston, and the Hawes family.

6. *Innovations from Philadelphia*

WHEN John Plumbe, Jr., opened his Philadelphia branch in 1842, Robert Cornelius had abandoned his gallery. For two years this pioneer had been taking portraits, using the lighting scheme devised by Wolcott and Johnson in New York. "His laboratory was conspicuous. On the outside could be seen a large mirror swung on a bracket, for illuminating his sitters with reflected sunlight."[1] But few of Cornelius's portraits have survived; they are distinguished by the solid brass frames in which they were encased.

To judge from the city directories, Plumbe had at first no competition, for no other daguerreotypist is listed in 1842. But in the following year the entry appears: "LANGENHEIM, W. & F., daguerreotypers."

Frederick Langenheim and his brother William were born in Germany. William, who was the elder by two years, came to America in 1834, at the age of twenty-seven. He settled in Texas. When hostilities broke out with Mexico, he joined the patriot army, which won the independence of Texas. Although he escaped the massacre at the Alamo, he was captured by the Mexicans, and languished in prison for upward of a year, until a truce was established. He continued a military career: in 1837 he served as commissary sergeant in the campaign against the Seminole Indians in Florida. On his discharge three years later he joined his brother Frederick in Philadelphia. They joined the staff of the German language newspaper *Die Alte und Neue Welt*.

The Langenheims became involved in daguerreotyping by pure chance. Back home in Brunswick, Germany, their sister Louisa had married Johann Bernhard Schneider, a teacher in the Carolo Wilhelmina Polytechnic Institute. Schneider's fellow student in Vienna, Peter Friedrich Wilhelm Voigtländer, was building daguerreotype cameras and lenses. He sent an outfit to Schneider who, after mastering its use, sent it to his brothers-in-law in Philadelphia. It was a small camera, for plates barely an inch in diameter; with it the Langenheims took a portrait of their employer, John Schwakke, editor and publisher of *Die*

49

Alte und Neue Welt.[2] Soon they became American agents for Voigtländer's all-metal camera and his portrait lens, designed by Josef Petzval. The lens was revolutionary. It was greater in diameter than any other lens of the same focal length: by today's nomenclature it would be marked $f/3.6$. Consequently it passed more light than other lenses, and by its use exposures could be greatly reduced.

The all-metal camera took circular pictures 2½ inches in diameter. It was at once a success; by 1842, six hundred had been sold. It resembled a spyglass, recollected Alexander Beckers, a daguerreotypist who worked for the Langenheims. "The camera rested on a candlestick-like tripod, with three set screws for adjustment, and was placed on an ordinary table. To interchange the ground glass and round daguerreotype plate, it was necessary to unscrew a flanged ring, and replace the same by reverse motion. For the adjustment of the focus, there was the rack and pinion, as Voightlander's [sic] instruments still have. . . ."[3]

The new apparatus was expensive. Charles G. Page of Washington wrote Southworth, on January 12, 1843, that he had received from Philadelphia a new camera imported from Vienna. "I paid—$275.00—I can hardly say if the results will warrant this great expense . . . but from a single trial I am satisfied that the pictures will surpass anything I have ever seen. (Nous verrons.)"[4]

On the twenty-fourth he reported: "My new lenses work admirably. They require 40 seconds to 25 with your apparatus [i.e., camera], but it takes magnificent large pictures."[5] He discarded the camera, the workmanship of which he reported to be crude. But Voigtländer's lenses became famous—so famous that they were counterfeited. Daguerreotypists were warned that the signature of Voigtländer was being forged on tubes of local manufacture by unscrupulous dealers.

In 1845 the Langenheims took eight sets of five daguerreotypes of Niagara Falls. They framed them side by side to form panoramas, and sent sets to President Polk, Daguerre, Queen Victoria, the Duke of Brunswick, and the kings of Prussia, Saxony, and Wurtemberg. The eighth set was formerly in the American Museum of Photography in Philadelphia, together with letters and medals from the illustrious recipients of the other sets. These letters the Langenheims printed in a broadside, to promote their enterprise.

More than any other daguerreotypists in America, the Langenheims kept in touch with European developments. In 1846 Frederick bought, and patented in the United States as assignee, a technique for coloring daguerreotypes in-

vented by a Swiss miniaturist and pioneer daguerreotypist, Johann Baptist Isenring.[6] It was so simple a trick that it is a wonder that its validity was not challenged by the patent office. A sheet of glass was laid over the daguerreotype, and the outline of the area to be colored was traced on the glass with a fine brush and India ink. Next, tracing paper was put on the glass and the outline marked with a lead pencil. The outline was followed with a sharp knife. The stencil thus produced, covering all of the area except that to be colored, was fastened on the daguerreotype, which was shaken up with dry pigment in a closed box. For years, daguerreotypists had achieved the same results applying the colors with a brush.

John Edward Mayall, a competitor in Philadelphia who had received a similar patent in 1843,[7] wrote Southworth: "I should like to hear your opinion of Langenheim's patent. I intend to learn if he can legally substantiate it and if not shall resist. Otherwise I must agree."[8] A few days later he wrote: "First about the Langenheim patent for coloring backgrounds. He has got one and served me a notice to desist. I have written to the Patent Office in Washington but their answer is that if I have any redress it is in the Courts of Law. Mr. Van Loan [his partner] brought this process from England but we can not swear to having colored any until Mr. L. began it and I am afraid we could not sustain our claim legally. . . . I am so busy with Daguerreotype that I cannot attend to anything else at present."[9]

Mayall, with Samuel Van Loan, pioneered in making daguerreotypes of those allegorical subjects which are usually the province of painting: his most famous production was a set of ten daguerreotypes each representing a line of the Lord's Prayer. He moved to London in 1846. His Philadelphia gallery was bought by Marcus A. Root, a writing master turned photographer. Mayall became the most fashionable portraitist in London; his are the finest portraits of Queen Victoria. He later moved to Brighton; for one year he was mayor of the city. He died not far from there in 1904, aged ninety-one.

William Langenheim visited England in 1849 to negotiate with William Henry Fox Talbot for the purchase of his United States patent for making photographs with paper negatives. Talbot had discovered, four years before Daguerre's process had received public notice, and without knowledge of his work, a totally different photographic system. On reading the report of Arago's address in January, 1839, to the Academy of Science in the *Comptes Rendus* of that official body,

51

Talbot found himself "in a very unusual dilemma (scarcely to be paralleled in the annals of science)." He hastened to send, first to the Royal Institution and then to the Royal Society, an account of his invention, the results of which seemed in theory to duplicate Daguerre's work. It turned out that Talbot's technique was different from Daguerre's. Instead of silvered copper plates, Talbot used sheets of paper; instead of sensitizing them with fumes of iodine, he soaked the paper first in an aqueous solution of sodium chloride and then in silver nitrate solution. Instead of a unique, direct positive, Talbot secured a negative—from which a limitless number of positive prints could be made. Modern photographic techniques are based on Talbot's discovery; Daguerre's process became obsolescent twelve short years after its publication. Because Daguerre had patented his process in England, Talbot patented his improved "calotype" or "talbotype" process in England, France, and the United States.[10]

Edward Anthony, the stock dealer, was the first to inform Talbot in 1847 that he had been granted a United States patent, and asked for an option to purchase the rights. Two months later, Anthony wrote that he was no longer interested; and for two years there were no takers. Then, in the spring of 1849, William Langenheim went to visit Talbot in the village of Lacock, Wiltshire, where he lived. From the Red Lion Inn, Langenheim wrote Talbot that he would pay him a thousand pounds for the American rights to the patent. The deal was closed on May 11, 1849.[11]

But Americans would have nothing to do with the English process, even though the Langenheims circulated a thousand copies of a brochure pointing out the advantages:

> The common method of taking Daguerreotype Portraits on silvered copperplates, although very valuable, is liable to many objections which are avoided by this process. In the first place a paper surface is substituted for the highly polished metallic one, and in consequence the pictures can be seen in any direction, and at a considerable distance. After obtaining the first (negative) impression, *any required number of* (positive) *Copies can be procured, all equally perfect, at any time thereafter, without another sitting, and, at a very trifling expense.* . . . As the pictures are not only on paper, but even penetrate into the mass of the paper itself, they cannot be rubbed out, and can, therefore, be enclosed in a letter and sent by mail.[12]

They offered to take portraits at from $5.00 to $12 per dozen, depending on the

52

sizes, which ranged from 4½ by 6 inches to 8 by 10½ inches. Despite these inducements, the new process did not capture the public's fancy.

To judge from existing examples of the Langenheims' "Portraits from Life on Paper," the public's apathy is understandable, for the pictures are weak, poorly lighted, and with none of the quality seen in the product of even a journeyman daguerreotypist. They painted out the background to silhouette the figures, which were monotonously alike: head, shoulders, and one arm propped on a side table or on the top of a truncated, fluted column. Photographers were disinterested, for they were reluctant to pay for the use of any restricted process; they looked upon payment of the license fee as a needless expense, and they saw no reason to abandon the daguerreotype process, which the American public was most enthusiastically endorsing.

The Langenheims became financially embarrassed. Less than a year after they bought his patent, the brothers wrote Talbot that they had not sold a single license. They suggested that accounts might be settled if Talbot were to purchase rights to *their* patent, a technique for making negatives on glass.

This process was a modification of an invention by Niépce de Saint-Victor, the nephew of Daguerre's partner, by which light-sensitive silver salts were bound to the surface of a glass plate by white of egg. The Langenheims called glass positives made from these negatives "hyalotypes."[13] For this invention they received a United States patent on November 19, 1850.[14]

It was not new, and daguerreotypists knew that it should not have been allowed. It hardly differed from the albumen plates of John Adams Whipple, for which a patent[15] had been granted just a few months earlier, and which Whipple called "crystalotypes." But from the practical standpoint, the Langenheims scored a novelty: they used the material to make slides for the magic lantern. To them goes the credit for producing the first photographic transparencies for projection; from this invention rose a thriving industry, which gradually merged into the motion pictures. They exhibited a collection of their hyalotypes at the Great Exhibition in London in 1851.

The Langenheims also pioneered in stereoscopic photography, and founded the American Stereoscopic Company for the sale and distribution of paper prints and transparencies produced from hyalotype negatives.

Just when they began to expand in this field is not clear. Root states that

53

they produced stereoscopic pictures in 1850. By 1854 they were producing them in quantity.

> *Photographic Art-Journal, September, 1854.* We had the pleasure of a call from Mr. Langenheim, who has just returned from Europe, and of seeing a few of his beautiful stereoscopic pictures. . . . These pictures surpass anything of the kind we have ever seen, and we do not think they can be excelled.

The Library of Congress owns a scrapbook, obviously intended as a catalogue, of twenty-four paper stereographs of views in Pennsylvania and New York, with the manuscript title, "Photographic Views at Home and Abroad, taken and published by F. Langenheim, 188 Chestnut St., Philadelphia, 1856."

Stereoscopic daguerreotypes were not uncommon. Besides Southworth and Hawes, there were others who invented viewing devices. John F. Mascher, a Philadelphian, described in the *Scientific American* for June 13, 1852, a box stereoscope which he made for two half-plate daguerrotypes; a year later he patented a folding daguerreotype case which contained, on a flap hinged to the inside cover, two spectacle glasses.[16] A similar daguerreotype case was patented by John Stull, also of Philadelphia: the lenses were set in holes pierced in the cover which, instead of being hinged, was fastened to the bottom by folding arms in such a way that it always remained parallel to the twin daguerreotypes.[17]

But the daguerreotype was not a satisfactory technique for the stereoscope. The pictures were expensive, fragile, and bulky. It was difficult to look at them through magnifying lenses, because of the highly polished surface. The Langenheims' paper prints and glass transparencies became at once popular. They soon faced competition when the London Stereoscopic Company opened an American branch and sent a cameraman here. Edward and Henry T. Anthony began in 1859 to publish paper prints in vast quantities, printed from negatives made by the wet collodion process which soon displaced the hyalotype technique. By the time of the Civil War the Langenheims were putting all their attention into the production of lantern slides. When William Langenheim died in 1874, his brother Frederick retired.

For a while the Langenheims had a branch gallery in New York, in partnership with Alexander Beckers. So, too, did M. A. Root, in partnership with his brother Samuel. For New York in the 1850's was the center of the daguerreotype industry.

54

7. *The Broadway Galleries*

"THERE is probably no city in the United States where the Daguerreian art is more highly appreciated and successfully practiced than New York," Humphrey wrote in 1850.[1] There were 77 rooms, he said, employing 127 operators at $10.00 a week, 11 ladies at $5.00 a week, and 46 boys at $1.00 a week. In 1853 it was estimated that a thousand New Yorkers made their living by daguerreotyping. There were eighty-six portrait galleries in the city then, and thirty-seven of these were on Broadway.

Broadway was the favored location of daguerreian artists, not only because it was the center of business, but because it was fashionable to promenade along the thoroughfare when the week's work was done. "Broadway is in full force through Sunday, and with an increased power on Sunday evening," a New Yorker wrote in 1853.[2] "It is then that the nice dressing of New Yorkers is to be seen in the highest perfection—a perfect Mississippi, with a double current up and down, of glossy broadcloth and unblemished DeLaines. . . . There are hundreds and thousands in New York who cannot live out of Broadway: who must breathe its air at least once a day, or they gasp and perish." As a hit tune of the era put it:

> The O.K. thing on Saturday
> Is walking down Broadway
> The festive, gay, Broadway

A popular diversion, while walking down Broadway, was to drop into a daguerreotype gallery. To choose which one was baffling. Daguerreotypists advertised in the newspapers, hung banners outside their galleries, and arranged display cases with samples of their work at the street entrance to entice promenaders to climb the flights of stairs. For all the galleries were walk-ups, since the great skylights essential to indoor portraiture in those days had to be built on the upper floors, and elevators were not yet common. It was hardly possible to choose a gallery in advance, and make an appointment for a sitting, because only if the

55

day was fair could daguerreotypes be taken. If promenaders dropped into a gallery and found a lot of people waiting their turns, the temptation would be to seek another, less popular establishment. So daguerreotypists took pains to make their reception rooms as comfortable and attractive as they could.

The most famous of the Broadway galleries were those of Mathew B. Brady, Martin M. Lawrence, and Jeremiah Gurney.

Brady was a jewel-case manufacturer who had just taken on a new line, miniature cases, when Southworth's pupil L. C. Champney visited him in 1843. At Champney's suggestion, he wrote Southworth on June 17, 1843:

> Sir:
> I beg leave of communicating these few lines soliciting your attention, I being informed by L. Champney and several of your frends [sic] that you are one of the most successful prof. of daguerreotype and doing the most extensive

business in Boston and invariably use a great number of miniature cases. I have been engaged some time past in manafucturing [sic] miniature cases for some of the principal operators in this city and recently in business for myself and anxious for engagements. I have got up a new style case with embossed top and extra fine diaframe [sic]. This style of case has been admired by all the principal artists in this city. If you feel desirous to see my style of cases if you will favor me with an answer I will send them by Horse Express. If my style of cases should suit you I can supply you on reasonable terms.[3]

In 1844 Brady opened a Daguerrean Miniature Gallery at 205 Broadway, just below Fulton Street. His success was immediate, and on March 19, 1853, he opened a branch "uptown" at 359 Broadway, over Thompson's Saloon. On the very same day his competitor, Martin M. Lawrence, opened *his* new gallery at Number 381. Humphrey was invited to both openings. He partook of "a collation of the choicest supplies of good things in the most epicurean order," and inspected the galleries in detail. The two establishments were almost identical. He described Brady's:

> *Humphrey's Journal of the Daguerreotype, June 15, 1853.* The floors are carpeted with superior velvet tapestry, highly colored and of a large and appropriate pattern. The walls are covered with satin and gold paper. The ceiling frescoed, and in the center is suspended a six-light gilt and enamelled chandelier, with prismatic drops that throw their enlivening colors in abundant profusion. The light through the windows is softened by passing the meshes of the most costly needleworked lace curtains, or intercepted, if occasion requires, by shades commensurate with the gayest of palaces, while the golden cornices, and festooned damasks indicate that Art dictated their arrangement. The harmony is not the least disturbed by the superb rosewood furniture—tête-à-têtes, reception and easy chairs, and marble-top tables, all of which are multiplied by mirrors from ceiling to floor. Suspended on the walls, we find Daguerreotypes of Presidents, Generals, Kings, Queens, Noblemen—and *more nobler men* —men and women of all nations and professions.

Past the reception room was an office and a ladies' parlor, all in gold and green, with rosewood furniture. Two operating rooms led from the reception room—one with a northern, the other with a southern exposure. Humphrey, who was writing for the profession, does not waste words on these rooms: "To go into a description of the apparatus and arrangements, would be repeating what every

57

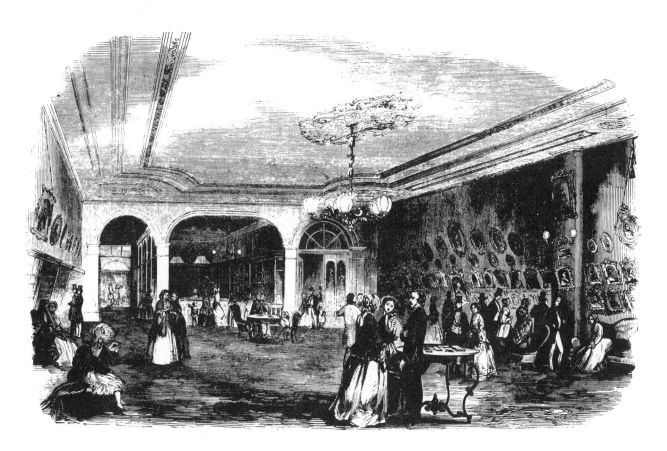

first-class operator is familiar with." A wood engraving of the gallery, which Brady used for advertising and on his billhead, shows the reception room in exaggerated perspective. Far in the distance can be seen a camera on a tripod and a man standing beside it.

To assume that this cameraman is M. B. Brady himself, would be a mistake. Like all the other Broadway daguerreotypists, Brady employed operators to do the work of photographing. Otherwise he could not have managed two galleries on Broadway and a third in Washington. Nor could he have taken off eighteen months for a trip to Europe in 1851-52, leaving George S. Cook in charge. His position was made clear in the *Photographic Art-Journal*, March, 1851: "Brady is not an operator himself, a failing eyesight precluding the possibility of his using

the camera with any certainty, but he is an excellent artist nevertheless—understands his business so perfectly, and gathers around him the first talent to be found." This observation was repeated in 1854: "Although Mr. Brady is not a practical operator, yet he displays superior management in his business and consequently deserves high praise for the lofty position he has attained in the Daguerreian fraternity."[4]

The operators were journeymen, and it was a problem to keep a good one. Some left the employ of the big houses to start their own galleries. Brady's first operator, James A. Brown, set up for himself on Broadway in 1848. Polycarp von Schneidau, the Swede who was the first to make a daguerreotype of Jenny Lind in Brady's gallery, opened in Chicago and became famous for his memorable portrait of Abraham Lincoln. Others were snapped up by rival proprietors. Edwin Bronk left Brady to take charge of the St. Louis gallery of T. C. Dobyns, who ran a chain of daguerreotype galleries in the South. He recruited his cameramen in New York. "Principles, take bonds on your operators to remain with you," Humphrey warned, "or you lose them. Mr. D. will never take an operator in the actual employment of any establishment, but when they resign he picks them up."[5] Lawrence yielded his chief operator, Edwin Church, to Dobyns for his Memphis, Tennessee, gallery. And Gurney lost his man Litch to England. Of the daguerreotypists whose skill brought fame to Brady and his competitors, we know but little. Only those whose activities made copy for the trade papers can even be named.

It is not difficult to visualize the operating rooms at Brady's, which Humphrey took for granted. There would be, of course, a slanting skylight, preferably dirtied over to diffuse the light. There would be a number of iron headrests, either the plain cast-iron model or the newly introduced Jenny Lind model with ornate base and fluted column. There would be a simple background of dark Roman ocher, moleskin color, or bluish gray. (Elaborate painted backdrops did not come into general use until the time of the Civil War.) There would be a movable reflector, or screen to bounce light into the shadow side of the face. Except for the camera on its tripod there would be nothing else in the operating room. The preparation of the plates, their polishing and sensitizing before exposure, their development by hot mercury, and the final fixing, gilding, and coloring, would be taken care of in the mechanical department on the fourth floor.

59

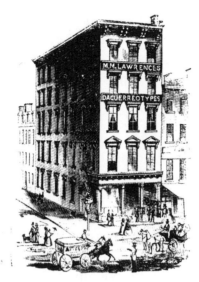

Martin M. Lawrence, Brady's neighbor in the next block, was particularly noted for two specialties: the extra large (12-by-15-inch) daguerreotypes called "mammoth," and allegorical subjects. His "Past, Present, and Future," three young ladies facing to the left, front, and right, had won for him a prize at the 1851 Great Exhibition in the Crystal Palace, London—an honor he shared with Brady. (Gossip had it that the daguerreotype was in fact the work of Lawrence's operator Gabriel Harrison, late of Plumbe's gallery, who soon left him to establish his own business in Brooklyn. There he took a daguerreotype of an unknown poet named Walt Whitman, who used an engraving from it as a frontispiece to his volume *Leaves of Grass.*)

Humphrey described Lawrence's gallery with the same detail as Brady's. It was almost identical: a reception room on the third floor, richly furnished; two 25-by-30-foot operating rooms on the fifth floor, with 16-foot ceilings and skylights each 12 by 15 feet.

Jeremiah Gurney boasted that his was "the oldest and most extensive establishment in the world," having been founded in 1840. The only biographical information we have of Broadway's most popular daguerreotypist is a profile in the New York *Star* for November 6, 1887, which states that Gurney was a jeweler in Saratoga, New York, in 1839. There he met an Englishman named Shaw, from whom he bought a camera in exchange for a watch.

60

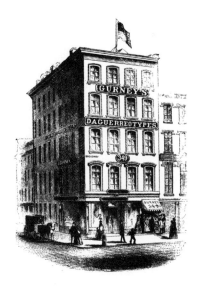

He brought this crude affair to New York and started in the daguerreotype in connection with his jewelry business. He opened a jewelry shop at No. 189 Broadway and in his show case put four daguerreotypes. They were small affairs, but he charged $5 each for a portrait. The first day he had one sitter, the second two, and from then on success was assured. Daguerreotypes were the rage, and the public clamored for them as loudly as they do now for first night seats at the debut of a society belle.

In 1852, when the gallery of Jesse H. Whitehurst at 349 Broadway was destroyed by fire, Gurney bought it, refurnished it, and operated it as a branch of his downtown gallery. In the following year he sent daguerreotypes in competition with Brady and Lawrence to the Exhibition of the Industry of All Nations, New York's answer—complete with Crystal Palace—to the London Great Exhibition. He won only honorable mention, against the bronze medals awarded to Brady and Lawrence.

Winning the Anthony pitcher, first prize in America's first strictly photographic competition, however, more than made up for this disappointment. In an effort to raise the standards of daguerreotyping, Edward Anthony, owner of the nation's largest stockhouse of daguerreotype materials, apparatus, and cameras, had offered in 1851 a $500 prize for the best set of daguerreotypes. To his dismay, not one daguerreotypist entered, "probably in consequence of the natural mod-

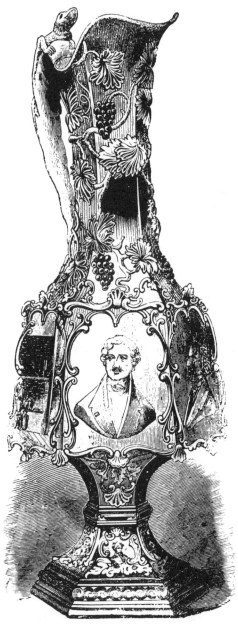

THE ANTHONY PRIZE.

esty of inventors," he wrote, and went on to explain: "Inasmuch, however, as the money has been offered, I myself consider that it no longer belongs to myself but to Art. Therefore . . . I have decided to invest the above amount in a MASSIVE SILVER PITCHER, of appropriate design, to be awarded as a prize for the *best four daguerreotypes* that shall be offered for competition previous to November 1st, 1853."[6]

The pitcher was described in *Gleason's Pictorial Drawing-Room Companion*:

> On one side is the sun rising over a beautiful landscape, with a daguerreian apparatus, seemingly ready to catch the most interesting features of the picture, as it throws its golden rays over the scene. On the other side is represented a chemical laboratory —showing that to chemistry the art is chiefly indebted; and on the two front tablets are portraits of those two illustrious artists — Daguerre and Niépce. On the handle we have again the vine, in which is a lizard creeping to the mouth of the pitcher, the whole finished with a most exquisitely chased base.[7]

The pitcher was awarded to Gurney for his whole-plate portrait of his daughter. The second prize, of two silver cups, went to Samuel Root, brother of Marcus. The prizes were awarded by Anthony at Gurney's gallery four days before Christmas, 1853. Professor James Renwick of Columbia College, one of the judges, was chairman; letters from Samuel F. B. Morse and J. W. Draper, the two other judges, were read; toasts were made; and the party went on to "a second edition . . . the corks, toasts, bottles and tumblers were as thick as fog on a damp morning."[8]

Encouragement of the kind Anthony offered was needed, for a vicious price war was going on all over the country and on Broadway in particular. Humphrey and Snelling were constantly writing editorials against the price cutters; mutual-protection societies were formed; but all in vain. Snelling attacked the morals of what he called the "two shilling operators": "Their rooms are frequently the resort of the low and depraved, and they delight in nothing more than desecrating the Sabbath by daguerreotyping these characters in the most obscene positions."[9]

The price charged for a medium-sized daguerreotype at such a first-rate gallery as Brady's was, in 1853, $2.00. At the same time, in the "picture factories" of Reese & Co., Rufus Anson, and Carden & Co., the cost was but 50 cents. Miniature sixteenth-size (1⅝ by 1⅜ inch) daguerreotypes could be had for 25 cents. The two-shilling operators were a constant threat to those daguerreotypists who, often not without reason, called themselves artists. Brady stated his position in an advertisement in the *New York Tribune* for April 10, 1854: "I wish to vindicate true art, and leave the community to decide whether it is best to encourage real excellence or its opposite; to preserve and perfect an art, or permit it to degenerate by inferiority or materials which must correspond with the meanness of price."[10] Yet he was to announce that "by a new arrangement" of his downtown gallery he would "make better pictures for from 50 cents to $1, than have ever been made before at these prices."[11]

The reason for the success of the 50-cent men was not only the relaxation of standards, the pushing of smaller size, and aggressive advertising, but especially the division of labor and industrial organization which they introduced. Established daguerreotypists saw only their sloppy workmanship, and called them "the blue bosom operators" because they did not have skill enough to record a white shirt white: their careless technique brought about solarization, which in the

daguerreotype process renders the highlight areas blue. Humphrey said they exhibited at the American Institute Fair only to get a free pass.

Reese and Company, of 289 Broadway, claimed to have inaugurated the mass-production system. In a thirty-six-page brochure published by the firm with the somewhat misleading title *Daguerreotype Directory,* it is explained that Professor Reese was a political refugee from Germany, and that on coming to America in 1852 he introduced the "German system" of daguerreotyping. The principle of division of labor was carried out to a greater degree than in other galleries. The establishment was divided into departments: polishing, two sky-lights north and south, mercurializing, gilding, and coloring, each the charge, if we are to believe the Professor, of Ph.D.'s and baronets, for he names them: "Dr. Dutton Van Skoik, Sir John Clark, Prof. Marat." He claimed in his booklet that "300 to 500 or even 1000 portraits were made daily"—a production far above that of the older galleries. (Humphrey, for instance, boasted that on the day after Christmas, 1853, he made sixty-four portraits between 9:30 and 4 o'clock.)

In contrast to the big Broadway galleries, with their emphasis on the palatial splendor of the reception rooms, the picture factories were bare and unadorned. There were no delicate rosewood tête-à têtes; the customers sat on wooden benches, "forms," as a British visitor, John Werge, wrote:

> I had a dollar's worth of these "factory" portraits. At the desk I paid my money, and received four tickets, which entitled me to as many sittings when my turn came. I was shown into a waiting room crowded with people. The customers were seated on forms placed around the room, sidling their way to the entrance of the operating room, and answering the cry of "The next" in much the same manner that people do at our public baths. I being "the next," at last went into the operating room, where I found the operator stationed at the camera, which he never left all day long, except occasionally to adjust a stupid sitter. He told the next to "sit down" and "look thar," focussed, and putting his hand into a hole in the wall which communicated with the "coat-ing room," he found a dark slide [i.e. plate holder] ready filled with a sensitized plate, and putting it into the camera, "exposed," and saying "that will dew," took the dark slide out of the camera, and shoved it through another hole in the wall communicating with the mercury or developing room. This was re-peated as many times as I wanted sittings, which he knew by the number of tickets I had given to a boy in the room, whose duty it was to look out for "the next" and collect tickets. The operator had nothing to do with the preparation

of the plates, developing, fixing, or finishing of the picture. He was responsible only for the "pose" and "time," the "developer" checking and correcting the latter occasionally by crying out "Short" or "Long" as the case might be. Having had my number of "sittings," I was requested to leave the operating room by another door which opened into a passage that led me to the "delivery desk," where, in a few minutes, I got all my four portraits fitted up in "matt, glass, and preserver,"—the pictures having been passed from the developing room to the "gilding" room, thence to the "fitting room" and the "delivery desk," where I received them. Thus they were finished and carried away without the camera operator ever having seen them. Three of the four portraits were as fine Daguerreotypes as could be produced anywhere.[12]

Professor Reese was a man of marked prejudice. That he should attack the established daguerreotypists with violent sarcasm is understandable, but his unchivalrous blast at the few lady daguerreotypists then active is not so readily explained. "Much has been said, written and whistled with regard to females being capable of taking daguerreotypes . . . it's all gammon . . . we shall yet believe that female Daguerreans are out of place, pants or no pants."

Already, by the time this was written in 1854, the daguerreotype was doomed. Its place was soon to be taken by an entirely different technique, the wet-collodion process, invented by Frederick Scott Archer in England, and published by him in *The Chemist* for March, 1851.

Archer's process, like Whipple's crystalotypes and the Langenheims' hyalotypes, was basically a modification of H. Fox Talbot's calotype process. The negatives were on glass. To sensitize them, Archer first coated the glass with collodion, a viscous solution of guncotton which dries to form a hard, skinlike film. In this collodion, potassium iodide had been dissolved. While the coating was still tacky, he plunged the plate into a bath of silver nitrate solution. By this action, light-sensitive silver iodide was produced in suspension within the collodion coating. After exposure the plate was developed by pouring over it a solution of pyrogallic acid and silver iodide. It was fixed with sodium thiosulphate (then called "hyposulphite of soda"), washed, and dried. Prints were made from these negatives with paper sensitized by Talbot's process, or with albumen paper, which had been coated with white of egg. In the daguerreotype days the word "photography" was reserved for this new collodion process. By the outbreak of the Civil War, photographs became cheaper than mass-produced daguerreotypes.

65

Snelling warned of the coming revolution. In August, 1853, he complained that "the daguerreotypists of America have so long heard their praises sung, and so long been tickled with the assertion of their superiority in the art, that they seem to think that there is no possibility of their ever being surpassed. . . . They even laugh at the idea that paper photographs can ever equal the daguerreotype." He saw the end of Daguerre's invention as a parlor ornament: "Enlarge the daguerreotype above that of 9 x 11 inch size and it becomes coarse and unsightly, whereas the paper photograph is improved in its details, its sharpness, and its beauty; and does not deteriorate in softness of tints or brilliancy of tone."[13] By March, 1854, he reported that there was "more apparatus, &c., sold in the United States within the last three months for paper manipulation than during the whole previous time since its discovery."[14] Of the Broadway daguerreotypists who had switched to paper and glass, Snelling named Brady, Gurney, and Lawrence. "In view of the hosts of 25 cent galleries springing up in all quarters, our most respectable artists begin to look to the crystalotype to redeem their artistic skill from the odium cast upon the daguerrean art by its prostitution to such paltry results."

The paper processes were introduced to the daguerreotypists by a new class of operator. Brady employed Austin A. Turner, who while in the employ of the Boston daguerreotypist Marcus Ormsbee was sent to learn the crytalotype process at Whipple's gallery. Having learned the technique, Turner held out for higher wages, striking every few weeks, until he was earning $36 a week—more than three times the average operator's pay. He finally left for New York, learned the collodion process, taught it at $50 a lesson, and wound up in Brady's gallery.

Lawrence obtained the services of Caleb Hunt.

Gurney was joined in 1853 by his former pupil Charles DeForest Fredricks, who had picked up the new technique in Paris, where it was already well established. The partnership was short-lived, for in 1855 Fredricks opened his own gallery at 585 Broadway. Over the entrance, spelled out in a semicircle of giant wooden letters, were the words PHOTOGRAPHIC TEMPLE OF ART. The days of the Broadway Daguerreian Galleries were drawing to a close.

8. *Itinerants and Travelers*

FROM shore to shore the motto,

> Secure the shadow 'ere the substance fade,
> Let Nature imitate what Nature made!

was blazoned forth on handbills and in newspaper advertisements by the proprietors of daguerreian galleries named Sunbeam, Apollo, National, Premium. In their advertising they appealed to sentiment:

> Nobody who travels knows that he shall return. Therefore he ought to leave something behind for his friends to remember him by. What can be more appropriate than a Daguerreotype? because nothing can represent the features so well and so accurately. At LANGENHEIM'S establishment, Exchange, 3d story, good ones can be procured.[1]

While some daguerreotypists scorned advertising—Lawrence said, "I prefer to write my own advertisements on well-prepared and polished plates"[2]—most of the proprietors had a keen and ingenious sense of publicity. Brady hung a huge dummy camera, surmounted by an eagle, on the side of his building. Banners were strung up and the walls of buildings covered with signs. Gurney had handbills printed to resemble in size and typography paper money; in each corner were the figures 100 in large type; beneath, written out in fine print, were the words "and forty nine"—the address of his Broadway gallery. Premiums were offered; the first person to appear each morning was given a free sitting. William A. Pratt, of Richmond, Virginia, offered shares in a $30,000 "donation" of real estate, which could be purchased either in cash or in the cash value of daguerreotypes taken by him. Even "tie-in deals" were offered: a New York hatter inserted free a daguerreotype in the lining of each hat sold.

Galleries in the smaller cities rivaled the luxury and elegance of Broadway establishments. In 1851 Charles Cist, the historian of Cincinnati, stated that

there were thirty-seven daguerreotypists and seventy-eight assistants in that city; they did an $80,000 business. He proudly reported: "Our daguerreian artists stand high everywhere. Reed, the artist, who carried portraits taken by Hawkins and Faris* to Europe, states, in a letter home, that their works were recognized at a glance in Florence, by Frenchmen and others, as American productions, and superior to anything produced on the continent of Europe."[3]

The most elaborate of the Cincinnati galleries was James P. Ball's Great Daguerreian Gallery of the West, opened in 1853. "There are nine artists employed in this gallery," Ball boasted, "consequently visitors are not obliged to wait a whole day for a picture, but can get what they desire in a few minutes."[4] A wood engraving of the gallery appeared in *Gleason's Pictorial Drawing-Room Companion* for April 1, 1854, with a description. It was twenty feet wide by forty feet long.

> The walls are tastefully enamelled by flesh-colored paper, bordered with gold leaf and flowers. The panels on the south side and west end are ornamented with ideal figures. . . . On the ceiling is a centre piece representing the aerial regions, in which Venus, the goddess of Beauty, is sitting recumbent on a splendid throne. . . . The very seat on which you sit and the carpet on which you tread seem to be a gem culled from the fragrant lap of Flora. . . .

Even the smaller cities and towns had show places. Anson Clark fitted up the rooms adjacent to his West Stockbridge, Massachusetts, gallery "for a cabinet of minerals and natural curiosities," he wrote in 1842. "It already contains several hundred specimens of minerals together with models of machines—the pictures of all the heathen Gods and Goddesses—eggs of various kinds of birds several hundred—shells of various kinds—and other natural and artificial curiosities among which are—the cane that kill'd Abel and one of the Rams horns that blow'd down the walls of Jericho, etc. etc."[5] Andrew Wemple Van Alstin, active in Worcester, Massachusetts, went around the world collecting birds, which he mounted and displayed in his daguerreotype rooms.

Platt D. Babbitt, of Niagara Falls, reversed this pattern. Instead of bringing natural curiosities to his gallery, he set up an outdoor studio with the nation's most popular tourist attraction as a background. By arrangement with the man-

*Ezekiel C. Hawkins and Thomas Faris were partners in Cincinnati from 1844 to 1849, when Hawkins opened his Apollo Gallery and Faris his Melodeon Gallery.

ager of the American side of the falls, he set up a daguerreotype camera on a permanent tripod, pointing straight at the Horseshoe Falls across Prospect Point. Above the camera he built a hip-roofed pavilion—as much to advertise his presence as to protect his equipment from the elements. When visitors stood on the brink of Prospect Point to admire the falls, he took their pictures. Dozens of daguerreotypes exist, all identical except for the people (Plate 34). Babbitt continued at his stand from 1854 well into the last quarter of the century, making group photographs in all the techniques which followed the daguerreotype. He held a monopoly: when a Scotsman, William Thompson, attempted to photograph the falls from Prospect Point, "Mr. Babbitt would not have it. . . . Every time Mr. Thompson made an attempt to take the cap off the camera for an exposure, Mr. Babbitt and his forces would stand between the camera and the falls swinging large-sized umbrellas to and fro, thus preventing Mr. Thompson from getting a picture. The war between the two men came to such a pitch that Mr. Babbitt was finally forced to vacate and thereafter the Scotch artist held the fort."[6]

Where galleries had not been established, traveling daguerreotypists set up their cameras in rented rooms, or drove their wagon-studios into town, unhitched the teams, and set up shop in a vacant lot or public square. All of the needed apparatus, including a tripod and a headrest to clamp on the back of a chair, could be packed into a small trunk. Any well-lighted room would serve as a studio, and a blanket across the corner of the room would serve as a darkroom. Southworth's pupils traveled up and down New England.

L. C. Champney to A. S. Southworth, Bennington, Vermont, March 9, 1843. I think I shall stay up this way for the present. They all say that my pictures are the best that they ever saw. I have tride the light as you proposed, but they do not like the dark on one side of the face, and I cant sell a picture that where one side of the face is darker than the other, altho it seems to stand out better and look richer.

Business was going well with Champney when, on April 13, he ordered more plates. They did not arrive when he needed them, and he wrote again nine days later: "I have bin watering ever since for the plates, and one day seems one week to me. Please forward directly." In July he wrote that he had been to New York. He bought some cases from Brady. "I thought they were as good as yours when

69

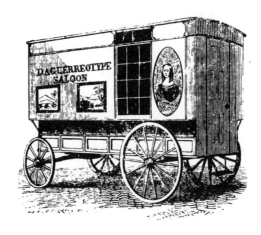

I was there, but to come back and compare them I found they would not be durable. They will never know the difference in the country." Champney was not long a customer. In reply to a dun in 1844 he wrote: "I was unfortunate in the Daguerreotype Business. I was obliged to drop it and go to work at my Traid."[7]

The itinerants went from town to town. Sarah Holcomb, also a pupil of Southworth's, left Saxonville (near Boston) for Manchester, New Hampshire, in the winter of 1846. There she found that someone had already set up a gallery, so she went on to Concord. A storm held her up. At Claremont, New Hampshire, she found that there had been no operator for a year. The prospects were good but, "on unpacking my things, found all my chemicals frozen. The bottle of bromide . . . burst and made sad work for me. . . . I can do nothing till I get more," she wrote Southworth.

Enterprising daguerreotypists fitted up wagons as "Daguerreotype Saloons," hitched teams of horses to them, and drove around the countryside.

> *New York Mirror, October 31, 1846.* There is a chap traveling in Connecticut, who has fitted up a large double wagon into a sort of saloon, with a daguerreotype apparatus, and is going about like a tin pedlar, calling at houses and taking pictures here and there, as he can find customers.

Humphrey called these wagons "rotary establishments," and noted in 1852 that there were four working out of Syracuse, New York. In the nearby town of

70

Lockport, E. R. Graves and Henry Pruden built a "mammoth Daguerreotype Gallery on wheels" in 1853 at a cost of $1,200; "it was 28 feet long, 11 feet wide and 9 feet high, with a beautiful skylight and tastefully furnished."[8] Along the riverways, floating galleries were not uncommon. John R. Gorgas spent three years on the Ohio and Mississippi Rivers, "the happiest of my life, with a hand-some boat 65 feet long, well appointed, a good cook, with flute, violin and guitar, had a jolly time, did not need advertising, and never did any Sunday work."[9]

The itinerants traveled far and wide. The history of the daguerreotype in South America is a record of American travelers; for even though Daguerre's process first came to South America directly from France, it was not followed up. The Franco-Belgian school-ship *La Orientale,* on a trip around the world, touched at Rio de Janeiro in 1840. The chaplain, Louis Compte, who had mastered the daguerreotype process in France just before the ship sailed, gave a demonstration to the citizens.

> *Journal de Commercio, January 17, 1840.* One must have seen the thing with one's own eyes to have an idea of the rapidity and the result of the operation. In less than nine minutes the fountain of Paço Square, Peixe Park, and the monastery of São Bento and all surrounding objects were reproduced with such fidelity, precision and detail that they really seem made by the very hand of nature, almost without the intervention of the artist.[10]

Compte made similar demonstrations in Baía and, on February 27, in Montevideo.[11] But not until a handful of adventurous American daguerreotypists traveled to South America was the daguerreotype established there as an industry.

In 1842 Augustus Morand of New York visited South America. Shortly after arriving in Rio de Janeiro, where he set up rooms in the Hotel Pharoux, he was invited by the Emperor, Dom Pedro II, to demonstrate the process. The Emperor was entranced, learned the process himself, and commanded Morand to take views of the Imperial residence at São Cristóvão and portraits of the royal family. In a biographical sketch of Morand in the *Photographic Art-Journal,* the Rev. D. P. Kidder tells of a triumph of photographic skill:

> It was the custom of the Emperor to visit, every Saturday morning, his Palace in the city. One of these occasions he conceived to be an excellent opportunity for producing a fine picture of the Emperor with his body guard and splendid equipage. Having prepared his plates at an early hour, he awaited their arrival.

71

At the usual time the guard drew near in advance of the Emperor's carriage; the instant it halted, and while the Emperor was in the act of stepping out of his carriage, Mr. M. exposed his plate, and in a second of time, procured a picture truly beautiful.

The body guard composed of 40 horsemen, were with but one or two exceptions all perfect, also the "Major Domo" in the act of kneeling to kiss the Emperor's hand as he stepped from the carriage. The likeness of the Emperor himself was very correct.

The whole time consumed in taking, finishing, and framing the picture was less than forty minutes from the time he arrived at the Palace. The Emperor doubted the fact, until his attention was called to the carriage in the plate, when he immediately assented, for it was the one presented to him by Queen Victoria, and one that he had not used for several months previous. The Emperor was in raptures with the picture and ordered that it should be hung in the Imperial Gallery, where it now remains, a testimonial of the enterprise and skill of our American artist. Mr. M's studio was enriched by many views taken from the most beautiful sites around Rio de Janeiro— and but for feeble health, a complete Daguerrean Panorama would have been the result of his abode within the tropics.[12]

Morand returned to the United States in April, 1843. He traveled through the southern states and then opened a gallery in New York in 1848.

John A. Bennett, whose Mobile, Alabama, gallery was purchased by M. A. Root, was in Buenos Aires in 1845. He had changed his first name to Juan sometime during his travels in Colombia, the Antilles, and Venezuela. He was in competition with his compatriots Tomás C. Helsby, Henrique North, Guillermo Weston, and Carlos D. Fredricks.

The latter was the very same Charles DeForest Fredricks who was Gurney's partner on Broadway. In 1843, when he was twenty years old, he went to Venezuela to join his brother, who was a trader there. Just before sailing he bought a complete daguerreotype outfit from Gurney and learned how to use it. When he arrived at Angostura (the present Ciudad Bolivar), the customs officials made such a fuss over this strange apparatus, and demanded such exorbitant duty for its importation, that he left it on the dock, to be returned to New York. Fredricks was the guest of the leading merchant in town. During his visit the merchant's son died. The brokenhearted father had no portrait of the child. He offered to clear Fredricks' outfit through customs if he would take a posthumous daguerre-

72

otype. The daguerreotypist agreed, and at the first trial succeeded. The inhabitants had never seen the like before; they demanded that he take their portraits; in three weeks he ran out of materials and had earned $4,000. He sent to New York for plates and chemicals, joined his brother in San Fernando, and made his way up the Orinoco River to Brazil and down the Amazon, daguerreotyping all the way. At the rapids of the Mapuera, deep in the jungle, the Indian guides ran off with the canoes and provisions. There was nothing to do but wait for help. For twenty-two days they subsisted on sour mandioc, an Indian food, until they were rescued by a party of government officials and soldiers.

Fredricks returned to New York to recuperate, but the next year, 1844, he was back. Except for quick trips to New York he traveled all over South America for the next nine years. He ran a gallery in Belim (Para), then moved to Maranhão, Baía (Salvador), Rio de Janeiro, and Porto Alegre. On a trip through the province of Rio Grande, en route to Montevideo and Buenos Aires, he traded a horse for each picture: "our photographer arrived at his journey's end in patriarchal style, surrounded by an immense drove of horses, which he finally sold, at $3 each."[13] The Governor of Corrientes pressed upon Fredricks a live tiger in exchange for a daguerreotype portrait. The beast was chained securely to the boat, and Fredricks planned to bring this bounty to New York, but the tiger did not survive captivity. Fredricks lived in Buenos Aires and Montevideo for about a year; a few of his daguerreotypes, stamped "Carlos D. Fredricks & Co." exist, including a whole plate of the harbor. He went to Paris in 1853 to learn the new glass-plate process, which he brought back to his former teacher, Jeremiah Gurney; he never again visited South America.

John Lloyd Stephens, travel writer and explorer, sailed to Central America on October 3, 1839, where he and Frederick Catherwood made a study of the ancient ruins there. In his report of the expedition, *Incidents of Travel in Central America, Chiapas and Yucatan,* he regretted that he had left New York too soon to take along a daguerreotype camera. He knew of it, for he sponsored Seager's demonstration, which took place just two days after he left New York.

On his second trip, in 1841, Stephens and Catherwood had a complete daguerreotype outfit. It proved to be of little use for their objective.

At Uxmal, Mr. Catherwood began taking views, but the results were not

73

sufficiently perfect to suit his ideas. At times the projecting cornices and ornaments threw parts of the subject in shade, while others were in broad sunshine; so that, while parts were brought out well, other parts required pencil drawings to supply their defects. They gave a general idea of the character of the building, but would not do to put into the hands of the engraver without copying the views on paper . . . which would require more labor than that of making at once complete original drawings. He therefore completed everything with his pencil and camera lucida, while Doctor Cabot [the third member of the party] and myself took up the Daguerreotype; and, in order to ensure the utmost accuracy, the Daguerreotype views were placed with the drawings in the hands of the engravers for their guidance.[14]

But if the daguerreotype proved unsatisfactory for scientific purposes, it offered the party much satisfaction of another sort.

The process was still a novelty in Yucatán, although even at that early date someone had been there with a camera. They set up a portrait studio in their quarters in Mérida and for a while met with great success. Their first subject was "a delicate and dangerous blonde, simple, natural, and unaffected, beautiful without knowing it, and really because she could not help it." She was posed by Stephens, "and as this required great nicety, it was sometimes actually indispensable to turn the beautiful little head with our own hands, which, however, was a very innocent way of turning a young lady's head." The exposure was "eternity": one minute and thirty seconds by the watch. While Catherwood processed the plate, Stephens "took occasion to suggest that the process was so complicated, and its success depended upon such a variety of minute circumstances, it seemed really wonderful that it ever turned out well. The plate might not be good, or not well cleaned; or the chemicals might not be of the best; or the plate might be left too long in the iodine box, or taken out too soon; or left too long in the bromine box, or taken out too soon; or a ray of light might strike it putting it into the camera or in taking it out; or it might be left too long in the camera or taken out too soon; or too long in the mercury bath or taken out too soon; and even though all of these processes were right and regular, there might be some other faults of omission or commission which we were not aware of; besides which, climate and atmosphere had great influence, and might render all of no avail." But happily Stephens did not need to catalogue the sources of failure, "for the young lady's image was stamped upon the plate and made a picture which en-

74

chanted her and satisfied the critical judgment of her friends and admirers. Our experiments upon the other ladies were equally successful . . . our reputation increased, and we had abundance of applications."

A few days later all that Stephens had feared occurred. They had gone, upon invitation, to a private house.

It was our intention to go through the whole family, uncles, aunts, grandchildren, down to Indian servants, as many as would sit; but man is born to disappointment. I spare the reader the recital of our misfortunes that day. It would be too distressing. Suffice it to say that we tried plate after plate, sitting after sitting, varying light, time, and other points of the process; but it was all in vain. The stubborn instrument seemed bent upon confounding us; and, covering our confusion as well as we could, we gathered up our Daguerreotype and carried ourselves off. What was the cause of our complete discomfiture we never ascertained, but we resolved to give up business as ladies' Daguerreotype portrait takers.[15]

9. *Facing the Camera*

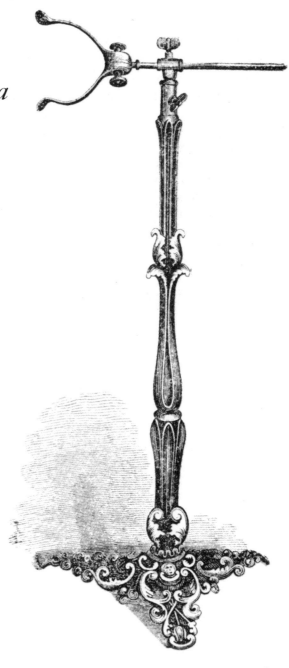

HEAD-REST

WITH an exposure of approximately twenty seconds, it was an ordeal to sit for one's likeness, whether in Central America or in a luxurious Broadway gallery. Absolute immobility was required during the time that the lens was uncovered, and to help the sitter hold still, heavy iron headrests were provided, with adjustable horns forming a semicircle to accommodate the back of the head. These were not clamps; the head was not held rigid; they were rests against which one could lean. The heavier they were, the better, and one daguerreotypist found that moving them around his gallery was a healthy daily exercise. Ralph Waldo Emerson entered in his journal for October 24, 1841:

> Were you ever daguerreotyped, O immortal man? And did you look with all vigor at the lens of the camera, or rather, by direction of the operator, at the brass peg a little below it, to give the picture the full benefit of your expanded and flashing eye? and in your zeal not to blur the image, did you keep every

76

finger in its place with such energy that your hands became clenched as for fight or despair, and in your resolution to keep your face still, did you feel every muscle becoming every moment more rigid; the brows contracted into a Tartarean frown, and the eyes fixed as they are fixed in a fit, in madness, or in death? And when, at last you are relieved of your dismal duties, did you find the curtain drawn perfectly, and the hands true, clenched for combat, and the shape of the face or head?—but, unhappily, the total expression escaped from the face and the portrait of a mask instead of a man? Could you not by grasping it very tight hold the stream of a river, or of a small brook, and prevent it from flowing?[1]

Emerson's disappointment in his likeness was a not uncommon reaction. When a sitter complained to Abraham Bogardus, "My picture looks like the *Devil*," the Broadway daguerreotypist said, "I told him I had never seen that personage and could not say as to resemblance, but sometimes a likeness ran all through families."[2]

Snelling urged his readers to avoid stilted poses.

Photographic Art-Journal, February, 1851. "Look right into the camera," is a direction often given to the sitter by the Daguerreotypist, which cannot be too highly censured; for a more palpable error, where grace and ease is desired, could not be committed.

That the position of every portion of the sitter's person should be carefully studied, may be illustrated by a single incident that came under our observation but a short time since. A gentleman had a daguerreotype of his wife taken by one of our best artists, and so far as the tone and boldness of the picture was concerned, it could have no superior—still, when it was delivered, he expressed himself dissatisfied, declaring that it had no more resemblance to his wife than to any other lady. We were appealed to to decide, and gave our opinion as above expressed, but nothing could move his decision, although he acknowledged that he perfectly agreed with us, as to its merits in other respects, and as he could not censure the artist, he willingly took the daguerreotype, deciding to make another trial at a future day. We then explained the cause of his disappointment, and he was satisfied that the fault was with the lady, although we, in our mind, were positive it was with the artist. The fact was, she had elevated her eyebrows to such a degree, as to give her eyes a very disagreeable stare, and produce a contraction in other portions of her features.

Had the operator paid attention to his subject, he would have studied her face more minutely, detected the defect, and watched his opportunity to secure the impression of the image, at the moment when a more pleasing expression

77

crossed the features. This he might readily have produced by some pleasant re-
mark, or delicate compliment.

Yet all could not be left to the operator. The sitter had to be something of
an actor. "Some of us know better than others how to put on the best look," N.
P. Willis, the novelist, observed. "Some are handsome only when talking, some
only when the features are in repose; some have more character in the full face,
some in the profile; some do the writhings of life's agonies with their hearts and
wear smooth faces, some do the same work with their nostrils. A portrait-painter
usually takes all these matters into account, and, with his dozen or more long
sittings, has time enough to make a careful study of how the character is worked
out in the physiognomy, and to paint accordingly. But in daguerreotyping, the
sitter has to employ this knowledge and exercise this judgment for himself."[3]

The comparison with the portrait painter was inevitable. Samuel F. B.
Morse, himself a distinguished portraitist with the brush, had already pointed out
that the daguerreotype should prove to be valuable to the artist. "How narrow
and foolish the idea which some express that it will be the ruin of art, or rather
artists, for every one will be his own painter," he wrote to his fellow artist,
Washington Allston.[4] The painter Rembrandt Peale, however, expressed con-
cern: "Daguerreotype and photographs all have their relative merit; and as
memorials of regard, are not to be despised. The task of the portrait painter is
quite another thing—an effort of skill, taste, mind and judgment . . . to render
permanent the transient expression of character which may be the most agree-
able."[5]

Yet painters did not hesitate to make use of daguerreotypes, particularly
when their assignment was to make portraits of famous people. William Willard's
solution to the problem of painting the aged Daniel Webster by having a daguerre-
otype made of him by Southworth & Hawes was a common practice. A painting
of Webster in the Memorial Art Gallery of the University of Rochester, New
York, is from a daguerreotype by F. DeBourg Richards of Philadelphia—even
though it is signed "G. W. Merrick." Plumbe's daguerreotype of Washington
Irving (Plate 61) was used by several painters as a substitute for the presence in
their studios of that illustrious writer. The painting by Henry F. Darby in the
Sleepy Hollow Restorations, Tarrytown, New York, is clearly copied from the
daguerreotype. Plumbe's image appears again, copied in every detail, in the

group portrait of "Irving and his Friends" in the same collection by Christian Schussle. It is likely that this painting is based entirely on daguerreotypes, for the features of James Fenimore Cooper bear a striking resemblance to the daguerreotype which was made in Brady's gallery for the *International Magazine* in 1851—the very same daguerreotype from which Charles Eliot Loring derived the painting which now hangs beside Schussle's in the Tarrytown museum.

This use of daguerreotypes appeared entirely legitimate in the middle of the nineteenth century, when photography was considered an automatic process. Photography was called the pencil of Nature, the child of light, Nature's amanuensis: daguerreotypes were advertised as sun-drawn miniatures. "It is a work of Nature, not of Art—and as far surpassing the production of the pencil as all Nature's effort do those of man."[6] The professional press noted with pride that painters were using the work of daguerreotypists.

> *Humphrey's Journal, April 15, 1852.* Thomas Faris of Cincinnati has made a portrait of Kossuth full length from which Eaton* is to paint a portrait.

> *American Journal of Photography, November 1, 1860.* Edgar A. Poe's daguerreotype, in the possession of Ossian E. Dodge, has been enlarged to life size in a copy, taken from it by a Cleveland photographer, and painted in oil by Walcutt,† the western artist.

It is surprising that today art historians, with their delight in probing into the prototype of every artist's work, should so generally fail to recognize that photography has been ever since 1839 both a source and an influence to hosts of painters. Nor was the role of photography unnoticed by critics of the day. Théophile Gautier, reviewing the 1861 Salon, remarked that "the daguerreotype, which has been given neither credit nor a medal, has nevertheless worked hard for the exhibition. It has yielded much information, spared much posing of the model, furnished many accessories, backgrounds and drapery which had only to be copied and colored."[7]

Illustrated magazines began to reproduce daguerreotypes by means of wood engravings, steel engravings, or other graphic arts techniques. The demand for portraits of celebrities was so great that Humphrey warned his readers:

*Probably Joseph Oriel Eaton, active in Cincinnati in 1853.
†Probably William Walcutt, who was in Cleveland 1859-60.

It is no uncommon saying by our first men, that they "wish there was no such discovery as Daguerre's, for it is so annoying that it is impossible to go to New York, Boston or Philadelphia, without being tormented by a dozen invitations to sit for a daguerreotype likeness." This we heard from a gentleman, who, during a stay of a single day in this city, received no less than TWENTY-ONE "very polite invitations" to allow the ARTIST "the gratifying pleasure of adding a portrait of his most honorable sir to their collection."[8]

The first of these collections of celebrities was The National Daguerreotype Miniature Gallery, founded by Edward Anthony in partnership with Jonas Edwards, Howard Chilton, and J. R. Clark. Humphrey was impressed by the effort which the firm made to obtain portraits. "Mr. Anthony," he wrote in 1852, "went from this city to the residence of *Gen. Andrew Jackson,* for the purpose of securing a likeness of the old hero before his death." The national Capitol itself was invaded; the firm succeeded in having a committee room set aside for their use as a studio. The most famous product of the gallery was a 27-by-36-inch mezzotint, "Clay's Farewell to the Senate," drawn by J. Whitehorne "from Daguerreotype likenesses," and published in 1846. It contains ninety-six portraits: who made them is not stated. An engraving of Daniel Webster, copied from a daguerreotype by John Adams Whipple and published by the firm, was so popular that it was recopied by the daguerreotype process.

The originals, with countless others, were lost when the gallery, then owned by Daniel E. Gavit, burned to the ground on February 7, 1852. "The next day," Humphrey wrote, "as some gentlemen were looking over the ruins where all seemed a mass of ashes, coals, melted glass, brass, copper, and silver, all were startled by the announcement 'Here is a perfect specimen'; and what added more to the happy feeling of all present, it was immediately recognized as the likeness of *John Quincy Adams,* as pure and unspotted as himself. The enthusiasm manifested on this occasion, can be better imagined than described. Should that *good* man appear in person before the living Representatives of our country, no greater surprise could be manifested than was on the finding of his perfect likeness in *these* ruins."[9]

Undoubtedly inspired by Anthony—it is no accident that his first New York gallery was in the same building as Anthony's shop—Mathew B. Brady began in 1845 to make a similar collection of portraits of celebrities, a project which he

80

pressed with such vigor that his gallery was to be called the "Valhalla of America." In 1850 he announced the publication of twenty-four lithographs by Francis D'Avignon, drawn from daguerreotypes. Only twelve were published, in a folio volume titled *The Gallery of Illustrious Americans*. Although it was clearly stated on the title page that the illustrations were "From daguerreotypes by Brady, engraved by D'Avignon," beneath the portrait of William Ellery Channing appears the credit: "S. Gambardella pinx." Other portraits in Brady's collection, not reproduced in the 1850 publication, originated from other galleries. The portrait of Edgar Allan Poe (Plate 62), so often reproduced as the work of Brady, was taken in the Providence, Rhode Island, gallery of Masury & Hartshorn on November 9, 1848; the operator was a Mr. Manchester,—either Henry N. or his brother Edwin H., who took over the gallery in 1850. Poe was persuaded by a friend to sit for his daguerreotype in the gallery a few days after he had attempted suicide. The cause of Poe's acute distress was his failure to win the hand of Mrs. Sarah Helen Whitman in marriage, for which purpose he visited Providence. He gave Mrs. Whitman the daguerreotype, which she considered "wonderful . . . all the stormy grandeur of that Via Dolorosa had left its sullen shadow on his brow, but it was very fine."[10] Three identical daguerreotypes exist, all of which can be traced to Mrs. Whitman. They are without doubt copies of a now lost original.

Four identical daguerreotypes of Henry Clay have been located: one in the Southworth & Hawes collection, one with the name LAWRENCE stamped on the mat, a third from Brady's studio, and a fourth—undocumented—in the A. Conger Goodyear collection. We do not know who took the portrait of John Howard Payne, the author of "Home, Sweet Home"; identical daguerreotypes are in the Southworth & Hawes collection, in the George Eastman House, and in the Goodyear collection (in a frame bearing the label of J. Vannerson).

It was a widespread custom for daguerreotypists to publish daguerreotype copies of daguerreotypes. Apprentices did the duplicating. "Thinking that perhaps Daguerreotypists in the country would like to have a copy of Jenny Lind," Frederick DeBourg Richards advertised in the *Daguerreian Journal*, August, 1851, "and as it is allowed by all that my picture is the best in America, I will sell copies at the following prices:—one sixth, $2; one-fourth, $4; one-half, $6." Daguerreotypists exhibited copies without disclosing their authorship, a practice

81

that has led to utter confusion in the attribution of daguerreotypes to individual makers. Direct provenance from a known gallery is not evidence that the daguerreotype was the work of the proprietor.

When the collodion process replaced the daguerreotype, Brady copied his entire collection on glass negatives. E. and H. T. Anthony sold photographs from these plates. Although these "cartes-de-visite" are plainly marked on their backs "Published by E. & H. T. ANTHONY, 501 Broadway, New York, from photographic negative in BRADY'S National Portrait Gallery," historians have assumed that Brady himself posed the sitter and was responsible for the photograph. Brady's activity was the counterpart of the present-day picture agency's. He both commissioned photographs and collected them. He followed a practice that was fully accepted in the day.

The lack of concern on the part of daguerreotypists and public alike for exact credit makes it impossible to study the work of individuals, as one studies the oeuvre of a painter, or the opera of a composer. Even in the work of Southworth & Hawes, who boasted that they never employed operators, there are daguerreotype copies of daguerreotypes that are quite likely the work of others.

Mathew B. Brady, because of the extraordinary documentation of the Civil War, an outgrowth of his *Gallery of Illustrious Americans,* which he had the imagination and daring to accomplish, has rightfully won a place as a pioneer photographic historian. Yet, as proprietors of galleries, neither he nor his competitors can be judged as photographers. The late Robert Taft summed it up in his book, *Photography and the American Scene* (1938):

> I have no sympathy with some of the pseudo-critics of the modern day who see in any photograph bearing Brady's imprint the hand of the artist. Although it is true that, during his early years, Brady worked long and diligently to master his art, once this mastery had been achieved, and his competence assured, Brady left the actual photographic work to others. He kept abreast of his times, however, employed only the most competent operators, and did not hesitate to spend money upon the introduction of new devices or new methods. But he was absent from his business for long intervals, and during such periods the quality of the work turned out by his galleries did not suffer. Even during the Civil War, when actually engaged in photographic work, he employed a large number of operators, and many of the photographs, in fact a large proportion, of those credited to Brady were made by his employees. The credit which is

due Brady is for his original idea as a photographic historian, his persistence in this idea, and for sufficient business acumen and management to carry it out—and not for any artistic merit his work may possess. One judges an artist by the work of his own hand, not by the work turned out by his employees. This is not to say that some of the work turned out from Brady's studio may not have artistic value, but in most instances we do not know who deserves the praise for such merit.[11]

Brady constantly maintained the highest ideals of taste. He was deeply concerned with the status of photography as an art. He wrote Samuel F. B. Morse on February 15, 1855:

> Permit me to request your opinion in reference to the aid which the progress of Daguerreotyping has afforded the kindred arts of painting drawing & engraving. As the first successful introducer of this rare art in America, the first President of the National Academy of Design, and in virtue of your long & distinguished artistic experience your views upon this topic will be received by the public & the world of art with high consideration.
>
> The influence which Daguerreotyping has exercised upon the social amenities, universalizing as it has the rarest & most subtle of artistic effect, placing within general reach the results which before its introduction were laboriously & slowly wrought with the pencil, is understood and appreciated. The fact that it has found its way where other phases of artistic beauty would have been disregarded is recognized. During my experience, however, I have endeavored to render it as far as possible an auxiliary to the artist. While the other features of its development have not been disregarded I have esteemed this of paramount importance. How far I have succeeded & whether the recognition of the effort among Artists has been commensurate with the aid they have derived from it I know of none so eminently qualified to judge as yourself.[12]

Only a handful from the thousands of daguerreotypes, by daguerreotypists known and unknown, have the magic inner life which distinguishes a work of art. Emerson could write "'Tis certain that the Daguerreotype is the true Republican style of painting. The artist stands aside and lets you paint yourself."[13] His friend Henry David Thoreau was more perceptive: "Nature is readily made to repeat herself in a thousand forms, and in the daguerreotype her own light is amanuensis. . . . Thus we may easily multiply the forms of the outward; but to give the within outwardness, that is not easy."[14]

10. *The Explorers*

ALTHOUGH the overwhelming majority of daguerreotypes taken in America during the two decades when the process flourished were portraits, daguerreotypists took pictures of everything on which the sun shone—and the sun itself. They turned their cameras on cities and landscapes; they invaded the gold fields; they planted their tripods on summits of the Rocky Mountains and on the island of Okinawa, and in Japan.

Most daguerreotypists were frequently called upon to take pictures out-of-doors. These were universally called "views," and required the use of lenses better corrected than those made for portraiture, where sharpness of field was sacrificed for speed. Since a daguerreotype image is normally reversed, as in a mirror, a prism or mirror had to be placed over the lens—unless the daguerreotype served as a model for an engraver, who needed a reversed image. While portraits were wholly acceptable when reversed—the sitter knows his own features only in a mirror—city views with signs reading backward were not acceptable, particularly if merchants had commissioned them.

With one exception, the face of every major city of America can be studied in daguerreotypes. Views of New York City do not exist. They were taken; wood engravings from some of the daguerreotypes were published in *Putnam's Magazine* in 1853. Not one of them has survived.

The finest city views are panoramas, made by taking a series of pictures from one position by turning the camera exactly the angle of view of the lens between each exposure. The finished daguerreotypes were framed with the edges butting.

Charles Fontayne and William Southgate Porter set up their whole-plate camera in Newport, Kentucky, opposite Cincinnati, in 1848. They took eight plates which embrace two miles of the Ohio River from the village of Fulton to the foot of Vine Street in Cincinnati (Plates 37-38). The magnificent panorama is now owned by the Cincinnati Public Library. It won fame for Fontayne and

84

Porter when they exhibited it at the Franklin Institute, the Maryland Institute, and the Great Exhibition in London, 1851. So detailed is this striking panorama that the river craft have been identified.

But of all American cities, San Francisco was the most frequently daguerreotyped. Its rapid growth, the pride of its citizens, and international curiosity about the City of Gold created a demand for pictures, and this demand the daguerreotype satisfied in part.

Daguerreotypists flocked to San Francisco along with the gold hunters. A. S. Southworth was there, not with his camera, but to seek his fortune in the mines. Other, wiser, daguerreotypists found that fortunes could be made by sticking to their trade. There were fifty of them in San Francisco between 1850 and 1864. The earliest was a lady, Mrs. Julia Shannon; but she was not in business long, for her profession is listed in the 1852 directory as "accoucheur." Cameramen came from Massachusetts, South Carolina, Florida, and New Brunswick, Canada. Their prices were high, yet they did a thriving business. Henry Bradley, formerly of Wilmington, South Carolina, "practised his art on the west side of Montgomery, between Washington and Jackson. His prices were from eight dollars upward, according to the size and style of the portrait and frame. The courteous artist was hardly allowed time to breathe, much less to eat, or take a moment's rest or two before the departure of a steamer. Californians were so anxious that their friends in civilized countries should see just how they looked in their mining dress, with their terrible revolver, the handle protruding menacingly from the holster, somehow, twisted in front, when sitting for a daguerreotype to send to the States! [Plate 77] They were proud of their curling moustaches and flowing beards; their bandit-looking *sombreros;* and our old friend Bradley accumulated much *oro en polvo* and many yellow coins from private mints."[1]

The most memorable work of the San Franciscan daguerreotypists were the panoramas they made of the city.

In 1852 William Shew, who had given up his Boston gallery and case factory and settled in San Francisco, made a panorama of five plates of the city from Rincon Point (Plates 70-74). This vivid document is now in the Smithsonian Institution in Washington. The inner harbor is choked with ships abandoned by their crews and left to rot or become floating storehouses. Later the area was filled in; it now forms downtown San Francisco. Five other panoramas exist, all

85

looking toward the Bay.[2] Who took them is not known. Perhaps one, or more, can be ascribed to S. C. McIntyre, dentist turned daguerreotypist from Tallahassee, Florida, who took a panorama described in the *Alta California* for February 1, 1851, as the first of its kind:

> DAGUERREOTYPE OF SAN FRANCISCO.—Decidedly the finest thing in the fine arts produced in this city, which we have seen, is a consecutive series of Daguerrean plates, five in number, arranged side by side so as to give a view of our entire city and harbor, the shipping, bay, coast and mountains opposite, islands, dwellings and hills—all embraced between Rincon Point on the right, to the mouth of our beautiful bay on the left, included between lines proceeding from the hills to the west of the city as the point of vision.
>
> This picture, for such it may be termed, although the first attempt, is nearly perfect. It is admirable in execution as well as design. It is intended for the "World's Industrial Convention" in London. We venture the assertion that nothing there will create greater interest than this specimen of Art among us, exhibiting a perfect idea of the city which all of the world carries with its name abroad more of romance and wonder than any other. It is a picture, too, which cannot be disputed—it carries with it evidence which God himself gives through the unerring light of the world's great luminary.
>
> The people of Europe have never yet seen a picture of this, to them, the most wonderful city. This will tell its own story, and the sun to testify to its truth. . . . The views were taken by Mr. McIntyre of this city. He proposes, if his efforts meet with sufficient encouragement, to finish and furnish duplicates of this excellent and artistical picture to the lovers of art, at one hundred dollars. It may be seen at this office.

There is no record that the panorama was shown at the Great Exhibition of the Works of Industry of All Nations in London. But Europeans soon became familiar with a similar panorama of San Francisco in an etching, measuring 39 by 9½ inches, made by the French artist Charles Méryon from a set of five daguerreotypes in 1856. Charles Baudelaire, poet and art critic, considered the print Méryon's masterpiece. The commission was irksome to the artist. He found it difficult to resolve the perspective, for each daguerreotype had its own vanishing point. Méryon was not content to copy the plates; he wanted to produce a picture as if he had drawn it on the spot, and used the daguerreotypes as documents, rather than as models. They were confusing: some areas contained too much detail, other areas were so indistinct that it took him days of study to disentangle one building from another.[3]

Humphrey praised McIntyre's panorama; he was especially enthusiastic about a set of six half-plates of gold mining, "picturing 'all sorts'—men, with spade and tin pan in hand, eagerly looking after dust; some examining a lump just found, others up to their knees in water, and, among the rest is, in a bent position, a man, pan in hand, looking up with a grin, exhibiting 'something' in his pan which he no doubt would try to make us believe was the metal."[4] (Cf. Plate 85)

Eduard Vischer, in a report of a trip to the mining regions in 1859, wrote:

> The daguerreotype is especially suited to reproduce all these mechanical mining devices. In the mining region nature, too, seems bare of all cheerful embellishment, with a stark contrast between the naked masses of rock and the thin, straggly pine woods. Luxuriant foliage is seen but rarely. Rich material for observation is offered in the photographic views of the American River region exhibited in Vance's Panorama. Similar photographs of other mining regions would complete a picture gallery the inspection of which would almost be a substitute for a visit to the places themselves.[5]

A large number of these documentary daguerreotypes exist (Plates 85-87). Who made them we do not know. Robert H. Vance, whose "Panorama" Vischer praises, specialized in them and put three hundred on exhibition in New York in 1851. In the catalogue he wrote:

> These Views are no exaggerated and high-colored sketches, got up to produce effect, but are as every daguerreotype must be, the stereotyped impression of the real thing itself.
> They embrace among a variety of others, a splendid Panoramic View of San Francisco. . . . Also, views of Stockton, Coloma, Carson's Creek, Makelame Hill, the Old Mill where the gold was first discovered, Nevada, Gold Run, Marysville, Sacramento, Benicia, &c., &c. Also, a large collection of views taken of the miners at work, in different localities; also a likeness of Capt. Sutter, and a large collection of sketches of the different tribes of Indians on the Pacific Coast.[6]

This magnificent collection no longer exists. How or when these historical documents disappeared is not known. The exhibition was not a financial success, and Vance offered the daguerreotypes for sale in 1852. They were bought by Gurney, but a year later he sold them to John H. Fitzgibbon of St. Louis, who had them on display in his gallery in 1856. Perhaps they disappeared when Fitzgibbon

87

sold his gallery in 1861 and moved to Vicksburg, Mississippi. It was an unlucky move for him, for he was captured by the Union Army and sent to a prisoner-of-war camp in Cuba. On his release he made his way back to St. Louis and reopened his gallery. In 1877 he retired, and began publication of a magazine, *The Saint Louis Practical Photographer,* in which he presented reminiscences of the pioneers and his own early experiences as a daguerreotypist. In spite of his historical interest, he gave no clue in the magazine to the disappearance of the Vance collection.

Curiously, and to the despair of the historian, not one daguerreotype is known to exist from those that were taken under even more difficult conditions by the handful of daguerreotypists who accompanied official government expeditions and exploring parties to little-known parts of the country.

Edward Anthony was the first to serve as official photographer on a government survey. When Professor James Renwick of Columbia College was appointed by the President chairman of a commission to survey and explore the northeast boundary of the United States and Canada, he invited his former pupil, Anthony, to accompany him and take daguerreotypes of terrain. On March 28, 1842, the commission submitted its report, together with supporting documentation, including "copies of some daguerreotypes."[7]

Perhaps influenced by this official acceptance of daguerreotypes as topographical documents, Colonel John Charles Frémont took a camera with him on his first government expedition to explore the Oregon Trail from the Mississippi to Wyoming. Charles Preuss, the German cartographer of the expedition, noted in his diary on August 2, 1842: "Yesterday afternoon and this morning, Frémont set up with daguerreotype to photograph the rocks; he spoiled five plates that way. Not a thing was to be seen on them. That's the way it often is with these Americans. They know everything, they can do everything, and when they are put to a test, they fail miserably."[8] Five days later Frémont again failed. Preuss commented: "Today he said the air up here is too thin; that is the reason his daguerreotype was a failure. Old boy, you don't understand the thing, that is it."[9] No record exists of Frémont's daguerreotypes—nor any other reference to them.

In making preparations for his fifth crossing of the Rocky Mountains in 1853, Frémont decided to leave photography to a professional. He chose Solomon

88

N. Carvalho, a daguerreotypist from Charleston, South Carolina, after a contest with another candidate, a certain Bomar, for the position of photographer. The daguerreotype process was already threatened by the negative-positive process, and Frémont did not know which technique would be better suited to the rigors of mountain travel. As a practical test, he ordered a contest between the two. "In half an hour from the time word was given," Carvalho recounted in his *Incidents of Travel and Adventure in the Far West,* "my daguerreotype was made; but the photograph could not be seen until next day, as it had to remain in water all night, which was absolutely necessary to develop it."[10] Evidently Bomar was far from skilled in the art of paper and glass photography, for no such all-night processing time is specified in the technical literature.

Carvalho joined the party, and soon was setting up his camera at a Cheyenne village on Big Timber to photograph the daughter of the Great Chief. "She attired herself in her most costly robes, ornamented with elk teeth, beads, and colored porcupine quills—expressly to have her likeness taken. I made a beautiful picture of her." He touched her brass bracelet with quicksilver: "it instantly became bright and glittering as polished silver."[11] To the Indians, it was magic.

Around New Year's Day, 1854, the party was high in the Rockies. Carvalho climbed to mountain peaks with Frémont and photographed the landscape.

> To make daguerreotypes in the open air, in a temperature varying from freezing point to thirty degrees below zero, requires a different manipulation from the processes by which pictures are made in a warm room. My professional friends were all of the opinion that the elements would be against my success. Buffing and coating plates, and mercurializing them, on the summit of the Rocky Mountains, standing at times up to one's middle in snow, with no covering above save the arched vault of heaven, seemed to our city friends one of the impossibilities—knowing, as they did, that iodine will not give out its fumes except at a temperature of 70° to 80° Fahrenheit. I shall not appear egotistical if I say that I encountered many difficulties, but was well prepared to meet them by having previously acquired a scientific and practical knowledge of the chemicals I used, as well as of the theory of light: a firm determination to succeed also aided me in producing results which, to my knowledge, have never been accomplished under similar circumstances.
>
> While suffering from frozen feet and hands, without food for twenty-four hours, travelling on foot over mountains of snow, I have stopped on the trail, made pictures of the country, repacked my materials, and found myself . . . frequently some five or six miles behind camp, which was only reached with

great expense of bodily as well as mental suffering. The great secret, however, of my untiring perseverance and continued success, was that my honor was pledged to Col. Frémont to perform certain duties, and I would rather have died than not have redeemed it.[12]

The going became even more difficult. All fifty pack animals fell several hundred feet to the bottom of a ravine; two were killed, and the tent poles were smashed. The men "had to sleep out upon the open snow, with no covering but our blankets." Provisions got low, they were forced to slaughter the horses for food; twenty-seven were butchered. To save themselves, Frémont ordered all superfluous baggage buried in the snow, including the daguerreotype apparatus. The party finally arrived at Parawan in Little Salt Lake Valley, southern Utah, on February 8, 1854. One of them died. Carvalho was too ill to continue. He and F. W. Egglofstein, the topographical engineer, left the party and proceeded by foot to Salt Lake City.

The daguerreotypes which cost Carvalho such great effort have never been found, although Mrs. Frémont, in the introduction to her husband's memoirs, states that he managed to save them and sent them to Brady to be copied.[13]

While Frémont, at his own expense, was exploring for a route for the proposed transcontinental railroad straight across the Rocky Mountains, four official government surveys were being made for alternate routes. Isaac I. Stevens left St. Paul in June, 1853, to explore a northern route to Fort Vancouver (now Vancouver, Washington), where he arrived in December. John Mix Stanley, the most celebrated painter of Indians since George Catlin, was a member of the party. He had a camera. The official United States War Department report states that on September 4, 1853, "Mr. Stanley commenced taking daguerreotypes of the Indians with his apparatus. They were delighted and astounded to see their likenesses produced by the direct action of the sun. They worship the sun, and they considered that Mr. Stanley was inspired by their divinity, and he thus became in their eyes a great medicine man."[14]

Stanley's daguerreotypes shared the fate of Carvalho's. Perhaps they perished in the fire in the Smithsonian Institution which destroyed Stanley's entire collection of paintings.

The daguerreotype flourished in an age of government expeditions. When a fleet of vessels of war sailed around the world under the command of Commodore Matthew Calbraith Perry on the delicate mission of opening diplomatic

relations with the empire of Japan, there were but two civilians on board the flagship: William Heine, a painter from Dresden, and E. Brown, daguerreotypist.

Perry was besieged by scientists and explorers who wished to accompany him, for it was planned to make a complete report of the flora and fauna of the island of Japan and the life and customs of the people. On the grounds that military discipline, which he considered essential to the success of the mission should the Japanese prove hostile, could be enforced only with regular, trained Navy personnel, Perry refused these requests. The only exception was for the two artists, who were added to the crew of the U.S.S. *Mississippi* as acting master's mates.

The *Mississippi* set sail in 1852, bound for Japan by way of the Cape of Good Hope, Mauritius, Singapore, and Shanghai. At Lew Chew, as the island of Okinawa was then called, Brown was settled in a house on the outskirts of Tumai; his companion drew him photographing, with a whole-plate camera on a cast-iron studio stand, four Lew-Chewans in front of a temple. The picture appears as a lithograph in the richly illustrated, three-volume report issued by the United States government.[15] Twenty-one lithographs and thirteen wood engravings in the report are based on Brown's daguerreotypes; the remainder are either signed by Heine or bear the double credit, "From life by Heine. Figures by Brown." It is not improbable, therefore, that Brown's daguerreotypes served as models for these pictures. Most of the daguerreotypes credited to Brown are portraits; a few are temples and buildings.

Perry's fleet, numbering four ships and 560 men, entered Uraga Bay, Japan, in July, 1853, and lay at anchor there. The Japanese were thrown into confusion; never had they seen so many western vessels. Ten days later, after demanding an audience with the Emperor's representatives and announcing that he would return in the spring, Perry steamed away. In February he returned with ten ships and two thousand men. He was welcomed, presents were exchanged, exploring parties organized, and a treaty signed in which Japan agreed to allow foreign vessels to obtain stores and provisions.

The diplomatic success of the expedition, which marks the beginning of the rise of Japan as a national power, has overshadowed its scientific and ethnological significance. No comparable description of the life and customs of the Japanese and the natural resources of their country had ever been published. The reliance on photographs in the pictorial documentation published in the report pointed the way to the future.

91

11. *A Tool for Scientists*

BESIDES its use on scientific expeditions, the daguerreotype was found of great value by astronomers.

Humphrey reported that the solar eclipse of May 26, 1854, had been photographed by John Campbell, John Kelsey in Rochester, New York, C. Barnes in Mobile, Alabama, George E. Hale in Detroit, and by the Langenheims in Philadelphia.[1] Snelling added M. A. Root and Victor Prevost.[2] All used the daguerreotype process except Prevost, a Frenchman who had just come to America, bringing with him an adaptation of the calotype paper-negative technique. In the literature of astronomy yet another photographer is recorded, Professor William Holmes Chambers Bartlett of West Point, who took four daguerreotypes.[3]

Never before had so many people been able to take astronomical photographs. Solar eclipses had been photographed before—first, without much success, in Milan by G. A. Majocchi on July 8, 1842. Though only partially visible in the United States, the eclipse of July 28, 1851, was daguerreotyped by John Adams Whipple at Harvard College Observatory.[4]

Whipple was scientifically trained. He was a chemist by profession when the daguerreotype process came to America, and supplied chemicals to daguerreotypists. But the manufacturing processes proved detrimental to his health and in 1843 he took up the camera as a profession in partnership with Albert Litch until, in 1846, Litch left to become Gurney's operator. Whipple had great mechanical ingenuity. To produce a vignette effect in his portraits he interposed between the camera and the sitter a circular mask; he patented this technique, which he called "crayon portraiture" in 1849.[5] Humphrey visited him in Boston.

Daguerreian Journal, July, 1851. Whipple is going it by steam . . . a large fan is so arranged and worked by steam that it keeps a cool and rather inviting breeze and prepares the complexion of the sitter for one of his best, even in the warmest weather; by steam he cleans his plates, heats his mercury, distils water and *steam like* sits his picture—hence we conclude that Mr. W. lives by steam.

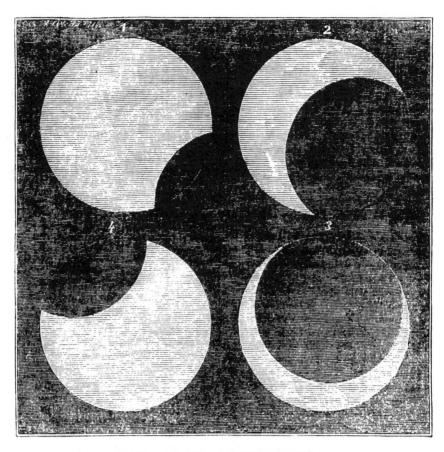

VIEWS OF THE RECENT ECLIPSE.

[Engraved for Moore's Rural New Yorker, from Daguerreotypes taken by John Kelsey.]

Whipple used a wood engraving of a steam engine in the advertisement of his Washington Street gallery in the *Boston Almanac for the Year 1851*. He said that it was one horsepower, with 3¼-inch bore and 6-inch stroke. The boiler was 18 inches by 5 feet; coal to run it cost 25 cents a day.[6]

Professor William Cranach Bond, and his son George Phillip Bond, the director of Harvard College Observatory, found Whipple an ideal technician to realize their desire to daguerreotype the heavenly bodies with their great 15-inch telescope, then the largest in the world. To do this, the delicate adjustments of the telescope had to be altered, and the eyepiece removed: the telescope itself was

93

used as a camera. Experiments were begun in 1848, with indifferent success, Bond reported. On December 18, 1849, the astronomers recorded in the observatory log book the visit of Whipple and his assistant William B. Jones "to take a Daguerreotype of the Moon." Normal observations were interrupted, and the astronomers were vexed: "very much against our inclinations we unscrewed the Micrometer (for the first time for more than a year past I should judge)."[7]

On the night of July 16/17, 1850, the micrometer was again taken off. A star was daguerreotyped, the star Alpha Lyrae—the first star (except the sun) ever to be photographed. A newspaper marveled at this accomplishment; it calculated that the light by which the daguerreotype was taken "took its departure from the star more than twenty years ago, long before Daguerre had conceived his admirable invention."[8]

Whipple and Jones continued in March, 1851, and by altering the focus of the telescope by half an inch, to compensate for chromatic aberration, succeeded in obtaining a daguerreotype of the moon which, Bond wrote, was "a better representation of the Lunar surface than any engraving of it, that I have ever seen."[9]

They sent a copy of the moon daguerreotype to Humphrey. It was a quarter plate, and must have been of extreme interest to the editor for, while he was living in Canandaigua, New York, he had tried the same thing. On the night of September 1, 1849, he took nine exposures on a single plate, moving the plate holder between each, ranging in time from 2 minutes 10 seconds to less than a second. His camera was an ordinary portrait camera with a relatively short focal-length lens: the moon was recorded as a disk one tenth of an inch in diameter. Snelling pasted in each copy of the July, 1853, issue of the *Photographic Art-Journal* a copy of one of Whipple's moon daguerreotypes made by Whipple himself with his crystalotype process (Plate 66). It won for him a prize medal at the Great Exhibition in London in 1851. Bond sent two other daguerreotypes by Whipple to Sir John F. W. Herschel; they are now in the Science Museum, London.

Other natural phenomena were daguerreotyped. Both Alexander Hesler of Chicago and T. M. Easterly of St. Louis captured the flash of lightning on daguerreotype plates. W. H. Goode of Yale University wrote in 1840, "I have taken proofs of microscopic objects magnified 600 times, by receiving images from a solar microscope on the iodized surface. Perfect images of insects and

94

other small objects are thus obtained."[10] Microphotography—the reduction of printed matter to minute size, for reading under magnification— was accomplished:

> *Philadelphia Public Ledger, December 30, 1843.* A copy of the Boston Transcript has been daguerreotyped of the size of an inch by an inch and a half. The heading, capital letters, and pictorial figures are clear to the naked eye, and by the aid of a twelve-power microscope the letter press may be read with ease.

Had the unknown experimenter sent this daguerreotype to the Great Exhibition in London, 1851, he might have won a medal. The jury was disappointed to find "no miniature of printed books (holding out the promise of future publications in miniature), or that of condensing in volume for preservation in museums, etc., the enormous mass of documentary matter which daily more and more defies collection from the mere impossibility of storage, but which will one day become matter of history."[11]

12. A Quest for Color

WHEN Daguerre first showed his daguerreotypes in 1839, the public regretted that the colors of nature were not recorded in the wonderfully autographic manner that light and shade was reproduced. To fill this deficiency, the only recourse was to tint the daguerreotype by applying color to its delicate surface. Plumbe and Langenheim peddled their patented techniques for accomplishing this coloring by electroplating or by the use of stencils; two other similar processes were patented.[1] But for the most part daguerreotypists applied dry powdered pigment directly to the metal surface with a finely-pointed camel's-hair brush. A very slight amount of isinglass dissolved in water was first applied to the surface. It was allowed to dry and then was made tacky by breathing on it. Diamonds were made to shine by digging into the surface of the plate with the sharp point of an awl, laying bare a point of silver. Jewelry was painted gold. The delicacy of the surface of a good daguerreotype made any handwork beyond tinting impractical; retouching was out of the question, for it was impossible to imitate by hand the fine detail and rich tonal scale of a well-made plate.

The best daguerreotypists preferred to leave their work uncolored.

Photographic Art-Journal, April, 1854. Although some of our finest artists use this style of coloring, they must in their own minds condemn it, as they know that they are working to please the bad tastes of the community and not their own. What is finer in the daguerreian art than a fine, sharp, bold picture without color (or a slight flesh tint,) or a drab background, not killed with too much mercury?

The judges of the 1848 Exhibition of the Massachusetts Charitable Mechanic Association in Boston had this to say of Nancy Southworth's handiwork on her brother's daguerreotypes: "The coloring is managed so as to diminish the regret that it should be attempted." Their judgment coincided with that of the French critic Louis Figuier, who wrote in the same year (we translate): "To color a daguerreotype plate is as ridiculous as to illuminate an engraving by Reynolds

96

or Rembrandt. The essential merit of photographic images rests in the beautiful gradations of tone and in a harmony of light and shade so perfect that it defies the engraver's burin. All these qualities become submerged in this absurd paste of colors."[2]

But the public demanded that their likenesses be colored. When they read in newspapers the announcement that a daguerreotypist by the name of Rev. L. L. Hill had discovered a method of color photography, they put off having their pictures taken, waiting the promised day when they could have them in full color. Hill had issued in November, 1850, a technical manual, *The Magic Buff.* On the last page he wrote:

NATURAL COLORS

Several years' experiments have led us to the discovery of some remarkable facts, in reference to the process of daguerreotyping in the *colors of nature.* For instance, we can produce *blue, red, violet,* and *orange* on one plate, at one and the same time. We can, also, produce a landscape, with these colors beautifully developed—and this we can do in only one-third more time than is required for daguerreotype. The great problem is fairly solved. In a short time it will be furnished to *all* who are willing to pay a moderate price for it. Our friends will please keep us apprized of their P.O. address.

Levi L. Hill was known to daguerreotypists as the author of *A Treatise of Daguerreotype,*[3] published in Lexington, New York, in 1849. It was an excellent manual; three thousand copies were said to have been sold. He was former pastor of the Baptist Church in Westkill, New York, and a publisher of religious tracts; his *Baptist Library* had seven thousand subscribers in 1843. He renounced the cloth because of acute bronchitis, which prevented him from preaching. By accident he found that the fumes of bromine and chlorine he inhaled when visiting a daguerreotypist's shop were beneficial, so he took up daguerreotyping. He began his color experiments, he said, in 1847.

Snelling congratulated Hill in the January, 1851, issue of the *Photographic Art-Journal* with a certain reserve: "We learn with pleasure that Mr. L. Hill has succeeded in impressing the image upon the daguerreotype plate in all the beauty and brilliance of the natural colors. If this be true, we congratulate Mr. Hill on his success. . . . Mr. Hill, however, is not the first who has made experiments towards its investigation."

Hill replied in a letter dated February 4, 1851, which Snelling printed,[4] that some two years before he had discovered *"a singular compound"* (the italics are Hill's) the vapors of which he used instead of mercury to develop a *"latent colored image* on a prepared sensitive surface." The process was different from Daguerre's and that of Alexandre Edmond Becquerel, who was experimenting toward the same end in Paris. "All is perfectly simple," Hill wrote, "and a good Daguerreotypist would master the process in one day." He listed among his forty-five specimens:

1. *A view,* containing a *red house, green grass and foliage,* the *wood-color of the trees,* several cows of different shades of *red* and *brindle,* colored garments on a clothesline, *blue sky,* and the *faint blue of the atmosphere,* intervening between the camera and the distant mountains, very delicately spread over the picture, as if by the hand of a fairy artist.
2. *A sun-set scene,* in which *the play of colors upon the clouds* are impressed with a truthfulness and gorgeous beauty which I cannot describe.
3. *Several Portraits,* in which I have the *true complexion of the skin,* the *rosy cheeks and lips, blue and hazel eyes, auburn, brown and sandy hair,* and every *color of the drapery. Changeable silk* is given in all its fine blending of colors, and delicate richness of hues. I not only get red, blue, orange, violet &c., but their *various tints.*

Hill stated that he had not completed his experiments; yellow was still difficult to obtain. "I am *fully resolved,"* he concluded, "to carry my process *as far as I can,* before making it public. Till then, all will be kept a profound secret. My wife and myself alone know the process, and not a scrap or item shall ever be communicated until I am made *perfectly sure* of a suitable compensation." To finance his experiments, he announced that he planned to write a new book.

Daguerreotypists were impatient; already news of the discovery was hurting their business. Anthony made a suggestion:

Edward Anthony to L. L. Hill, February 13, 1851. You deserve a liberal reward for a discovery so perfect as your article describes it to be. Make up your mind what sum of money would be a fair equivalent, so that you could freely give the benefit of it to the whole world.

Let a subscription list be started, to which all who are interested in the progress of the art, shall be invited to contribute, . . . no money to be paid over until all is subscribed, and until certain gentlemen selected as judges—say Draper, Morse, &c., shall pronounce the discovery true, and in all its parts as represented. . . .

98

I will be happy to head the list with a subscription of one hundred dollars.[5]

L. L. Hill to Edward Anthony, March 28, 1851. Since arriving home I have been very unwell—my old bronchial difficulty, excited by a severe cold. I have not done a day's work, and it has been a sore affliction to me. I am now somewhat better, and hope to resume my wonted labors in a day or two.

It has been a question with me—How shall I get through? I am a poor man, and must have means of supporting my family, without embarrassment, or I cannot work. In New York offers of money were made to me—I have received the same from other sources—but which I have been all along fearful to do, I am now fully resolved not to do, viz: to receive advances on a process, in the disposition of which I *will* act independently. After much deliberation, therefore, and seeing no other way short of *committing myself,* I am about getting up another book.[6]

Humphrey visited Hill and rushed back to New York to announce that the reverend had accepted his invitation to become co-editor of his magazine. He inserted in the May 15, 1851, issue an engraving of the new editor, from a daguerreotype he had taken of him. Humphrey editorialized: "Could Raphael have looked upon a *Hillotype* just before completing his Transfiguration, the palette and brush would have fallen from his hand, and this picture would have remained *unfinished.*"

Samuel F. B. Morse now added his enthusiastic praise. He wrote Anthony on May 29: "My Dear 'Son of Art'—Yours of the 27th inst. I have this day received, and in reply would say that I visited Mr. Hill some days since, and was much gratified with my visit, although you are misinformed in regard to my having seen his results. From my conversations with him, however, *I have no doubt whatever of the reality of his discovery.*"[7] He concluded that he advised Hill to sell his new book at $100 a copy. Anthony answered that he thought the price "a moderate one."

But Morse found it difficult to defend Hill.

Samuel F. B. Morse to L. L. Hill, June 21, 1851. The publicity of the fact that I have visited you, has occasioned correspondence between some of the Daguerreotypists and myself evincing on their part a very natural anxiety and curiosity to know if the discovery is indeed a fact. I have been questioned also by some who follow the *trade,* not the *profession,* of Photography, in a way that required some effort on my part to keep down my rising indignation. Among others a Mr. Clark who was formerly, not now, with Messrs Anthony & Edwards, whom

99

I had never before seen, but who accosted me in the street respecting you in a manner which at once put me on my guard. 'Well, sir, I hear you have been to see Mr. Hill, the thing is all humbug, I suppose.' He used an oath with it, and apologized for the expression, to which I replied 'there was no need of an apology. . . .' Mr. C. spoke very patronizingly towards you, however, he thought of visiting you, could render you very valuable assistance, although not now in the profession, having left it and become a merchant, &c., &c. I told him you refused all visitors and therefore he had better not lose his time, and as for assistance, you did not need it. Another, Mr. Haas, is among the incredulous, especially when I told him I *had not seen* the *results*. This was proof positive that there was nothing to it, and he seemed to exult for a moment, but when I told him that the results existed nevertheless, whether he chose to believe it or not, and that I had no doubt of the reality of the discovery, he seemed sobered and thoughtful.[8]

Humphrey assured his readers, in the July 15 issue of the *Daguerreian Journal*, that he had complete confidence in Hill; he hoped to arrange an exhibition in New York of hillotypes "on or before September next." In the meantime Hill asked to be left alone. Snelling, in the August issue of the *Photographic Art-Journal*, was less patient. He stated that Hill was under moral obligation to produce, having caused such injury to the daguerreotype industry by his premature announcement.

On September 29, Hill was forced to write Humphrey that he could no longer serve as joint editor of the *Daguerreian Journal*. He further stated: "The information . . . that I would finish my experiments in September, I will not be able to ful-fill."[9] Humphrey went to see Hill. He came back disillusioned. "We cannot see that Mr. H. has advanced a single step for the last six months. . . . We do not wish to deprecate Mr. Hill's alleged discovery. . . . We can only give the reader the facts in relation to what we and others have seen, and leave him to draw his own conclusions."[10]

The New York State Daguerreian Association—formed to present a solid front to the competition of cheap operators—held a special meeting in Brady's gallery on November 11, 1851. Humphrey reported that he saw only copies, and no pictures made from life. He was not shown the originals which Hill had copied, and so could not judge the quality of the colors. A committee was appointed: D. D. T. Davie, J. M. Clark, and William A. Tomlinson. Brady was in Europe.

The daguerreotypists went to Westkill. Hill, they said, received them courteously, but refused to show them anything.

Hill's account was somewhat different:

> The *"Committee"* of the miserable apology for a "New York State Daguerreian Association" who visited me during this stage of the proceedings well illustrated, in their course, the character of justice I received. . . . Three men— D. D. T. Davy [sic], "Phot." of Utica, Clark of New York, and Tomlinson of Troy—came to my house. . . . This Davy, after a liberal effusion of flattery, and after a kind reception from me, proceeded to threaten me with exposure as a humbug, and more than intimated that a banditti of ruffians, like himself, would visit this quiet valley with the laudable purpose of *breaking into my laboratory.* . . . I candidly confess that I was afraid of the threatened attack.

Hill procured a revolver, the loan of a watchdog, and the offer by neighbors to serve as the "Westkill Police." In case of trouble, he was to sound a watchman's rattle.

> One dark night we were alarmed by the terrific barking of the faithful dog. I immediately rose from bed, and after listening for a few moments at one of the doors, I became satisfied that the enemy was around. . . . I forgot all about the "rattle," and the thought of summoning the "Police" did not enter my mind. . . . With no other soldier but the dog, I opened the door, rushed upon the enemy ——when, lo and behold, instead of meeting the chivalrous "Phot" and his ruffian army—instead of having a chance to display our valor, and to spit out the fire of our patriot souls—we encountered *our old cow.*[11]

Back in New York, the committee made their report, which was released to the New York *Times.* Their conclusion was shattering:

> They have found no evidence to satisfy them that any person has ever seen any picture colored by any process, new to the scientific world, at the hands of Mr. Hill. On the contrary they are of the opinion that the pictures in colors which have been exhibited by Mr. Hill are mere transfers of colored prints. . . . Your Committee have come to the conclusion that Mr. L. L. Hill has not only deluded many Professors of the Daguerrean Art, but that he has deluded himself thoroughly and completely—that the origin of the discovery was a delusion —that the assumed progress and improvement of it was a delusion—and that the only thought respecting it, in which there is no delusion, is for everyone to abandon any possible faith in Mr. Hill's abilities to produce natural colors in Daguerreotypes—of which the whole history has been an unmitigated delusion.[12]

101

Hill wrote to the *Tribune:* "Allow me, through your journal, to ask the public to give me time to present some *authentically* established facts. At present my health is very poor; I hope that Divine Providence will grant me the strength to complete my labors."[13]

"We pity Mr. Hill, but we do not censure or abuse him," Snelling wrote, and then reprinted from a Philadelphia newspaper a devastating exposé signed "A Practical Daguerre," charging that the color announcement was a means of promoting the sale of Hill's books. The letter was translated in *La Lumière,* the French professional journal, with the note: "Dear Readers: You will hear nothing further about Mr. Hill."

But the reverend was not crushed by the report of what he called the "self constituted and rowdy committee." He wrote Morse, asking if, in his position as a respected artist and scientist, he would write a certificate. Morse offered sound advice in his reply.

> *S. F. B. Morse to L. L. Hill, February 28, 1852.* If the result be shown to a few friends, who can testify that they have seen it, although the process be concealed, yet this is such a publication as will secure to you the honor of the discovery, but if result as well as process is concealed your simple declaration cannot be permitted by the world to stand in the way of others' discovery, and others' results.[14]

In further correspondence, Hill explained over and again to Morse that he could not do as he suggested. On September 24, 1852, he wrote Morse that he was sick, feared death, and needed Morse's name in testimony. He implored Morse to come to Westkill. Morse came, saw twenty hillotypes, and was convinced. He wrote the *National Intelligencer:*

> The colors in Mr. Hill's process are so fixed that the most severe rubbing with a buffer only increases their brilliancy, and no exposure to light has as yet been found to impair their brightness. They are produced in twenty seconds. . . . Mr. Hill has made a great discovery. It is not perfected . . . who have a right to demand him to reveal it to the public now? Who, indeed, have a right to demand it at any time?[15]

The New York operators again made overtures to Hill. James P. Weston and Alexander Beckers went to Westkill, offering to raise by subscription $50,000 to $100,000.

Hill's answer came in the form of a circular, *To the Daguerreotypists of the United States and to the Public at Large,* in which he again stated that the invention he announced was his own, and all he had ever claimed for it. The delay in publication was due to difficulties, "invisible goblins of a new photogenic process." To raise funds, he announced the sale of chemicals and "a new edition of *Photographic Researches.*"

This was too much for the daguerreotypists. Wrote "Mercury" in the *Photographic Art-Journal,* December, 1852: "I fear his 'child of light' will, at no distant day, discombulate his flobnolix without any compunctious scruples of conscience." And when Hill persuaded the Patents Committee of the United States Senate to publish an official "Memorial,"[16] endorsing the process and testifying to Hill's priority, the *Scientific American* commented:

> Mr. Hill comes out with a Report of the Senate Committee on Patents, and would compel the world, *nolens volens,* to acknowledge his right to the title of discoverer of Heliochrome. To do this will require, however, something more than a Senate Report, and we must be convinced by deeds, and not by words, before we can place implicit reliance upon what has been affirmed. . . . Instead of taking the proper steps to substantiate his claims as an inventor in the Patent Office, he exhibits a few specimens of what he calls sun-coloring, to a committee in no ways suited, either professionally or otherwise, to give an opinion upon the subject, and imagines that, by a favorable report, his claims as the discoverer is confirmed.[17]

For a whole year, the hillotype lay dormant. Then, in December, 1854, through the medium of the professional press, Hill asked daguerreotypists who wanted to know of his plans of publishing his heliochromatic process to write him. They got in response a circular, offering a reflector at $5.00, to invert the image in taking views, and five formulas. About color photography they read only another testimonial by Morse—and an appeal for funds. He had mastered, Hill said, the reproduction of all colors, but still was not satisfied with yellow. Whereupon "R.R." suggested to Humphrey that a procession of believers should march on Westkill wearing chrome-yellow breeches. The Liverpool (England) Photographic Society read the circular. It had been sent to them from New York by William Ross, with a letter.

William Ross to the Liverpool Photographic Society, July 10, 1855. I have been given to understand that doubts exist in Britain as to whether *any one* ever issued such a

circular as has been imputed to Hill, or if such has been issued, it could never have emanated from any one claiming to be a Christian, far less a *clergyman;* yet such is the fact; a pity, to be sure, but still a fact, painful though it may be.[18]

Ross, in a second letter, praised the society for reading the circular, "for it would be a great pity so much valuable information should not be widely diffused." He hoped the members might "be induced to erect in their hall a statue of *brass* in his honor."[19]

At last, in 1856, came the announcement which, for six years, daguerreotypists had awaited. In a twenty-page pamphlet "in the genuine well known style Hillesque," Hill offered the process for sale in a book at $25.

But by then the furor had died down; daguerreotypists were taking up new processes—the ambrotype, the tintype, and paper photographs. The book, *A Treatise on Heliochromy; or, The Production of Pictures by Means of Light in Natural Colors,* appeared, with the imprint of Robinson and Caswell, New York. It is a curious publication, part autobiographical, part technical—if the confused, wordy, and seemingly interminable account of his experiments can be taken seriously.

What did Hill produce? His pictures were seen and praised by trained daguerreotypists: Fitzgibbon, Marcus A. Root and his brother Samuel, Whipple, Caleb Hunt from Gurney's gallery, and Gurney himself. Morse specifically stated that the colors were vivid and resisted buffing—which no hand-colored plates could withstand.

From the perspective of a hundred years, we now realize that in a bungling, inefficient way, Hill must have stumbled on the phenomenon of the color sensitivity of photochlorides. There is more than one recorded instance where a daguerreotypist noted that he had obtained colors upon the silvered plate. P. H. Van der Weyde in Holland found a distinct blue tint in the skies of landscape daguerreotypes.[20] The "blue bosom" operators got their nickname because the shirt fronts of their sitters turned out to be blue instead of white.

It is the property of certain silver salts to assume the colors of the light thrown upon them. In 1810 Thomas Johann Seebeck pointed this out to Johann Wolfgang von Goethe: "I found the chloride of silver changing as follows,—It had become red-brown in the violet—occasionally more violet, at other times more blue—and this colouration reached also beyond the line of the violet designated before, but was not deeper than in the violet. In the blue of the spectrum the

104

chloride of silver became true blue, and this color, decreasing and gradually getting lighter, extended into the green. In the yellow I found the chloride of silver mostly unchanged. Sometimes it appeared to me more yellow than before; however, in the red, and often a little beyond the red, it had taken the red of a rose."[21]

Sir John Herschel, apparently unaware of what Seebeck had written, and inspired by the work of Fox Talbot, noted the same phenomenon: "When a slip of sensitive paper is exposed to a highly concentrated spectrum, a picture of it is rapidly impressed on the paper, not merely in black, but in colour. . . . I have not been able to fix these tints. They are, however, susceptible of half-fixing by the mere action of water, and may be viewed at leisure in moderate daylight or by candlelight."[22]

These experiments were upon paper. In France the scientist Alexandre Edmond Becquerel was working along the same lines when he discovered that the identical phenomenon occurred with daguerreotype plates. He reported to the Academy of Sciences on February 7, 1848: "When a well-polished metal plate, either of silver or silver plated, is put a few centimeters above the surface of chlorinated water, it assumes at the end of several minutes a whitish tint due to the formation of a chloride of silver; if there is thrown upon its surface a concentrated solar spectrum, a few centimeters in length, before long a photographic impression is obtained which covers all the visible part of the spectrum."[23]

Becquerel noted that the plate assumed colors analogous to the spectrum. Orange was the first to appear. Where red rays fell on the plate, it became reddish-purple; green was slightly yellow and turned gradually to blue and to violet. On prolonged exposure, the colors darkened until, in an hour or two, they disappeared.

Becquerel improved his technique for sensitizing the plate to colors by electroplating with platinum; he found that if these plates were exposed while heated to 212°F., the color sensitivity was further increased. He made color reproductions by this "photochromatique" technique, simply by placing the colored print face down on the sensitized plate and exposing it to light through the back. He tried his photochromatic plates in a camera, but the time required was hopelessly long: "ten or twelve hours were required to obtain a good image of a colored engraving put 4 ft. 10 in. in front of the lens, even though the print was

105

exposed to full sunlight during this time."[24] The colors were good—better than contact prints from engravings. He failed to get satisfactory landscapes, however, for the plates were less sensitive to green than to white light. "Perhaps with practise, working often, one will succeed; for my part, I have looked upon this as secondary and I have stopped working with it, knowing that, at present, one cannot make use of this process in the arts."[25]

For there was no way to fix the images so that they would be no longer affected by light. "I have tried every kind of reaction in the attempt to render the images inalterable to light, but I have not succeeded."[26] Hill knew of Becquerel's work: he admitted so in his first description of the process in the *Photographic Art-Journal* for February, 1851. He also knew of the work Niépce de Saint-Victor was doing. This French experimenter, the nephew of Daguerre's partner, repeated Becquerel's experiments and achieved partial success. One of his color daguerreotypes, of a colored, geometrical drawing, is now in the George Eastman House.[27] It was made in 1867. It is kept in the dark and seldom looked at, for it is feared that the colors are unstable; only the reds and blues appear, and they are pale.

It is, therefore, entirely possible that Hill could have taken daguerreotypes in color by a similar photochloride process. But how he fixed these images to bear exposure to light, as Morse testified, remains his secret. Probably the only explanation of the whole affair was that offered by John Towler, editor of *Humphrey's Journal,* when Hill died in 1865: "He always affirmed to this writer that he *did* take pictures in their natural colors, but it was done by an *accidental* combination of chemicals which he could not, for the life of him, again produce!"[28]

13. *Photography Triumphant*

THE WORD "photography" was reserved by daguerreotypists to refer to the wet-plate, or collodion, process invented by Frederick Scott Archer in England in 1851. Although it was introduced to America within a year, photography did not become a serious threat to the daguerreotype until it was used to make imitation daguerreotypes on glass.

These glass positives were called "ambrotypes"—a name coined by Marcus A. Root, meaning, he said, "imperishable picture." They were popularized by James A. Cutting, a Boston daguerreotypist, and his partner Isaac A. Rehn of Philadelphia in 1854.

Basically an ambrotype is a glass negative backed with black, to make it appear positive. The areas of a negative representing the shadows of the subject are relatively transparent; having received but little light, only a small portion of the sensitive material has been reduced to opaque silver. Consequently the black backing becomes visible. The highlights, on the other hand, having received the maximum amount of light, are converted by processing to opaque silver, which hides the black backing.

The backing was various: a piece of black velvet, or black cardboard, or blackened tin was common. Other ambrotypists used black paint, or black asphalt varnish. Frequently the glass itself was of a deep violet tint; no backing was needed.

Ambrotypes were made in the same sizes as daguerreotypes, bound up with ornamental brass mats, and put into cases made for daguerreotypes. They are often confused with daguerreotypes. The test is simple. Take the picture out of the case and examine the back. If it is copper, or copper lightly silver plated, the picture is a daguerreotype.

Cutting was granted three United States patents.[1] Two were for the composition of the collodion; the third was for a technique for cementing the cover glass to the developed photographic plate by the use of Canada balsam. He and his

107

partner Rehn rigidly enforced their patents. It was impossible for anyone to produce photographs by the collodion process without making use of some of the "improvements" specified in the patents. In vain photographers complained to the courts that potassium iodide and potassium bromide had long been used in photography. Not until the patents expired in 1868 could photographers use the collodion process without either paying a royalty or facing the likelihood of court action.

Ambrotypes enjoyed a short period of popularity. Robert Taft, in his *Photography and the American Scene,* notes that of the 123 wood engravings in *Frank Leslie's Illustrated Newspaper* for 1856 drawn from photographs, 100 were reproduced from ambrotypes, 10 from paper photographs, and only 13 from daguerreotypes.

Veteran daguerreotypists deplored the trend. They pointed out that the ambrotype cannot match the quality of a daguerreotype—an observation with which we most certainly agree. J. H. Fitzgibbon wrote the editor of the *American Journal of Photography:*

> I was glad to see by your Journal that there is a chance once more of the star of Daguerre shining forth again. I fought hard once for it till it got entirely obscured by a black cloud called Ambrotype, which laid me in the shade as well as the Daguerreotypes; but the black, nasty, filthy, ghastly, dead, inanimate, flat, shade of shadows, are beginning to burst, break, peel, turn, change all colors (but the natural one) and must in time die out without any other exertion than their own selves.[2]

They were already dead when Fitzgibbon wrote the editor in 1861; their place was taken by the tintype, known in its day as the "melainotype," or, more commonly, the "ferrotype."

The process was invented by Professor Hamilton L. Smith, of Kenyon College, Gambier, Ohio. He patented his invention in 1856;[3] it was bought by William Neff and Peter Neff, Jr., of Cincinnati, who baptized the process "melainotype." It was a modification of the ambrotype; instead of flowing collodion on a glass surface, sensitizing it, developing it, and backing the resulting negative with black, Smith used a sheet of thin iron, japanned black, as the support of the sensitized collodion. No backing was needed. The Neffs' chief competitor in the manufacture of plates was Victor M. Griswold; he called his product "ferrotype plates." The word tintype is a misnomer. As one ferrotypist remarked, the

only tin in a tintype is "the 'tin' that goes into the happy operator's pocket."[4]

At first cased like daguerreotypes and ambrotypes, tintypes were soon delivered in inexpensive cut-out paper mats. They were indestructible and needed no protection; they were light in weight; they could be sent in an ordinary letter through the mails. They could be cut with tinsnips into circles and ovals to be fitted into jewelry. During the Presidential campaign of 1860, lapel buttons bearing the portraits of the candidates appeared by the hundreds.

At the outbreak of the Civil War tintypes suddenly became extremely popular. Soldiers sent back home their portraits, taken at camp by itinerants who posed them against painted backgrounds of tents, cannons, and battle scenes. They carried into combat precious likenesses of their loved ones. The "cheap operators" found the tintype more suited to economical production than the daguerreotype. Established galleries preferred photography on paper, and "cartes-de-visite" in particular.

This style of photograph came from France. In 1854 a Parisian photographer, Adolphe-Eugène Disdéri, conceived the idea of using a camera with four lenses to record several images at a time, or in rapid succession, upon one plate. A single print from this negative was then cut up into small prints, which were mounted on cards 2¼ by 4 inches, about the size of a visiting card: hence the name, which Americans retained when they began to produce them in 1859.

> *Humphrey's Journal, February 15, 1861.* These portraits, as we shall call them—for they are indeed nothing more than full-length miniatures of the human face and form—are generally taken in a standing position. . . . A great degree of the beauty of the picture is obtained by the backgrounds which are used. The usual stereoscopic camera with two tubes is the one generally employed—the advantage is that by a new and beautiful arrangement of the box, an operator is enabled to produce four or more of these negatives upon one glass plate, thereby facilitating their rapid production. . . . In most cases these portraits are taken in a standing position and with outdoor dresses, overcoats, hats, shawls, etc.

The sale of portraits became lucrative. When Fort Sumter was attacked, George S. Cook took an ambrotype of the commander, Major Robert Anderson. The Anthonys bought the portrait, copied it, and were making a thousand prints a day in January, 1861. Daguerreotypes of famous people were multiplied by the carte-de-visite: Brady's *National Portrait Gallery* was published by the An-

thonys; people began to collect portraits of kings and emperors, soldiers and statesmen, poets and musicians, and put them in albums along with family portraits and pictures of friends.

The daguerreotype era was over. "Ten years ago we had here (in the North) only Daguerreotypes, now not one," the editor of the *American Journal of Photography* wrote in the October 15, 1861, issue. "The Daguerreotype had many friends, but it was doomed; we shall not hear of it again—peace to its ashes! . . . The series of fashions we have had in the art are steps of progress—the daguerreotype, ambrotype, 4-4 [i.e. whole plate] photograph, stereoscope, and at last the card portrait." Joseph H. Ladd, the new editor of *Humphrey's Journal,* protested: "We believe that the march of improvements is *onward,* and that even the card pictures will have their rivals for the favor of the fickle public. But as for the daguerreotype, the first in the race, we affirm that the time has not yet arrived when it is to be considered as 'doomed.' "

But Daguerre's beautiful process was already obsolete. Veterans looked back to it with fondness. "I shall always remember with pleasure the good old daguerreotype," said Abraham Bogardus. "No glass to clean and albumenize; no black fingers; few or no re-sittings; no retouching; no proofs to show for his grandmother, and his sister, and his cousins, and his aunts to find fault with; no waiting for sunshine to print with; no paper to blister, and no promising of the pictures next week if the weather was good. The picture was gilded, finished and cased while the lady was putting on her bonnet; delivered, put in her pocket, and you had the money in your pocket."[5] The anonymous author of *Sunlight Sketches,* a popular manual published by Snelling in 1858, wrote that a well-exposed collodion plate should be developed and defined in all its parts, "like the beautiful daguerreotype . . . beautiful as the light of heaven can make it,"[6] and then paid tribute to the obsolete process of Daguerre:

"O sad fate of the beautiful daguerreotype! l would to heaven I could forget it. But it lingers in my soul like fond remembrance of a dear departed friend."

110

PART II

Plates

No attempt to eliminate the marks of age has been made in reproducing the original daguerreotypes. Over the years the delicate surfaces of many of the most striking daguerreotypes were marred by scratches, tarnish, and corrosion which defy restoration. It was felt that any attempt to eliminate these blemishes by even the most skillful hand retouching would be unwarranted. Occasionally we have trimmed away blank areas along the edges of the plate, the better to reveal the main subject. In this cropping we have followed the custom of the period, for daguerreotypists invariably put the plates behind gilded mats of varying format.

The size of each original is indicated by the size of the plate.

Whole plate	6½ by 8½ inches
Half plate	4½ by 5½ inches
Quarter plate	3¼ by 4¼ inches
Sixth plate	2¾ by 3¼ inches
Ninth plate	2 by 2½ inches

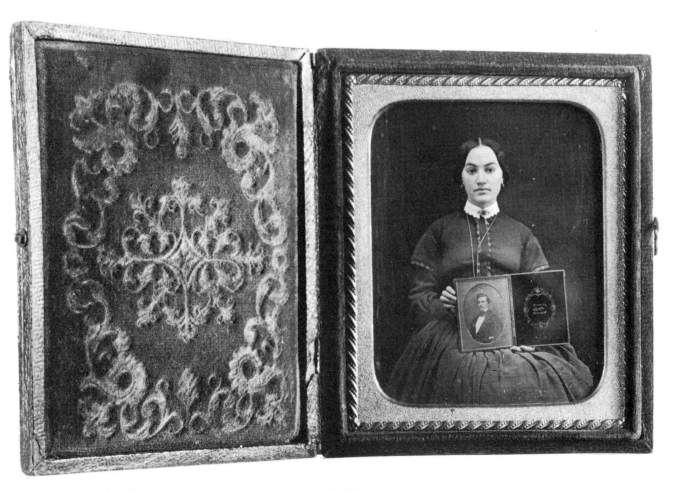

1. THE FAMILY DAGUERREOTYPE, ABOUT 1850.
 Sixth plate; daguerreotypist not known. International Museum of Photography, Rochester, N. Y.

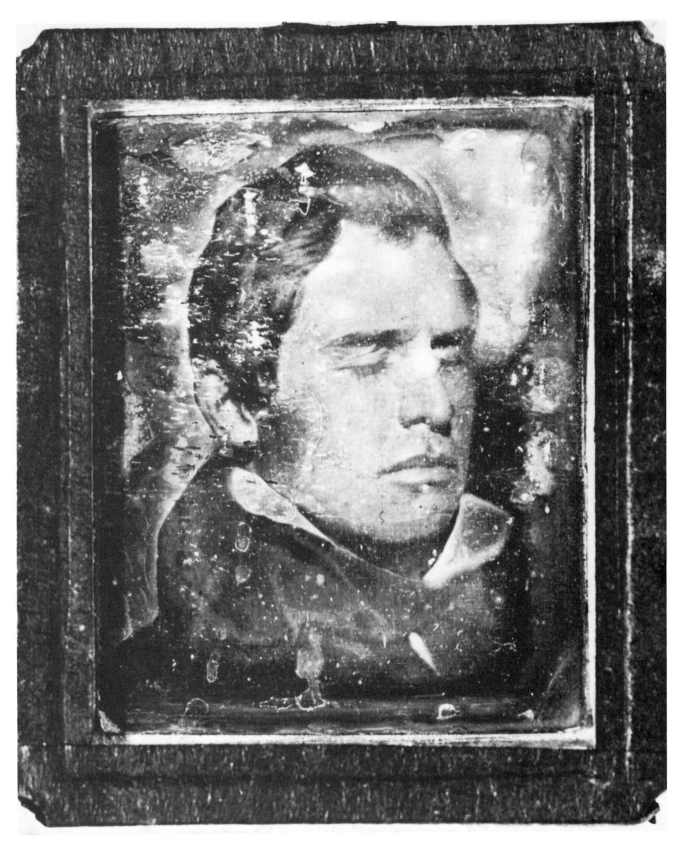

2. SELF-PORTRAIT OF HENRY FITZ, JR., PROBABLY 1839.
Ninth plate daguerreotype. Smithsonian Institution, Washington, D. C.

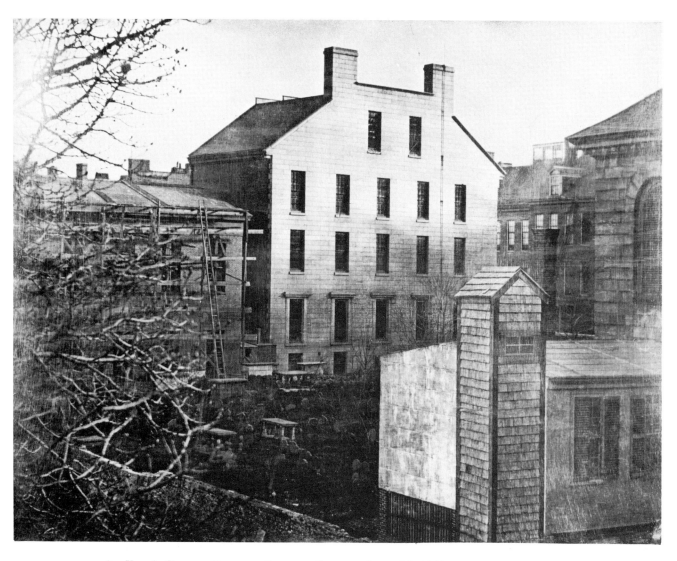

3. KING'S CHAPEL BURYING GROUND, BOSTON, APRIL 19, 1840.
Whole plate daguerreotype by Samuel Bemis. International Museum of Photography, Rochester, N. Y.

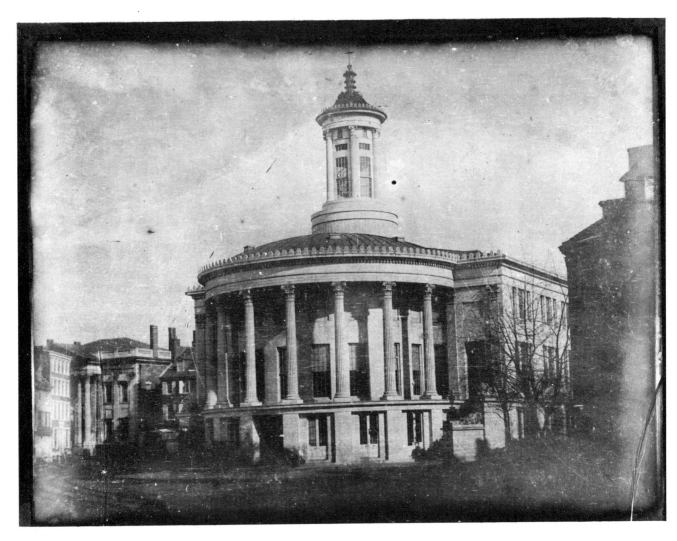

4. MERCHANTS' EXCHANGE, PHILADELPHIA, FEBRUARY, 1840.
Whole plate daguerreotype by Walter R. Johnson. Franklin Institute, Philadelphia.

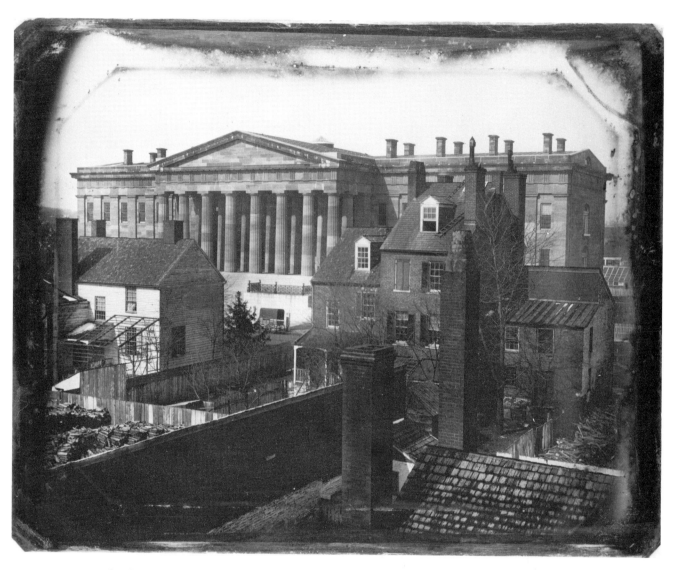

5. OLD PATENT OFFICE, WASHINGTON, D. C., ABOUT 1846.
Half plate daguerreotype by John Plumbe, Jr. The Library of Congress,
Washington, D. C.

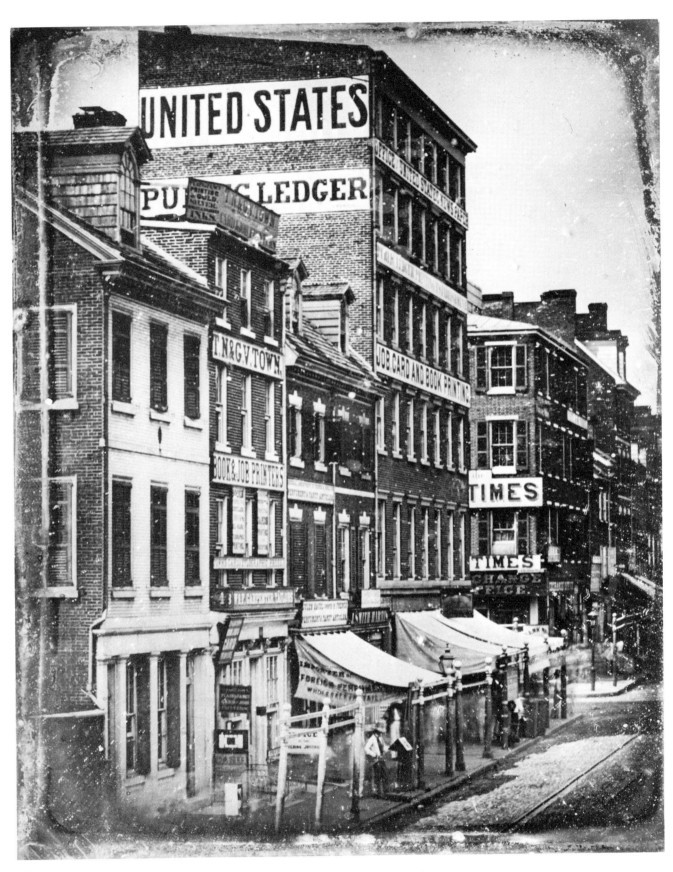

6. THIRD STREET AT CHESTNUT, PHILADELPHIA, JULY, 1842.
Sixth plate daguerreotype by George Read. International Museum of Photography, Rochester, N. Y. (Zelda P. Mackay Collection.)

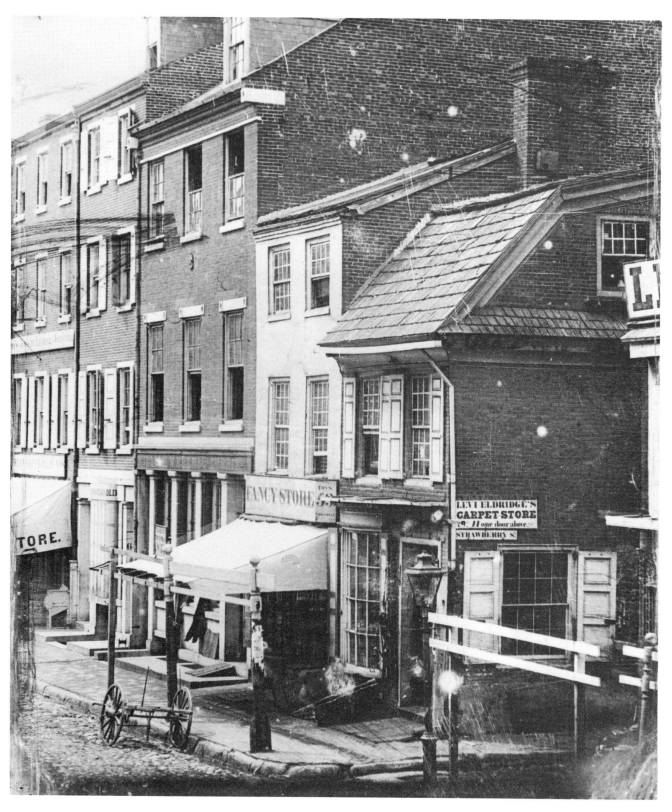

7. CHESTNUT STREET, PHILADELPHIA, ABOUT 1844.
 Sixth plate; daguerreotypist not known. International Museum of Photography, Rochester, N. Y.

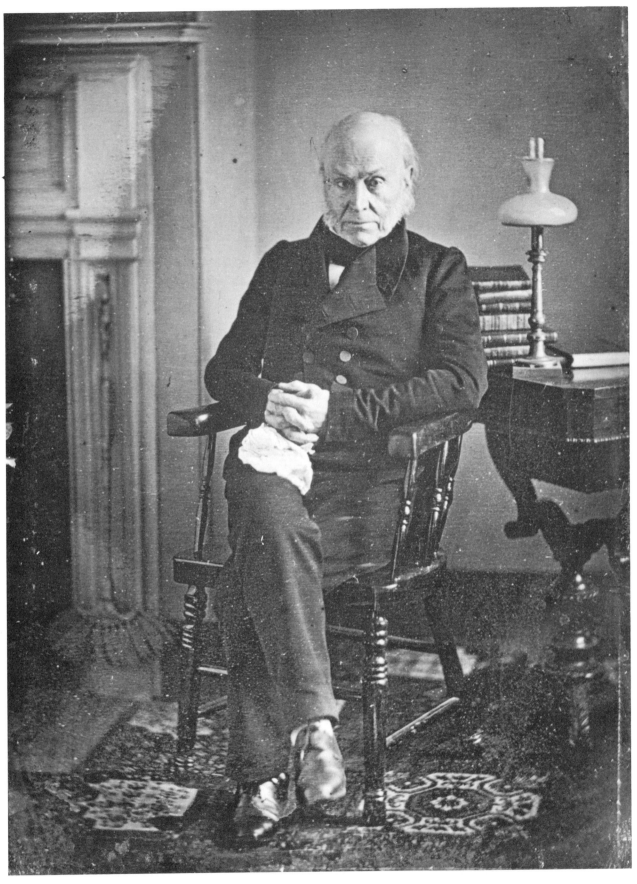

8. JOHN QUINCY ADAMS, SIXTH PRESIDENT OF THE UNITED STATES, 1843.
*Half plate daguerreotype by Philip Haas. The Metropolitan Museum of Art,
New York. (Gift of I. N. P. Stokes and the Hawes family.)*

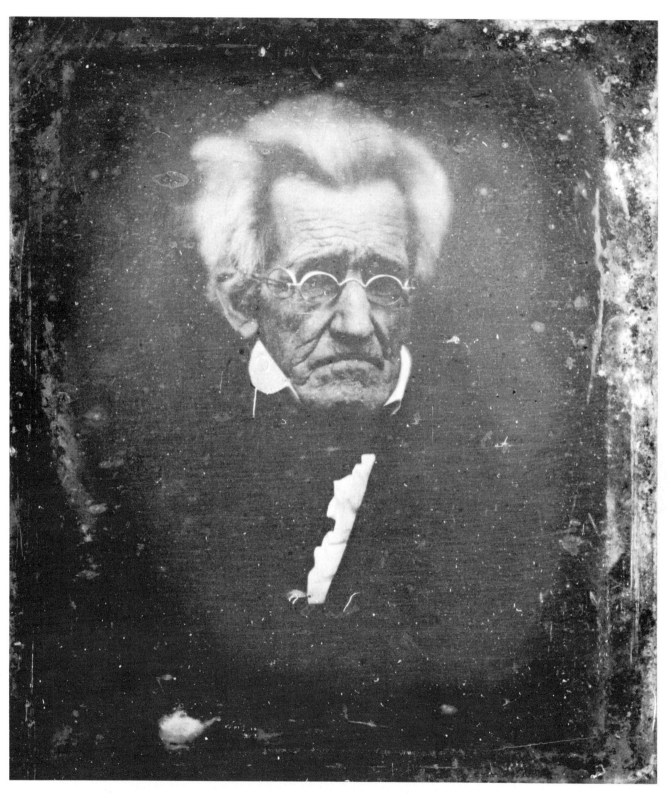

9. ANDREW JACKSON, SEVENTH PRESIDENT OF THE UNITED STATES, BEFORE 1845.
*Sixth plate daguerreotype, probably by Dan Adams. International Museum
of Photography, Rochester, N. Y. (Gift of A. Conger Goodyear.)*

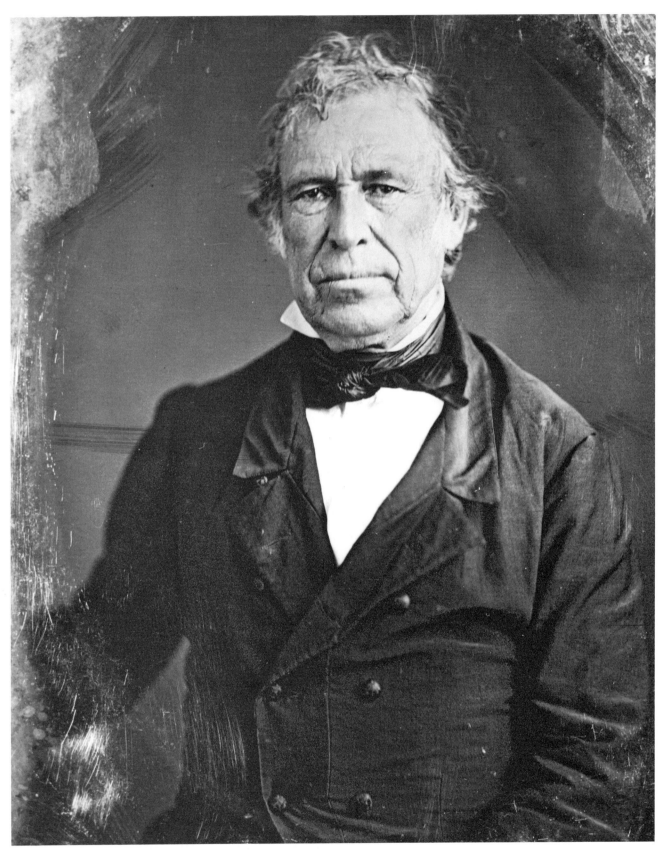

10. ZACHARY TAYLOR, TWELFTH PRESIDENT OF THE UNITED STATES, ABOUT 1850.
Whole plate; daguerreotypist not known. Chicago Historical Society, Chicago.

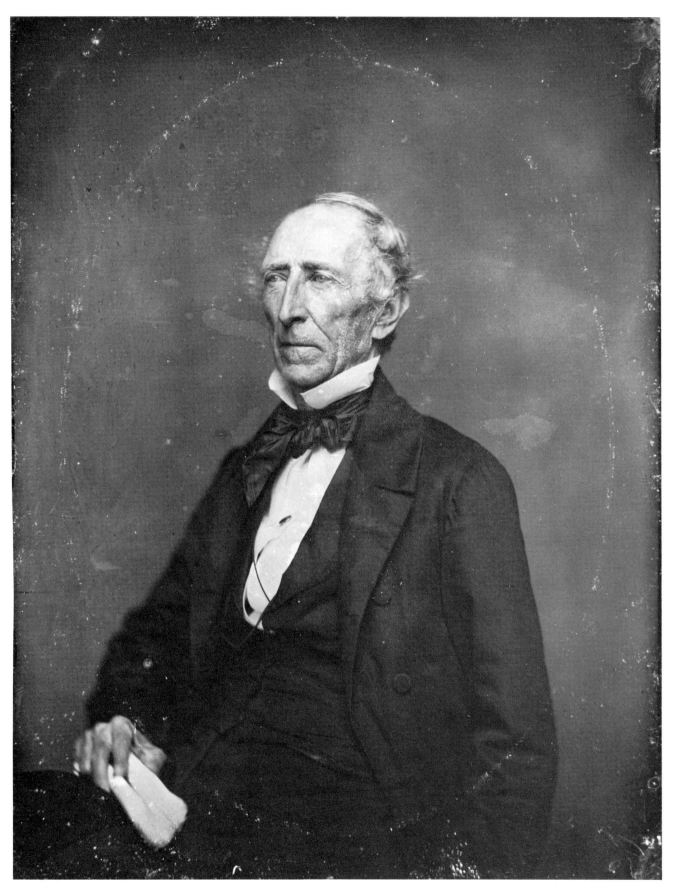

11. John Tyler, tenth president of the United States, about 1845.
Whole plate; daguerreotypist not known. Chicago Historical Society, Chicago.

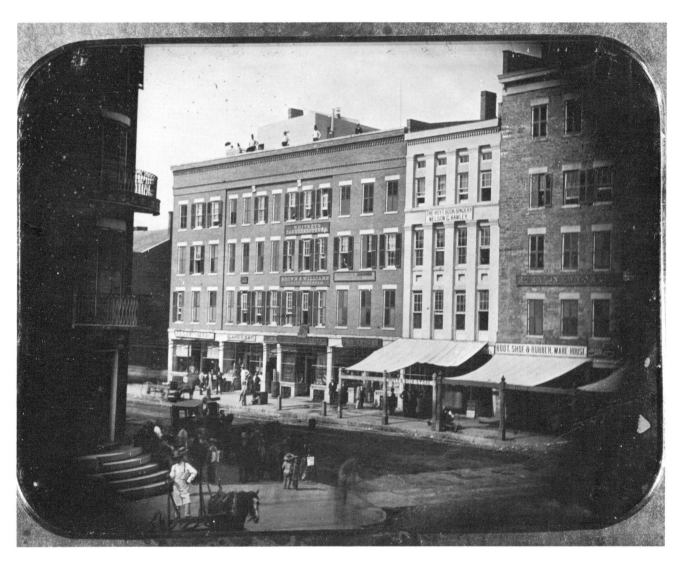

12. STATE STREET AT MAIN, ROCHESTER, NEW YORK, ABOUT 1852.
Whole plate daguerreotype by Edward Tompkins Whitney. International Museum of Photography, Rochester, N. Y.

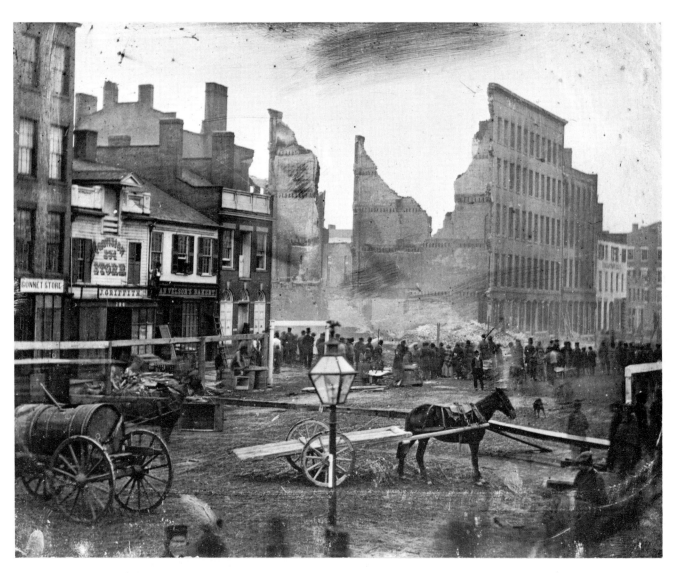

13. RUINS OF THE AMERICAN HOTEL, BUFFALO, NEW YORK, MARCH, 1850.
*Whole plate; daguerreotypist not known. Buffalo Historical Society, Buffalo,
N. Y.*

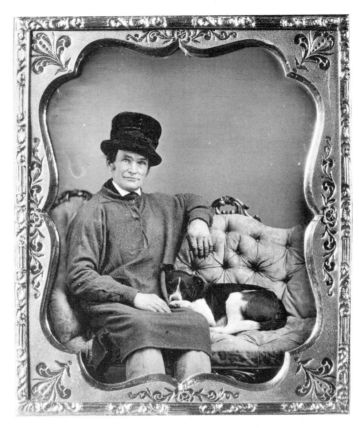

14. MAN SITTING ON SOFA WITH DOG, ABOUT 1850.
Sixth plate; daguerreotypist not known. Northampton Historical Society, Northampton, Mass.

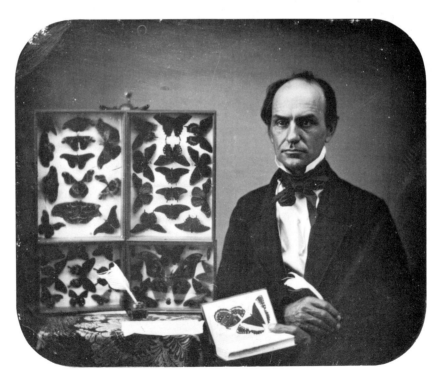

15. BUTTERFLY COLLECTOR, ABOUT 1850.
Sixth plate; daguerreotypist not known. International Museum of Photography, Rochester, N. Y.

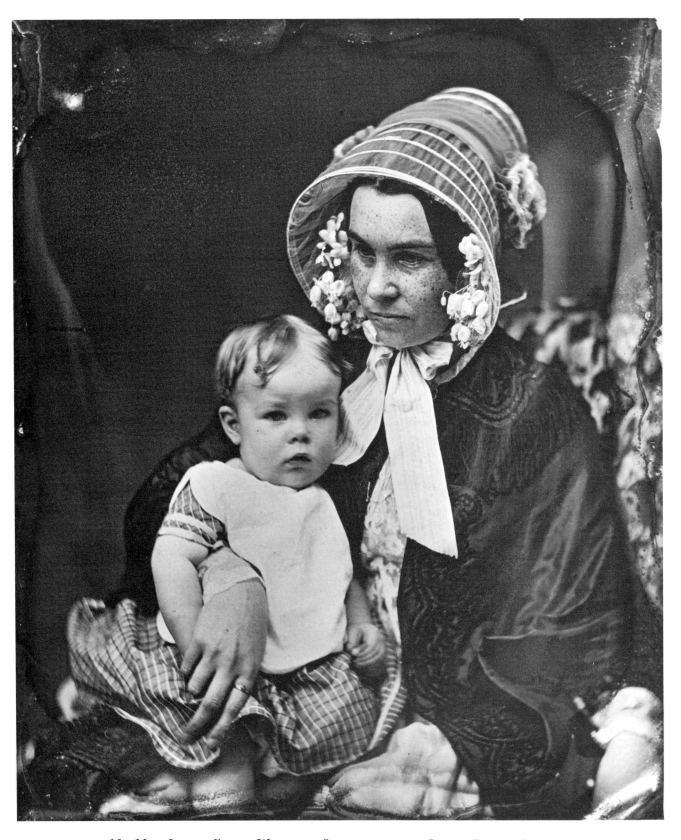

16. Mrs. Joseph Elisha Whitman, Sr., and her son Joseph Elisha, Jr., born 1853.
Sixth plate; daguerreotypist not known. The Society for the Preservation of New England Antiquities, Boston.

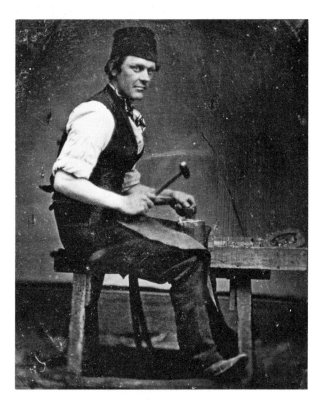

17. COBBLER, ABOUT 1850.
Location of original not known.

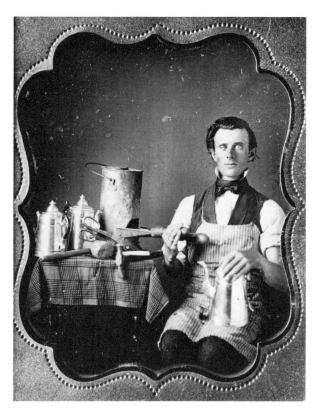

18. TOLE WARE MAKER, ABOUT 1850.
Sixth plate; daguerreotypist not known. International Museum of Photography, Rochester, N. Y. (Zelda P. Mackay Collection.)

19. Frederick Warren (died 1858), city marshal of Worcester, Massachusetts, with prisoner, about 1850.
Half plate; daguerreotypist not known. American Antiquarian Society, Worcester, Mass.

20. "The Woodsawyer's Nooning," 1853.
Whole plate daguerreotype by George N. Barnard. Location of original not known; 1908 photocopy courtesy Onondaga Historical Association, Syracuse, N.Y.

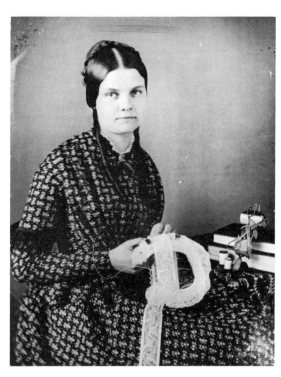

21. SEAMSTRESS, ABOUT 1850.
 Sixth plate; daguerreotypist not known. Minnesota His-
 torical Society, St. Paul, Minn.

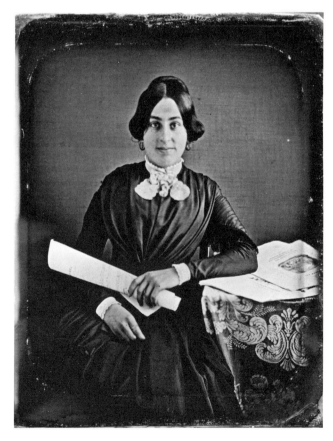

22. WOMAN WITH SHEET MUSIC, ABOUT 1850.
 Sixth plate; daguerreotypist not known. Society for the
 Preservation of New England Antiquities, Boston.

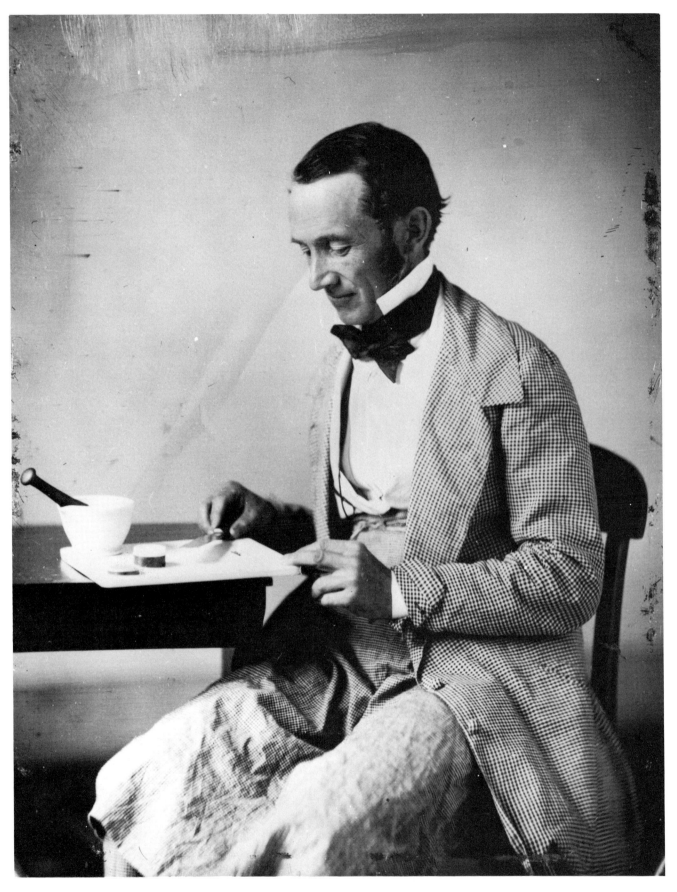

23. Henry Brewer, of the H. & J. Brewer Drug Store, Springfield, Massachusetts, about 1850.
Half plate; daguerreotypist not known. Connecticut Valley Historical Museum, Springfield, Mass.

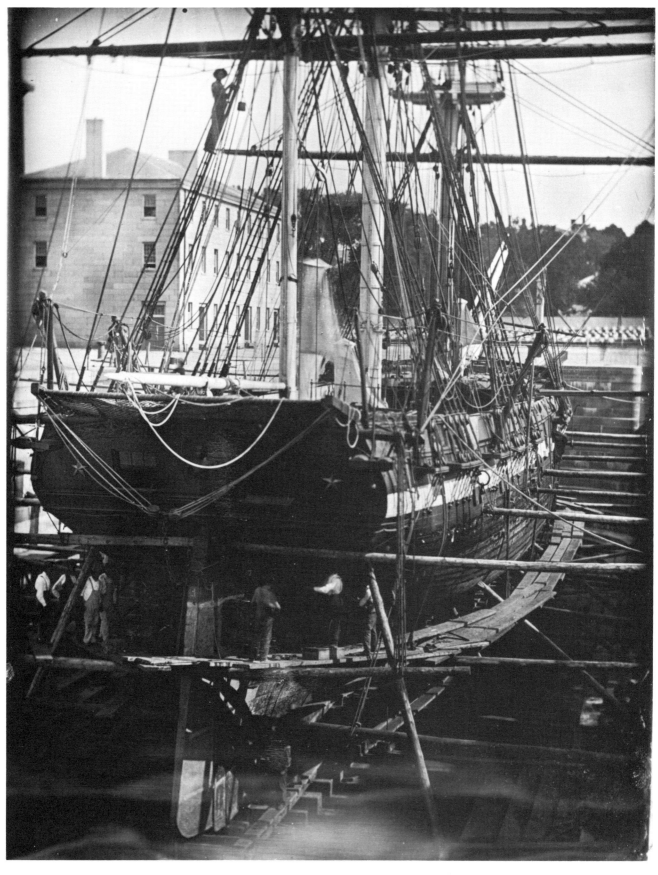

24. SHIP IN DRY DOCK, BOSTON NAVY YARD, ABOUT 1852.
*Whole plate daguerreotype by Southworth & Hawes. International Museum
of Photography, Rochester, N.Y.*

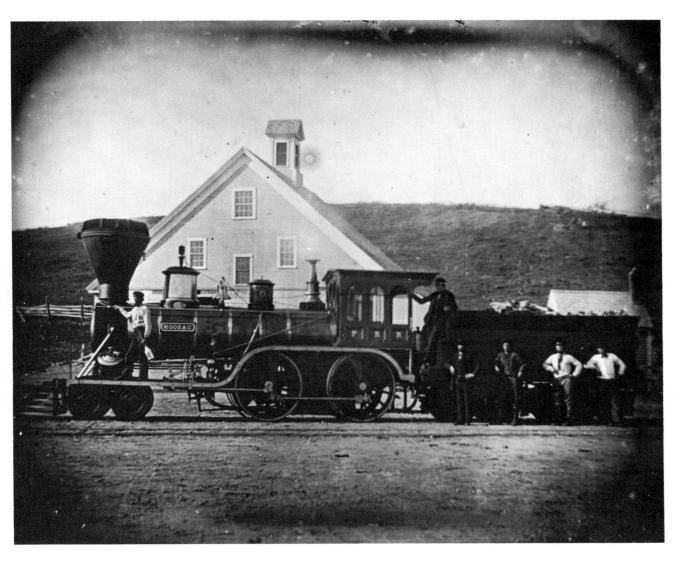

25. Locomotive "Hoosac," owned by Fitchburg Railroad, 1854–62.
Half plate; daguerreotypist not known. Collection of the late Frank R. Fraprie, Boston.

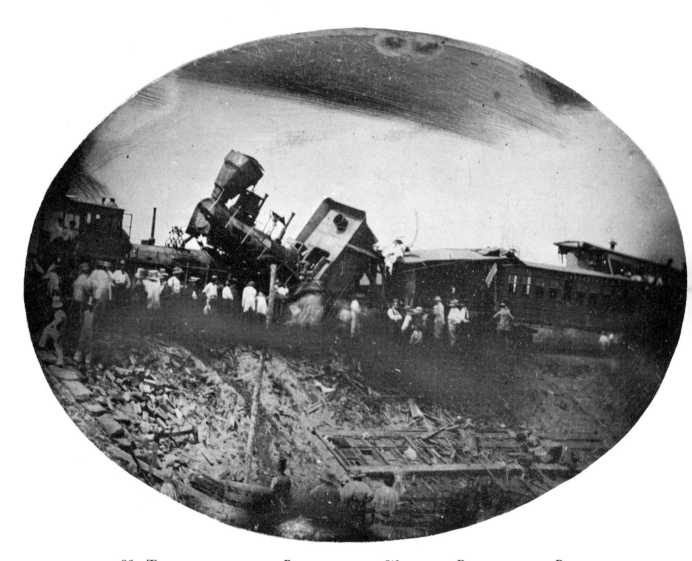

26. Train wreck on the Providence and Worcester Railroad near Paw-
tucket, Rhode Island, August 12, 1853.
*Half plate daguerreotype by L. Wright. International Museum of Photog-
raphy, Rochester, N. Y. (Zelda P. Mackay Collection.)*

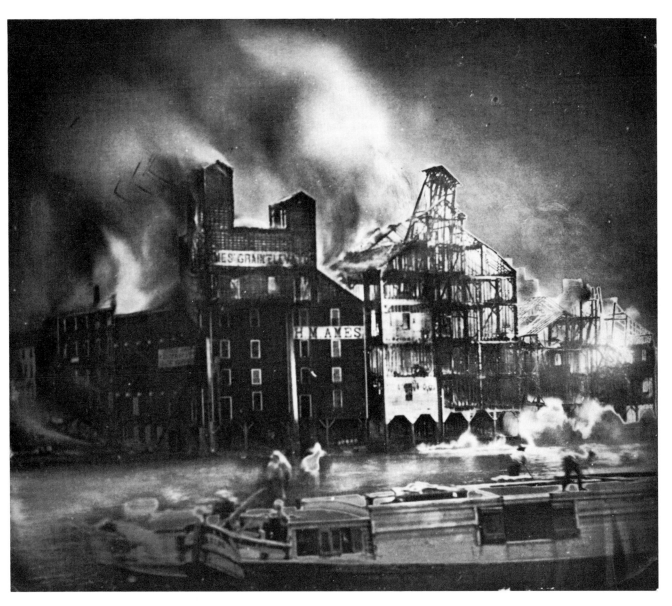

27. BURNING MILLS AT OSWEGO, NEW YORK, JULY 5, 1853.
Sixth plate daguerreotype; copy of a whole plate daguerreotype by George N. Barnard. International Museum of Photography, Rochester, N. Y.

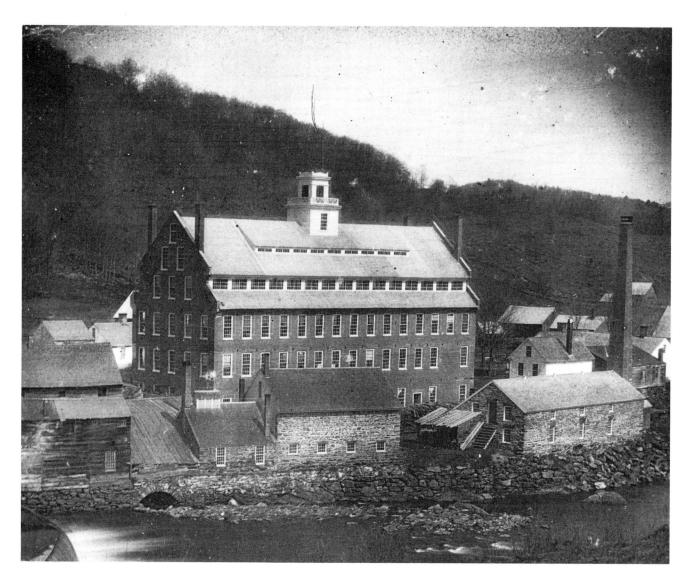

28. WOODWARD WOOLEN MILL, WOODSTOCK, VERMONT, ABOUT 1850.
*Detail of half plate; daguerreotypist not known. International Museum of
Photography, Rochester, N. Y.*

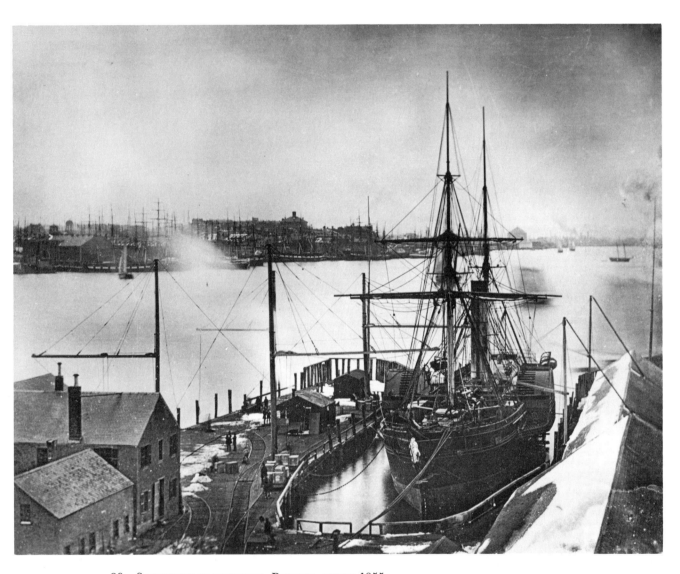

29. STEAMSHIP IN DRY DOCK, BOSTON, ABOUT 1855.
*Whole plate daguerreotype by Southworth & Hawes. Collection Richard
Parker, Marblehead, Mass.*

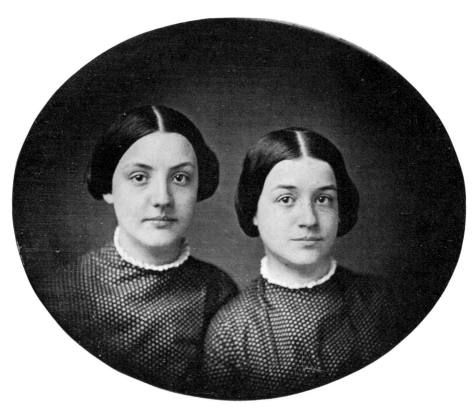

30. QUAKER SISTERS, ABOUT 1850.
Sixth plate; daguerreotypist not known. International Museum of Photography, Rochester, N. Y. (Zelda P. Mackay Collection.)

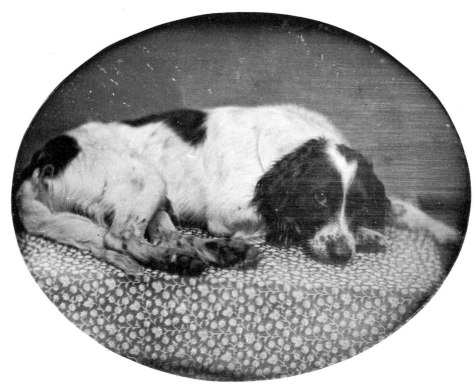

31. DOG, ABOUT 1855.
Sixth plate daguerreotype by Sheldon Nichols. International Museum of Photography, Rochester, N. Y. (Zelda P. Mackay Collection.)

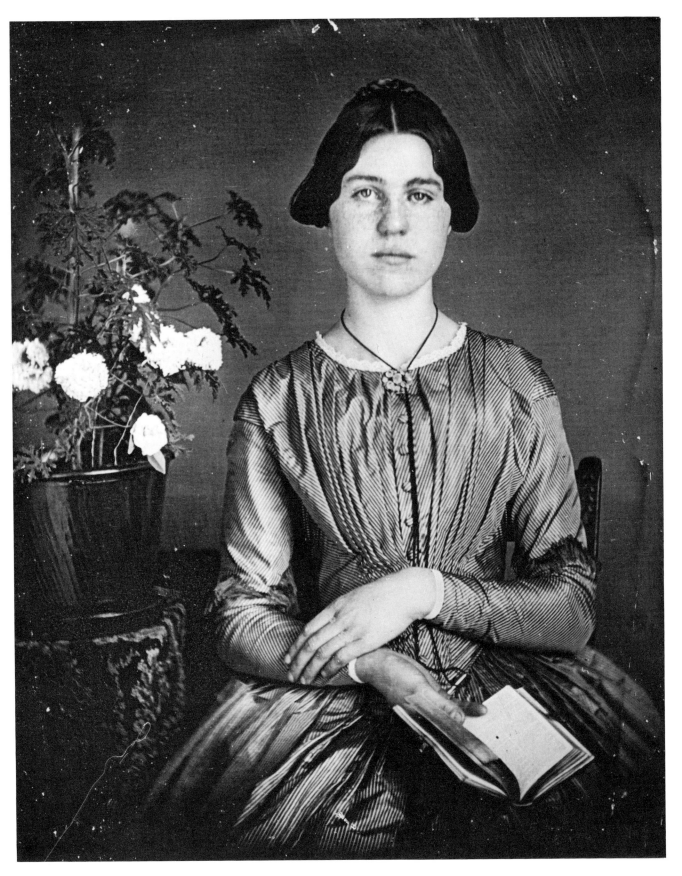

32. Girl, about 1850.
Sixth plate; daguerreotypist not known. Collection Estate of Edward Weston, Carmel, Calif.

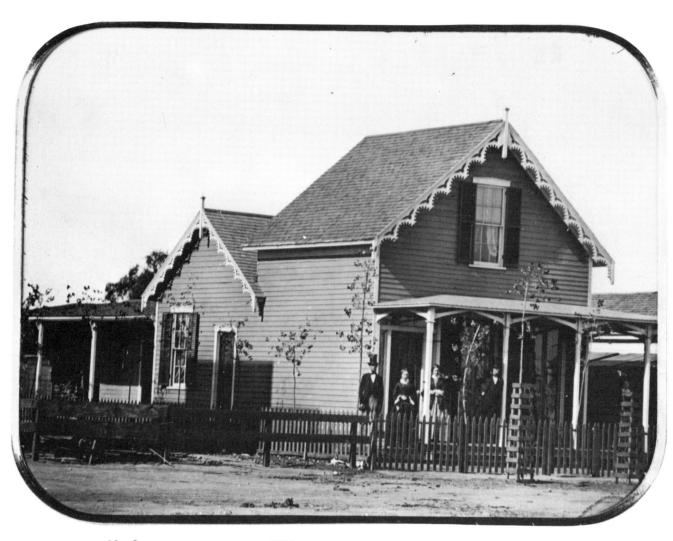

33. SUBURBAN HOUSE, ABOUT 1850.
Half plate; daguerreotypist not known. Collection Emmanuel Weil, Albany,
N. Y.

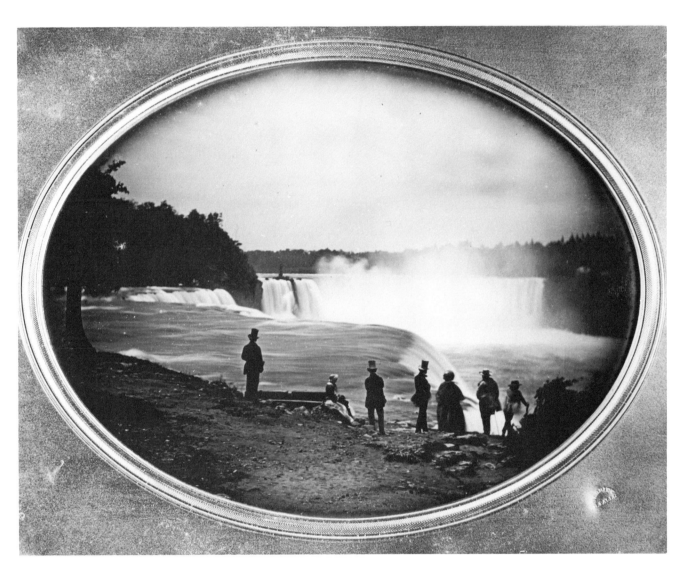

34. GROUP AT NIAGARA FALLS, ABOUT 1855.
*Whole plate daguerreotype by Platt D. Babbitt. International Museum of
Photography, Rochester, N. Y.*

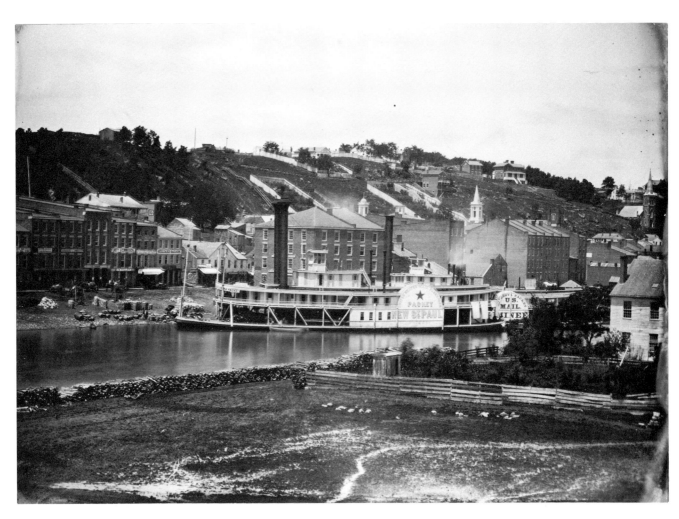

35. GALENA, ILLINOIS, BETWEEN 1852 AND 1854.
Whole plate daguerreotype by Alexander Hesler. Chicago Historical Society, Chicago.

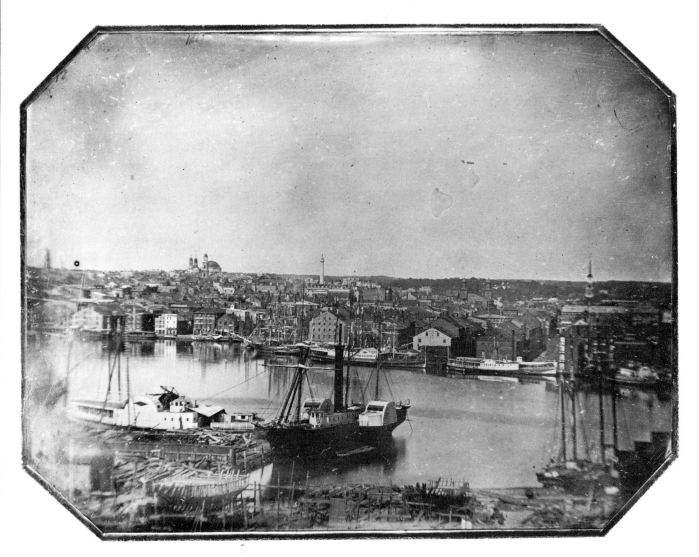

36. BALTIMORE, FROM FEDERAL HILL, LOOKING NORTH-NORTHWEST, BETWEEN 1853
AND 1854.
Whole plate daguerreotype by H. H. Clark. The Peale Museum, Baltimore.

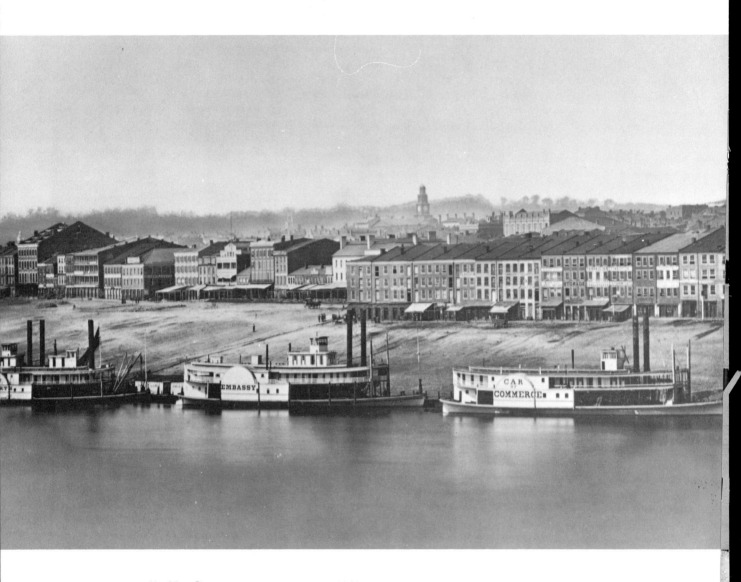

37–38. CINCINNATI WATERFRONT, 1848.
Two of eight whole plate daguerreotypes forming a panorama, by Charles Fontayne and William Southgate Porter. The Public Library of Cincinnati and Hamilton County, Cincinnati, Ohio.

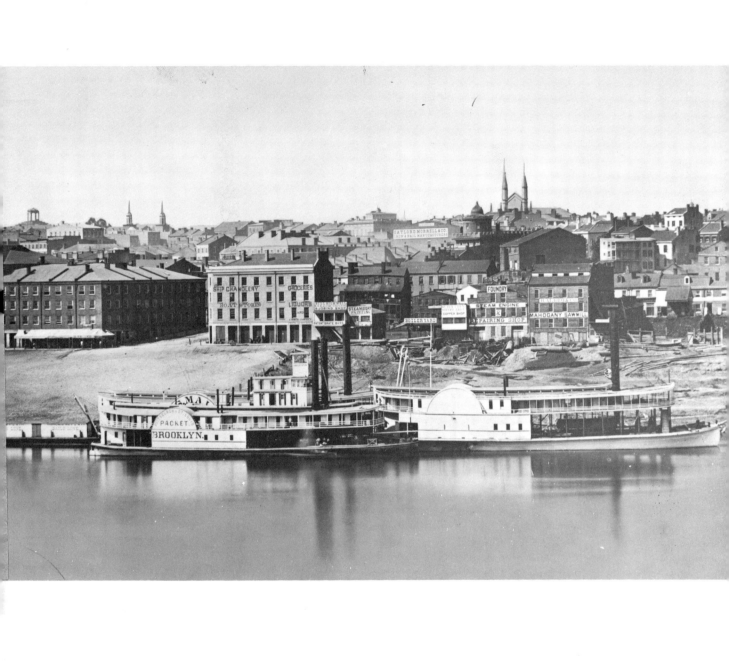

39. DAN BRYANT, MINSTREL, ABOUT 1855.
 Half plate daguerreotype, probably by John H. Fitzgibbon.
 Chicago Historical Society, Chicago.

40. BRASS ENSEMBLE, ABOUT 1850.
 Half plate; daguerreotypist not known. International Museum of Photog-
 raphy, Rochester, N. Y.

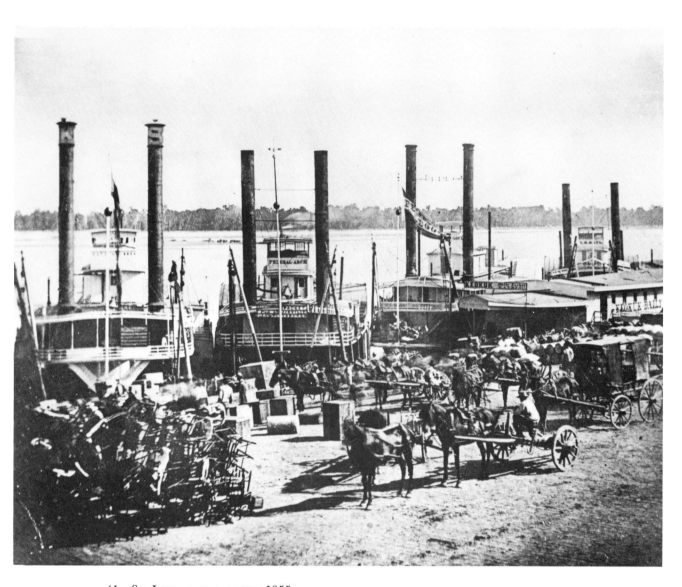

41. ST. LOUIS LEVEE, ABOUT 1855.
 Whole plate; daguerreotypist not known. Missouri Historical Society,
 St. Louis.

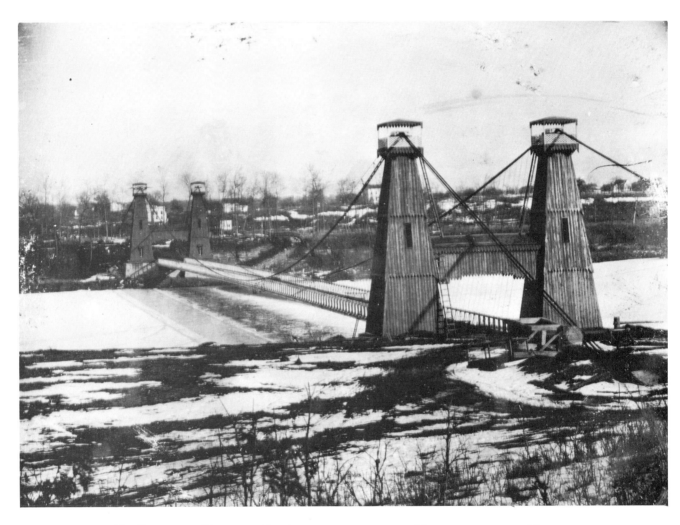

42. SUSPENSION BRIDGE OF ST. ANTHONY, CONNECTING MINNEAPOLIS WITH NICOLET ISLAND; OPENED JANUARY 27, 1855.
Half plate; daguerreotypist not known. Minnesota Historical Society, St. Paul, Minn.

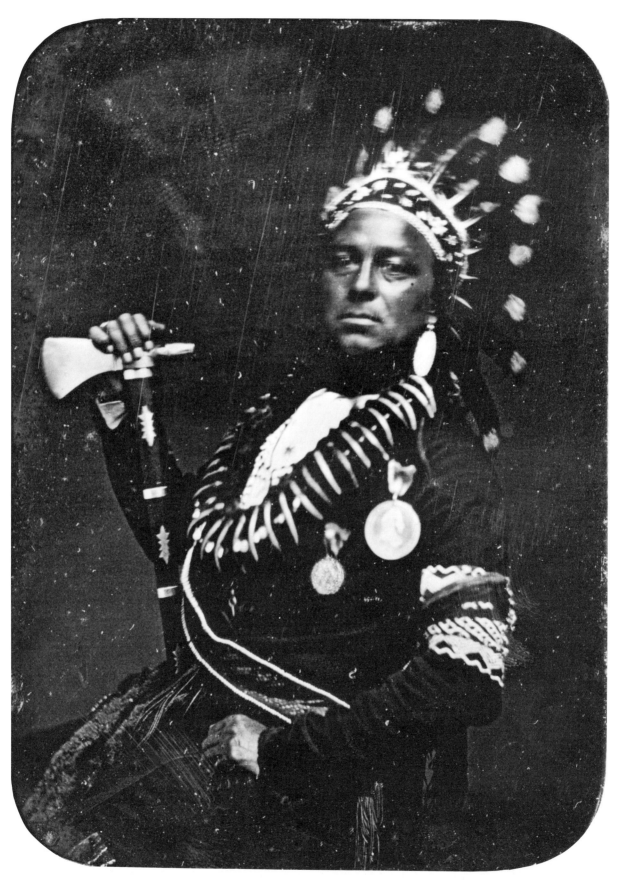

43. MAUNGWUDAUS, CHIEF OF THE OJIBWAY TRIBE OF PENNSYLVANIA, ABOUT 1850. *Quarter plate; daguerreotypist not known. International Museum of Photography, Rochester, N. Y.*

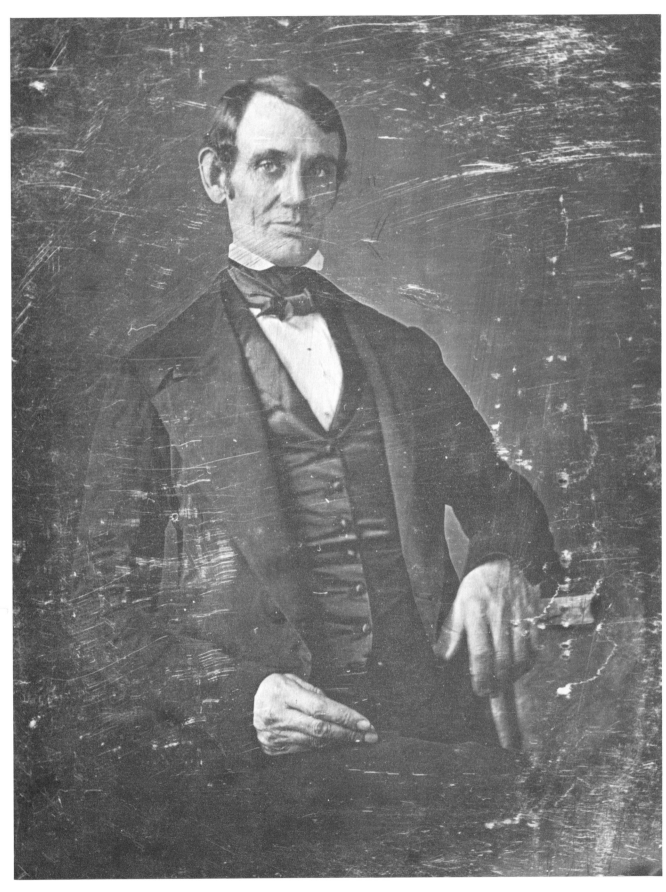

44. ABRAHAM LINCOLN, ABOUT 1847.
 Quarter plate daguerreotype by N. H. Shepard. The Library of Congress,
 Washington, D. C.

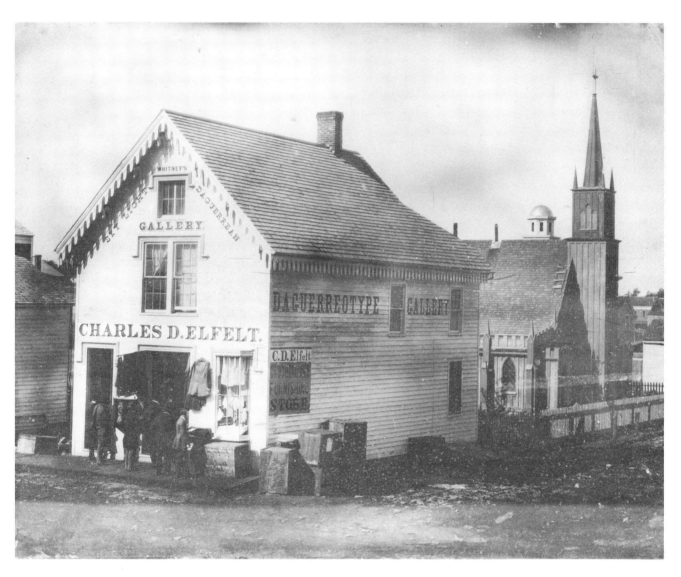

45. DAGUERREOTYPE GALLERY OF JOEL EMMONS WHITNEY, CORNER OF THIRD AND CEDAR STREETS, ST. PAUL, MINNESOTA, ABOUT 1852.
Whole plate daguerreotype, probably by Joel Emmons Whitney. Minnesota Historical Society, St. Paul, Minn.

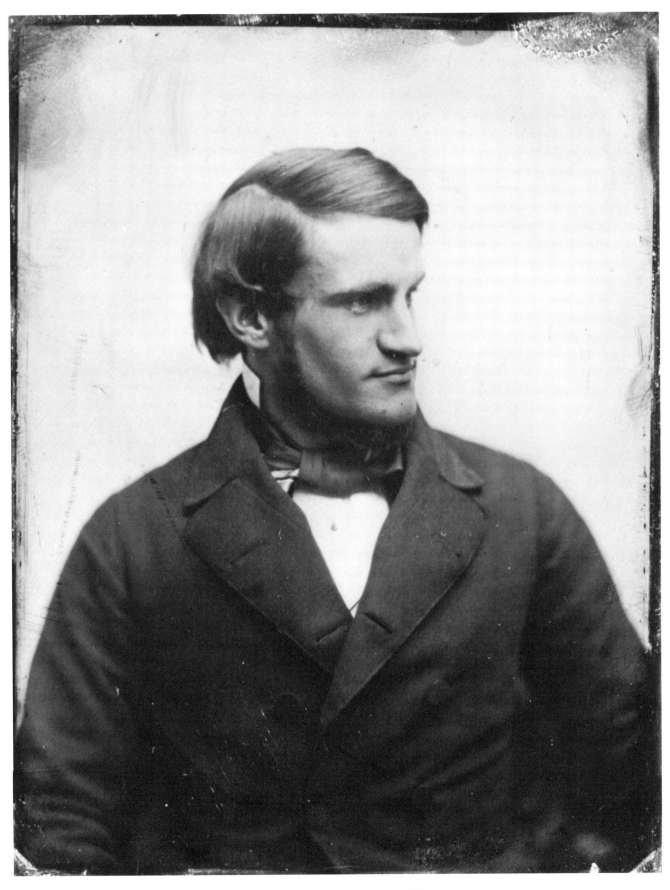

46. FRANCIS PARKMAN, AMERICAN HISTORIAN, ABOUT 1850.
*Quarter plate daguerreotype by Southworth & Hawes. The Metropolitan
Museum of Art, New York. (Gift of I. N. P. Stokes and the Hawes family.)*

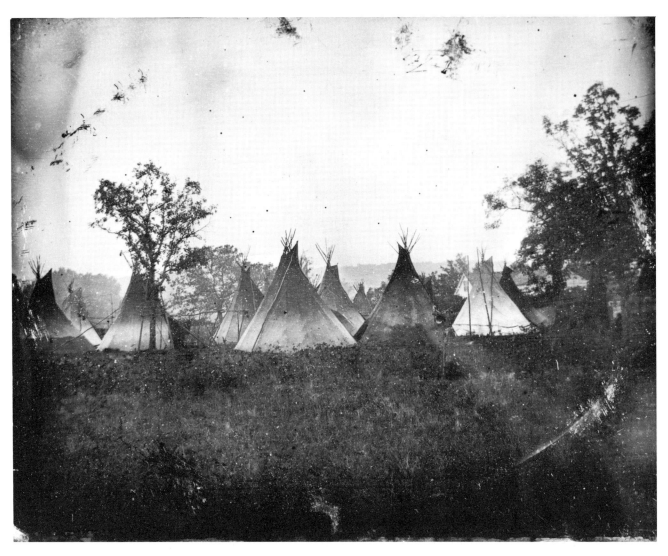

47. INDIAN CAMP ON SITE OF DOWNTOWN MINNEAPOLIS, 1854.
*Quarter plate; daguerreotypist not known. Minnesota Historical Society,
St. Paul, Minn.*

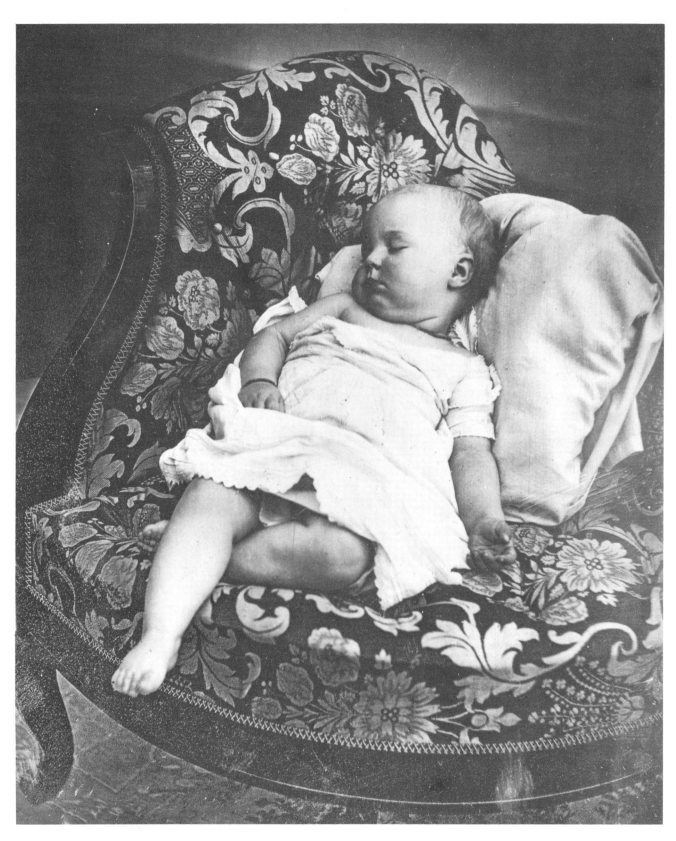

48. SLEEPING BABY, ABOUT 1850.
*Whole plate daguerreotype by Southworth & Hawes. Collection Ansel Adams,
Carmel, Calif.*

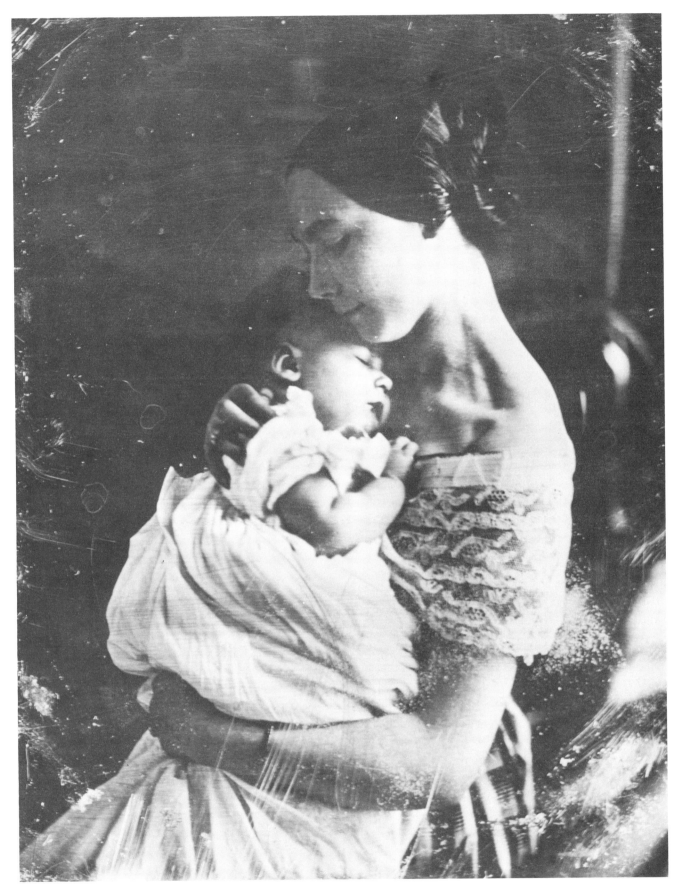

49. MOTHER AND CHILD, ABOUT 1850.
*Sixth plate; daguerreotypist not known. Collection Beaumont Newhall,
Santa Fe, New Mexico.*

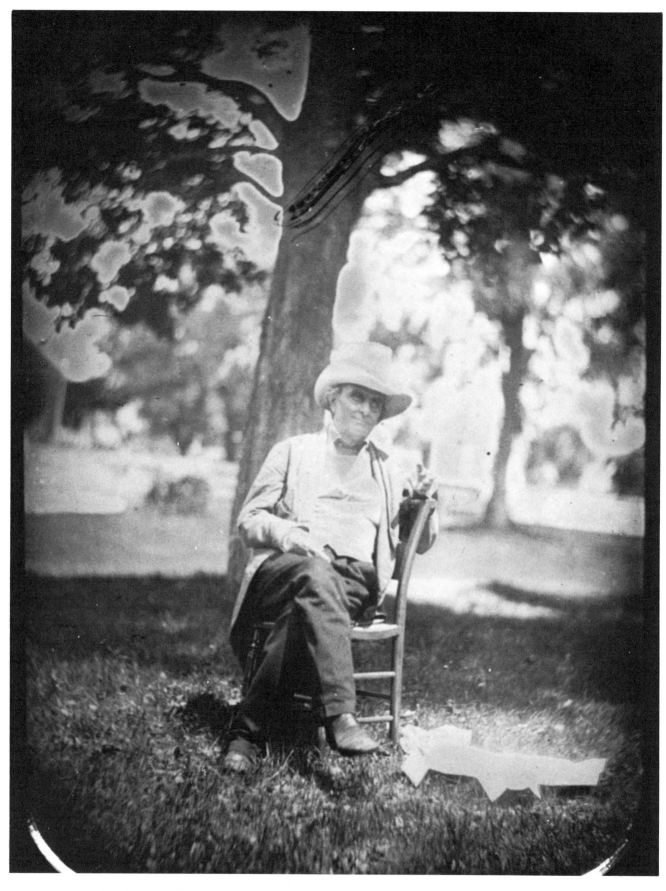

50. DANIEL WEBSTER SITTING OUTDOORS AT HIS MARSHFIELD, MASSACHUSETTS, HOME, ABOUT 1848.
Half plate; daguerreotypist not known. International Museum of Photography, Rochester, N.Y. (Zelda P. Mackay Collection.)

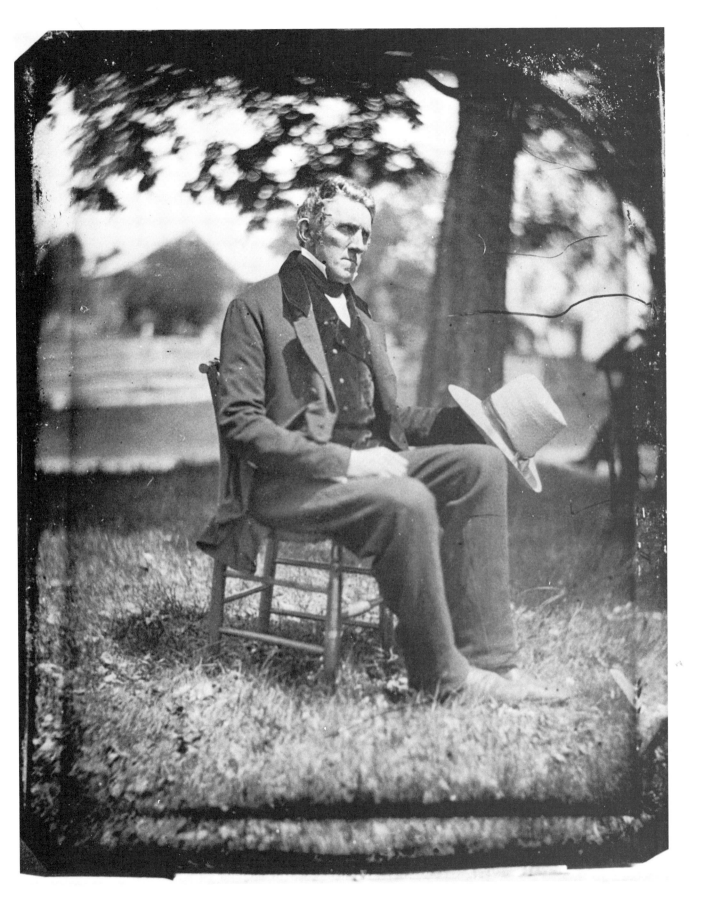

51. COMPANION OF DANIEL WEBSTER, ABOUT 1848.
*Half plate; daguerreotypist not known. Collection Charles Swedlund, Buffalo,
N.Y.*

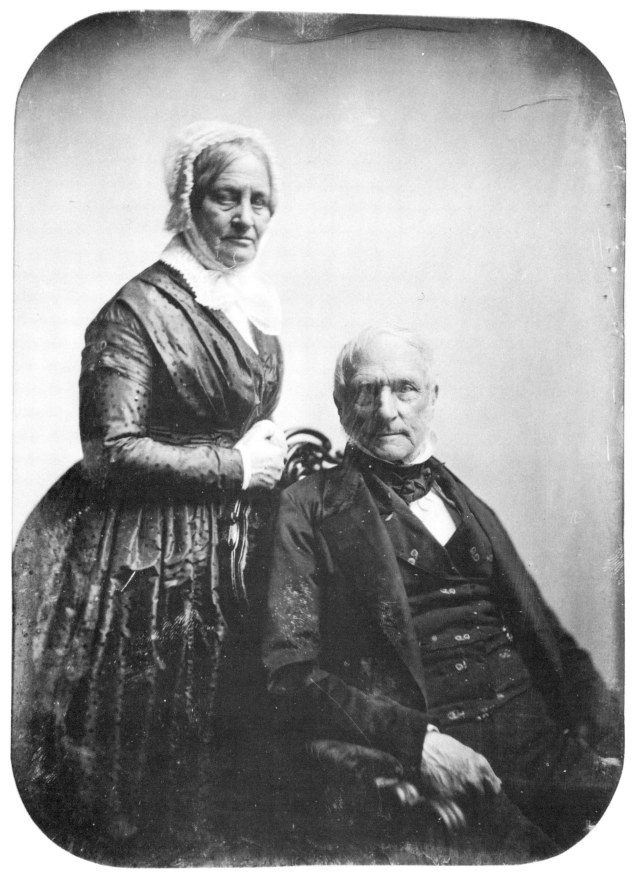

52. ELDERLY COUPLE, ABOUT 1850.
Whole plate daguerreotype by Southworth & Hawes. International Museum of Photography, Rochester, N. Y. (Gift of Alden Scott Boyer.)

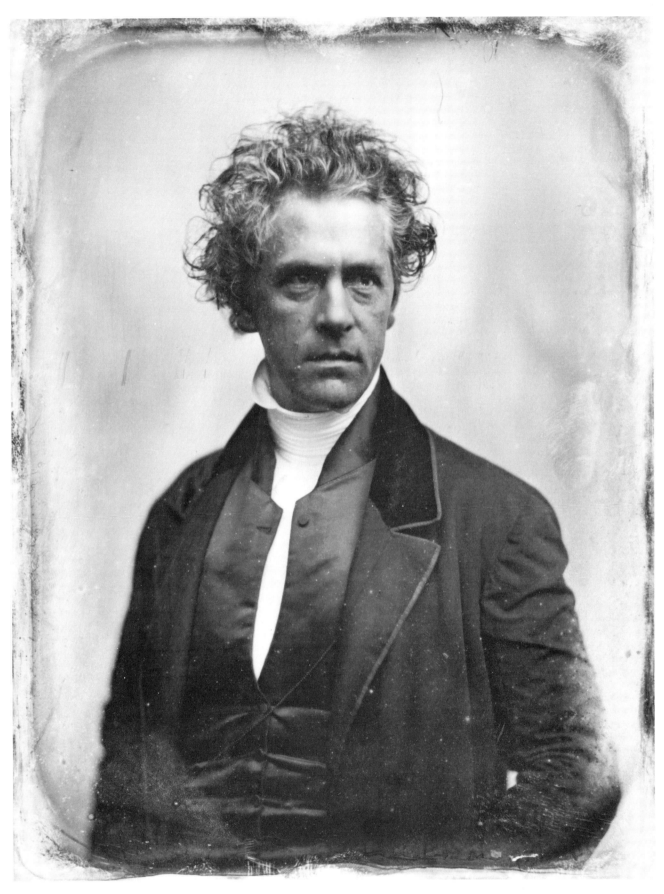

53. ROLLIN HEBER NEAL, PASTOR OF THE FIRST BAPTIST CHURCH, BOSTON, ABOUT 1850.
Sixth plate daguerreotype by Southworth & Hawes. International Museum of Photography, Rochester, N.Y. (Gift of Alden Scott Boyer.)

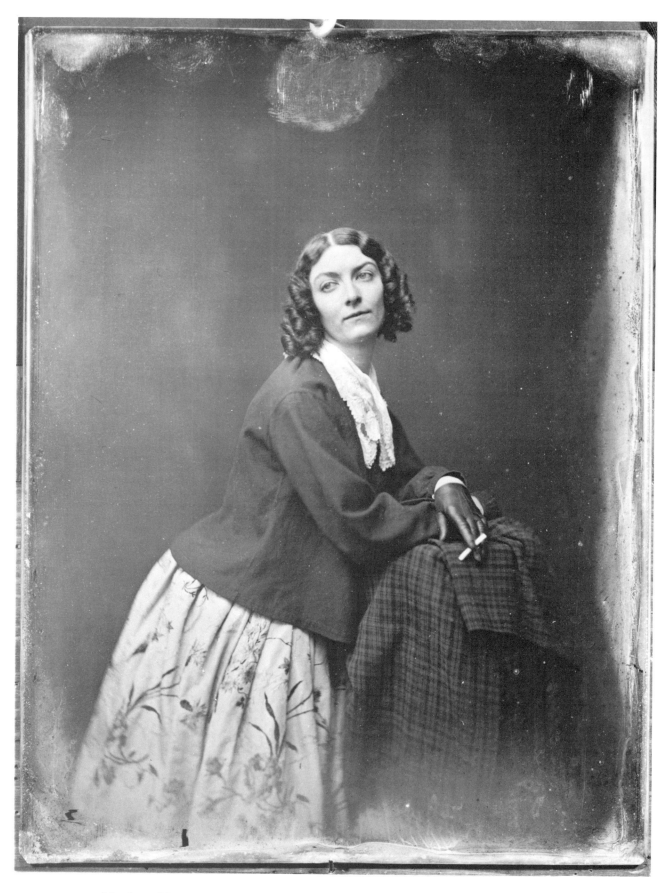

54. LOLA MONTEZ, IRISH-BORN DANCER, ACTRESS, ADVENTURER, ABOUT 1852.
Whole plate daguerreotype by Southworth & Hawes. The Metropolitan
Museum of Art, New York. (Gift of I. N. P. Stokes and the Hawes family.)

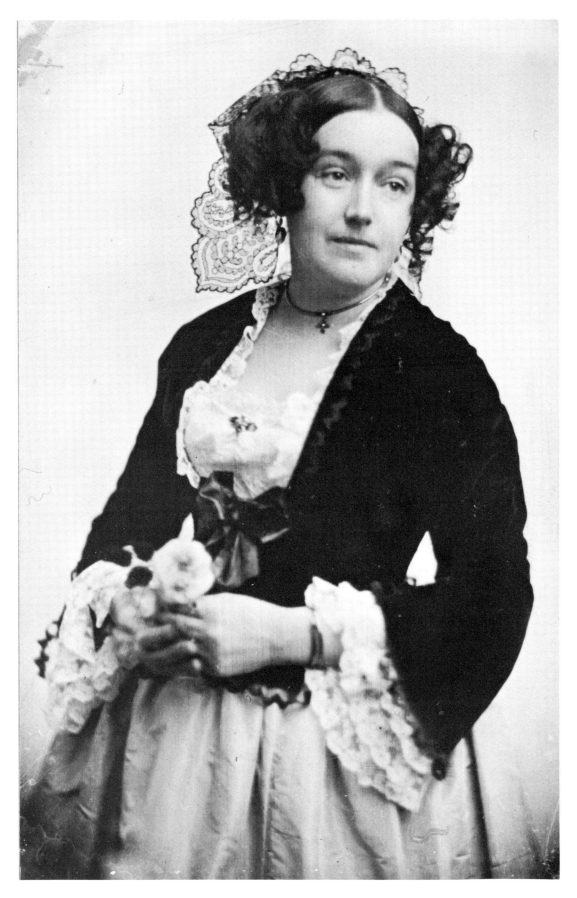

55. MRS. JAMES R. VINCENT, BOSTON ACTRESS, ABOUT 1852.
*Whole plate daguerreotype by Southworth & Hawes. Society for the Preserva-
tion of New England Antiquities, Boston.*

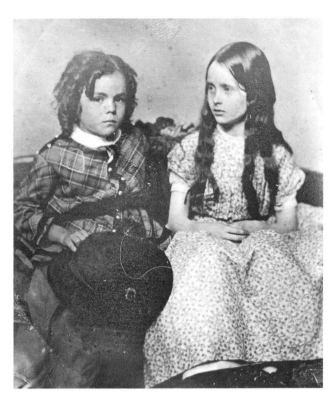

56. Una and Julian Hawthorne, children of Nathaniel Hawthorne, about 1850.
Sixth plate; daguerreotypist not known. The Boston Athenaeum, Boston.

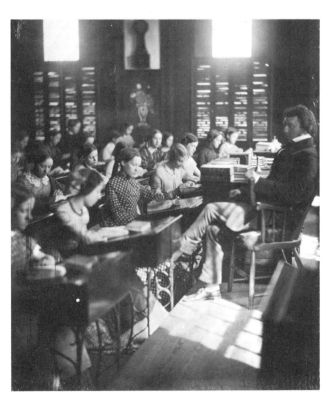

57. Girls' school, about 1855.
Whole plate daguerreotype by Southworth & Hawes. The Metropolitan Museum of Art, New York. (Gift of I. N. P. Stokes and the Hawes family.)

58. HENRY WADSWORTH LONGFELLOW, AMERICAN POET, ABOUT 1850.
*Quarter plate daguerreotype by John Adams Whipple. The Museum of
Modern Art, New York. (Gift of A. Conger Goodyear.)*

59. WILLIAM HICKLING PRESCOTT, AMERICAN HISTORIAN, PROBABLY 1842.
Half plate daguerreotype by Southworth & Hawes. The Metropolitan Museum of Art, New York. (Gift of I. N. P. Stokes and the Hawes family.)

60. Asher B. Durand, American painter, about 1855.
 Half plate; daguerreotypist not known. The New-York Historical Society,
 New York.

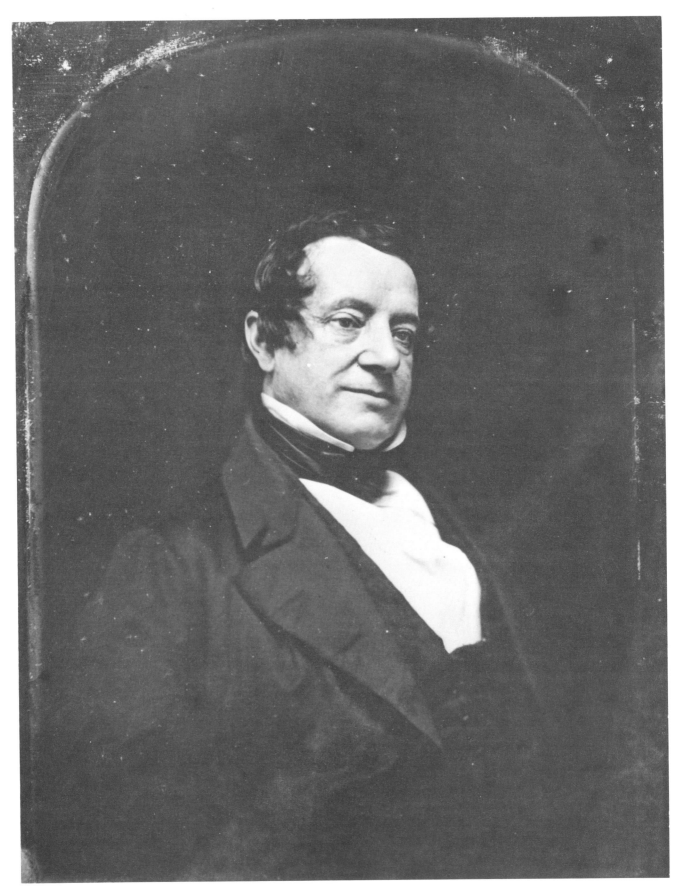

61. WASHINGTON IRVING, AMERICAN WRITER, ABOUT 1849.
Half plate daguerreotype by John Plumbe, Jr. The New-York Historical Society, New York.

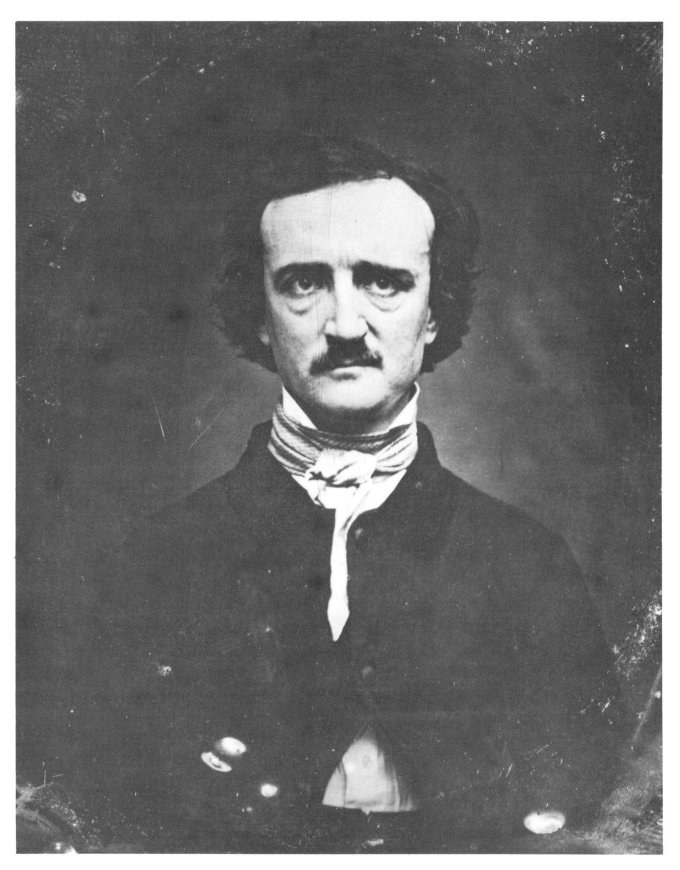

62. EDGAR ALLAN POE, AMERICAN WRITER, 1848.
Quarter plate daguerreotype by Henry N. or Edward H. Manchester. American Antiquarian Society, Worcester, Mass.

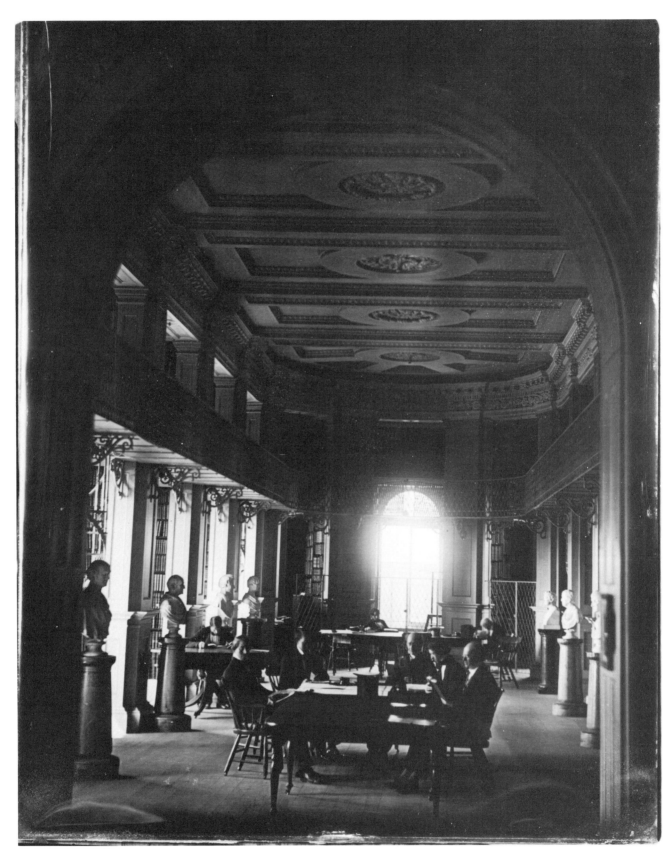

63. THE BOSTON ATHENAEUM, ABOUT 1855.
Whole plate daguerreotype by Southworth & Hawes. International Museum of Photography, Rochester, N.Y.

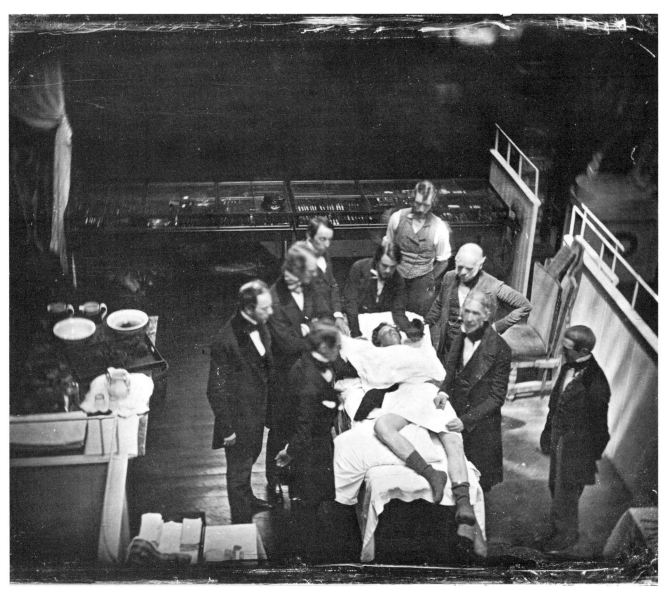

64. Operating room of the Massachusetts General Hospital, Boston; re-enactment of the demonstration of ether anesthesia by W. T. G. Morton on October 16, 1846.

Daguerreotype by Southworth & Hawes. Location of original not known.

65. ELIHU BURRITT, AMERICAN LINGUIST AND ADVOCATE OF INTERNATIONAL PEACE,
ABOUT 1850.
*Half plate; daguerreotypist not known. American Antiquarian Society,
Worcester, Mass.*

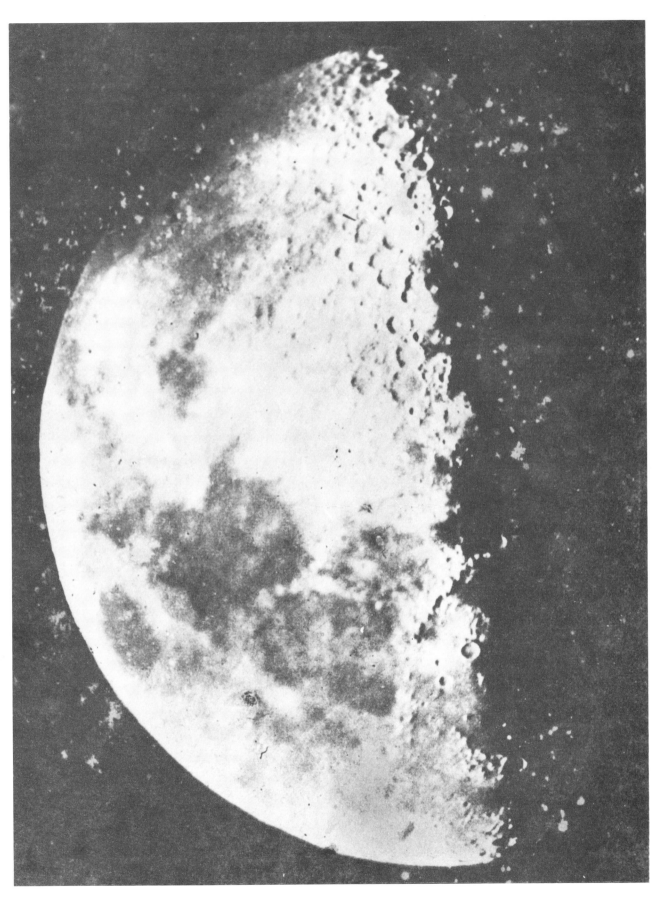

66. THE MOON, 1851.
 Daguerreotype by John Adams Whipple. Location of original not known; reproduced from an original calotype copy in The Photographic and Fine Arts Journal, *July, 1853.*

67. DONALD McKAY, CLIPPER SHIP BUILDER, ABOUT 1855.
Whole plate daguerreotype by Southworth & Hawes. The Metropolitan
Museum of Art, New York. (Gift of I. N. P. Stokes and the Hawes family.)

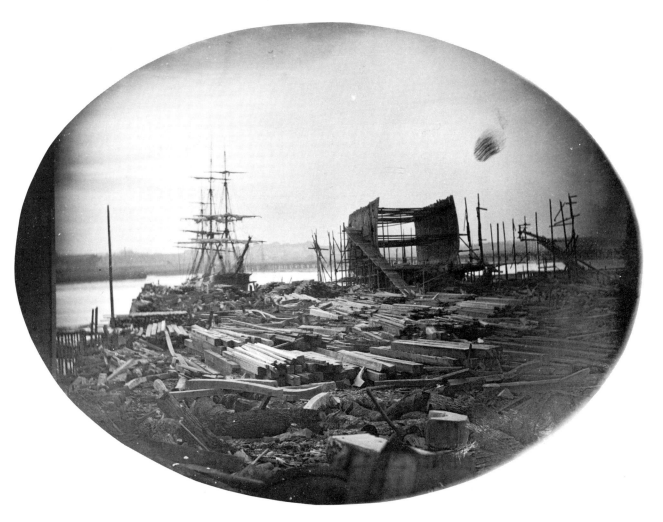

68. SHIPYARD, PROBABLY DONALD MCKAY'S, EAST BOSTON, ABOUT 1855.
Whole plate daguerreotype by Southworth & Hawes. Collection Richard Parker, Marblehead, Mass.

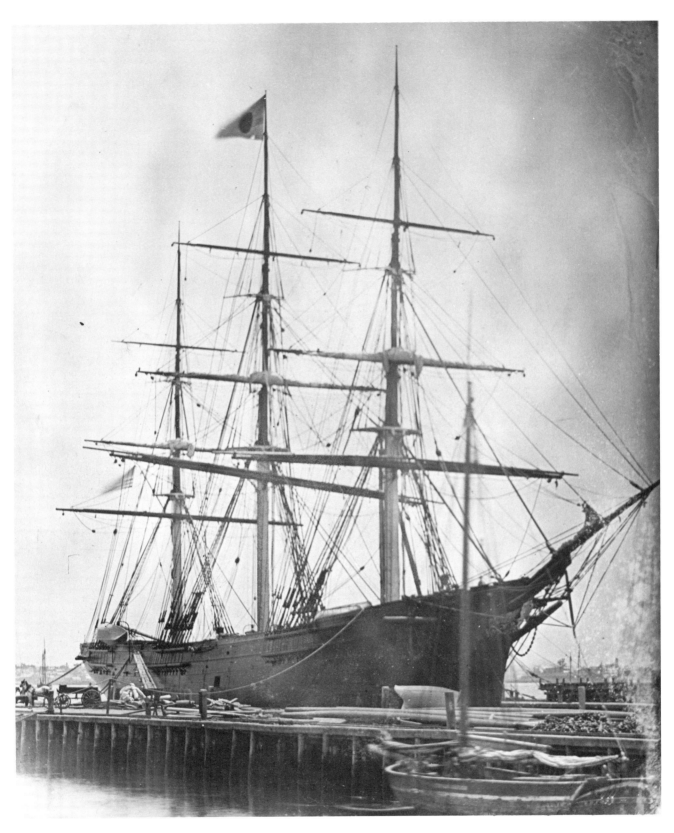

69. CLIPPER SHIP "CHAMPION OF THE SEAS," ABOUT 1858.
Whole plate daguerreotype by Southworth & Hawes. Collection Richard Parker, Marblehead, Mass.

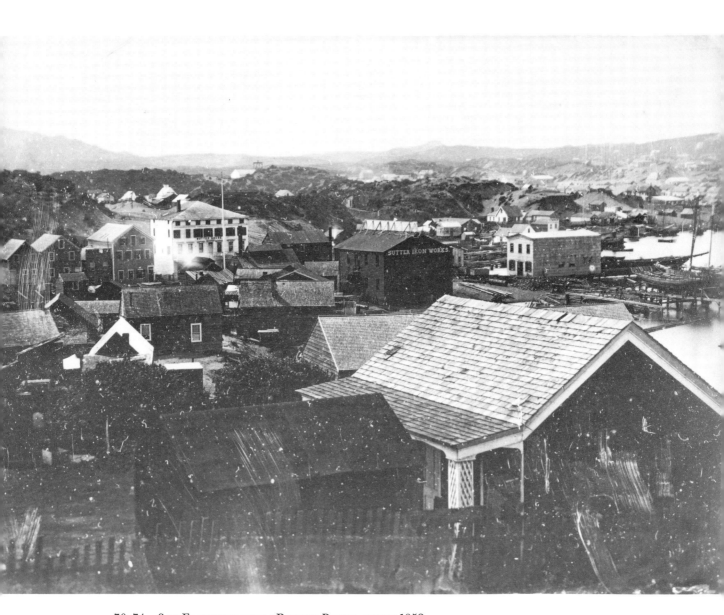

70–74. SAN FRANCISCO FROM RINCON POINT, ABOUT 1852.
Panorama of five whole plate daguerreotypes by William Shew. Smithsonian Institution, Washington, D. C.

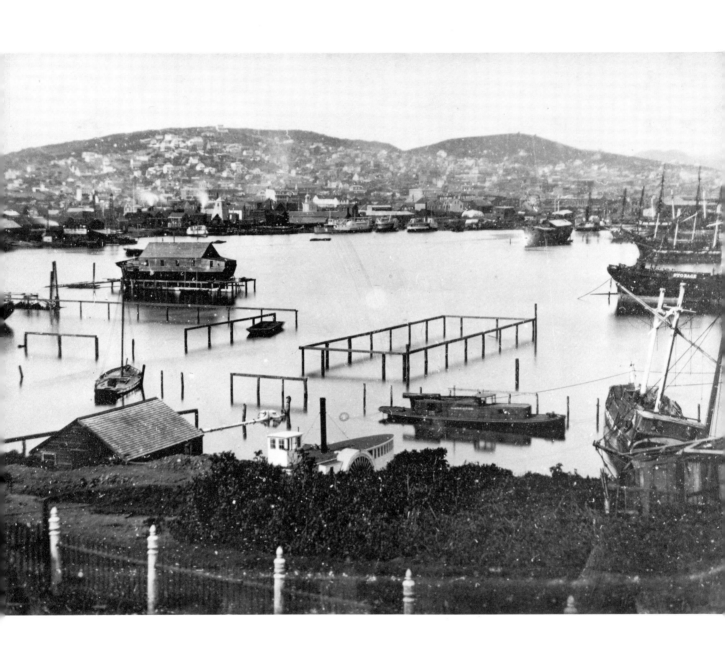

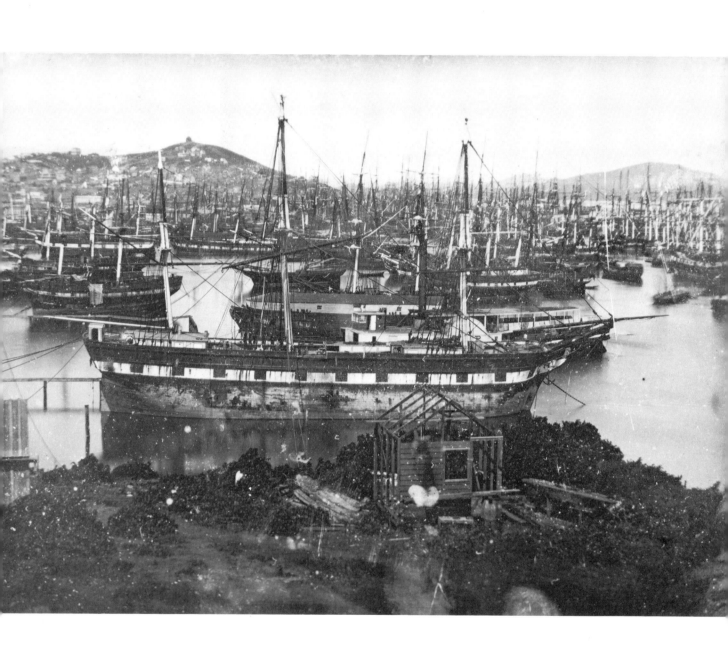

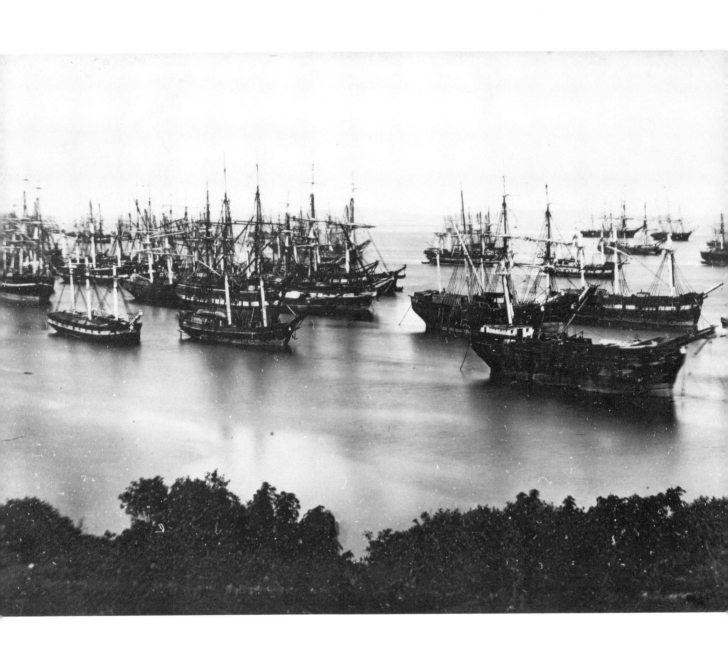

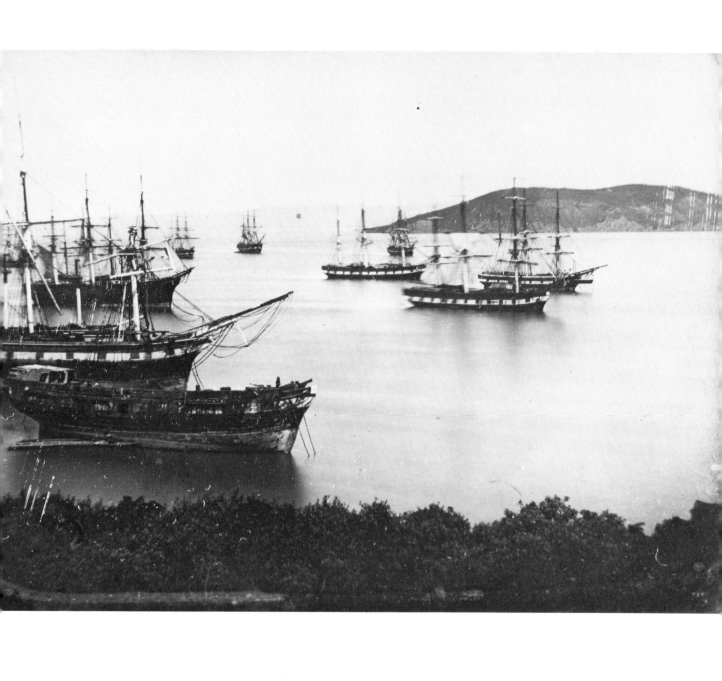

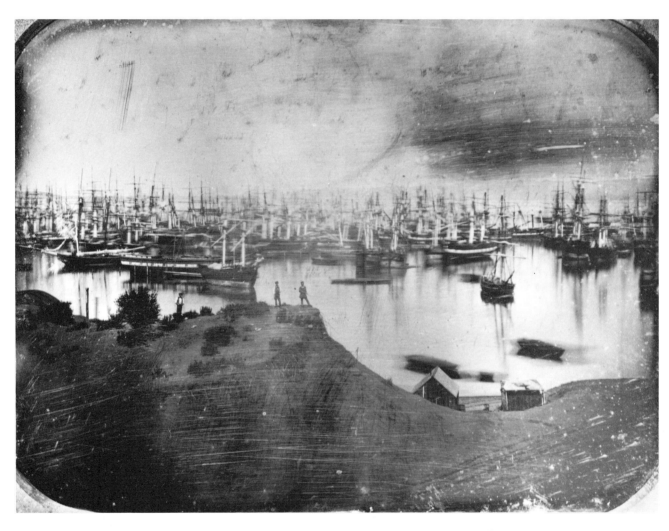

75–76. SAN FRANCISCO, LOOKING NORTHEAST TOWARD YERBA BUENA ISLAND, ABOUT 1851.
Plates 5 and 6 of a panorama of six whole plates; daguerreotypist not known. California Historical Society, San Francisco.

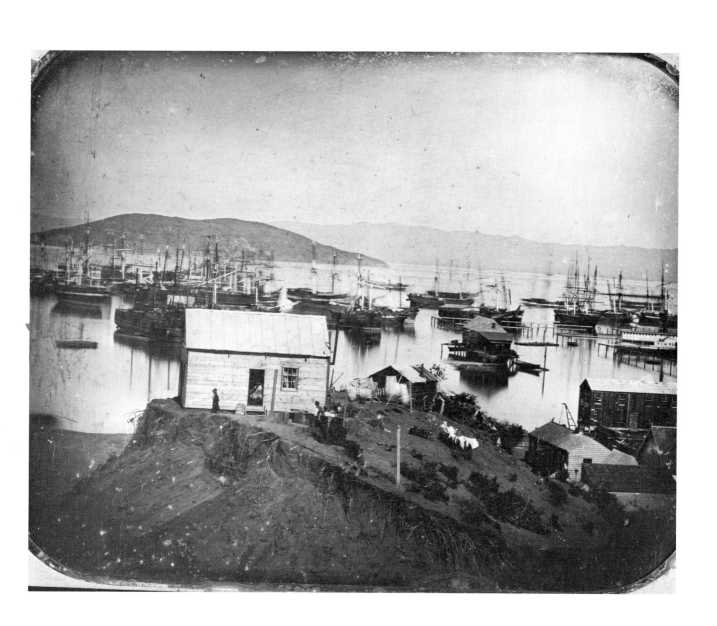

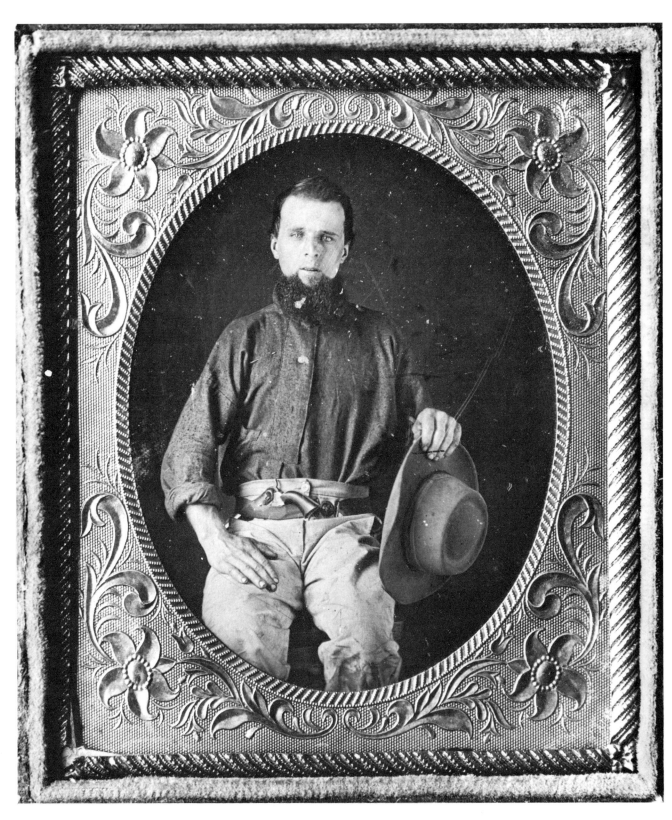

77. SOLOMON YEAKEL, '49ER, ABOUT 1850.
 Sixth plate; daguerreotypist not known. The Bancroft Library, University of California, Berkeley; reproduced by permission of the Director, The Bancroft Library.

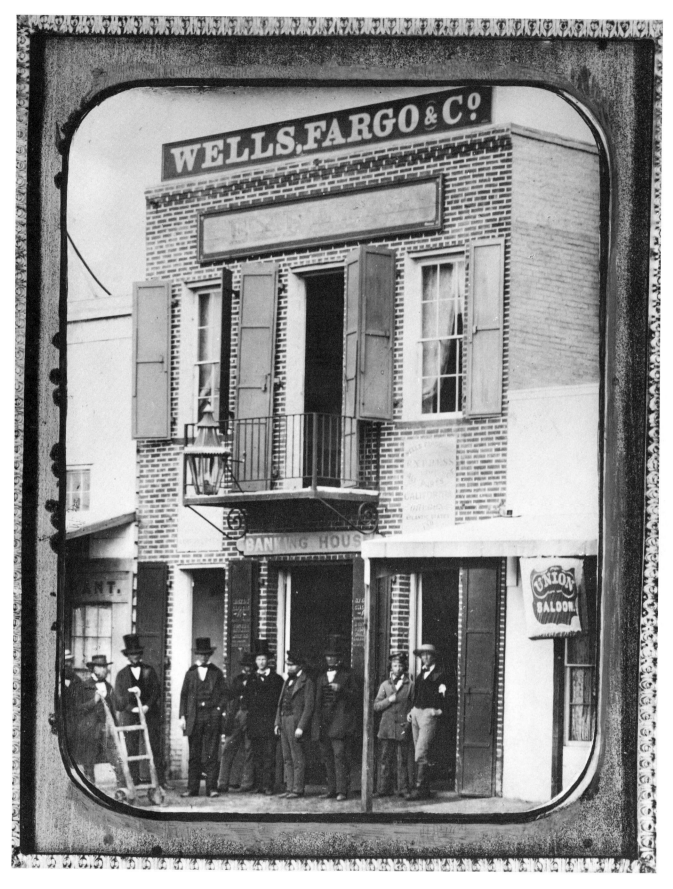

78. WELLS FARGO BANK, SAN FRANCISCO, 1852.
 Whole plate; daguerreotypist not known. Wells Fargo History Room, San Francisco.

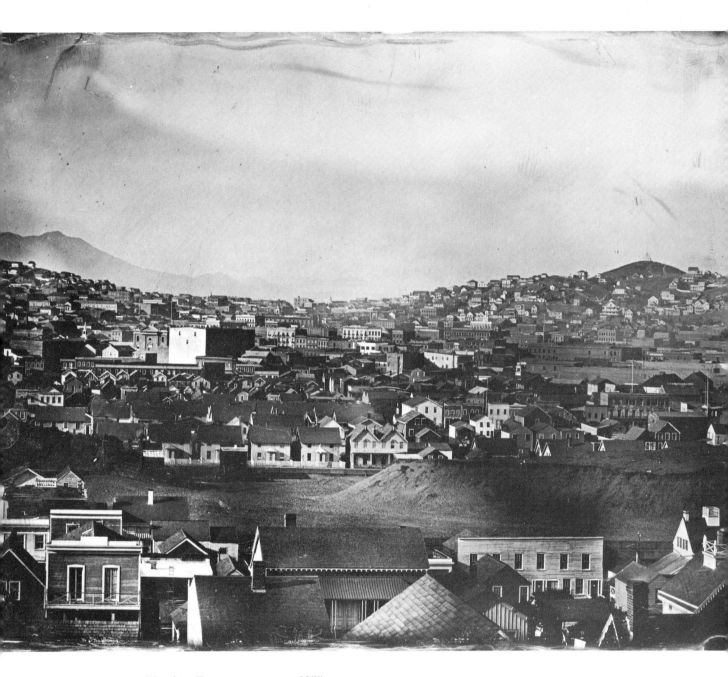

79. SAN FRANCISCO, ABOUT 1855.
 Whole plate; daguerreotypist not known. American Antiquarian Society,
 Worcester, Mass.

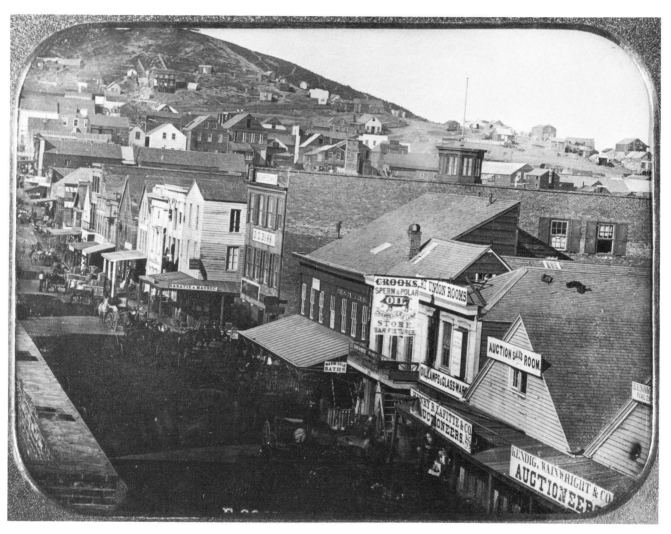

80. MONTGOMERY STREET LOOKING NORTH, SAN FRANCISCO, 1850.
Half plate daguerreotype by Fred Coombs. International Museum of Photography, Rochester, N. Y.

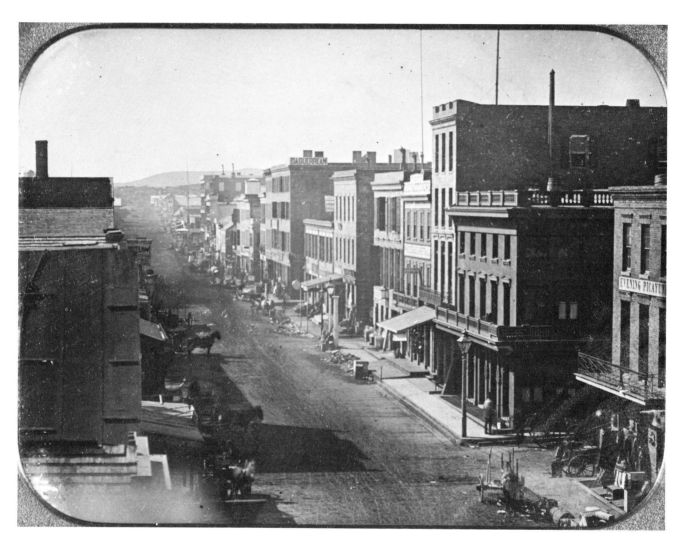

81. MONTGOMERY STREET LOOKING SOUTH, SAN FRANCISCO, 1850.
Half plate daguerreotype by Fred Coombs. International Museum of Photography, Rochester, N. Y.

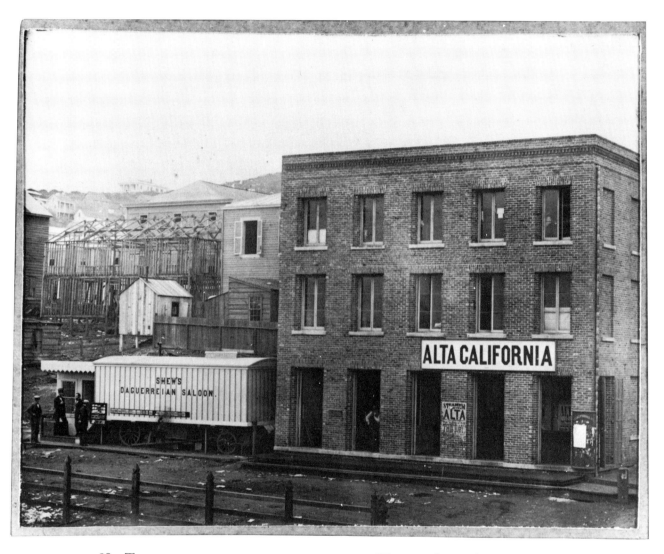

82. THE TRAVELING DAGUERREOTYPE WAGON OF WILLIAM SHEW, SAN FRANCISCO, 1851.
Whole plate daguerreotype probably by William Shew. Collection of the Exchange National Bank, Chicago.

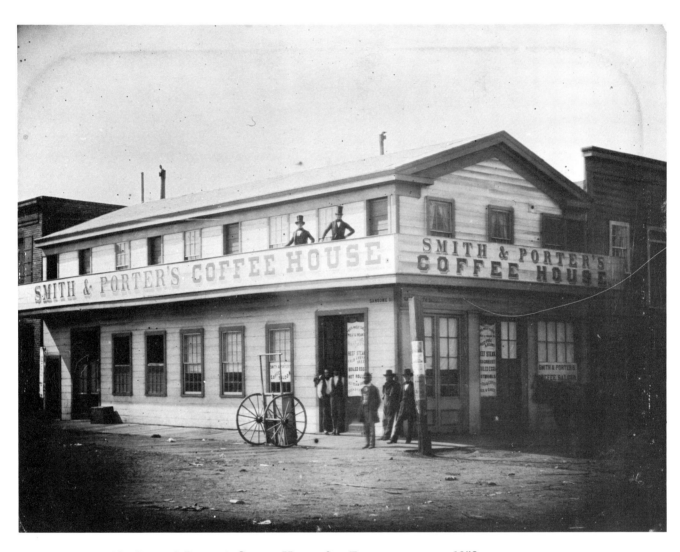

83. SMITH & PORTER'S COFFEE HOUSE, SAN FRANCISCO, ABOUT 1852.
Whole plate; daguerreotypist not known. The Bancroft Library, University of California, Berkeley; reproduced by permission of the Director, The Bancroft Library.

84. RIX FAMILY HOUSE, SAN FRANCISCO, AUGUST 20, 1855.
*Whole plate daguerreotype by Robert H. Vance. The Oakland Museum,
Oakland, Calif.*

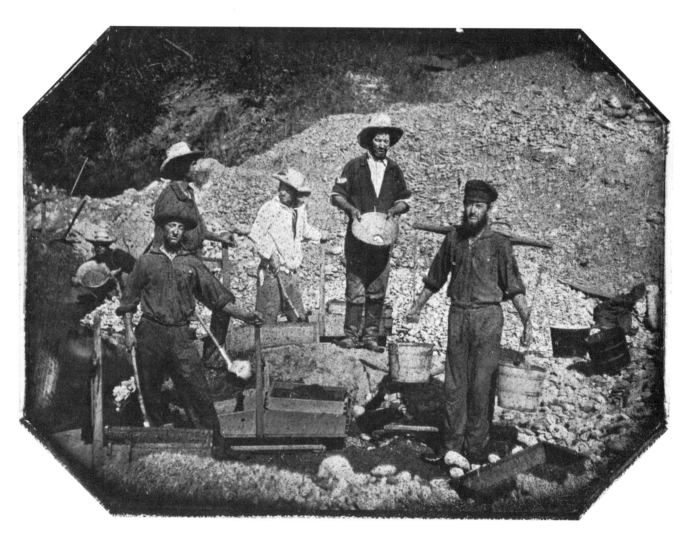

85. GOLD MINERS, CALIFORNIA, ABOUT 1852.
 Quarter plate; daguerreotypist not known. The Bancroft Library, University of California, Berkeley; reproduced by permission of the Director, The Bancroft Library.

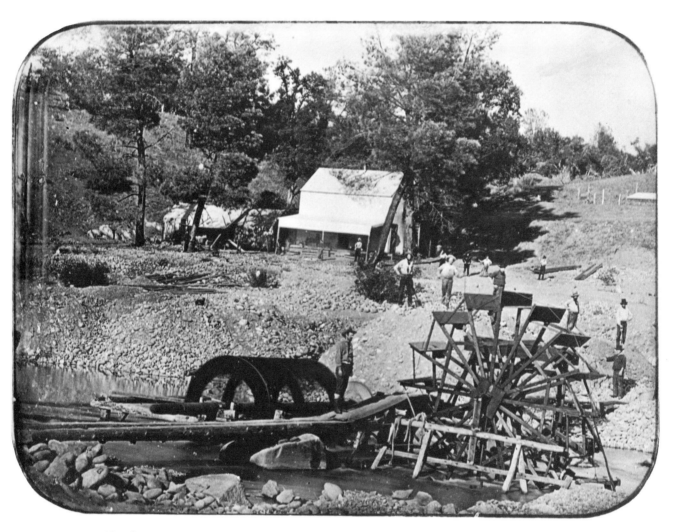

86. Gold mining, Horseshoe Bar, north fork of the American River, California, about 1853.
Half plate; daguerreotypist not known. Collection A. R. Phillips, Jr., Los Angeles.

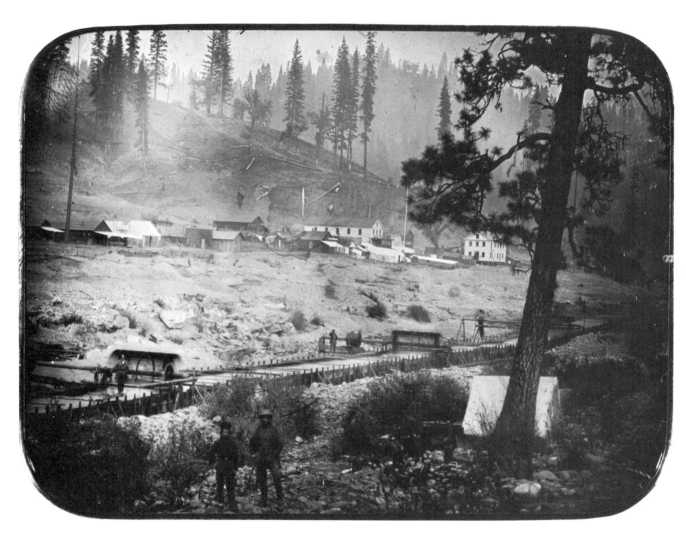

87. GOLD MINING; IN DISTANCE, GRIZZLEY FLAT, CALIFORNIA, ABOUT 1853.
Half plate; daguerreotypist not known. The Bancroft Library, University of California, Berkeley; reproduced by permission of the Director, The Bancroft Library.

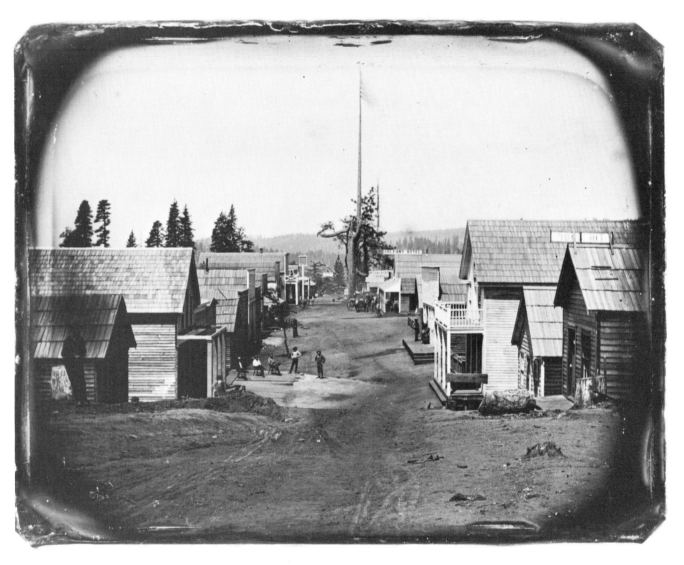

88. TOWN, PROBABLY IN CALIFORNIA, ABOUT 1852.
*Whole plate; daguerreotypist not known. Collection Mrs. Violet Mayborn
Schenk, Rochester, N. Y.*

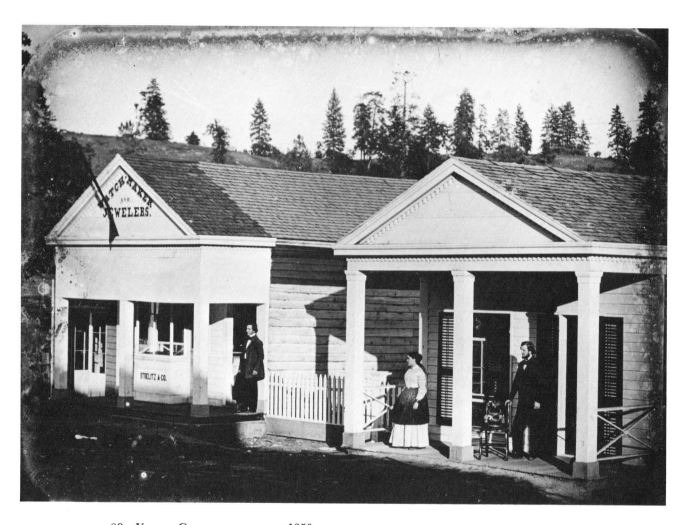

89. YREKA, CALIFORNIA, ABOUT 1850.
Half plate; daguerreotypist not known. Collection Edwin Grabhorn, San Francisco.

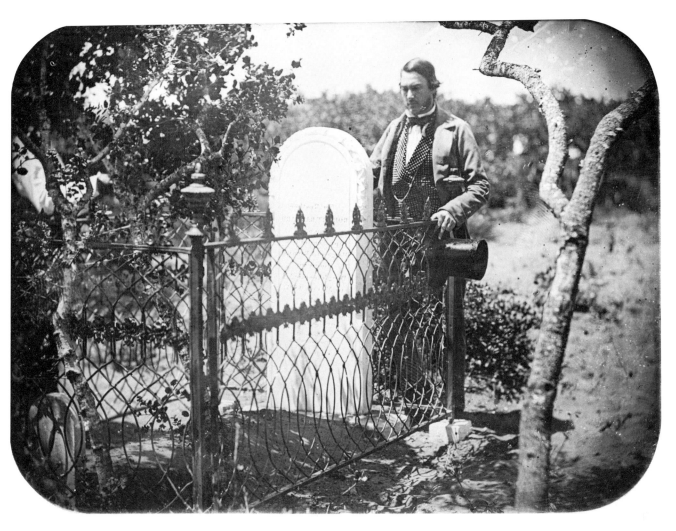

90. GRAVE OF ROBERT BARNARD, DIED 1856.
*Half plate daguerreotype by J. M. Ford, San Francisco. The New-York
Historical Society, New York.*

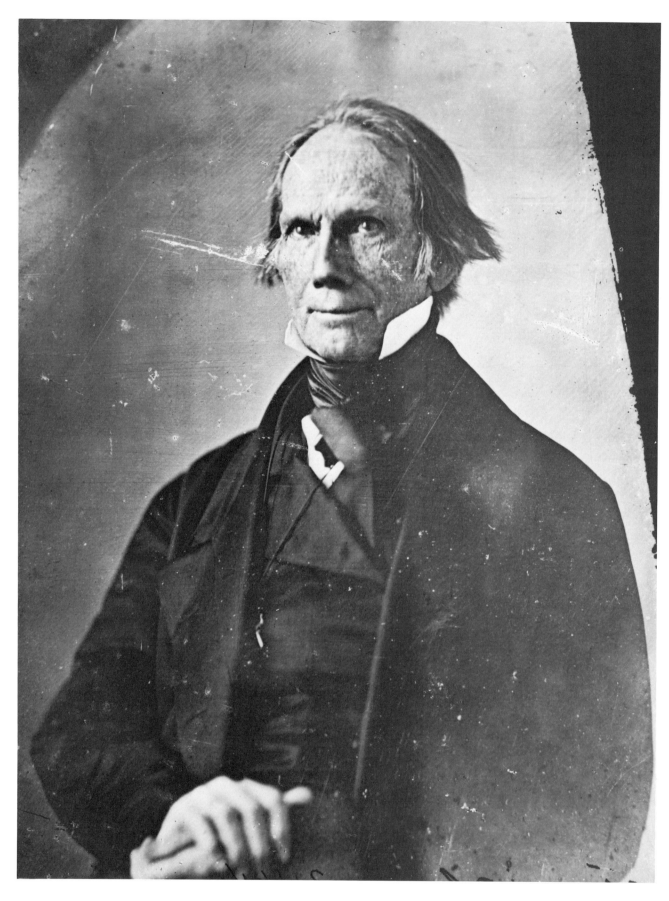

91. HENRY CLAY, BEFORE 1852.
*Copy on collodion plate of a daguerreotype from the gallery of Mathew B.
Brady. The Library of Congress, Washington, D. C.*

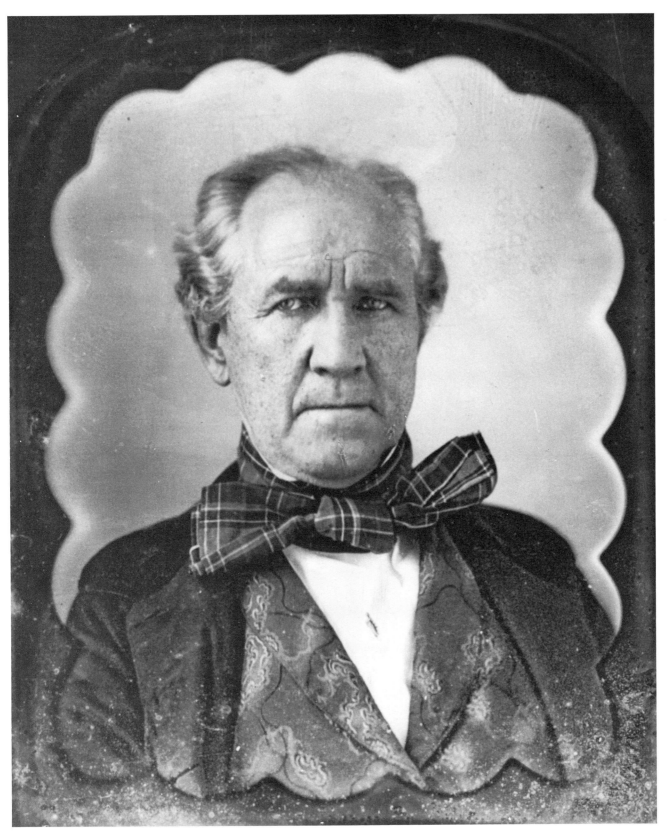

92. SAM HOUSTON, PRESIDENT OF THE REPUBLIC OF TEXAS, ABOUT 1850.
Sixth plate; daguerreotypist not known. International Museum of Photography, Rochester, N. Y. (Gift of Alden Scott Boyer.)

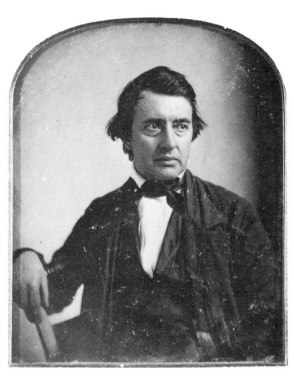

93. ALBERT SANDS SOUTHWORTH, ABOUT 1850.
Sixth plate daguerreotype from the gallery of Southworth
& Hawes. The Metropolitan Museum of Art, New York. (Gift
of I. N. P. Stokes and the Hawes family.)

94. JOSIAH JOHNSON HAWES, ABOUT 1850.
Sixth plate daguerreotype from the gallery of Southworth
& Hawes. The Metropolitan Museum of Art, New York.
(Gift of I. N. P. Stokes and the Hawes family.)

95. LEMUEL SHAW, CHIEF JUSTICE OF THE MASSACHUSETTS SUPREME COURT, 1851. *Half plate daguerreotype by Southworth & Hawes. The Metropolitan Museum of Art, New York. (Gift of I. N. P. Stokes and the Hawes family.)*

96. Caesar, the last Negro slave owned in New York State, 1851.
*Sixth plate; daguerreotypist not known. The New-York Historical Society,
New York.*

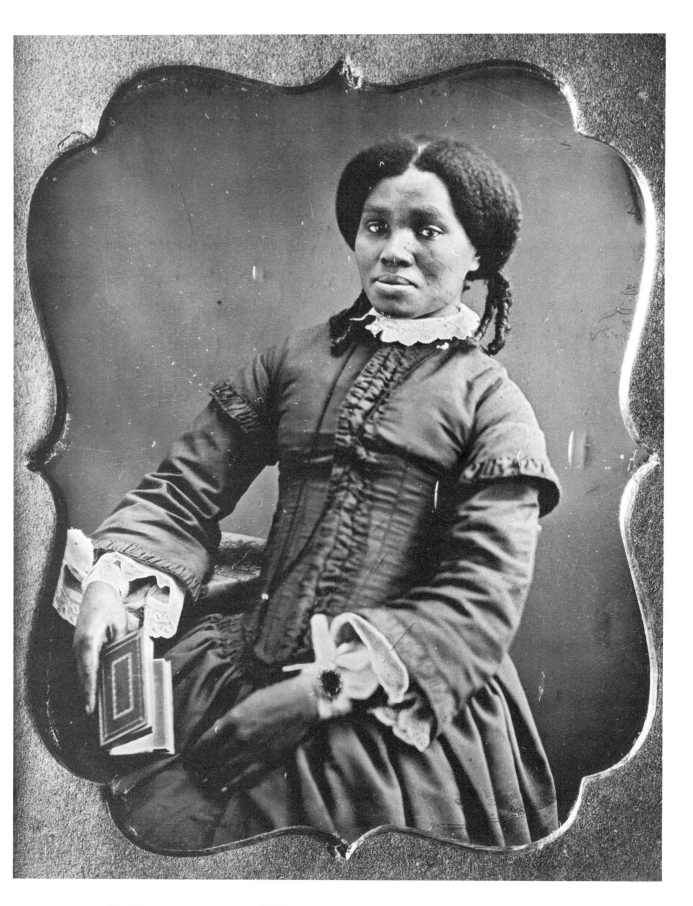

97. NEGRO WOMAN, ABOUT 1850.
Sixth plate; daguerreotypist not known. The International Museum of Photography, Rochester, N. Y. (Zelda P. Mackay Collection.)

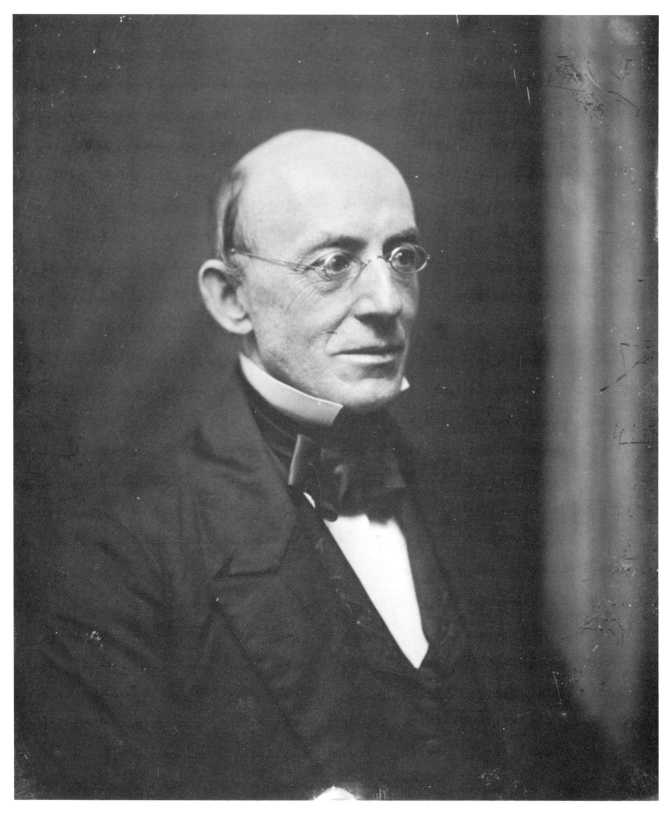

98. WILLIAM LLOYD GARRISON, AMERICAN ABOLITIONIST, ABOUT 1850.
Half plate daguerreotype by Southworth & Hawes. The Metropolitan Museum of Art, New York. (Gift of I. N. P. Stokes and the Hawes family.)

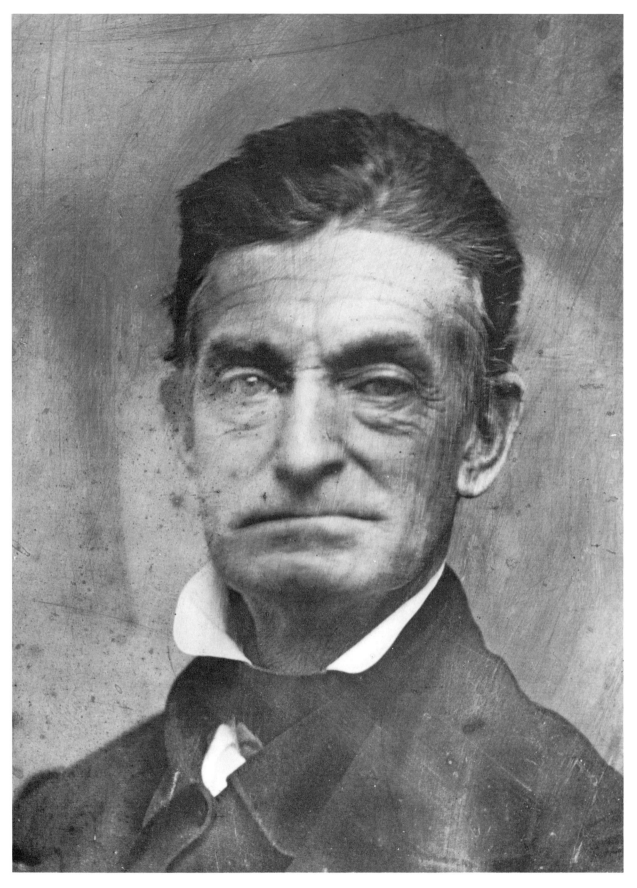

99. JOHN BROWN, ABOLITIONIST, WINTER OF 1856–57.
Detail of half plate daguerreotype by John Adams Whipple and James Wallace Black. The Boston Athenaeum, Boston.

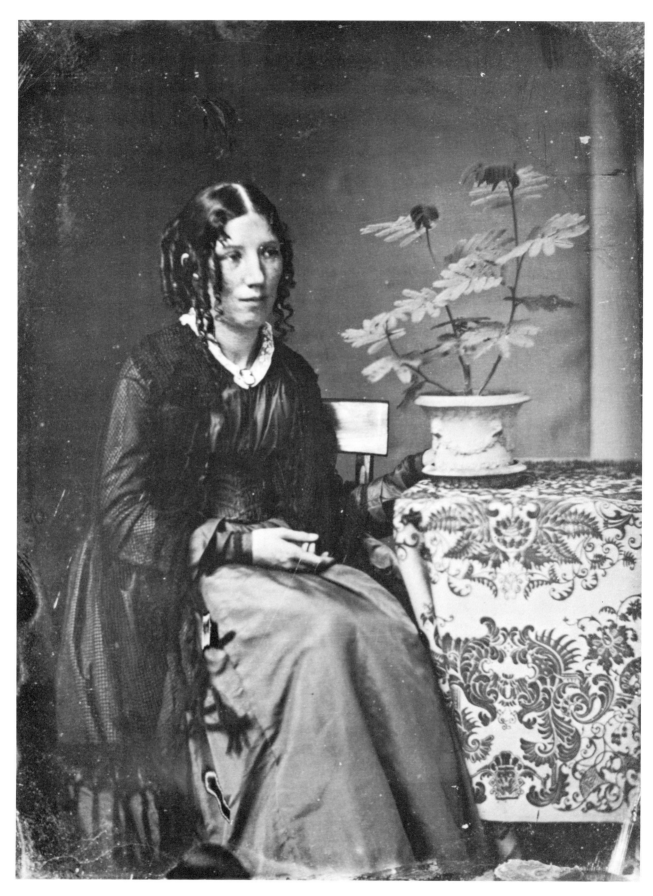

100. HARRIET BEECHER STOWE, AMERICAN AUTHOR, ABOUT 1850.
Quarter plate daguerreotype by Southworth & Hawes. The Metropolitan Museum of Art, New York. (Gift of I. N. P. Stokes and the Hawes family.)

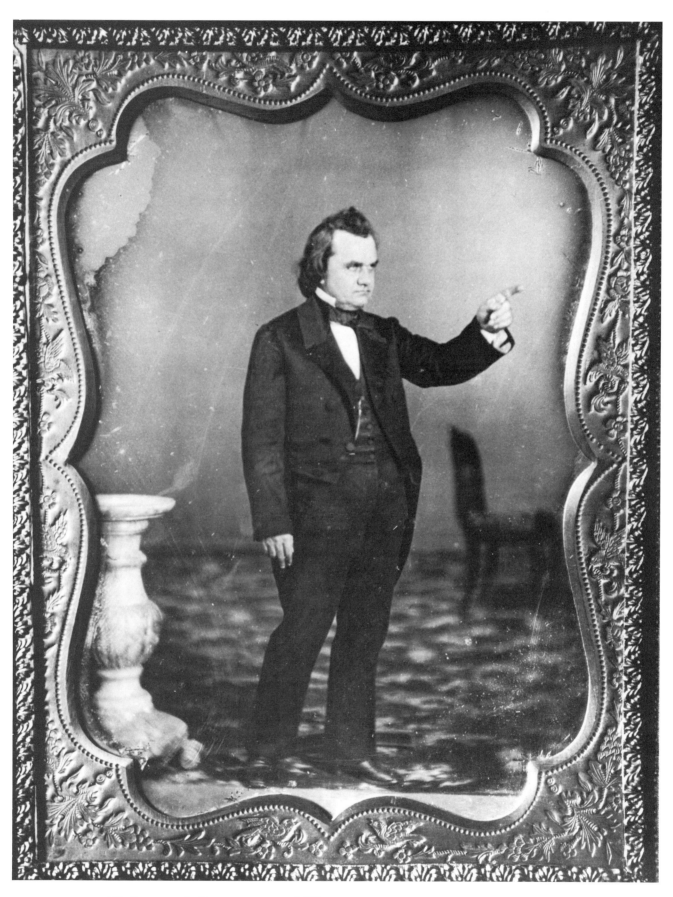

101. STEPHEN A. DOUGLAS, ABOUT 1853.
Whole plate; daguerreotypist not known. International Museum of Photography, Rochester, N. Y. (Zelda P. Mackay Collection.)

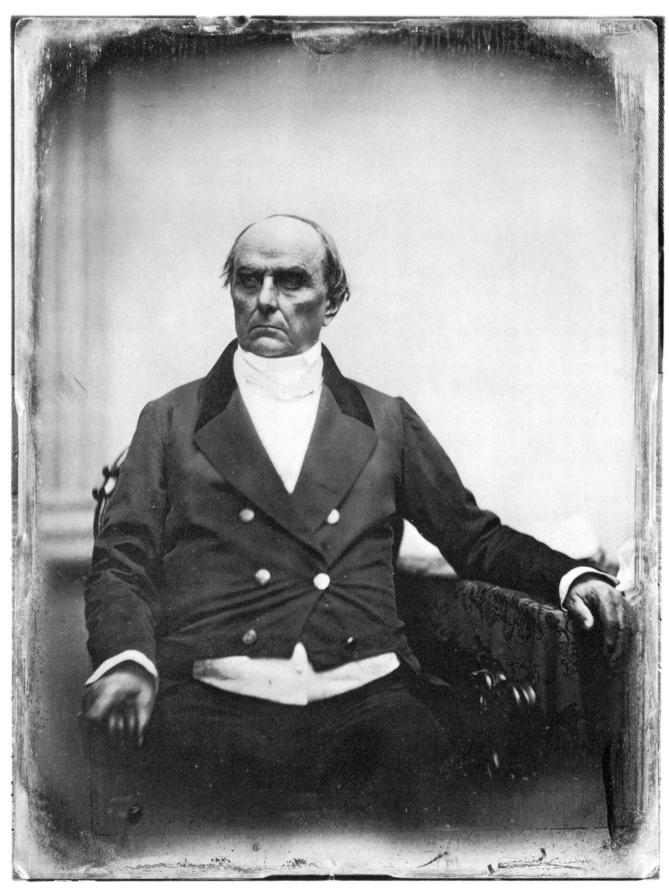

102. DANIEL WEBSTER, 1850.
Whole plate daguerreotype by Southworth & Hawes. The Metropolitan Museum of Art, New York. (Gift of I. N. P. Stokes and the Hawes family.)

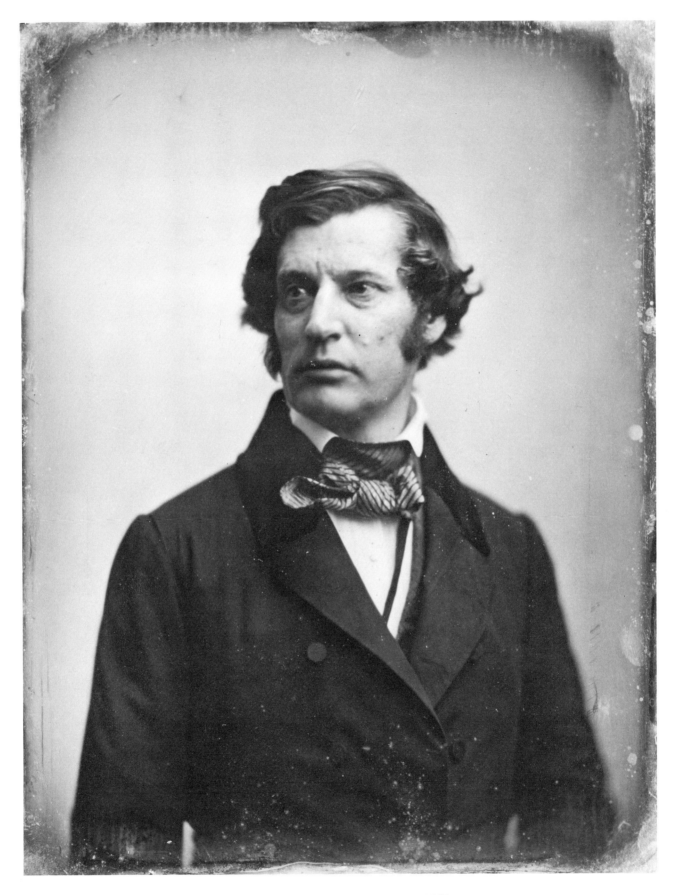

103. Charles Sumner, United States senator, about 1850.
Whole plate daguerreotype by Southworth & Hawes. The Metropolitan Museum of Art, New York. (Gift of I. N. P. Stokes and the Hawes family.)

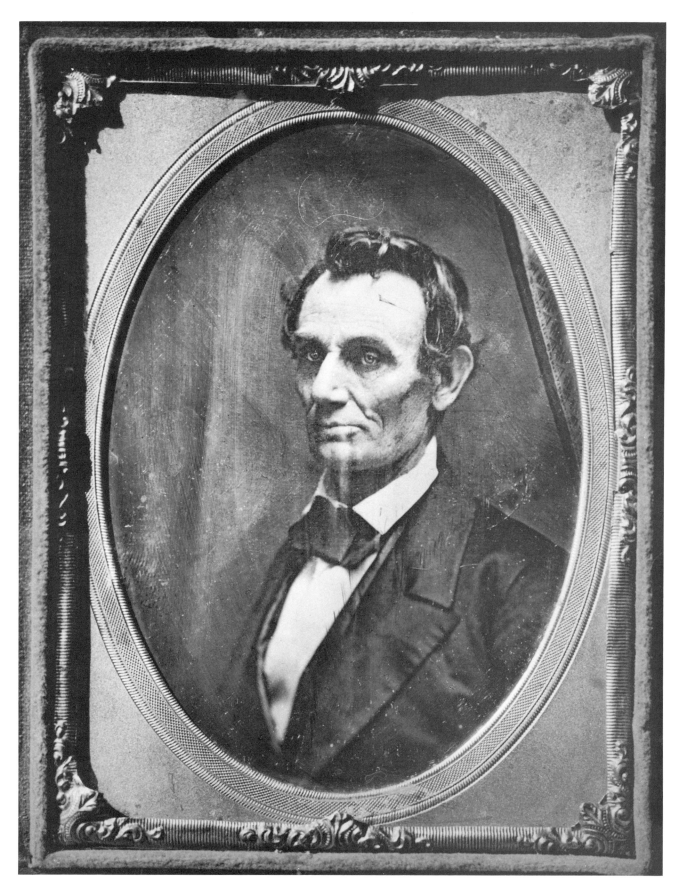

104. ABRAHAM LINCOLN.
Quarter plate daguerreotype, copy of a portion of a paper print made in 1858. Daguerreotypist not known. Collection America Hurrah Antiques, New York.

PART III

A Technique and a Craft

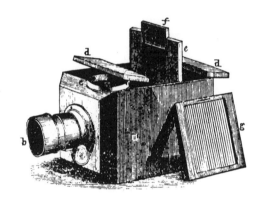

14. *The American Process*

DAGUERRE'S technique was so greatly modified by Americans that within a decade European daguerreotypists advertised that they worked "The American Process." At first daguerreotypists jealously guarded their trade secrets. John H. Fitzgibbon, who was a student in 1841, recollected that every operator had a "secret process—the gilding, the bromide, the quick, the galvanizing, the magic buff, the crayon, the coloring . . . all of which we poor *beginners* had to pay for to keep up with the times and produce as good work as our brother artists."[1]

Soon manuals began to appear. In 1849 Humphrey, Snelling, and Hill brought out standard works which went into several editions and were followed by other treatises. (See Bibliography, p. 169.) From them, and from *Humphrey's Journal* and the *Photographic Art-Journal,* we can reconstruct in detail every step of the process.

CAMERAS AND LENSES

The equipment required to set up a permanent gallery represented a fair amount of capital. Snelling, in his *A Guide to the Whole Art of Photography* (1858), printed a list of everything needed, down to the carpet, furniture, and window shades: the inventory totaled $453.82. The most expensive item was the lens—or "tube," as it was familiarly called—at $75. Snelling recommended either Harrison's or Holmes, Booth and Hayden's. He might well have recommended the Voigtländer lens, which the Langenheims imported.

Snelling itemizes "Improved rose wood camera box" at $18.00. He does not specify the make, but they were all similar, whether manufactured by W. and W. H. Lewis at Daguerreville, by Palmer and Longking, by Holmes, Booth and Hayden, or by E. and H. T. Anthony. A pioneer daguerreotypist, James F. Ryder, had fond recollections of this type of camera.

> I can see its rosewood veneer, the edges at front and back chamfered to an Angle of forty-five degrees; its sliding inside box, with the focusing glass which was drawn up and out of the top through open doors and the plateholder was

115

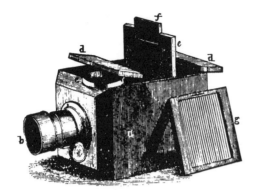

A CAMERA

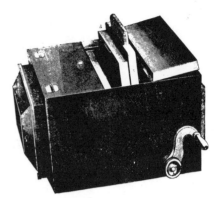

ALLEN'S CAMERA BOX

A UNION CAMERA STAND

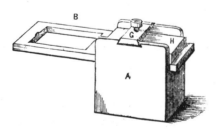

A COATING BOX

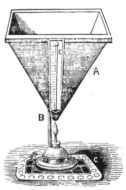

A MERCURY BATH

slid down into its place. These doors were hinged to open one toward the front and the other toward the back, each having a little knob of turned bone by which to lift it, and there were two little inset knobs of the same material turned into the top of the box upon which the knobs of the door should strike, and the concussion of these bone knobs more than fifty years ago is remembered today as plainly as though I had been hearing them every day from then until now; while the odor of iodine from the coated plates in that dear old box lingers with me like a dream.[2]

In 1851 W. and W. H. Lewis brought out their newly patented camera embodying two improvements. It was fitted with a bellows "making it very compact, which is a very essential requisite, particularly for packing in transit or for traveling operators."[3] This is, to our knowledge, the first use of the bellows for a photographic camera; it soon became a universal feature of camera design. It was not, however, this improvement which the Lewis brothers sought to protect by patent. They fitted a sliding panel on the back of the camera, on one end of which was a ground glass for focusing and on the other the plate holder.

U. S. Patent 8,513, November 11, 1851. The advantages of this mode of constructing cameras over the old and usual methods are that in cameras that open at the top the light from the skylight particularly is apt to enter the joint of the lid, that allows the glass to be removed and the plate to be put in; but in ours the top of the camera is perfectly tight. . . . In the old cameras the ground glass had to be withdrawn and then the plate and frame put in, which occupied much more time than in our arrangement, in which by merely sliding the frame across the camera the ground glass is removed at the same time the daguerreotype-type plate is put into place, and the speed with which daguerreotypes are taken is a great object, particularly with children, as they as well as others are apt to move if too much time is employed, thereby spoiling the picture.

The "tripod camera stand" listed by Snelling at $3.20 was wooden: three turned legs screwed into an iron collar through which passed an upright wooden shaft that could be fastened at any height by a set screw. Cast-iron camera stands were also popular in the 1850's.

PLATES

The budding daguerreotypist was advised by Snelling to budget $20 for "an assortment of plates." They were made by silversmiths, who brazed a sheet of

117

pure silver to a block of copper and ran the composite block again and again between rollers until it was a sheet approximately .02-inch thick. They cut it up into standard sizes:

Whole plate, or 4/4	6½ by 8½ inches
Half plate	4¼ by 5½ inches
Quarter plate	3¼ by 4¼ inches
Sixth, or medium plate	2¾ by 3¼ inches
Ninth plate	2 by 2½ inches
Sixteenth plate	1⅜ by 1⅝ inches

The fractions of the standard whole plate were approximate, for the pieces were trimmed to preserve more or less the proportion of 1:1.3. One ingenious Yankee found a way to cut ten ninths from a whole.

Oversize plates were occasionally used. These "mammoth" plates, sometimes called double or 8/4, were not made in standard sizes. Southworth & Hawes boasted that their 13½ by 16½-inch daguerreotype of Hiram Power's popular sculpture, "The Greek Slave," had "nearly 100 more square inches than any plate shown outside of our rooms."[4] But, if we are to believe the statement that Gouraud showed, in Boston in 1840, plates of 480 square inches, made by Daguerre, their boast was idle.[5]

American daguerreotypists preferred French plates. Like all silverware, each French plate was stamped on the edge with official government hallmarks. Usually there were three: (1) a star; (2) a number denoting the proportion of silver to copper (thus *40* indicated that 1/40 of the thickness was silver and 39/40 copper); and (3) a design, varying with the individual maker but always enclosed in a rectangle often incorporating the word *doublé* (plated). The practice of stamping plates with names or initials was adopted by American platemakers, although it was not required by law. In a few instances enough is known about the American makers to establish the date when certain brands of plates were introduced, and this evidence is of value in the dating of finished daguerreotypes that bear these hallmarks. The largest manufacturer was the firm of J. M. L. and W. H. Scovill, of Waterbury, Connecticut, and New York City. Joseph Pennell, who left Southworth to work with Scovill, wrote his former partner in 1848 that they were "getting out 1000 plates per day all winter thus far and there is prospect of a hard year's work ahead in this line of business."[6]

1

Anthony

2

3

A.B. & P.

4

L.B. BINSSE & Cº N.Y.

5

L B B & Cº

6

CORDUAN & Cº N.Y.

7

B.F. 40

8

H B H

9

JONES & CO.

10

PEMBERTON & CO.
CONN.

11

SCOVILLS

12

SCOVILLS Nº2

13

SCOVILL MFG. CO.
EXTRA

14

FINEST QUALITY Nº1 E WHITE MAKER N.Y.

1, 2 Anthony, Clark and Company, New York. In business, 1846-51.

3 A. Beckers and V. Piard, New York. In business, 1851-55.

4, 5 L. B. Binsse and Company. Used by C. G. Page, 1843[7]; advertised price list of P. N. Horseley, New York, 1847.

6 Joseph Corduan, New York, Advertised, N.Y. *Observer,* Feb. 29, 1840; won diploma for plates, American Institute, 1843.

7 Benjamin French, Boston. Began to deal in daguerreotype materials, 1848.

8 Holmes, Booth and Hayden, New York.

9 Jones and Co., New York.

10 Pemberton and Co., Connecticut.

11-13 J. M. L. and W. H. Scovill; Scovill Manufacturing Co., Waterbury, Conn. Began manufacture of plates, 1842; name changed to Scovill Manufacturing Co., 1850.

14 Edward White. Began manufacture, 1844.[8]

Plates at first were expensive. Dr. Samuel Bemis paid Gouraud $2.00 apiece for whole plates in 1840, and Plumbe charged 67½ cents for a single quarter plate in 1841. By 1850, however, the price had come down and the best imported "star, phoenix or crescent" plates of the popular medium (sixth) size cost $2.00 a dozen; American plates of the same size cost $1.37½ a dozen.

The plates were seldom used just as they came from the stockhouse, for daguerreotypists liked to add more silver to them by electroplating them or, as they called the process, "galvanizing," a technique invented at the same time as the daguerreotype process itself. This method of plating one metal upon another by electric action was described by Daniel Davis, Jr., in his *Manual of Magnetism,* the first American book on electricity, published in Boston in 1842. The article to be plated is attached to a wire and suspended at one end of a tank filled with potassium cyanide solution; a block of the other metal, attached to a second wire, is suspended at the other end of the tank. When both wires are connected to the terminals of a wet battery, molecules of metal are transferred by electrolytic action from the block to the article. In the second edition of his *Manual* (1847), Davis specifically described silver plating daguerreotype plates.

Galvanizing soon became standard practice. "I would as soon think of making hay without sunshine as daguerreotypes without galvanized plates," declared D. D. T. Davie in 1853.[9] A wet battery was a part of the kit of every first-rate operator; Snelling included one at $3.00 in his inventory, plus "1 plate of silver for galvanic battery" at $8.00.

Warren Thompson of Philadelphia introduced galvanizing to France as a part of "le procédé américain," and the firm of Christofle began to manufacture in 1851 their "scale" plates, so-called because of the hallmark, a pair of scales, the government symbol for electroplated wear. Their product was endorsed by Thompson in a letter dated March 20, 1851, which Christofle reprinted in an advertisement in the French professional photographers' magazine, *La Lumière.* We translate: "It is well known by almost all experienced operators that silver deposited by the galvanic process is highly favorable for daguerreotypes, the whites being much less liable to solarize* and the darks more transparent and more per-

*"Se solidariser" in the original; probably a typographical error for "se solariser," or "to solarize"—a technical term for the reversal of tones on overexposure, to which daguerreotypes were prone.

120

fect in their details. Almost all the best operators in America for the past five years have galvanized their plates themselves. I did the same until I began to use yours which, I find, allow me to dispense with this process that has given me so much bother. . . ."

BUFFING

Immediately before use each plate, whether galvanized or not, had to be polished to a brilliant, mirror-like finish. To hold the plate while he polished it, the daguerreotypist first turned over the edges with a plate bender ($2.00) just enough so that the plate could be gripped by the plate block ($4.50), two wooden blocks which expanded by springs or a screw. He then fastened the plate block in the plate vise ($2.50).

The daguerreotypist now began the long, tedious operation of buffing. He sprinkled the plate with rottenstone (56 cents per bottle) or pumice, and polished it with a buff stick (three for 38 cents) covered with buckskin ($2.00). The buff was a swordlike wooden blade, upward of two feet long exclusive of its wooden handle. He polished with slow, deliberate strokes, always parallel to one of the edges, alternating from the shorter to the longer dimension. If the buff became clogged with the abrasive, he cleaned it with a buff brush (25 cents). Some daguerreotypists heated the buffs in a can on the stove until they were almost charred. After the plate seemed well polished, the daguerreotypist picked up a second buff, identical to the first but covered with canton flannel (four yards, 75 cents) or perhaps silk, and with the finest of jeweler's rouge (25 cents per ounce) finished the polishing. By now the plate had no longer a silver appearance, but seemed black. The daguerreotypist took care to give the final strokes in a direction parallel to the bottom of the finished daguerreotype—that is, crosswise for the usual vertical portrait, lengthwise for a group or landscape. This was done so that the tiny scratches, which even the most skillful buffing could not eliminate, would be parallel to the viewing light, and would cast no shadows.

There were tricks of the trade. Some daguerreotypists claimed that lampblack was better than rouge; others made their own abrasive by calcining flour in homemade crucibles. There were those who put tallow on their buffs, "not quite enough to grease a griddle."[10] Hill in his pamphlet, *The Magic Buff,* instructed the daguerreotypist to spread on the buff leather a mixture of silver oxide and spermaceti, suet or lard.

121

Yankee ingenuity soon led to the construction of machines to lighten the labor of buffing. Alexander Beckers claimed to have made the first of these buff wheels when he was with the Langenheims in 1843. "It was constructed like an ordinary grindstone," he recollected, "the wheel being cushioned and covered with buckskin."[11] To make a seamless leather covering, daguerreotypists sometimes cut a strip right around the carcass of a calf, had this endless strip tanned, and then built a wheel to fit it. In Boston, John Adams Whipple ran his buff wheel with his steam engine; elsewhere foot power was the rule.

COATING

Once buffed, the plate was made light sensitive. Nothing like total darkness was required; "a hiding place," Beckers said, was all that was necessary. Humphrey told his readers to build a framework in the corner of a room and cover it with dark muslin; it should have a window in it covered with white paper. Two specially constructed pieces of apparatus were now needed, called "coating boxes" ($11 the pair), identical except that one was not the height of the other. Each was a wooden box containing a blue-green, hand-blown glass jar. The cover was a piece of ground glass fitted to the underside of one end of a board; a recessed opening at the other end held the daguerreotype plate. The taller of the two coating boxes contained a small amount of iodine crystals (75 cents per ounce); the shorter, a mysterious substance called "quickstuff," "the quick," or "dry sensitive" (50 cents the bottle), the exact formula of which was each daguerreotypist's secret, but which always contained bromine and chlorine compounds. In 1839 John Frederick Goddard, who was working Wolcott's camera in London, discovered that by subjecting the plate to other haloids as well as iodine, its sensitivity was increased.[12] His improvement in the process marked a turning point in the technique, for exposures were reduced radically.

> *G. W. Prosch to A. S. Southworth, March 30, 1841.* Last Saturday I tried Bromine with the Iodine and was able to take pictures in an ordinary room with diffused light in 25 seconds, without the Bromine it required 4 minutes.[13]

The plates were put into position over these chemicals simply by sliding the lid. They changed color over the iodine: yellow, then orange, red, violet, blue, green, and again yellow. Humphrey recommended that the plate be left over the iodine from fifteen to sixty seconds until it was orange-yellow, then over quick-

122

stuff to a deep rose; then back again over the iodine for one tenth of the time of the first coating.

The stench of a daguerreotype workroom was overpowering. Iodine, bromine, and chlorine compounds at normal room temperature continually release vapors and still today, more than a hundred years later, coating boxes give forth a marked odor. Daguerreotypists tried to make their boxes airtight, and tested them by dropping pieces of burning paper inside. If smoke came out when the lid was closed, the coating box was unsatisfactory. Humphrey advised a correspondent who complained of the strong odor of bromine in his rooms to "sprinkle freely about the floor acqua ammonia."[14]

On cold days coating was impossible without specially warming the equipment. A friend wrote Southworth that Martin M. Lawrence couldn't take his portrait on the day he called at the Broadway daguerreotypist's gallery because "his stove was down and the temperature of his room was below 70°, and he could not operate at a temperature less than this."[15] Alexander Beckers complained that his employer, Edward White, would not allow a fire in his gallery overnight, and consequently it became impossible to take pictures during the winter. There were other despairs. Turpentine fumes were certain to interfere with coating, and it was impossible to work in a freshly painted room, or even in a building where house painting was going on in other rooms. One luckless daguerreotypist had just started business when a hatter moved next door; the dust which flew about when the furs were whipped into felt "caused such a commotion among the operator's chemicals, and covered everything about his room so completely, that he was unable to get a picture at all, and was obliged to abandon his premises."[16]

The daguerreotypist put the now sensitized plate into a "plate holder" or "plate shield"—a wooden frame with a removable back held in place by a wooden button, and sliding panel on front. Its purpose was to protect the plate from light while it was not in the camera. It fitted inside the camera in place of the ground-glass focusing panel. The slide was pulled out, and then the exposure made by uncapping the lens.

EXPOSURE

Only experience taught the daguerreotypist how long to expose his plates. There were three variables to be taken into account: the strength of the light, the

123

light-passing power of the lens, and the sensitivity of the plate. The first two could be measured; as early as 1839 light meters of the actinometer type were in use: the time taken by sensitive material to darken to a standard tint was used as a measure of the intensity of the illumination. There is no evidence, however, that American daguerreotypists ever resorted to exposure meters. Lenses were not fitted with adjustable diaphragms. The sensitivity of the plate varied enormously. It was hardly possible to duplicate results, even though attempts were made to standardize coating techniques. Daguerreotypists noticed that the relative humidity of the air affected sensitivity. Before a thunderstorm the plates were especially "fast," and it was suggested that electricity played a part in the phenomenon. Experiments were made in passing an electric current through the plate while exposing.

In the early days, exposures were measured in minutes. D. W. Seager published an exposure table in the appendix to a reprint of Daguerre's manual which appeared in the *American Repertory of Arts, Sciences and Manufactures* for March, 1840. The shortest exposure is five minutes and the longest is seventy minutes. This corresponds almost exactly to an exposure table published in France by Daguerre's assistant, Hubert, as an appendix to Macedoine Melloni's *Rapport sur le Daguerréotype* (Paris, 1840).

With the introduction of Voigtländer's large-aperture lenses and quickstuff, exposures were reduced to seconds. The average sitting required from twenty to forty seconds, to judge from the few records which have survived:

Date	Daguerreotypist	Exposure time
Mar. 20, 1841	George W. Prosch	25 sec.
Aug. 26, 1841	Elias Howe	20-30 sec.
Jan. 24, 1843	Charles G. Page	25-40 sec.
Mar. 29, 1843	Henry Moore	30 sec.
Feb. 11, 1844	E. H. Baker	30-45 sec.
Mar. 6, 1846	J. E. Mayall	3-9 sec.

Children were always a problem, for they would not sit still. E. T. Whitney, of Rochester, New York, found a way to trick them into periods of immobility long enough to allow an exposure of sorts to be made. "I use, with good success," he wrote in 1855, "a little toy bird, that I make sing inside the camera, occasionally showing a part of it to attract attention to the instrument."[17]

124

Outdoors, snapshots were occasionally obtained. Alexander Hesler of Galena, Illinois, set up his camera on the deck of the steamboat *Nominee* in 1851 and photographed the river landings on the Mississippi from Galena to St. Paul, to be used as illustrations for a guidebook. He claimed that he gave instantaneous exposures with a shutter driven by a rubber band. Years later he exposed his secret: the plates were coated two or three weeks before use. "The longer they were kept, the more rapid they became," he wrote, and added that they "could be exposed and developed at any future time."[18]

MERCURIALIZING

It was not the usual practice, however, to postpone the processing of the exposed plate, and most daguerreotypists developed them at once. The process was called "mercurializing." The mercury bath ($2.50) was an inverted, truncated hollow pyramid of cast iron, supported on an iron stand over an alcohol or spirit lamp (two for 62 cents). Along the side of the bath was the scale of a thermometer, the bulb of which lay inside the pot where a quarter pound of mercury (94 cents) had been poured. On coming to work in the morning, the daguerreotypist lit the alcohol lamp so that the mercury would vaporize; it was kept hot all day at a temperature between 70° and 80° C. (158° to 176° F.). This custom of quoting in the centigrade rather than the Fahrenheit system caused confusion. "You told me the mercury should not rise above 70°," a student wrote to Southworth in 1844, and asked, "But if the atmosphere was warmer than that—what is to be done? Would it require the lamp at all?"[19] When the plate was put face down over the mercury, the vapors formed an amalgam on it in proportion to the amount of light received by it in the camera. Development ranged from two to four minutes; George Barnard noted that his daguerreotype "Woodsawyers' Nooning" (Plate 20) was over the mercury two minutes. Humphrey furnished a table of effects produced by mercurializing:[20]

Time Mins.	Effect
½	Deep blue.
1	Ashy and flat—no shadows, linen deep blue.
1½	Coarse and spongy—shadows muddy—drapery dirty reddish brown.
2¼	Soft—face scarcely white, shadows neutral, drapery fine dark brown, linen somewhat blue.

125

Time Mins.	Effect
2½	Clear and pearly, shadows clear and positive, of a purple tint, drapery jet black, with the dark shade slightly frosted by the mercury.
2¾ to 3	Hard and chalky—shadows harsh, drapery roughened and misty with excess of mercury.

The average daguerreotypist's rooms were poorly ventilated, and the air was so charged with mercury vapor that gold watch chains became coated with amalgam. Humphrey, concerned over the health of his readers, tested the purity of the atmosphere in his own workroom by hanging a piece of gold foil "four feet above, and two from the perpendicular, at the side of the bath; and in two days the leaf began to turn slightly white, and at the expiration of the fifth day it was so alloyed as to cause the amalgam to drop."[21] He was much concerned, for he reported that his friend Jeremiah Gurney "has been confined to his bed by his system being charged with *mercury*—he has suffered the most acute pain, and been unable to move his limbs; his legs and arms have been swollen to nearly double the ordinary size, and his situation has been of the most perilous nature. We have known several instances of effects produced by mercury, but never to such an extent. No operator can observe too much caution in being exposed to the vapors of this metal."[22] L. L. Hill urged his readers "to ventilate your mercury—its fume is loaded with rheumatism, sciatica, lumbago, toothache, neuralgia and decrepitude."[23] Everything used in processing was toxic; the vapors of mercury, the gasses of chlorine, iodine, bromine, solutions of potassium cyanide. Some died; it is a wonder that more did not.

FIXING AND GILDING

The plate was finished by washing it with a 10 per cent solution of sodium thiosulphate (then called "hyposulphite of soda"—50 cents a pound) which removed the unexposed coating of silver halide. The plate was not immersed, but the solution was poured over it while it was held over an alcohol lamp with a pair of pliers (50 cents). Humphrey gives explicit directions:

First, light your spirit lamp, then, with your pliers take the plate by the lower right hand corner, holding it in such a manner that the pliers will form in a line with the upper left hand corner; pour on, slowly, the hyposulphite solu-

126

tion, slightly agitating the plate, until all the coating is dissolved off, then rinse off with clean water.[24]

By the same manipulation, the plate was washed with a 1.25 per cent solution of gold chloride (42 cents per bottle) mixed with a 2 per cent solution of sodium thiosulphate. "Gilding," as this gold-toning technique was called, was invented by the Frenchman Hippolyte-Louis Fizeau in 1840; it was the first significant improvement on Daguerre's original process, and was at once universally adopted. It increased the brilliance of the image. Fizeau explained that "silver has been dissolved, and gold has been precipitated upon the silver, and also upon the mercury; but with very different results. The silver, which by its polish, forms the dark parts of the picture, is in some degree browned by the thin coating of gold which covers it, whence results an increased intensity in the black parts; the mercury, on the contrary, which, under the form of infinitely small globules, forms the whites, increases in strength and brilliancy, by its amalgamation with gold, whence results a greater degree of fixity, and a remarkable augmentation in the light parts of the image."[25] Humphrey notes that at first the plate became cloudy when treated with the gilding solution. "This is generally the best sign that the gilding will bring out the impression with the greatest degree of distinctness," he wrote. "Soon the clouds gradually begin to disappear, and 'like a thing of life' stands forth the image, clothed with the brilliancy and clearness that the combined efforts of nature and art can produce."[26]

All that was now required of the daguerreotypist was to rinse the plate in water, dry it over the alcohol lamp, put it into a case, and hand it to the customer.

CASES

The surface of a daguerreotype was so fragile—Arago, when describing Daguerre's first results, compared them to the wings of a butterfly—that immediate protection of the plate was imperative. On the Continent, daguerreotypes were framed like drawings, behind large cut-out mats of the style called by the French "passe-partout." Often the cover glass was painted white, brown, purple, or black on the underside; frequently the maker put his name in a lower corner.

In England, and particularly in America, daguerreotypes were put into cases designed for miniatures: two shallow boxes hinged on one side, with a fastening on the other.

The standardization and mass-production techniques which characterized the American daguerreotype process were highly developed in the manufacture of cases. They were sold to the daguerreotypists by stockhouses along with plates and chemicals; the price a sitter paid for his likeness varied according to the case which he chose. Most daguerreotypists kept a large variety on hand. Some had their names stamped on the lining of the cover. While it is tempting to consider the presence of a gallery name and address as documentation of the maker, it must be remembered that the cases throughout the daguerreotype period were interchangeable; a sixth-plate daguerreotype can readily be fitted into *any* sixth-plate case with no more trouble than putting a book into a slip case. Over the years families and collectors have put treasured daguerreotypes in better cases than the original ones. Thus the design of a case can only help in the attribution and dating of a daguerreotype; it cannot determine it.

Leather miniature cases were more expensive than daguerreotypes: Southworth paid the Boston case maker J. H. Smith $17 for one of goatskin in 1845. They were replaced by imitations, made of paper, pressed in dies to resemble tooling. Among the earliest manufacturers was William Shew, the Boston daguerreotypist. His cases often have a delicate design of roses. Frank Roy Fraprie, for years editor of *American Photography* and an ardent collector of daguerreotype cases, found twenty-six different designs of the rose case. He put forth the ingenious hypothesis that the number of leaves on the lower branches secretly indicated the date that the case was made: one lower branch invariably showed four, indicating the decade; the number of leaves on the opposite branch indicated the year in the decade. Other, identical cases bear the label of H. Studley, Boston.

Brady designed a case with a harp while he was a case manufacturer; it is one of the few paper cases which are signed. This may well be the pattern which Southworth's pupil L. C. Champney bought at $5.00 per dozen in 1843.

At first the covers were lined with padded silk; later velvet was used. The date of the change in style can be judged by correspondence of Southworth with a pupil:

> *Henry Moore to A. S. Southworth, April 1, 1843.* I enclose five dollars and should like to have you send me a dozen plates and a doz. cases—8 cases the size of the one you sent and 4 smaller. I like those that are lined with silk velvet better than those lined with silk.[27]

Southworth to Moore, not dated. We have no velvet lined cases now. We have Satin of different colors—Blue—and Purple or Claret. You shall have them at $5.00 per doz.[28]

On April 14 Moore returned Southworth's letter endorsed, "Please send a doz. cases lined with purple and claret—half each." Southworth's customers found that designs with roses and harps sold best.

Before they were put into these cases the daguerreotypes were bound up with a gilded mat, or border. At first the material was paper, then gilded brass was substituted. The rectangular opening gave way to fancy shapes:

J. M. L. and W. H. Scovill to A. S. Southworth, October 30, 1843. After about two weeks we shall have Fig[d] Border Oval & Octagon & Acorn &c., &c.[29]

Snelling illustrated in his *Dictionary of the Photographic Art* four types of mats: the "elliptic" (curved top), "double elliptic" (rounded corners top and bottom), the "oval," and the "non-pareil" of rococo ornateness. He recommended the double elliptic and the oval.

The daguerreotype, border, and glass were bound together with goldbeater's skin or gummed paper. Often the sandwich was surrounded by the "preserver," a thin frame of highly malleable oroide brass. The unit was simply pushed into the bottom of the case, which had velvet sides to make a snug fit.

About 1853 an entirely new style of daguerreotype case was introduced, made of plastic. It was called the "Union case." The earliest reference to it in the professional press is Humphrey's description of Mascher's stereoscopic viewer in the June 15, 1853, issue of his *Journal*. Referring to a wood engraving, he wrote, "The view is perspective, and exhibits the attachment to a Union Daguerreotype case."

These molded cases were produced in a great variety of designs. A check list, which is by no means complete, of the various designs is given in K. M. McClintock's *Handbook of Popular Antiques* (1946): 110 are described. These are the cases commonly referred to as hard rubber or gutta-percha. They are nothing of the sort, but are true thermoplastic products. Samuel Peck, who invented a way of strengthening them by pressing gilded paper against the composition, described the plastic in the specification for his U.S. Patent 11,758, granted October 3, 1854: "The composition of which the main body of the case is made, and

to which my invention is applicable, is composed of gum shellac and woody fibers or other suitable fibrous material dyed to the color that may be required and ground with shellac between hot rollers so as to be converted into a mass which when heated becomes plastic so that it can be pressed into a mold or between dies and made to take the form that may be imparted to it by such dies." Peck made no claim to the invention of the composition, or to its use to form daguerreotype cases.

Just twenty-seven days after Peck had received his patent, his brother-in-law Halvor Halvorson filed another patent *identical* to Peck's which he assigned to one Horace Barnes. The specifications of the Halvorson patent (No. 13,410, granted August 7, 1855) repeat those of Peck's verbatim, except that Peck's "nonporous" has become, incorrectly, "porous," and his "combined" is written "confined," which is meaningless in the context. It would appear that Halvorson literally copied out Peck's words. Why this duplication? There was no competition, for there is no record that Halvorson manufactured cases. Were the brothers-in-law trying out the validity of the patent? Did they feel that a second patent made assurance doubly sure? We know from the label pasted in a number of Union cases that the patents were merged, and that the unknown Mr. Barnes dropped out:

GENUINE UNION CASE
Improved

————

Fine Gilt and Burnish-
ed Hinge.

————

S. PECK'S PATENT,
Oct. 3d, 1854

————

H. HALVORSON'S PATENT,
Aug. 7th, 1855,
Assigned to S. Peck.

In 1856 Peck filed another patent (No. 14,202): "Fastening for the Hinges of Daguerreotype Cases." Again he takes for granted the plastic composition. The

specifications read: "Daguerreotype and other similar cases are now largely manu-
factured of a plastic material the base of which is gum shellac." What Peck sought
to protect was a means of imbedding brass strips in the plastic, to which hinges
could be fastened. "Hitherto the hinges have been fastened by rivets through the
material . . . nearly thirty percent of the cases were spoiled by breaking them in
rivetting on the hinges."

Samuel Peck was a typical Yankee Jack-of-all-trades—carpenter, storekeeper,
grocer, theater owner, undertaker, daguerreotypist. In 1850 he patented a device
to hold daguerreotype plates while polishing them. And in the same year he be-
gan the manufacture of daguerreotype cases. He formed the firm of Samuel Peck
& Co. in 1855. Five years later he withdrew and the assets of the company were
sold to Scovill and Co., the photographic stockhouse.

The third to patent an improvement on plastic daguerreotype cases was
Alfred P. Critchlow, who began to make cases in 1852 in Florence, Massachusetts.
He was granted U. S. Patent 15,915 on October 14, 1856 (re-issued April 21,
1857), for "embracing rivetted hinges." Instead of fastening the hinges to the
sides or walls of the case, he fastened them to the top and bottom.

Critchlow formed a partnership with Samuel L. Hill and Isaac Parsons in
1853; in 1857 David G. Littlefield joined the firm. The company claimed the
plastic case as its invention. A case in the writer's collection bears the label:

<div align="center">

A. P. CRITCHLOW & CO.

Manufacturers of

Daguerreotype Cases

A. P. C. & Co.

Are the **Original Inventors** of the
Composition for the **Union Case** (so
called,) including all the various
shades of color and fineness of tex-
ture peculiar to their manufacture
and of the **Embracing Rivited Hinges**,
thus securing them from breaking out
as do others that are inserted with
or without a metal brace.

</div>

131

But in his patent Critchlow made no such claim, for he wrote: "the kind of daguerreotype or picture case for which I have particularly devised my improvement is that which is common and well known as being made of composition."

Critchlow left the company in 1858; the firm name Littlefield, Parsons & Co. was then adopted. The name of the firm was again changed to Florence Manufacturing Company and, more recently, the Pro-Phy-Lac-Tic Brush Company. The original die of the proudest of the company's productions, an 8-by-10-inch case for whole-plate daguerreotypes bearing a bas-relief from the painting "Washington Crossing the Delaware" by Emmanuel Leutze, is still owned by the Pro-Phy-Lac-Tic Brush Company. A brilliant impression of it was made with modern thermoplastic material for the George Eastman House collection.

The dies for this case were cut by F. B. Smith and Hartmann, New York. They also cut for Peck a whole-plate case from the painting "The Landing of Columbus" by John Vanderlyn in the rotunda of the Capitol, Washington, D.C. Raphael's "Madonna of the Chair" served as model for Henning and Eymann. Perhaps the finest of all Union cases is the utterly simple transcription into bas-relief of Sir Thomas Lawrence's "The Calmady Children," a painting now in the Metropolitan Museum of Art. It is the only die signed by H. W. Hayden. Four cases are signed "Goll," probably Frederick Goll, listed in the New York City directory for 1853-54 as die-sinker: the designs show the Washington Monument in Richmond, Virginia, a medallion of George Washington, a horse race, and a copy of the painting by Asher B. Durand, "The Capture of Major André." Other less impressive cases are signed "A. Schaefer" and "J. Smith."

Some of the finest cases are unsigned; many, such as "American Country Life; Summer's Evening" from the Currier and Ives lithograph by F. F. Palmer of 1855, exist in several variants. For each variation a separate set of dies must have been made; the investment in the case industry must have been substantial.

Besides those of Peck, Critchlow, Littlefield, Parsons & Co., and the Florence Manufacturing Co., other labels are found inside Union cases: Holmes, Booth & Hayden; Scovill Manufacturing Co.; Wadhams Manuf'g Co. (Kinsley & Parker's Hinge, Patented June 1, 1858). The products of these firms are indistinguishable.

Modern experts marvel at the quality of these pioneer plastic products. Sig-

132

nificantly, the largest collection of them is in the possession of the Waterbury Companies, one of the leading plastic manufacturers of the country.

Papier-mâché cases, inlaid with mother-of-pearl, and handsomely painted with landscapes or flowers, were also popular, and a great variety of lockets, brooches, and other jewelry was designed to hold small daguerreotypes cut into oval or circular shapes.

RESTORATION

Like all objects made of silver, daguerreotypes tarnish. They cannot be cleaned by friction, for the image would then be rubbed off. Daguerreotypists knew how to clean even those which were completely hidden beneath tarnish. Abraham Bogardus told the Society of Amateur Photographers in 1889:

"Only a few years ago a lady came to me with a half-sized picture, and you could not see anything at all upon it. She wanted to know if I could clean it. . . . In about five minutes I brought it to her . . . she fainted dead away. . . . It was her husband who had been dead twenty years, and she had not seen the picture in fifteen years. It was so completely covered with a film that there was nothing to be seen, and I brought it up as good as it was originally. As I say, the lady fainted immediately. It was just as if her husband had been brought back from the grave for her to see."[30]

Daguerreotypists cleaned the plate by washing it with a solution of potassium cyanide. For years this deadly poison was the only known solvent for the tarnish. It is not a chemical to be used by the layman. A grain of it will kill a man if taken internally.

Fortunately a nontoxic technique has been recently discovered by Mrs. Ruth K. Field, assistant curator of the Missouri Historical Society, St. Louis.

Remove the daguerreotype from the case, unframe it, and wash it in distilled water to remove surface dirt. Drain and immerse, until the discoloration is washed away, in the following solution:

Distilled water . 500 cubic centimeters
Thiourea . 70 grams
Phosphoric acid (85%) . 80 cc.
Non-ionic wetting agent
 (e.g. Kodak "Photo-Flo" Solution) 2 cc.
Distilled water to make . 1000 cc.

133

Remove plate from bath and rinse under running water. Place in a mild solution of ordinary soap and water and agitate briefly. Rinse again with tap water, then distilled water. Immerse in 95% grain alcohol; drain; dry over alcohol lamp.

Provided it does not suffer physical damage, no photograph is more permanent than a daguerreotype. The image will bear the action of light, for the light-sensitive salts were completely removed in processing. Heat, however, must be avoided, for it will drive out the mercury which, in amalgam with the silver, forms the highlights. For this reason, daguerreotypes should not be exposed to sunlight or kept near radiators or hot electric bulbs.

COPYING DAGUERREOTYPES

The successful copying of daguerreotypes with modern photographic materials depends upon properly illuminating them, and shielding the camera to eliminate reflection. Daguerreotypists built velvet-lined boxes, one end open, the other closed, with two slits on each side to admit light. The daguerreotype was laid against the closed end. The lens of the camera was put inside the open end.

We have found that excellent results are obtained simply by shielding the camera during exposure with a three-foot square of black velveteen, with a hole in its center the diameter of the lens, suspended in front of the camera from a stand for photographic lamps to which a cross bar is fixed by a laboratory clamp. An ordinary lens hood painted black is slipped through the hole in the velvet and over the lens mount.

Camera equipment is optional. We use a 4-by-5-inch view camera of ancient vintage, medium-speed panchromatic film, and a 6-inch Goerz Dagor lens, usually set at $f/22$.

The majority of the copies in this book were made by daylight, since photographing was done in private homes and museum galleries. When copying, it is essential to orient the daguerreotype in the position in which it was intended to be viewed. This is because, in the buffing, daguerreotypists always finished with strokes horizontal to the dimension of the plate which was to be the bottom of the final picture. Vertical scratches, under normal illumination, are more conspicuous than horizontal ones.

The density scale of a daguerreotype is approximately that of conventional

134

modern developing-out paper. The densities of a typical Southworth & Hawes portrait measured

$$D \text{ min } = 0.36$$
$$D \text{ max } = 1.70$$

Thus the density scale of this sample is 1.34.

Pragmatically, it has been found that the best results are secured with a development 50 per cent beyond normal.

We calculate exposure with a standard gray card as used in color photography placed in the position of the daguerreotype, from which we take a reading with a photo-electric exposure meter. Due allowance must be made, of course, for bellows extension.

A portable copying stand made of elements from a discarded view camera has proved most convenient for traveling. The double-extension bed is clamped onto the end of the copying camera bed. The rising front of the discarded view camera was converted to an easel, fitted with two ledges between which a daguerreotype in its case can be held. Grooves in the ledges enable us to hold a naked daguerreotype plate. It is strongly urged that, whenever possible, the daguerreotype be removed from its case and cover glass.

Experiments were made with polarizing the incident light and photographing through a polarized filter. No practical advantage was gained. A technique described by Truso Leslie in *Photo Era*, XXIV (1910), 250, was also tried with little success. Leslie recommends using a white, rather than a black, shield over the camera to secure a positive image on the film. He states that more evenly lighted and brilliant results are thus obtained. Our experiments did not bear out this claim.

Excellent results have been obtained by the use of color film, not only for tinted originals, but for monochromatic daguerreotypes: the characteristic deep-brown tint of a well-gilded plate is beautifully reproduced on modern multi-layer reversal films.

Since daguerreotypes have no grain—a 3,000X magnification by an electron microscope reveals only a pitting of the surface—they stand enlargement excellently well, particularly when thrown on a screen by a lantern slide projector.

135

The photographic quality of a well-made daguerreotype is beyond compare. We cannot imagine that they ever were more brilliant, more detailed, more beautiful. Through them we can see the past with the eyes of the past. It is not by chance that they are endowed with this evocative power; daguerreotypists had the future in mind. Humphrey urged his readers to make each daguerreotype "worthy of preserving as a remembrance of the past. It would call to mind the men of generations gone by. For such let every ambitious Daguerreotypist strive."[31]

PART IV

Biographies and Notes

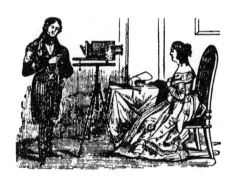

Standard abbreviations, as listed in *Webster's New Collegiate Dictionary,* are used throughout, plus the following:

AJP	*American Journal of Photography*
APB	*Anthony's Photographic Bulletin*
dag'type	daguerreotype
DAB	*Dictionary of American Biographies*
DJ	*The Daguerreian Journal*
Exh. London 1851	Exhibited at the Great Exhibition of the Works of Industry of All Nations in the Crystal Palace, London, 1851.
Exh. N. Y. C. 1853-54.	Exhibited at the Exhibition of the Industry of All Nations in the Crystal Palace, New York City, 1853-54.
GEH	George Eastman House Collection.
HJ	*Humphrey's Journal.*
PAJ	*The Photographic Art-Journal* and its continuation, *The Photographic and Fine Art Journal.*
Taft	Robert Taft, *Photography and the American Scene* (New York: The Macmillan Company, 1938; reprinted New York: Dover Publications, 1964).

Biographies

ADAMS, DAN
Active Nashville, Tenn., 1845.

ANSON, RUFUS
Active N. Y. C., 1851-67.

ANTHONY, EDWARD
Born N. Y. C., 1818. Studied civil engineering at Columbia College, N. Y. C. Taught dag'type process by S. F. B. Morse. Photographer, U. S. Govt. survey of Canadian border, 1842. Proprietor of "National Daguerreotype Miniature Gallery," N. Y. C., with Jonas M. Edwards, Howard Chilton, J. R. Clark: (Anthony, Edwards & Chilton, 1843; Anthony, Edwards & Co., 1844-45; Anthony, Clark & Co., 1846-47). Opened dag'type stockhouse, N. Y. C., 1847. Partnership with bro., 1852. Offered prize for best dag'types, 1852-53. Died N. Y. C., 1888. *Wilson's Photographic Mag.*, Jan. 5, 1889; *HJ*, IV (1852), 12-13; *Photographic Times*, XVIII (1888), 631 (portrait).

ANTHONY, HENRY T.
Born 1814. Joined bro. Edward in his photographic stockhouse, 1852. Discovered instantaneous process with wet plates, 1858; as a consequence the firm went into business making stereoscopic pictures. Died N. Y. C., 1884. *APB*, XV (1884), 52-53, 453; *Phila. Photog-*

rapher, XXI (1884), 341; *Yearbook of Photog.*, 1885; Taft, 463.

BABBITT, PLATT D.
Active Niagara Falls, 1854—c. 1870. Taft, 96.

BAKER, E. H.
Active in Providence, R. I., 1884.

BALL, JAMES P.
Active Cincinnati, 1853-59; to Europe, 1856.

BARNARD, GEORGE N.
Active in Oswego, N. Y., 1851-54? Secretary, N. Y. State Daguerreian Assoc., 1853. Purchased Clark's gallery in Syracuse, 1854. Hon. Mention, Anthony's Prize Competition, 1854. During Civil War, official photographer at Chief Engineer's Office, Division of the Mississippi, U. S. Army; documented Sherman's campaign (61 photographs, published in portfolio, 1865). *HJ*, V (1853), 190, 320; Taft, 230, 232, 486.

BARNES, C.
Active in Mobile, Ala., 1850-54.

BEALS, A. T.
Active, N. Y. C. Exh. N. Y. C. 1853-54.

139

BECKERS, ALEXANDER

Born Germany. To Phila., 1836. Learned dag'type process from Frederick Langenheim, 1842. To N. Y. C., 1843: operator for E. White, 1844. Partner of Langenheims, N. Y. C., 1848; of Victor Piard, 1849. U. S. Pat. 6,812 (block for holding dag'type plates), 1849. Sold dag'type business, 1858. U. S. Patents for cabinet stereoscope: 16,962 (1857); 23,438 (1859); 23,543 (1859); 24,855 (1859); 26,407 (1859). U. S. Pat. 23,342 (hinge for stereoscope reflectors) issued to Alen Beckers, 1859, claimed by Alexander Beckers. *St. Louis & Canadian Photographer,* XXIII (1899), 324 (portrait); Reminiscences: *British Jour. Photog.,* XXVI (1889), 510-11; *Wilson's Photographic Mag.,* XXVI (1889), 182-84; *Photographic Times,* XIX (1899), 131-32.

BEMIS, SAMUEL

Born 1789. Jeweler, dentist, amateur photographer. Learned dag'type technique from François Gouraud, 1840. Died Boston, 1881. Boston *Evening Transcript,* May 25, 1881.

BENNETT, JOHN A.

Active Mobile, Ala., 1844 and (under name Juan A. Bennett) Buenos Aires, 1845, Montevideo, 1842-43, Bogota, 1852. J. F. Riobó, *Daguerrotipos . . . en Buenos Aires* (1949).

BISBEE, A.

Active Dayton, O. Exh. N. Y. C., 1853-54.

BLACK, JAMES WALLACE

Learned dag'type process from John Lerow, Boston, 1845. Partner of J. A. Whipple, 1856-59. Took first aerial photographs in U. S. from balloon, 1860. Taft, 186. Reminiscences: *St. Louis Practical Photographer,* I (1877), 220.

BOGARDUS, ABRAHAM

Born, Dutchess Co., N. Y., 1822. To N. Y. C., 1837; dry goods clerk. Learned dag'type process from G. W. Prosch, 1846. Opened gallery, N. Y. C., 1846. First president, Natl. Photographic Assoc., 1868-74. Made dag'types of bank note designs for Amer. Bank Note Co., 1873. Gave up photog., 1887. Died Brooklyn, 1908. *Phila. Photographer,* VIII (1871), 313-15 (portrait); *St. Louis & Canadian Photographer,* XXII (1899), 324; *Photo-Miniature,* No. 72 (1905), 664-65 (portrait); Boston *Evening Transcript,* Mar. 24, 1908; Taft, 332, 416. Reminiscences: *APB,* XV (1884), 62-67; *British Jour. Photog.,* XXXVI (1884), 183-84, 200-201; *Century Mag.,* new series, XLVIII (1904), 84-91.

BRADLEY, HENRY W.

Born Wilmington, N. C. To San Francisco. Partner of W. H. Rulofson, 1863-?

BRADY, MATHEW B.

Born Warren Co., N. Y. 1822 (?). To N. Y. C. with William Page, painter, 1837. Manufacturer of jewel and dag'type cases, 1843-45. Opened dag'type gallery, 205 Broadway, 1844: James A. Brown, operator. Published *Gallery of Illustrious Americans* (12 lithographs after dag'types), 1850. Opened Washington gallery, 1847. To Europe, Jul. 1851-May 1852: George S. Cook in charge N. Y. C. gallery. Exh. London, 1851 (Prize Medal); N. Y. C., 1853-54. Opened 2nd N. Y. C. gallery, 359 Broadway, 1854; 26 employees ("artists, operators, salesmen") in 1858. Put

Alexander Gardner in charge of Washington gallery, 1856. N. Y. C. gallery moved to 785 Broadway, 1860. Organized "photographic corps," Civil War, 1861-65. Lost ownership of negatives, 1870's. Exhibited Phila. Centennial Exhibition, 1876. Died, N. Y. C., 1896. Taft, 465; J. D. Horan, *Mathew Brady* (1955); R. Meredith, *Mr. Lincoln's Camera Man* (1946); C. L. Edwards in *PAJ*, I (1851), 36-40 (portrait). Obituary: *Wilson's Photographic Mag.*, XXXIII (1896), 121-23 (portrait).

BRONK, EDWIN

Active N. Y. C. (operator for Brady); St. Louis (operator for T. C. Dobyns); Winchester, Columbus, O.

BROWN, E.

Probably active N. Y. C. Accompanied U. S. Navy expedition to the China Seas and Japan, 1852-54.

BROWN, JAMES A.

Born 1819. Active N. Y. C. (operator for Brady, 1843; own gallery, 1848-54). Exh. N. Y. C. 1853-54. U. S. Pat. 10,255 (ornamenting and embellishing dag'types), 1853. *Wilson's Photographic Mag.*, XXX (1893), 235.

BURGESS, NATHAN G.

Learned dag'type process in Paris, 1840. Active N. Y. C., 1844-59. Author: *The Ambrotype Manual* (1856), 2d ed., 1856; 3rd ed., 1857; 4th to 7th eds. (titled *The Photograph and Ambrotype Manual*), 1858, 1859, 1861; 8th ed. (titled *The Photograph Manual*), 1862. *AJP*, new series, I (1858), 10.

BUTLER, WILLIAM H.

Active N. Y. C. (operator for Plumbe; own gallery, 1847-53).

CAMPBELL, JOHN

Took dag'type of eclipse of sun, 1854. Active in Jersey City, N. J., 1860. *PAJ*, 3rd series, XI (1860), 148.

CARDEN & CO.

Active N. Y. C., 1853-54. (Carden & Norton, 1854).

CARVALHO, SOLOMON N.

Born Charleston, S. C., 1815; painter there. Took up dag'type, c. 1850. Invented technique of enameled dag'types, 1852; employed by Jeremiah Gurney, 1853. Cameraman on Frémont expedition across Rocky Mts., 1853-54. N. Y. C., 1862. Died there, 1899. Author: *Incidents of Travel and Adventure in the Far West with Col. Frémont's Last Expedition* (1860). *Natl Mag.*, II (1853), 572; *PAJ*, III (1852) 256; *HJ* IV (1853), 383; Taft, 490; A. W. Rutledge, *Trans. Amer. Philosophical Soc.*, XXXIX (1949), 164-65.

CATHAN, LUCIUS H.

Born 1817. Active Townshend, Vt., 1843-?; Boston, 1848-50; Townshend 1851-? Died c. 1890.

CHAMPNEY, L. C.

Learned dag'type process from A. S. Southworth; itinerant in Mass., Vt., 1842-44.

CHAPIN, MOSES SANFORD

Born Milford, Mass. Cabinetmaker. Active as dag'typist in Worcester, Mass., 1850-c.

141

1865. E. F. Coffin in *Worcester Hist. Soc. Publication,* new series, I (1935), 432-39.

CHILTON, HOWARD

Proprietor of "National Daguerreotype Miniature Gallery," N. Y. C., with Edward Anthony and Jonas M. Edwards, 1843.

CHILTON, JAMES R.

Born 1810. Chemist, pioneer dag'typist. Active N. Y. C. 1839-43(?). Died 1863. *AJP,* new series, VI (1863), 71.

CHURCH, EDWIN

Active St. Louis; sold gallery there to Dobyns, 1851. To N. Y. C.; operator for Lawrence; left to join Dobyns in Memphis, Tenn. *DJ,* II (1851), 338; *HJ,* V (1853), 190.

CLARK, ANSON

Born 1788. Active West Stockbridge, Mass., 1841-44. Died 1847. Hartford, Conn., *Courant,* Jan. 2, 1849; *Berkshire Whig,* Mar. 4, 1847.

CLARK, DAVID

Active New Brunswick, N. J. Exh. N. Y. C., 1853-54.

CLARK, J. M.

Member, N. Y. State Daguerreian Assoc.; on committee to investigate L. L. Hill's alleged color process, 1851.

CLARK, J. R.

Proprietor of "National Daguerreotype Miniature Gallery" with Edward Anthony, 1846-47.

COOK, GEORGE SMITH

Born Stratford, Conn., 1819. Boyhood in Newark, N. J. Traveled in South, 1838; settled in New Orleans; studied painting. Opened dag'type gallery in New Orleans, c. 1845. To Charleston, 1849. In charge of Brady's N. Y. C. gallery while Brady was in Europe, 1851-52. Returned to Charleston. Photographed Civil War from Confederate front. N. Y. C., 1874-75. To Richmond, Va., 1880. Died Bel Air, nr. Richmond, 1902. A. D. Cohen in *PAJ,* I (1851), 285-87 (portrait); A. L. Kocher & H. Dearstyne, *Shadows in Silver* (1954).

COOMBS, FRED

Active St. Louis, 1846; Chicago, 1849; San Francisco, 1850.

CORNELIUS, ROBERT

Born 1809. Lamp-shade manufacturer. Began dag'typing, 1839. Gallery in Philadelphia, 1840-42. Died, 1893. *AJP,* XIV (1893), 420 (portrait); Taft, 457-58.

CUTTING, JAMES A.

Inventor. Secured patent for beehive, 1842. Moved to Boston. Three U.S. Patents (11,213, 11,266; 11,267) for modification of collodion process, including ambrotype, 1854. Yachtsman: collected from his yacht *Ambrotype* aquatic specimens which he exhibited at "The Aquarial Gardens," Boston (later acquired by P. T. Barnum). Died in Insane Asylum of Worcester, Mass., 1867. *Worcester Daily Spy,* Aug. 12, 1867.

DAVIE, DANIEL T.

Born 1819. Began photog., 1846. Active

Utica, N. Y., 1848-51. Member N. Y. State Daguerreian Assoc.; on committee to investigate L. L. Hill's alleged color process, 1851. Took portraits "of all officers of government and Congress" in Washington. Opened Syracuse, N. Y., gallery, 1852. Author: *Photographer's Pocket Companion* (1857); *Secrets of the Dark Chamber* (1870). *PAJ*, II (1851), 165-66 (portrait); III (1852), 320, 351; *DJ*, I (1850), 29, 64.

DAVIS, ARI

Instrument maker, active in Boston with bro. Daniel, Jr., 1834-? Took dag'types in Boston and Lowell, Mass., 1841.

DAVIS, ASAHEL

Instrument maker, active in Boston with bro. Daniel, Jr. To Philadelphia to work in Plumbe's establishment. E. Z. Stone in *Contributions of the Old Resident's Assoc., Lowell, Mass.*, V (1892), 165-88.

DAVIS, DANIEL, JR.

Instrument maker, pioneer dag'typist, electrical experimenter. Born Princeton, Mass., 1813. Active in Boston with bro. Ari as instrument maker, 1834-52. Learned to dag'-type from François Gouraud, 1840; made apparatus and took dag'types same year. U. S. Pat. 2,826 (improvements in coloring dag'-type pictures), 1842, assigned to John Plumbe, Jr. Author: *Manual of Magnetism* (1842), first U. S. book on electricity. Retired, 1852. Died Princeton, Mass., 1887. E. F. Blake, *History of the Town of Princeton* (1915), II, 75-76; *Boston Weekly Transcript*, Mar. 29, 1887.

DOBYNS, T. C.

Established chain of dag'type galleries: New Orleans, Vicksburg, Louisville (1850); Nashville, St. Louis (1851); Memphis (1854). N. Y. C. gallery, 1853-? *HJ*, V (1853), 190, 222.

DRAPER, JOHN WILLIAM

Scientist, pioneer dag'typist. Born England, 1811. To U. S., 1832. Prof. Chemistry, N. Y. University, 1837-81; president, 1850-73. First dag'type experiments, 1839. Died Hastings, N. Y., 1882. *AJP*, I (1852), 2; M. A. Root, *The Camera and the Pencil* (1864), 340. See also his *Scientific Memoirs*, XIII, 197; *Amer. Repertory of Arts, Sciences and Manufactures*, I (1840), 401-404.

EASTERLY, THOMAS M.

Born Brattleboro, Vt., 1809. Active Liberty, Missouri, with F. F. Webb, 1846-47; St. Louis, 1848-82. Died, 1882. *APB*, III (1872), 611; C. Van Ravenswaay in *Bul. of the Missouri Hist. Soc.*, X (1953), 56-57; *Practical Photographer*, VI (1882), 144.

EDWARDS, JONAS M.

Proprietor of "National Daguerreotype Miniature Gallery," N. Y. C., with Edward Anthony, Howard Chilton, 1843-45.

EVANS, O. B.

Active Buffalo, N. Y., 1850 or earlier. Advertised as "oldest practical Daguerreian in America" in Buffalo Business Directory, 1855. Exh. London, 1851. *DJ*, I (1850), 29.

FARIS, THOMAS

Began dag'typing 1841. Active Cincinnati, 1844-52; N. Y. C., 1858-?

FITZ, HENRY

Telescope maker, pioneer dag'typist. Born Newburyport, Mass., 1808. To N. Y., 1818. Assisted Wolcott and Johnson in making their 1839 dag'type portraits. Gallery in Baltimore, 1840-42. To N. Y.; concentrated on making telescopes, including world's biggest (16 inches). Died N. Y. C., 1863. *AJP*, new series, VI (1863), 215.

FITZGIBBON, JOHN H.

Born London, 1816 (?). To N. Y. C. while a child. Apprenticed to saddler, then ran a hotel nr. Lynchburg, Va. Began to dag'type, 1841. Opened St. Louis gallery, 1846. Purchased from J. Gurney the R. H. Vance collection of dag'types of Pacific Coast, 1853. Exh. N. Y. C., 1853-54 (Hon. Mention). Moved to Vicksburg, 1861; captured by Union Army; prisoner of war in Cuba. Returned to St. Louis, 1866. Retired, 1876. Editor and publisher *St. Louis Practical Photographer* (first issue, 1877). Died on train en route to Convention of Photographers' Assoc. of America, of which he was president, 1882. *AJP*, new series, VI (1863), 143; *HJ*, V (1853), 299; *PAJ*, VII (1854), 104, 192; VIII (1855), 32; IX (1856), 128; *Photographic Mosaics*, 1871, p. 45; *St. Louis Practical Photographer*, I (1877) front. to no. 1 (portrait); C. Van Ravenswaay in *Bul. of the Missouri Hist. Soc.*, X (Oct., 1953), 58-60; Taft, 488.

FONTAYNE, CHARLES H.

Born 1814. Began photog. in Baltimore. To Cincinnati, 1846. Made, with W. S. Porter, 8-plate dag'type panorama of Cincinnati waterfront. Exh. London, 1851. Life-size photographs, 1854; 5½ x 7 ft. enlargements,

1855. Invented machine for bulk printing, 1858. Died Clifton, N. J., 1858. *AJP*, new series, III (1860), 104, 112; *PAJ*, VII (1854), 192; VIII (1855), 96, 192; X (1857), 349; *Wilson's Photographic Mag.*, XXXVIII (1901), 192; M. A. Root, *The Camera and the Pencil* (1864), 385-86.

FORD, J. M.

Active San Francisco and Sacramento, Calif., 1854-56.

FOSTER, B.

Active Portland, Me., 1843.

FREDRICKS, CHARLES DeFOREST

Born 1823. Taught dag'type process by J. Gurney. To Venezuela, 1843; traveled through S. America dag'typing, 1843-c.52. To Paris, 1853. To N. Y. C.; partner of J. Gurney, 1855-56; own gallery 1857-? *APB*, XII (1881), 110-12; Taft, 134.

GAGE, FRANKLIN B.

Active in St. Johnsbury, Vt., 1851-? Author: *Theoretical and Practical Photography on Glass and Paper* (1859). E. T. Fairbanks, *The Town of St. Johnsbury, Vt.* (1914), p. 488.

GAVIT, DANIEL E.

Born, 1819. Active Albany, N. Y., 1850; N. Y. C., 1850-52. Purchased "National Daguerreotype Miniature Gallery" of Anthony, Clark & Co., 1850. Exh. London, 1851. Delegate to formation meeting of N. Y. State Daguerreian Assoc., 1851. Gave up photog., c. 1852. Publisher of newspaper in Jersey City, 1853. Died N. Y. C., 1875. *New England Hist. & Geneal. Register*, Jan., 1923; *DJ*,

I (1850), 51; II (1851), 31; *HJ*, V (1853), 190; *PAJ*, II (1851), 123.

GORGAS, JOHN M.

Began photog. Pittsburgh, Pa., 1847. To Madison, Ind., 1853; floating gallery on Ohio and Mississippi Rivers, 1853-56. Reminiscences: *St. Louis & Canadian Photographer*, XXIII (1899), 327.

GOURAUD, FRANÇOIS

Full name: Jean-Baptiste François Fauvel-Gouraud. Arrived N. Y. C. from France, Nov. 23, 1839, purporting to be pupil of Daguerre and agent of Alphonse Giroux. Exhibited dag'types, taught, N. Y. C., 1839-40; Boston, 1840; Providence, R. I., 1840. To Buffalo, 1842. Began to lecture on memory training, 1842. Published three books on subject and a shorthand manual. Died c. 1848. Manuscript biography by J. E. Rockwell in N. Y. Public Library.

GRAVES, E. R.

Itinerant, working out of Lockport, N. Y., 1853.

GRISWOLD, VICTOR M.

Began to dag'type with bro. M. M. Griswold in Tiffin, O., 1850. Active Lancaster, O., 1852. Learned collodion process from S. D. Humphrey, 1853 (?) According to his son, devised technique for putting collodion emulsion on any surface, including tin. Began manufacture of "ferrotype" (i.e. tintype) plates, 1856. Author: *A Manual of Griswold's New Ferro-Photographic Process for Opal Printing on the Ferrotype Plates* (1866). Died Peekskill, N. Y., 1873. E. P. Griswold, "How the Tintype was Invented," *Amer. Amateur Photographer*, I (1889), 235-36; Obituary by M. M. Griswold in *Photographic Times*, II (1872), 107, 118-19.

GURNEY, JEREMIAH

Began to dag'type while a jeweler in Saratoga, N. Y., 1839(?). Active N. Y. C., 1840-after 1865. Bought Whitehurst's gallery, 1852. Exh. N. Y. C. 1853-54 (Hon. Mention). Won Anthony Prize Competition, 1853. Partner of Charles D. Fredricks, 1855-56. Author: *Etchings on Photography* (1856). *DJ*, I (1850), 51; II (1851), 340; III (1852), 66, 257; *HJ*, IV (1852), 127, 240; V (1853-54), 246, 273-78; *PAJ*, III (1852), 66, 257; VII (1854), 6; N. Y. *Star*, Nov. 6, 1887.

HAAS, PHILIP

Active N. Y. C., 1846, '48, '50-57. Exh. N. Y. C. 1853-54.

HARRISON, CHARLES C.

Active as dag'typist, N. Y. C., 1851; gallery purchased by George S. Cook; became camera maker (pupil of Henry Fitz). Exh. London, 1851; N. Y. C., 1853-54 (Bronze Medal). Died, N. Y. C., 1864. *AJP*, new series, III (1861), 279 (portrait); *DJ*, I (1851), 127; II (1851), 180; *HJ*, V (1854), 299; XVI (1865), 240, 256; *PAJ*, II (1851), 127; *Phila. Photog.*, II (1865), 16, 97.

HARRISON, GABRIEL

Born Philadelphia, 1817. To N. Y. C., 1822; worked for father printing bank notes. Brief career as actor (1838), painter. Learned dag'type process in Plumbe's N. Y. C. gallery; became assistant, later operator, for William

145

Butler, 1844-48. Operator for M. M. Lawrence, 1849-52. Own gallery, Brooklyn, N. Y., 1852; N. Y. C., 1859. Exh. N. Y. C., 1853-54 (Hon. Mention). *PAJ,* I (1851), 169-77 (portrait); III (1852), 320; *HJ,* IV (1852), 63; H. R. Stiles, *History of King's County* (1884), p. 1151-58.

HARTSHORN, W. S.

Active in Providence, R. I., with S. Masury, 1848; sold out to Manchester Brothers, 1850.

HAWES, JOSIAH JOHNSON

Born East Sudbury (now Wayland), Mass., 1808. Apprenticed to a carpenter; self-taught painter. On seeing Gouraud's demonstration of dag'type, took up process, 1840. Joined A. S. Southworth, Boston, 1844. Died, Crawford Notch, N. H., 1901. *Boston Herald,* Aug. 9, 1901; *Photo Era,* VII (Sept. 1901), 119; XVI (1906), 104-07; *Worcester Spy,* Jan. 6, 1888; also references under SOUTHWORTH, ALBERT SANDS.

HAWKINS, EZEKIEL C.

Active in Cincinnati, 1844-60. Exh. N. Y. C., 1853-54. *DJ,* I (1850), 29; II (1851), 242.

HELSBY, TOMAS C.

American, active in Buenos Aires, 1846. J. F. Riobó, *Daguerrotipos . . . en Buenos Aires* (1949).

HESLER, ALEXANDER

Born Montreal, Canada, 1823. Boyhood in Vermont. To Racine, Wisc., 1833. Learned photog. Buffalo, 1847; opened gallery in Madison, Wisc., 1847. To Galena, Ill., 1848; dag'typed Mississippi River from Galena to St. Paul from S.S. *Nominee,* 1851. Took dag'-type of Minnehaha Falls which inspired Longfellow to write "Hiawatha," 1852. To Chicago, 1853. Exh. N. Y. C., 1853-54 (Bronze Medal). Died "in harness—during the photographing of a group by flashlight," Evanston, Ill., 1895. *APB,* XXVI (1895), 259; *HJ,* V (1854), 299; *PAJ,* VII (1854), 384; Evanston, Ill., *Index,* July 6, 1895; Taft, 98, 471; B. Newhall in *Minnesota History,* XXXIV (1954), 28-33. Reminiscences: *Photographic Times,* XIX (1889), 130-31.

HILL, LEVI L.

Born Athens, N. Y., 1816. Father murdered, 1828. Apprentice printer, *Hudson Gazette,* 1829-31. To N. Y. C., and then Kingston, N. Y., as printer, 1831, in office of *Ulster Plebeian.* Joined Baptist Church; studied at Hamilton (N. Y.) Literary and Theological Seminary, 1833-34. Preacher, Baptist Church, New Baltimore, N. Y., c. 1836; Married, 1836. Settled in Westkill as pastor, 1836-45. Published *The Baptist Library* (3 vols., 1843), *The Baptist Scrapbook* (1845). Set up printing shop with bro. R. H. Hill in Prattsville, N. Y., c. 1844. Returned to Westkill, 1845: became dag'typist. Published *Treatise on Dag'type,* 1849 (2nd printing, 1850; 3rd printing, titled *Photographic Researches,* 1851; 4th printing, 1851; 2nd ed., 1854). Announced color process, 1850. Investigated by committee of N. Y. State Daguerreian Assoc., 1851; declared a humbug. Published *Treatise on Heliochromy,* 1856. To Hudson, N. Y., 1856. Died N. Y. C., 1865. A. J. Olmsted in *Jour. Photographic Soc. of America,* XI (1945), 164-66; obit., *British Jour. Photog.,* XII (1865), 155; *HJ,* XVI (1865), 315-16.

HILLS

Active with Gabriel Harrison, Brooklyn, 1853-?

HOLCOMB, SARAH

Taught dag'type by A. S. Southworth. Itinerant in Mass. and N. H., 1846.

HOLMES, S. A.

Active N. Y. C., 1855. *HJ,* VI (1855), 295, 327.

HOVEY, DOUGLAS

Born Hampton, Conn., 1828. To Grandville, O., c. 1836. To Philadelphia, c. 1849, to work in dag'type gallery of Samuel Root. To Rochester, N. Y., 1854 (partner of John Kelsey, 1854-55; of Henry G. Hartman, 1857-63; own business, 1866). Began to manufacture albumen paper, 1868. Died Rochester, N. Y., 1886. *Rochester Morning Herald,* Feb. 10, 1886; *PAJ,* VIII (1855), 59.

HOWE, ELIAS

Inventor of sewing machine. Born, Spencer, Mass., 1819. Instrument maker in shop of Daniel Davis, Jr., Boston. Worked for J. A. Whipple manufacturing dag'type supplies, 1841; own dag'type gallery, Cambridgeport, Mass., 1841-? U. S. Pat. 4,750 (sewing machine), 1846. Died Brooklyn, 1867. DAB; *Photographer's Friend,* III (1873), 70; *Boston Weekly Transcript,* Mar. 29, 1887.

HOWE, GEORGE M.

Active Portland, Me. Exh. N. Y. C., 1853-54.

HUDDLESTON, J. S. F.

Instrument maker in Boston. Built apparatus for J. Plumbe, Jr. (?) Exhibited dag'types, 1841.

HUMPHREY, SAMUEL DWIGHT

Active Canandaigua, N. Y., 1849, when he dag'typed moon. To N. Y. C., 1850, as dag'typist and editor and publisher of world's first magazine devoted to photog., the *Daguerreian Journal* (1850-51; title changed to *Humphrey's Jour.,* 1852). Stockdealer, c. 1854-58. Resigned editorship of *HJ,* 1859. Author: *A System of Photography* (1849; 2nd ed. same yr.); *American Handbook of the Daguerreotype* (1853; 5th ed. 1858); *Practical Manual of the Collodion Process* (2nd ed., 1856; 3rd ed., 1857).

HUNT, CALEB

Operator for J. Gurney. Active in Cleveland, 1854. *HJ,* V (1854), 335.

JOHNSON, JOHN

Made pioneer portrait dag'types with A. S. Wolcott, 1839. U. S. Pat. 2,391 (buff wheel), 1841. *AJP,* new series, VI (1864), 343; *DJ,* II (1851), 56-57, 73-80; see also references under WOLCOTT, ALEXANDER SIMON.

JOHNSON, WALTER R.

Prof. of Physics and Chemistry, Univ. of Penna., 1839-43. Brought dag'type apparatus from abroad to Phila., 1839; lectured about process and took dag'types, 1839-40. Died Phila. 1852. *U. S. Gazette,* Oct. 22, 1839; Jan. 31, Feb. 11, 1840; *Appleton's Cyclopaedia of Amer. Biography;* Taft, 457.

JONES, WILLIAM B.
Active in Boston; assistant to J. A. Whipple, 1849-50; co-patentee of crystalotype (U. S. Pat. 7,458), 1849.

KELSEY, C. C.
Active Chicago. Exh. N. Y. C., 1853-54.

KELSEY, JOHN
Active Phila. (operator for M. Shew); to Rochester, N. Y., 1853 (partner of James Heath, 1853; of Daniel Hovey, 1854-55). Dag'typed eclipse of sun, May 26, 1854.

KIMBALL, J. A.
Active N. Y. C. Exh. N. Y. C., 1853-54.

LANGENHEIM BROTHERS
WILLIAM LANGENHEIM. Born Brunswick, Germany, 1807. To U. S.; in Texas, 1834-36. To Phila., 1840, where he was associated rest of life with bro. Frederick. Died Phila., 1874.

FREDERICK LANGENHEIM. Born Brunswick, Germany, 1809. To Phila., 1840; after brief career as newspaperman for German language *Alte und Neue Welt* opened dag'type studio with bro. William, c. 1842. N. Y. C. gallery (with Alexander Beckers), 1845-48. Assignee of Johann B. Isenring's U. S. Pats. 4.369 and 4,370 (coloring dag'types), 1846. Purchased W. H. F. Talbot's U. S. Pat. 5,171 (calotype process), 1849. Invented albumen plates (hyalotypes); U. S. Pat. 7,784, 1850. Exh. London, 1851. Pioneers in stereoscopic photog.; by 1854 in business selling them under name "American Stereoscopic Company." Introduced photographic lantern slides; sold business to Caspar Briggs, 1874. Died Phila., 1879. F. Roemer, *Texas, with Particular Reference to German Immigration*

(1935), p. 167ff; L. W. Sipley, *Penna. Arts & Sciences,* II (1937), 25-29, 58-59; M. A. Root, *The Camera and the Pencil* (1864), pp. 355-56; 363.

LAWRENCE, MARTIN M.
Born 1808. Active N. Y. C., 1842-? Exh. London, 1851 (Prize Medal); N. Y. C., 1853-54. *DJ,* I (1851), 215; *HJ,* IV (1852), 63; V (1853), 10, 190; *PAJ,* I (51), 103-106 (portrait).

LITCH, ALBERT
Active Boston; partner of J. A. Whipple, 1844-46. Operator for J. Gurney; to England, 1853. *HJ,* IV (1853), 383.

LONG BROTHERS
ENOCH LONG. Born Hopkinton, N. H., 1823. H. H. LONG. Students of R. Cornelius, 1842. Gallery in Augusta, Ga. To St. Louis, 1846-65. Enoch L. operated galleries in Alton, Quincy, and Galena, Ill. Exh. N. Y. C., 1853-54. Enoch L. in business as "solar printer" Quincy, Ill., 1891. C. Van Ravenswaay in *Bul. of the Missouri Hist. Soc.,* X (1953), 63-64.

McDONNELL, DONALD & CO.
Active Buffalo, N. Y., 1850-? Exh. N. Y. C., 1853-54.

McINTYRE, S. C.
Dentist in Tallahassee, Fla.; advertised as dag'typist, 1845. To San Francisco, 1850. *DJ,* II (1851), 115.

MANCHESTER BROTHERS
HENRY N. MANCHESTER, EDWIN H. MANCHESTER. Active Providence, R. I., 1848-60

(operators for Masury & Hartshorn, 1848; Manchester & Co., 1850-51; Manchester & Chapin, 1853; Manchester & Brother, 1860).

MASCHER, JOHN F.

Active Phila. Pioneer in stereoscopic phot., 1852. U. S. Pats. 9,611 (stereoscope), 1853; 12,257 (stereoscopic medallion), 1855; 16,600 (imitation tortoise-shell dag'type case), 1857. *HJ*, VII (1855), 139.

MASURY, SAMUEL

Active Providence, R. I.; in partnership with Hartshorn, 1848; sold out to Manchester Bros., 1850. To Boston; partner of George M. Silsbee, 1852-54; of Silsbee & J. G. Case, 1855-57; own business, 1858-60. Exh. N. Y. C., 1853-54 (with Silsbee).

MAYALL, JOHN JABEZ EDWIN

Born (Birmingham, England?), 1810. To Phila. Learned dag'type process from Paul Beck Goddard and Hans Martin Boyé, 1840; partner of Samuel Van Loan, 1845-46. To England, 1846; established chain of galleries in London and provinces. British Pat. 193 (vignetting device), 1853. To Brighton, 1864; mayor, 1877-78. Died 1901. *AJP*, new series, III (1861), 260-63; VI (1864), 343; XIV (1893), 373-74; *British Jour. Photographic Almanac*, 1892; *Brighton Gazette & Hove Post Special Illustrated Edition*, June 30, 1904; *DJ*, I (1850), 46; II (1851), 32; *HJ*, IV (1853), 315; *PAJ* II (1851), 127-28.

MEADE, CHARLES RICHARD

Active Albany, with bro. Henry, 1842. Sent dag'types of Niagara Falls to King of France and Emperor of Russia. To Europe, 1849; took six portraits of Daguerre. Exh. London,

1851. N. Y. C. gallery, 1852-? (with bro.) Exh. N. Y. C., 1853-54; Paris Exposition, 1855. Died St. Augustine, Fla., 1858. See references below.

MEADE, HENRY

Active Albany, with bro. Charles Richard, 1842. To Europe before 1849. Associated with bro. in N. Y. C. gallery and exhibited with him. Died, 1865. *Gleason's Pictorial*, II (1852), 377; *PAJ*, III (1852), 293-95; E. Lacan, *Esquisses photographiques* (1856), p. 147-49; *DJ*, I (1850), 51; *HJ*, IV (1852-53), 233, 314; V (1853), 299; VI (1854), 160; IX (1858), 352; XVI (1864-65), 304; *PAJ*, II (1851), 123; XI (1858), 128; C. W. Canfield in *Amer. Annual of Photog.*, 1891 and 1893.

MOISSENET, DOBYNS, RICHARDSON & CO.

Active in New Orleans, Exh. N. Y. C., 1853-54.

MOORE, HENRY

Active Lowell, Mass., 1843.

MORAND, AUGUSTUS

Learned dag'type, 1840. To Rio de Janeiro, 1842; took dag'types for Dom Pedro II. Returned to U. S., 1843; traveled through South. Opened gallery in N. Y. C., 1848. President, N. Y. State Daguerreian Assoc., 1851. Last appearance in N. Y. C. directory, 1856. *PAJ*, I (1851), 237-39.

MORSE, SAMUEL FINLEY BREESE

Artist, scientist, inventor of the electric telegraph, pioneer dag'typist. Born Charlestown, Mass., 1791. First photochemical experiments while student at Yale College, 1805-10. Stud-

ied painting with Washington Allston. Patented electric telegraph, 1837. To Europe, 1837. Showed Daguerre telegraph; in return Daguerre showed him finished dag'types, but did not disclose process, Mar. 7, 1839. Returned to U. S., April 1839. Nominated Daguerre hon. member, Natl Academy of Design, May, 1839; election unanimous. Took his first successful dag'type, Sept. 28, 1839. Opened studio with Draper, 1840. Although he shortly gave up photography as a profession, maintained an interest rest of life: supported L. L. Hill's claims, 1851-52; judged Anthony Prize Competition, 1853. Died N. Y. C., 1872. Carleton Mabee, *The American Leonardo; a Life of Samuel F. B. Morse* (1943); S. I. Prime, *The Life of Samuel F. B. Morse* (1875). Reminiscences: M. A. Root, *The Camera and the Pencil* (1864), pp. 344-48.

NEFF, PETER, JR.

Purchased, with bro. William, H. L. Smith's melainotype (i.e. tintype) patent, 1856.

NEFF, WILLIAM

See reference above.

NICHOLS, JOHN P.

Active Boston, 1849-51 (proprietor of Plumbe's dag'type gallery). *DJ,* I (1851), 256.

NICHOLS, SHELDON K.

Active Hartford, Conn., San Francisco. Exh. N. Y. C., 1853-54.

NORTH, ENRIQUE

American, active Buenos Aires, 1848. J. F. Riobó, *Daguerrotipos . . . en Buenos Aires* (1949).

NORTH, WILLIAM C.

Active Dayton, O. Exh. N. Y. C., 1853-54.

ORMSBEE, MARCUS

Active Boston, 1852-60.

PAGE, CHARLES G.

Active Boston with Daniel Davis, Jr., in manufacture of electrical machines. To Washington, 1839; examiner of patents, U. S. Patent Office. Took dag'types, Washington, 1843. *Boston Weekly Transcript,* Mar. 29, 1887.

PAIGE, BLANCHARD P.

Active Washington, D. C. (proprietor of Plumbe's National Gallery), 1850-65; sold out to S. C. Mills.

PECK, SAMUEL

Active New Haven, Conn., 1847-60? U. S. Pat. 7,326 (block to hold dag'type plates when polishing), 1850. Opened factory for making dag'type cases, 1850. U. S. Pat. 11,758 (Union cases), 1854. Samuel Peck & Co. founded, 1855. U. S. Pat. 14,202 (hinge for dag'type case), 1856. *DJ,* I (1850), 29.

PENNELL, JOSEPH

Pupil and assistant of S. F. B. Morse, N. Y. C., 1840. Partner of A. S. Southworth in Cabotsville (now Chicopee), Mass., 1840, and in Boston, 1841-44. To South; schoolteacher. To Waterbury, Conn., 1845, as plate maker for Scovill until 1848.

PLUMBE, JOHN, JR.

Born Wales, 1809. Surveyed RR, 1832. Superintendent, RR Richmond, Va., to Roan-

oke, N. C., 1832. Appropriation from U. S. Congress to survey route for transcontinental RR. 1838. To Washington, 1840; took up phot. when funds ran out. Opened gallery Boston, 1841, sold 1846. Maintained other galleries across the U. S.: Baltimore, 1841-?; N. Y. C., 1843-47; Phila., 1842-45; Lexington, Ky., 1845-?; Washington, D. C., 1846-50. Purchased from D. Davis, Jr., U. S. Pat. 2.826 (coloring dag'types), 1842. Published *Plumbeian*, 1846; *National Plumbeotype Gallery*, 1846. Gave up photog., 1849. Killed himself by cutting throat, Dubuque, Iowa, 1857. R. Taft in *Amer. Phot.*, XXX (1936), 1-11; *Boston Advertiser*, Feb. 2, 1841; DAB; *HJ*, IX (1857, 112; Taft 49, 462.

PORTER, WILLIAM SOUTHGATE

Born 1822. Active Phila. To Cincinnati, 1848; partner of Charles Fontayne. Exh. London 1851. Died 1889. See also references under FONTAYNE, CHARLES.

PRATT, E. W.

Operator of Plumbe. Own gallery, N. Y. C., 1845. *Sci. Amer.*, Sept. 11, 1845.

PRATT, WILLIAM A.

Born England, 1818. To U. S., 1832. Opened dag'type gallery in Richmond, Va., 1846. U. S. Pat. 4,423 (coloring dag'types), 1846. To Europe, 1851. Exh. London 1851. Built "Pratt's Castle," Gothic Revival studio, Richmond, 1853-54. Supt. of bldgs. and grounds, Univ. of Va., 1858. *Bul. of Valentine Museum*, Spring, 1949; M. W. Scott, *Houses of Old Richmond* (1941), p. 286; *PAJ*, I (1851), 189; II (1851), 63, 190, 235 (illus. of gallery).

PROSCH, GEORGE W.

Active N. Y. C., 1840-41; Canada, 1842-43; N. Y. C., 1846; Newark, N. J., 1850-55. *HJ*, VI (1854), 327; *Sci. Amer.*, Apr. 9, 1846.

PRUDEN, HENRY

Itinerant, working out of Lockport, N. Y., 1853.

READ, GEORGE

Active Phila., 1842.

REED, G. M.

Active N. Y. C., 1854.

REESE & CO.

Active N. Y. C., 1853-54. Author: *Daguerreotype Directory* (1854).

REHN, ISAAC A.

Active Phila. Painter, 1848. Bought from J. A. Cutting one-quarter interest in ambrotype patents. Taft, 125.

RICHARDS, F. DE BOURG

Active Phila., 1848-?

ROOT, MARCUS A.

Born Granville, O., 1808. Studied painting with Thomas Sully, 1835. Teacher of penmanship, Phila., 1840-48. Learned dag'type process from R. Cornelius, 1843. Active as dag'typist, Mobile, Ala., 1844; thence New Orleans, St. Louis (with Miller). Bought gallery of J. E. Mayall, Phila., 1846. Exh. London, 1851; N. Y. C., 1853-54 (Hon. Mention). Opened N. Y. C. gallery with bro. Samuel, 1849; sold it to him, 1851. Said to

have coined name "ambrotype" for collodion positives, 1854. Died Phila., 1888. Author: *Philosophical Theory and Practice of Penmanship* (1842); *The Camera and the Pencil* (1864). *Phila. Press,* Apr. 16, 1888; *McClure's Mag.,* IV (1897), 945; *Photographic Times,* XVIII (1888), 195; *British Jour. Photographic Almanac,* 1889; *Sartain's Mag.,* V (1849), 189.

ROOT, SAMUEL

Born Ohio, 1819. Studied dag'type in Phila. Gallery in N. Y. C. with bro. Marcus, 1849-51; bought out gallery, 1851. To Dubuque, Iowa, 1857. Retired, 1882. Died Rochester, N. Y., 1889. Dubuque, Iowa, *Daily Times,* Mar. 15, 1889.

RULOFSON, WILLIAM HERMAN

Born nr. St. John, N. B., 1826. Began to take dag'types in St. John before 1846. To sea; shipwrecked; landed destitute in Liverpool; supported himself with his camera, 1846. Reopened St. John gallery, 1848. To California; arrived San Francisco, 1849; to Sonora, 1850 (partner of J. D. Cameron, 1850-51). To San Francisco, 1863 (partner of Henry W. Bradley). President, Natl Photographic Assoc., 1874. Alleged author of *The Dance of Death* by "William Herman," a work usually ascribed to Ambrose Bierce, 1877. Died from fall while inspecting skylight of gallery, San Francisco, 1878. R. Haas in *Calif. Hist. Soc. Quarterly,* XXXIV (1955), 289-300; XXXV (1956), 47-58.

RYDER, JAMES F.

Itinerant, 1847; settled in Cleveland, O., 1850. Introduced negative retouching to America, 1868, when he employed Karl

Leutgib, trained by H. W. Vogel in Germany. Retired, 1894. Died, Cleveland, 1904. Autobiography: *Voigtländer and I* (1902); also published by installments in *Photo Beacon,* XIII (1901). Taft, 326 (portrait); *Photo-Miniature* No. 62 (1904), 123-24.

SAXTON, JOSEPH

Employee of U. S. Mint, Phila. Took dag'-type before Oct. 24, 1839. *U. S. Gazette,* Oct. 24, 1839.

SEAGER, D. W.

Born England (?). In N. Y. C. when news of Daguerre's technique arrived. Claimed to have taken on Sept. 16, 1839, first dag'type in U. S. Lectured on dag'type, 1839-40. To Mexico as adviser to gov't on natl economy. Author: *The Resources of Mexico Apart from the Precious Metals* (1867).

SHEW, JACOB

Active Baltimore (in charge of Plumbe's gallery), 1841-?; Phila., 1850-? Purchased Van Loan gallery, 1851. San Francisco, 1854, 1860-62; 1863 (with Charles F. Hamilton); 1864-78. *DJ,* I (1850), 29; II (1851), 19.

SHEW, MYRON

Active Phila., 1841-51 or later. *DJ,* II (1851), 32.

SHEW, TRUEMAN

Active Phila., 1841-48.

SHEW, WILLIAM

Born nr. Watertown, N. Y. Pupil with bros. Jacob, Myron, and Trueman of S. F. B.

Morse. Hired by J. Plumbe to superintend his Boston gallery, 1841. Opened own gallery, Boston, 1845; began to manufacture dag'type cases and to sell photographic materials. To San Francisco, 1850; gallery there through 1903. Author: "Photography," *Pioneer, or California Monthly Mag.,* II (1854), 34-40. *Camera Craft,* V (1902), 101-107; *HJ,* IV (1852), 44.

SILSBEE, GEORGE M.

Active Boston, 1852-57 (with Masury, 1852-54; with Masury & Case, 1855-57). Exh. (with Masury) N. Y. C., 1853-54.

SIMONS, MONTGOMERY P.

Active Phila. Bought from Warren Thompson U. S. Pat. 3,085 (coloring dag'types), 1843. Casemaker, 1843-47. First listed in directory as dag'typist, 1848. Author: *Plain Instructions for Coloring Photographs* (1st and 2nd eds., 1857); *Photography in a Nut Shell* (1858); *Secrets of Ivorytyping Revealed* (1860).

SMITH, HAMILTON L.

Prof. of chemistry; inventor of tintype. Graduated from Yale Univ., 1839. Took dag'types in Cleveland, O., 1840. Prof. of chemistry, Kenyon College, Gambier, O., 1853. Invented melainotype (i.e. tintype); U. S. Pat. 14,300 (1856). To Geneva, N. Y., 1867: Prof. of chemistry Hobart College (1867-1900) and president (1883-84). *Natl Cyclopaedia of Amer. Biography;* Taft, 154-55 (portrait); *Amer. Jour. Science and Arts,* XL (1841), 139.

SMITH, L. C.

Active Sharon, Vt., 1843.

SNELLING, HENRY HUNT

Born Plattsburg, N. Y., 1817. Early life in military camps; Council Bluffs, N. W. Territory. To N. Y. C.; genl sales manager of E. Anthony, 1843-57. Editor and publisher, *Photographic Art-Journal* (1851-54), *Photographic and Fine Art Journal* (1854-59). Employed by Internal Revenue Dept., 1860. Editor Cornwall, N. Y., *Reflector.* Became blind, 1887. Author: *The History and Practice of the Art of Photography* (1849; 2nd ed., 1850; 3rd ed., 1851; 4th ed., 1853); *A Dictionary of the Photographic Art* (1854); *A Guide to the Whole Art of Photography* (1858); *Memoirs of a Boyhood at Fort Snelling* (1939); *Memoirs of a Life* (3 vols., ms. in Newberry Library, Chicago); "Colored Glasses in the Relation to Photography and the Eye," *Internat. Ann. of Anthony's Photographic Bul.,* 1883, 490-95. *PAJ,* VIII (1855), front. (portrait by Brady); *The Camera,* XLVII (1933), 391-94; *AJP,* XIV (1893), 188.

SOMERBY

Presumably active Boston before 1844.

SOUTHWORTH, ALBERT SANDS

Born West Fairlee, Vt., 1811. Attended Phillips Academy, Andover, Mass. On seeing Gouraud's demonstrations of dag'type in Boston, 1840, went to N. Y. C. Learned process from S. F. B. Morse with his friend J. Pennell. Formed partnership with him; opened gallery Cabotville (now Chicopee), Mass., 1840. To Boston, 1841. Pennell left, 1844; partnership with J. J. Hawes, 1844-61 (firm name: "Southworth & Hawes" adopted 1845). To Calif., 1849-51. U. S. Pats. 11,304 (stereoscopic camera), with Hawes, 1854; 12,700 (plate holder), 1855; 13,106 (stereo-

scope), with Hawes, 1855. Died Charlestown, Mass., 1894. Author: "Address to Natl Photographic Assoc. of the U. S.," *Phila. Photographer,* VIII (1871), 315-23. I. N. Phelps Stokes, *The Hawes-Stokes Coll. of Amer. Dag'-types by Albert Sands Southworth and Josiah Johnson Hawes* (Metropolitan Museum of Art, 1939); B. Newhall in *Art News Annual 1948,* pp. 91-98, 168-72; *DJ,* II (1851), 114-15; *HJ,* V (1853), 223; *Western Photographer,* Apr. 1876, p. 233.

STANLEY, JOHN MIX

Painter of Indian scenes; occasional dag'-typist. Born 1814. Active as dag'typist in Washington, D. C., 1842 (Fay & Stanley). On gov't expedition under Isaac I. Stevens to explore route for transcontinental RR, 1853, took dag'types. DAB; Taft, 261-62.

STULL, JOHN

Active Phila. U. S. Pat. 12,451 (stereoscope), 1857.

TALBOT, J. W.

Active Petersborough, N. H.

THOMPSON, WARREN

Active Phila., 1840-46. U. S. Pat. 3,085 (coloring dag'types), 1843, assigned to Montgomery P. Simons. To Paris, 1847; active there through 1859. Pioneer in production of enlargements of extreme size, 1855. *PAJ,* new series, I (1855), 253.

TOMLINSON, WILLIAM AGUR

Born 1819. Active Poughkeepsie, N. Y., 1846; Troy, N. Y., 1850, 1853; N. Y. C., 1857-62. Member, N. Y. State Daguerreian Assoc.; on committee to investigate L. L. Hill's alleged color process, 1851. Died 1862(?)

TURNER, AUSTIN A.

Operator for Ormsbee, Boston. Learned collodion process. Became operator for Brady. *PAJ,* VIII (1855), 129 (portrait), 160.

VAN ALSTIN, ANDREW WEMPLE

Born Canastota, N. Y., 1811. Pupil of George Adams, Worcester, Mass. In business there, 1843 to death, 1857. *Worcester Hist. Soc. Publications,* new series, I (1935), 433-39.

VAN LOAN, SAMUEL

Born England. Active Phila., 1844-54. Sold gallery to J. Shew, 1851.

VANCE, ROBERT H.

Produced over 300 dag'types of West Coast; exhibited them in N. Y. C., 1851; sold to Jeremiah Gurney, 1852. In San Francisco, 1854-61. Galleries in Sacramento and Marysville, Calif. Sold San Francisco gallery to Charles L. Weed, 1861. Left Calif., 1865. *DJ,* II (1851), 371; *HJ,* V (1853), 41, 89, 105; Book Club of Calif., *A Camera in the Gold Rush* (1946).

VANNERSON, J.

Active Washington, D. C. Exh. N. Y. C., 1853-54.

VON SCHNEIDAU,
JOHN FREDERICK POLYCARPUS

Born Stockholm, Sweden, 1812. To U. S. as refugee (reason: he married a Jewess), 1842.

To N. Y. C., 1849; operator for Brady. Active Chicago, 1849-55. Appointed Vice Consul for Sweden, Norway, Denmark. Exh. N. Y. C., 1853-54. Died Chicago, 1859; cause believed poisoning from photographic chemicals. Chicago *Tribune,* June 10, 1947 (portrait); *HJ,* IV (1853), 287.

WARREN, GARDNER
Active Woonsocket, R. I., 1843.

WEBSTER & BROTHER
E. L. WEBSTER. ISRAEL B. WEBSTER (born Plattsburg, N. Y., 1826). To Louisville, Ky., 1850. Exh. N. Y. C., 1853-54 (Bronze Medal). Israel B. W. retired, 1877. J. S. Johnston, ed., *Memorial History of Louisville,* I, 463.

WESTON, GUILLERMO
American; active Buenos Aires, 1849. J. F. Riobó, *Daguerrotipos . . . en Buenos Aires,* 1949.

WESTON, JAMES P.
Active, N. Y. C., 1851-52, '55-57.

WHIPPLE, JOHN ADAMS
Born Grafton, Mass., 1822. Manufactured chemicals for dag'typing. Opened gallery in Boston with Albert Litch, 1844-46. Dag'-type of moon, 1849; of star, 1850. U. S. Pats. 6056 (crayon dag'types), 1849; 7,458 (crystalotypes), with William B. Jones, 1849. Exh. London, 1851 (Council Medal); N. Y. C., 1853-54 (Silver Medal). Partner of J. W. Black, 1856. Gave up photography, 1874. Died Boston, 1891. *DJ,* II (1851), 83. 114-15, 210; *HJ,* IV (1853), 44; V (1854), 299; *PAJ,* II (1851), 94-95 (portrait); III (1852), 195, 271-72; *AJP,* new series, III (1860), 245, 319; VI (1864), 321-23; Boston *Evening Transcript,* Apr. 11, 1891; *Amer. Annual Photog.,* 1892, p. 242; *Natl Cyclopedia of Amer. Biography,* VII, 525 (portrait).

WHITE, EDWARD
Active N. Y. C., 1843, '44, '50. Dag'type platemaker as well as dag'typist.

WHITEHURST, JESSE H.
Born Virginia, c. 1820. Opened dag'type gallery in Norfolk, Va., 1844; also in Baltimore (opened 1844), Richmond, Va., Lynchburg, Va., Washington, D. C. (active 1850), N. Y. C. (destroyed by fire 1852; purchased by Lawrence). Exh. London, 1851; N. Y. C., 1853-54. Died Baltimore, 1875. *HJ,* IV (1852), 47; *PAJ,* III (1852), 257; *Phila. Photog.,* XI (1875) 300-01 (list of operators).

WHITNEY, EDWARD TOMPKINS
Born N. Y. C., 1820. Jeweler. Taught photog. by M. M. Lawrence, 1844. To Rochester, 1845; partner of Mercer, 1845-48; own gallery, 1849-51; partner of Conrad B. Denny, 1852-54. His photo. of Genessee Falls, Rochester, published *PAJ,* XI (1858), 254. To Norwalk, Conn., 1859. Reminiscences: *Photographic Times,* new series, XI (1881), 345-48.

WHITNEY, JOEL EMMONS
Born Phillips, Me., 1822. To St. Paul, 1850. Learned dag'type process from Alexander Hesler. Gallery in St. Paul, 1851-71. Exh. N. Y. C., 1853-54. Died St. Paul, 1886. T. M. Newton, *Pen Pictures of St. Paul* (1886), 243; B. Newhall in *Minnesota History,* XXXIV (1954), 28-33 (portrait).

WILLIAMSON, CHARLES H.

Active Brooklyn, N. Y. Exh. N. Y. C., 1853-54.

WOLCOTT, ALEXANDER SIMON

Optical designer, mechanic, pioneer dag'-typist. Active N. Y. C. Claimed to have taken portraits by dag'type process in Oct., 1839. Invented mirror camera: U. S. Pat. 1,582 (1840). Opened portrait gallery with John Johnson, 1840. Died Stamford, Conn., 1844. *AJP,* new series, IV (1862), 525.

WRIGHT, L.

Active Pawtucket, R. I., 1853.

ZUKY, ANTHONY

Active N. Y. C. Exh. N. Y. C., 1853-54.

Notes on the Text

1. A WONDER FROM PARIS

1. Morse to F. O. J. Smith, in Samuel Iraneaus Prime, *The Life of Samuel F. B. Morse* (N. Y.: D. Appleton and Co., 1857), p. 36.
2. *The Observer* (New York), April 20, 1839.
3. *Allgemeine Zeitung* (Augsburg), Jan. 27, 1839.
4. *The Observer, loc. cit.*
5. *Ibid.*
6. Charles Chevalier, *Guide du photographe* (Paris: Charles Chevalier, 1854), 3ᵉ partie, pp. 6-7.
7. Arthur Chevalier, *Etude sur la vie . . . de Charles Chevalier* (Paris: Bonaventure & Ducessois, 1862), pp. 18-19.
8. Louis Jacques Mandé Daguerre, *Le Daguerréotype.* An undated broadside, in GEH. Presumably issued in December, 1838, or January, 1839, since the opening of an exhibition of 40 daguerreotypes is announced for January 15, 1839. For facsimile and translation, see *Image,* VIII (1959), 32-36.
9. *The Observer, loc. cit.*
10. Prime, *Morse,* pp. 406-407.
11. *Ibid.,* p. 407.
12. François Arago, *Rapport sur le Daguerréotype* (Paris: Bachelier, Imprimeur -Libraire, 1839), pp. 5-6.
13. "The Daguerre Secret," *Literary Gazette* (London), No. 1179 (Aug. 24, 1839), 538-39. An almost identical account appeared in the *London Globe,* Aug. 23, 1839. It was widely reprinted in the United States *(National Intelligencer,* Sept. 25; *Niles' National Register,* Sept. 28; *Amer. Jour. of Science and Arts,* Oct.; *United States Mag. and Democratic Rev.,* Nov.).
14. Marc-Antoine Gaudin, *Traité pratique de photographie* (Paris: J. J. Dubochet, 1844), p. 6.
15. The first edition is known in only two copies, both in GEH. I am indebted to M. Pierre G. Harmant, archivist of the Société Française de Photographie, for establishing the exact date when this edition was published. For descriptions of the other editions and translations, see my bibliography in Helmut & Alison Gernsheim, *L. J. M. Daguerre* (New York, Dover Publications, Inc., 1968), pp. 198-205.
16. Prime, *Morse,* pp. 407-408.

2. FIRST TRIALS

1. *Journal of Commerce* (New York), Sept. 28, 1839. Reprinted in Carleton Mabee, *The American Leonardo: A Life of Samuel F. B. Morse* (N. Y.: Alfred A. Knopf, 1943), p. 229.
2. *Journal of Commerce,* Sept. 30, 1839. Mabee, *Amer. Leonardo,* p. 229.
3. *Image,* I (Jan., 1952), 2.
4. *Morning Herald* (New York), Oct. 3, 1839. Reprinted in Robert Taft, *Photography and the American Scene* (N. Y.: The Macmillan Co., 1938), pp. 16-17.
5. Seager wrote a 20-page booklet, *The Resources of Mexico Apart from the Precious Metals* (Mexico City: Printed by J. White, 1867), urging agricultural reforms through irrigation, storage of grain, and abolishment of local excise taxes on produce.
6. Letter, Morse to Marcus A. Root, Feb. 10, 1855: Prime, *Morse,* p. 403.
7. J. W. Draper in Marcus A. Root, *The Camera and the Pencil* (Philadelphia: M. A. Root, etc., 1864), p. 340.
8. Taft, *Photography,* p. 29.
9. Root, *Camera and Pencil,* p. 342.
10. Henry Hunt Snelling, *The History and Practice of the Art of Photography* (N. Y.: G. P. Putnam, 1849), p. 9.
11. Julius F. Sachse, "Early Daguerreotype Days," *AJP,* XIII (1892), 306-15.
12. *Ibid.*
13. *DJ,* II (1851), 56-57, 73-80.
14. *Ibid.*
15. U. S. Pat. 1,582 (May 8, 1840): "Method of taking likenesses by means of a concave reflector and plates so prepared as that luminous or other rays will act thereon."
16. François Gouraud, *Description of the Daguerreotype Process* (Boston: Dutton and Wentworth's Print, 1840), p. 14.
17. *The Observer* (New York), Dec. 14, 1839; quoted from *Journal des Débats* (Paris), Nov. 10, 1839.
18. Working directions were reprinted from the translation of Daguerre's manual by J. S. Memes (London: Smith Elder and Co., 1839) in: *The Observer* (New York), Nov. 3, 1839; *Amer. Repertory of Arts, Sciences and Manufactures,* I (Mar. 1840), 116-23; *The Family Magazine,* VII (1840), 415-23, and in Jacob Bigelow's *The Useful Arts* (Boston: T. Webb and Co., 1840), II, 350-67. A translation by J. F. Frazer appeared in *Jour. of the Franklin Inst.,* new ser. XXIV (Nov., 1839), 303-311. A condensation, by William E. A. Aikin, with facsimiles of the illustrations, was published in *Maryland Medical & Surgical Jour.,* I (April. 1840); it was reprinted as a brochure.

3. DAGUERRE'S AGENT

1. Philip Hone, *Diary* (N. Y.: Dodd, Mead & Co., 1927), I, 435.
2. Carleton Mabee, *The American Leonardo: A Life of Samuel F. B. Morse* (N. Y.: Alfred A. Knopf, 1943), p. 234.

3. *Evening Star* (New York), Feb. 24, 1840.
4. *Amer. Annual of Photog.* for 1894, p. 262.
5. François Gouraud, *Description of the Daguerreotype Process* (Boston: Dutton and Wentworth's Print, 1840).
6. [Josiah B. Millet], *George Fuller, his Life and Works* (Boston & New York: Houghton, Mifflin and Co., 1896), p. 14.

4. THE SHAPING OF AN INDUSTRY

1. Quoted from *Alexander's Weekly Messenger,* Jan. 15, 1840, by Clarence S. Brigham in his *Edgar Allan Poe's Contributions to Alexander's Weekly Messenger* (Worcester, Mass.: American Antiquarian Society, 1943), pp. 20-22.
2. Commonwealth of Massachusetts, *Statistical Information Relating to Certain Branches of Industry in Massachusetts for the Year Ending June 1, 1855* (Boston, 1856), p. 591.
3. *PAJ,* VIII (1855), 70.
4. Unpublished notebook of Anson Clark, Stockbridge, Mass., Public Library.
5. *HJ,* X (1858), 36.
6. *The Western Jour.,* VI (1851), 200-201.
7. *PAJ,* VI (1853), 63.

5. BOSTON PIONEERS

1. The only copy I have seen of *The Plumbeian,* Vol. 1, No. 1, Jan. 1, 1847, is in the N. Y. Public Library. It is uncatalogued but can be found bound with a miscellaneous collection of Plumbe's publications under the title *National Plumbeotype Gallery.*
2. Broadside, in Library of the Eastman Kodak Research Laboratories, Rochester, N. Y.
3. Unpublished letter, Apr. 14, 1843. GEH.
4. Unpublished letter from David Harris, Feb. 14, 1843. GEH.
5. Prospectus on back cover of sheet music published by Plumbe. In N. Y. Public Library, bound with *National Plumbeotype Gallery.*
6. *Daily Express & Herald* (Dubuque, Iowa), May 30, 1857.
7. *British Jour. of Photog.,* XVIII (1871), 530-31.
8. I. N. Phelps Stokes, *The Hawes-Stokes Collection of American Daguerreotypes by Albert Sands Southworth and Josiah Johnson Hawes* (N. Y.: The Metropolitan Museum of Art, 1939), p. 6.
9. *Ibid.*
10. Quoted by L. C. Champney in his unpublished letter to Southworth, Jul. 14, 1843. GEH.
11. Unpublished letter, Apr. 28, 1843. GEH.
12. Unpublished letter, Jul. 17, 1843. GEH.
13. Unpublished letter, Mar. 9, 1843. GEH.

14. Unpublished letter, Aug. 7 and 9, 1843. GEH.
15. Unpublished letter, Nov. 12, 1844. GEH.
16. *Photo-Era,* XVI (1906), 104-107.
17. *British Jour. of Photog.,* XVIII (1871), 583.
18. U. S. Pat. 3,085 (Jul. 11, 1854): "Improvement in taking daguerreotypes for stereoscopes." U. S. Pat. 12,700 (Apr. 10, 1855): "Plate-holder for cameras."
19. *Worcester Spy* (Worcester, Mass.), Jan. 6, 1886.

6. INNOVATIONS FROM PHILADELPHIA

1. *Wilson's Photographic Mag.,* XXVI (1889), 182-84.
2. In 1845, according to family records kindly sent us by Voigtländer A. G., Peter Friedrich Wilhelm Voigtländer married Nanny Langenheim, sister of Frederick, William, and Louisa Langenheim.
3. *Wilson's Photographic Mag.,* XXVI (1889), 182-84.
4. Unpublished letter. GEH.
5. Unpublished letter. GEH.
6. U. S. Pat. 4,369 (Jan. 30, 1846).
7. U. S. Pat. 3,085 (May 12, 1843).
8. Unpublished letter, Feb. 5, 1846. G.E.H.
9. Unpublished letter, Feb. 16, 1847. G.E.H.
10. British Pat. 8,842 (Feb. 8, 1841); French Pat. 10,627 (Aug. 20, 1841); U. S. Pat. 5,171 (Jun. 26, 1847).
11. Unpublished letters. Quoted by courtesy of Mr. Harold White, who is writing a definitive biography of H. Fox Talbot.
12. Undated broadside. GEH.
13. From the Greek, meaning "glass print." The word was used as early as 1840 by Fr. V. W. Netto in his *Die Glasdruckkunst, oder Hyalotypie* (Quedlinburg und Leipzig: Gottfried Bassel, 1840).
14. U. S. Pat. 7,784 (Nov. 19, 1850).
15. U. S. Pat. 7,458 (Jun. 25, 1850).
16. U. S. Pat. 9,611 (Mar. 8, 1853).
17. U. S. Pat. 12,451 (Feb. 27, 1855).

7. THE BROADWAY GALLERIES

1. *DJ,* I (1850), 49.
2. Cornelius Mathews, *A Pen-and-Ink Panorama of New York City* (N. Y., 1853), pp. 35, 37.
3. *Image,* I, No. 3 (Mar. 1952), 2.
4. *PAJ,* VII (1854), 103.
5. *HJ,* V (1853), 222.

6. *PAJ*, IV (1852), 384.
7. *Gleason's Pictorial Drawing-Room Companion,* IV (1853), 21.
8. *HJ*, V (1854), 273.
9. *PAJ*, VIII (1855), 76.
10. *HJ*, VI (1854), 15.
11. Undated trade card. GEH. Between Mar., 1853, and Dec., 1854, Brady operated two galleries in N. Y. C.
12. John Werge, *The Evolution of Photography* (London: Piper & Carter, 1890), pp. 200-203.
13. *PAJ*, VI (1853), 127-29.
14. *PAJ*, VII (1854), 96.

8. ITINERANTS AND TRAVELERS

1. From a clipping dated Mar. 4, 1848, in the Langenheim archives, The American Museum of Photography, Philadelphia.
2. *PAJ*, I (1851), 106.
3. Charles Cist, *Sketches and Statistics of Cincinnati in 1851* (Cincinnati: W. H. Moore & Co., 1851), p. 187.
4. *Cincinnati Daily Enquirer,* Jul. 15, 1854.
5. Unpublished letter, Anson Clark to Messrs. Bewell & Sizer, Feb. 17, 1842. Public Library, Stockbridge, Mass.
6. Reminiscences of Jacob J. Anthony, *Niagara Falls Gazette,* April, 1914.
7. Unpublished letters of L. C. Champney to Southworth, Nov. 2, 1844. GEH.
8. *Lockport Daily Courier,* Jul. 19, 1853.
9. *St. Louis & Canadian Photographer,* XXIII (1899), 327.
10. Quoted by Gilberto Ferrez, *A Fotografia no Brasil* (Rio de Janeiro: Privately published, 1953), p. 6. The three daguerreotypes taken by Compte are reproduced by Ferrez.
11. For a full account of the introduction of daguerreotyping by Louis Compte to S. America, see José Maria Fernández Saldaña, "La Fotografía en el Río de la Plata," *La Prensa,* Jan. 26, 1936; Julio F. Riobó, *La Daguerrotipia y los Daguerrotipos en Buenos Aires* (2d ed.; Rio de Janeiro: The Author, 1949).
12. *PAJ*, I, (1851), 239.
13. *APB*, XII (1881), 110-12.
14. John L. Stephens, *Incidents of Travel in Yucatan* (London: John Murray, 1843), I, 175.
15. *Ibid.,* pp. 100-105.

9. FACING THE CAMERA

1. Ralph Waldo Emerson, *Journals, 1841-1844* (Boston: Houghton Mifflin Co., 1911), pp. 100-101.
2. *APB*, XV (1884), 63.

3. Nathaniel Parker Willis, *The Convalescent* (N. Y.: Charles Scribner, 1859), pp. 286-87.
4. Samuel Iraneaus Prime, *The Life of Samuel F. B. Morse* (N. Y.: D. Appleton and Co., 1875), pp. 404-408.
5. *The Crayon*, IV (1857), 44-45.
6. Advertisement of H. N. Macomber in *Lynn Democrat* (Lynn, Mass.), Dec. 14, 1844.
7. Théophile Gautier, *L'Abécédaire du Salon de 1861* (Paris: E. Dentu, 1861), p. 297.
8. *DJ*, III (1851), 52.
9. *HJ*, IV (1852), 12.
10. Quoted in *N. Y. Times,* Oct. 8, 1933.
11. Robert Taft, *Photography and the American Scene* (N. Y.: The Macmillan Co., 1938), p. 59.
12. Unpublished letter. The Library of Congress.
13. Emerson, *Journals,* p. 111.
14. Henry David Thoreau, *Journal,* Walden ed. (Boston: Houghton Mifflin Co., 1906), I, 189.

10. THE EXPLORERS

1. T. A. Barry & B. A. Patten, *Men and Memories of San Francisco in the Spring of '50* (San Francisco: A. L. Bancroft and Co., 1873) pp. 143-44.
2. (1) Smithsonian Institution; (2) George Eastman House, Rochester, N. Y.; (3) Coll. Zelda P. Mackay, San Francisco (left hand half) and Library of Congress (right hand half); (4) American Antiquarian Society, Worcester, Mass.; (5) Coll. Mr. Billy Pearson, La Jolla, Calif.; (6) California Historical Society, San Francisco, Calif. Except for (1), which was taken by William Shew, the makers of the other plates are not known. In the Southworth & Hawes collection at the Metropolitan Museum of Art, New York, is a single plate, possibly taken by Southworth, which may well form part of a panorama.
3. No. 73 in Loys Delteil, *Le Peintre-graveur illustré, Tome second: Charles Méryon* (Paris, 1907).
4. *DJ*, II (1851), 115-16.
5. *Quarterly of the Calif. Hist. Soc.,* XI (1932), 229.
6. The only recorded copy is in the N. Y. Public Library: *Catalogue of Daguerreotype Panoramic Views in California, by R. H. Vance, on Exhibition at No. 349 Broadway* (New York: Baker, Godwin & Co., Printers, 1851). It is a pamphlet of eight pages (including cover-title), containing 131 entries for both single pictures and groups.
7. U. S. 27 Cong., 3 Sess., House of Representatives, Executive, Doc. No. 31.
8. Charles Preuss, *Exploring with Frémont,* translated and edited by Erwin G. and Elisabeth K. Gudde (Norman, Oklahoma: Univ. of Oklahoma Press, 1958), p. 32.
9. *Ibid.,* p. 35.
10. Solomon N. Carvalho, *Incidents of Travel and Adventure in the Far West with Col. Frémont's Last Expedition* (N. Y.: Derby & Jackson, 1860), p. 24.
11. *Ibid.,* p. 68.
12. *Ibid.,* pp. 20-21.
13. Robert Taft, *Photography and the American Scene* (N. Y.: The Macmillan Co., 1938), p. 267.
14. U. S. War Dept. *Reports of Explorations and Surveys . . . for a Railroad to the Pacific Ocean* (Washington, D. C., 1860), I, 103.

15. Francis L. Hawks, *Narrative of the Expedition of an American Squadron to the China Seas and Japan, performed in the years 1852, 1853, and 1854 under the command of Commodore M. C. Perry, United States Navy* (3 vols.; Washington, D. C.: A. O. P. Nicholson, Printer, 1856).

11. A TOOL FOR SCIENTISTS

1. *HJ*, VI (1854), 73.
2. *PAJ*, VII (1854), 224.
3. Dorrit Hoffleit, *Some Firsts in Astronomical Photography* (Cambridge, Mass.: Harvard College Observatory, 1950), p. 22.
4. *Ibid.*, p. 19.
5. U. S. Pat. 6,056 (Jan. 23, 1849).
6. *PAJ*, III (1852), 271-72.
7. Hoffleit, *Astronomical Phot.*, p. 25.
8. *Ibid.*, p. 27.
9. *Ibid.*
10. *Amer. Jour. of Science and Arts*, XL (1841), 139.
11. Great Exhibitions of the Works of Industry of All Nations, *Reports by the Juries* (London, 1852), p. 279.

12. A QUEST FOR COLOR

1. U. S. Pat. 2,522 (Mar. 28, 1842): Benj. R. Stevens and Lemuel Morse of Lowell, Mass., "Improvements in the mode of fixing daguerreotype impressions so as to allow of colors being applied to same." U. S. Pat. 3,085 (May 12, 1843): Warren Thompson, of Philadelphia, Penn., assignor to Montgomery P. Simons, "Improvements in coloring daguerreotype pictures."
2. Louis Figuier, "La Photographie," *Revue des Deux-Mondes*, XXIV (1848), 127.
3. No copy of the first edition has been located. A second edition appeared in 1850; it was published in four parts, of which the fourth was a pamphlet titled *The Magic Buff*.
4. *PAJ*, I (1851), 116.
5. *Ibid.*, p. 337.
6. *Ibid.*, p. 338.
7. *Ibid.*, p. 339.
8. Unpublished letter. The Library of Congress.
9. *DJ*, II (1851), 340.
10. *Ibid.*, ρ. 337-38.
11. Levi L. Hill, *Treatise on Heliochromy* (1856), pp. 28-30.

12. *New York Times,* Nov. 21, 1851.
13. The letter was translated into French in *La Lumière,* II (1852), 24.
14. Unpublished letter. The Library of Congress.
15. Quoted in *Scientific American,* Oct. 23, 1852.
16. U. S. 32 Cong., 2 Sess. Senate Report 427; Serial 671.
17. *Scientific American,* Apr. 2, 1853.
18. *Liverpool Photographic Jour.,* II (1855), 99-100.
19. *Ibid.*
20. *Amer. Jour. of Photog.,* new ser., IX (1867), 268-70.
21. *Yearbook of Photog.,* 1890, pp. 38-51.
22. *Ibid.*
23. Translated from *Annales de Chimie et de Physique,* 3ᵉ série, XXII (1848), 451-59.
24. *Ibid.*
25. Translated from *Annales de Chimie,* XXV (1849), 447-74.
26. *Ibid.*
27. A color reproduction of this unique color photograph appears in J. M. Eder, *Geschichte der Photographie* (Halle: Wilhelm Knapp, 1932), II, plate III.
28. *HJ,* XVI (1865), 315-16.

13. PHOTOGRAPHY TRIUMPHANT

1. U. S. Pat. 11,213 (Jul. 4, 1854), "Improvements in the preparation of collodion for photographic pictures." U. S. Pat. 11,266 (Jul. 11, 1854), "Improvement in compositions for making photographic pictures." U. S. Pat. 11,267 (Jul. 11, 1854), "Improvement in photographic pictures upon glass."
2. *AJP,* new. ser., IV (1861), 112.
3. U. S. Pat. 14,300 (Feb. 19, 1856): H. L. Smith of Gambier, Ohio, assignor to William Neff and Peter Neff, Jr., of Cincinnati, Ohio, "Photographic pictures on japanned surfaces."
4. Edward M. Estabrooke, *The Ferrotype and How to Make It* (Cincinnati, O., & Louisville, Ky.: Gatchel & Hyatt, 1872), p. 77.
5. *APB,* XV (1884), 62-67.
6. *Sunlight Sketches; or, The Photographic Text Book* (N. Y.: H. H. Snelling, 1858), p. 26.

14. THE AMERICAN PROCESS

1. *Photographic Mosaics,* 1871, p. 45.
2. James F. Ryder, *Voigtländer and I in Pursuit of Shadow Catching* (Cleveland: Cleveland Printing and Publishing Co., 1902), p. 16.

3. U. S. Pat. 8,513 (Nov. 11, 1851).

4. Advertisement in *The Massachusetts Register* (Boston: George Adams, 1852), p. 328.

5. *Daily Evening Transcript* (Boston, Mass.), May 30, 1840.

6. Unpublished letter, Jan. 25, 1848. GEH.

7. In a letter to Southworth, dated Apr. 14, 1843, Page states that he is using "Bince's" plates.

8. In a letter to Southworth, dated N. Y., Dec. 14, 1844, Edward White states: " . . . we have commenced manufacturing plates . . . $3.50 per doz. $36 per gross." On Dec. 20, White elaborated: "We import the metal, but it is rolled, planished, polished and finished in our own establishment. . . . The person who is working for us is the same person that showed Scovill first how to make plates (a Mr. Read)." Both letters in GEH.

9. *PAJ*, V (1853), 165-67.

10. Unpublished letter, A. E. Osborn to Southworth & Hawes, May 8, 1848. GEH.

11. *Wilson's Photographic Mag.*, XXVI (1889), 183.

12. The discovery of hypersensitizing the daguerreotype plate by the use of haloids other than iodine has also been credited to Paul Beck Goddard of Philadelphia by Julius F. Sachse, *Amer. Jour. of Phot.*, XIII (1892), 355-62. The Philadelphian, however, did not place his claim until Jan., 1842, more than a year after John Frederick Goddard described his process in the London *Literary Gazette* for Dec. 12, 1840. See "The Two Goddards and the Improvement of the Daguerreotype," *British Jour. of Photog.*, LXXXIV (1932), 58-59; J. Hughes, "The Bromine Question," *op. cit.*, XI (1864), 166-67.

13. Unpublished letter. GEH.

14. *DJ*, I (1850), 60.

15. Unpublished letter, A. E. Osborn to Southworth & Hawes, May 8, 1848. GEH.

16. *PAJ*, I (1851), 35.

17. *PAJ*, VIII (1855), 76.

18. *Photographic Times*, XIV (1889), 130-31.

19. Unpublished letter, C. K. Wentworth to Southworth, Oct. 7, 1844. GEH.

20. Samuel D. Humphrey, "The American Daguerreotype Process," in: Robert Hunt, *Photography* (N. Y.: S. D. Humphrey, 1852), pp. 229-51.

21. *HJ*, IV (1852), 288.

22. *Ibid.*

23. Levi L. Hill, *A Treatise on Heliochromy* (N. Y.: Robinson & Caswell, 1856), p. 25.

24. Samuel D. Humphrey, *A System of Photography*, (2nd ed.; Albany: Printed by C. Van Benthuysen, 1849), pp. 47-48.

25. Translated from Fizeau's memoir, read on Mar. 23, 1840, to the Academy of Science in N. P. Lerebours, *A Treatise on Photography* (London: Longman, Brown, Green, and Longmans, 1843), p. 55.

26. Samuel D. Humphrey, *American Hand Book of the Daguerreotype* (5th ed.; N. Y.: S. D. Humphrey, 1858), p. 47.

27. Unpublished letter, GEH.

28. Unpublished letter, GEH.

29. Unpublished letter, GEH.

30. *British Jour of Photog.*, XXVI (1889), 184.

31. *HJ*, V (1853), 201.

Notes on the Plates

6. Signed on back, "George Read, Phila.—July, 1842."

7. Philadelphia directories show that Ferdinand Arnold, 63 Chestnut Street, and W. W. Keene and Co., 61 Chestnut Street, were neighbors only in 1843-45.

8. The fine daguerreotype of John Quincy Adams was acquired by The Metropolitan Museum of Art, New York, from the estate of Josiah Johnson Hawes, and was catalogued as the work of the Southworth & Hawes gallery. The presence of the hallmark "SCOVILL MFG CO" on the upper right hand corner of the plate indicates that the daguerreotype was made after the death of Adams in 1848, for the firm of J. M. L. and W. H. Scovill did not adopt this name until 1850. It is thus clear that the daguerreotype is a copy. Recently I acquired a daguerreotype portrait of a certain Joseph Ridgway, seated in the identical chair, with the same carpet, table, lamp, fireplace and mantelpiece that appear in the Adams portrait. On the mat is printed "P. Haas. Washington City, 1843." My attribution of the Adams portrait to Haas is confirmed by the note in Adams's diary that he sat for Haas in October, 1843. Haas published a lithograph of a similar portrait of Adams "taken from a Daguerreotype" in the same year; it is an alternative pose, with the identical chair that appears in the Metropolitan Museum's daguerreotype. The discovery of the Ridgway portrait confirms the deductions of Marvin Sadik in his exhibition catalogue, *The Life Portraits of John Quincy Adams*, Washington, D. C., The National Portrait Gallery, 1970, plate 41.

9. Andrew Jackson's granddaughter, Mrs. Rachel Jackson Lawrence, was present when a daguerreotype almost similar to this was taken by Dan Adams of Nashville, Tennessee, on April 15, 1845. "I have a vivid recollection of the arrangement for taking this likeness," she wrote in *McClure's Mag.*, IX (1897), 803. "He was much opposed to having it taken and was very feeble at the time. I still have the old plates of some earlier daguerreotypes, but they are entirely faded out."

11. It is possible that this may be one of the daguerreotypes taken by Edward Anthony for his "National Daguerreian Miniature Gallery." See Paul M. Angle, "American Photography, 1845-1865," *Chicago History*, IV, No. 1 (1954), 2-5.

12. The penthouse is Whitney's gallery; the men standing on the roof are probably his assistants. Whitney moved into this new gallery in 1851; his neighbors Nelson Hawley, bookbinder, Brown and Williams, carpet ware, and James Z. Newcombe, dry goods, all moved out of the building in 1853.

19. Frederick Warren, city marshal of Worcester, Massachusetts, died November 13, 1858, by the accidental discharge of a revolver in the hand of the deputy sheriff of Charleston, South Carolina.

20. Barnard wrote in *PAJ,* VII (January, 1854), 9-10, that this daguerreotype "was made in my room by sky-light, on a scale plate. . . . It represents an aged Canadian Woodsawyer and his son, surrounded by the instruments and objects of their labor, enjoying their noon-tide meal. The old wood-sawyer is sitting on the buck, and on one end of the table, and the boy, in an attitude of overworked fatigue, is coiled up on the wheel-barrow, the instrument of his industry. . . ." It won honorable mention in Anthony's Prize Competition, 1854.

25. "The locomotive 'Hoosac' . . . was built by John Souther of Boston in 1854 for the Fitchburg R.R., at that time running between Boston and Fitchburg, Mass. . . . The locomotive had 16 x 20″ cylinders, 54″ drivers and weighed 54,000 lbs. . . . The Fitchburg R.R. sold this locomotive on March 15, 1862, to the United States Government and they placed the locomotive in service on the U. S. Military R.R. in Virginia. In 1865 it was sold to the Baltimore and Ohio R.R." From a letter to the author dated March 3, 1949, from Charles E. Fisher, President, Railway and Locomotive Historical Society, Inc.

26. A wood engraving from this daguerreotype was published in the *Illustrated News* (New York), August 27, 1853, with the note: "From an excellent daguerreotype by Mr. L. Wright of Pawtucket, R. I., taken a few minutes after the catastrophe." The collision between the trains, which were bound for Uxbridge and Providence respectively, happened on August 12, 1853. It was caused by miscalculation of the conductor—whose watch was slow. Fourteen were killed. Robert L. Wheeler, "Conductor's Watch Slow, 14 Die," *Providence Sunday Journal,* October 25, 1953.

37-38. The two daguerreotypes we reproduce are the second and third of the series of eight which form a panorama of two miles of the Ohio River, from the foot of Vine Street, Cincinnati, to the village of Fulton. The daguerreotypes were taken from Newport, Kentucky. All eight plates are reproduced in *Bul. of the Hist. and Philos. Soc. of Ohio,* VI (April 1948), 28-39, with identifications of the buildings by Carl Vitz. Capt. Frederick Way, Jr., has identified in detail the steamboats in a mimeographed report accompanying a set of twenty photographs, obtainable from the Steamboat Photo Company, 121 River Avenue, Sewickley, Pennsylvania. The panorama was exhibited at the Franklin Institute, Philadelphia, 1849 (highest premium); Maryland Institute, 1849 (highest premium); Great Exhibition of the Works of Industry of All Nations, London, 1851.

44. A photograph of this daguerreotype is reproduced as Figure 1 in F. H. Meserve and C. Sandburg, *The Photographs of Abraham Lincoln* (1944) with the note: "Believed to have been made by N. H. Shepherd in Springfield, Ill., in 1846. Mr. Robert Todd Lincoln, who owned the original, stated to the author that he believed it was made in Washington about 1848."

50. A wood engraving from this daguerreotype appears in *Harper's New Monthly Mag.* VI (1852), 88*.

54. Probably taken during Lola Montez's first American trip; she was in New York City from December 5, 1851, to January 19, 1853.

57. The school has been identified as the Emerson School, Boston. See I. I. Phelps Stokes, *The Hawes-Stokes Collection of American Daguerreotypes by Albert Sands Southworth and Josiah Johnson Hawes* (New York: The Metropolitan Museum of Art, 1939), p. 20.

58. From this daguerreotype a lithograph by F. D'Avignon, dated 1859, was published by C. H. Brainard, Boston.

61. A daguerreotype identical to this, except that it is a mirror image, is in the J. Pierpont Morgan Library, New York. A photograph of it, with the caption "Washington Irving—from Daguerreotype by Plumbe—1849—aet. 66" appears as an illustration in *Washington Irving: Mr. Bryant's Address on his Life and Genius* (New York: Putnam, 1860).

63. One of a stereoscopic pair, acquired by the George Eastman House with the original "Grand Parlor and Gallery Stereoscope" of 1854.

69. Tentatively identified as the ship *The Champion of the Seas,* by Mr. John Leavitt of Marblehead, Massachusetts.

80. Fred Coombs, whose name is stamped on the plate, appears as daguerreotypist in the San Francisco directory for 1850 only. In the following year the firms Sabatie and Maubec, and D. L. Ross, whose names appear on signs, moved from Montgomery Street, and Kendig and Wainwright changed their style to Wainwright, Byrne and Co. Hence this daguerreotype was undoubtedly taken in 1850, and is one of the earliest photographs of San Francisco in existence.

86. A wood engraving of this scene, "made in the fall of 1853," was published in *Gleason's Pictorial,* March 25, 1854. It is reproduced in J. H. Jackson, *Gold Rush Album* (New York: Charles Scribner's Sons, 1849), p. 192.

95. A wood engraving from this daguerreotype, with a short biography of Chief Justice Shaw, appears in *Gleason's Pictorial,* I (1851), 320.

96. In 1808 all slaves in New York State under sixty-five were freed. Caesar, owned by Francis Nicoll, was seventy-one at the time. The daguerreotype was taken in 1851, a year before his death at the age of 114. *N. Y. Genealogical and Biographical Record,* LVI (1925), 65-67.

99. A wood engraving from this daguerreotype in *L'Illustration* (Paris), XXXIV (December 17, 1859), 429, credits Whipple and Black as the photographers.

101. Dated "about 1854" by Robert Taft in his *The Appearance and Personality of Stephen A. Douglas* (reprinted from *The Kansas Historical Quarterly,* Spring, 1954). Taft knew the daguerreotype only from reproductions.

102. An almost identical daguerreotype is in the Museum of Fine Arts, Boston. An engraving of the head is reproduced in H. C. Lodge, *Daniel Webster* (Boston: Houghton, Mifflin and Company, 1899) with the note: "From a daguerreotype taken Apr. 29, 1850, by J. J. Hawes, Boston."

104. An image identical to this daguerreotype, but reversed, is reproduced as Fig. 9 in F. H. Meserve and C. Sandburg, *The Photographs of Abraham Lincoln* (1944) with the note: "A photograph of the daguerreotype believed to have been made by C. S. German in Springfield in 1860. Major William H. Lambert of Philadelphia, who owned the original, was unable to give the compiler its history, but he believed it was made in 1858."

168

Selected Bibliography

PERIODICALS

American Journal of Photography. New York: 1852–67.

Microfilm: Xerox University Microfilms, No. 4634.

The Daguerreian Journal. New York, 1850–51. Continued as *Humphrey's Journal, Devoted to the Daguerreian and Photogenic Arts* (1852–62), *Humphrey's Journal of Photography, Chemistry, and Pharmacy* (1862-63); *Humphrey's Journal of Photography and the Heliographic Arts and Sciences* (1863); *Humphrey's Journal of Photography and the Allied Arts and Sciences* (1863–70). New York: 1852–70.

Microfilm: Helios Microfilms, Daguerreian Era, Pawlet, Vermont.

The Photographic Art-Journal. New York: 1851–54. Continued as *The Photographic and Fine Art Journal.* New York: 1854–60.

Microfilm: Helios Microfilms, Daguerreian Era, Pawlet, Vermont.

DAGUERRE MANUAL

Daguerre, Louis Jacques Mandé. *Histoire et description du procédé nommé le Daguerréotype.* Paris: Giroux, 1839. 79 pp. + 6 plates.

This, now rare, first edition of Daguerre's manual is the basis of all others. It is reproduced, with one of the many translations into English, in facsimile by Winter House Ltd., New York, 1971. A bibliography of all known editions and translations in book form appears in the above work and in Gernsheim's *L. J. M. Daguerre,* cited below. The instructions were widely published in American periodicals: see p. 158, note 18.

AMERICAN MANUALS

The following titles are the most important. For a complete bibliography of books on photography published before the Civil War, see Albert Boni, *Photographic Literature,* New York; Morgan & Morgan, Inc., 1962, pp. 236–39.

Bisbee, Albert. *History and Practice of Daguerreotyping.* Dayton, O.: L. F. Claflin & Co., 1853. 104 pp.

Facsimile reprint: New York: Arno Press, 1973.

Croucher, John H. *Plain Directions for Obtaining Photographic Pictures by the Calotype and Energiatype . . . Also, Practical Hints on the Daguerreotype.* Philadelphia: A. Hart, late Carey & Hart, 1853. 224 pp.

Facsimile reprint: New York: Arno Press, 1973. This English manual also appeared under the imprint of H. C. Baird, Philadelphia, in editions dated 1855 and 1860.

Gilman & Mower. *The Photographer's Guide, in which the Daguerrean Art is Familiarly Explained.* Lowell, Mass.: Samuel O. Dearborn, printer, 1842, 16 pp.

Haley, W. S. *The Daguerreotype Operator. A Practical Work, Containing the Most Approved Methods for Producing Daguerreotypes.* New York: Printed for the Author, 1854. 80 pp.

Hill, Levi L. *A Treatise on Daguerreotype; the Whole Art Made Easy, and All the Recent Improvements Revealed.* Lexington, N. Y., Holman & Gray, Printers, 1850, 4 vols. in 1.

Facsimile reprint: New York: Arno Press, 1973.

2d ed., with title *Photographic Researches and Manipulations, Including the Author's Former Treatise on Daguerreotype.* Lexington, N. Y.: Holman & Gray, 1851. 2d ed. revised and enlarged, with same title: Philadelphia: Myron Shew, 1854.

Humphrey, Samuel Dwight. *A System of Photography; Containing an Explicit Detail of the Whole Process of Daguerreotype.* By S. D. Humphrey and M. Finley. Canandaigua, N. Y.: Printed at the Office of the Ontario Messenger, 1849. 82 pp.

Facsimile reprint in R. Sobieszek, ed., *The Daguerreotype Process: Three Treatises,* New York: Arno Press, 1973. Second edition, without by-line of Finlay: Albany, C. Van Benthuysen, 1849. 144 pp.

—— *American Handbook of the Daguerreotype.* New York: S. D. Humphrey, 1853. 144 pp.

Fifth ed., 1858. Facsimile reprint: New York: Arno Press, 1973.

Hunt, Robert. *Photography . . . with Additions by the American Editor.* New York: S. D. Humphrey, 1852. 290 pp.

Reprint of the most important English manual, with important original chapter by Humphrey.

Simons, Montgomery P. *Photography in a Nut Shell; or, The Experiences of an Artist in Photography, on Paper, Glass and Silver.* Philadelphia: King & Baird, 1858. 107 pp.

Snelling, Henry Hunt. *The History and Practice of the Art of Photography.* New York: G. P. Putnam, 1849. 139 pp.

Facsimile reprint: Hastings-on-Hudson, N. Y.: Morgan & Morgan, 1970. Second ed., 1850. 3rd ed., 1851. 4th ed., 1853.

—— *A Dictionary of the Photographic Art.* New York: H. H. Snelling, 1854. 236 pp.

—— *A Guide to the Whole Art of Photography.* New York: H. H. Snelling, 1858. 80 pp.

MODERN ACCOUNTS

Gernsheim, Helmut & Alison. *L. J. M. Daguerre: the History of the Diorama and the Daguerreotype.* New York: Dover Publications, 1968. 246 pp.

Contains a chapter on the daguerreotype in America.

Rinhart, Floyd and Marion. *American Daguerrean Art.* New York: Clarkson N. Potter, Inc., 1967. 140 pp.

Rudisill, Richard. *Mirror Image; the Influence of the Daguerreotype on American Society.* Albuquerque: University of New Mexico Press, 1971. 342 pp.

Sachse, Julius F. "Philadelphia's Share in the History of Photography." *Journal of the Franklin Institute,* CXXXV (1893), 271–87.

Taft, Robert. *Photography and the American Scene; a Social History, 1839–1889.* New York: The Macmillan Company, 1938. 546 pp.

Reprinted without change: New York: Macmillan, 1942, and (paperback) New York: Dover Publications, 1964.

Index

173